New Approaches to
Ruskin

New Approaches to
Ruskin

Thirteen Essays

Edited by
Robert Hewison

Routledge & Kegan Paul
London, Boston and Henley

First published in 1981
by Routledge & Kegan Paul Ltd
39 Store Street, London WC1E 7DD,
9 Park Street, Boston, Mass. 02108, USA and
Broadway House, Newtown Road,
Henley-on-Thames, Oxon RG9 1EN
Set in IBM Baskerville, 11 pt. by
Donald Typesetting, Bristol
and printed in Great Britain by
Redwood Burn Ltd, Trowbridge, Wiltshire

Library of Congress Cataloging in Publication Data

New Approaches to Ruskin.

1. Ruskin, John, 1819-1900 — Criticism and interpre-
tation — Addresses, essays, lectures. I. Hewison,
Robert, 1943- .
PR5264.N4 828'.8'09 81-10563
ISBN 0-7100-0915-1 AACR2

In Memoriam Alan Lee
1943-1981

Contents

vii

Contents

Illustrations

Editor's Preface

All the contributions to this volume were written specially
for the occasion. They were chosen to represent the wide
variety of approaches it is possible to make to the work of
John Ruskin, from art history to economic theory, and they
are not intended to present a particular 'view'. Rather, they
are a celebration of the multi-disciplinary nature of Ruskin's
own work. In the interests of simplicity, the essays have been
arranged chronologically in order of the works or periods in
Ruskin's life they discuss.

The editor and contributors wish to thank George Allen &
Unwin Ltd and the Ruskin Literary Trustees for permission
to publish previously unpublished Ruskin manuscript material,
and gratefully acknowledge the help of those institutions in
Britain and North America which granted access to Ruskin
manuscripts.

Robert Hewison

A Note on the References

References to Ruskin's published works, his diaries and editions of his correspondence have been standardized and included in the text according to the following code:

The Works of John Ruskin, Library Edition, eds E.T. Cook and A. Wedderburn, 39 vols (London, George Allen 1903-12) are referred to in parentheses, thus vol. 28, p. 312 = (28.312).

The Diaries of John Ruskin, eds J. Evans and J.H. Whitehouse, 3 vols (Oxford, Clarendon Press 1956-9) are referred to as *D*, thus vol. 2, p. 401 = (*D*2.401).

In like manner

(*LN*) = *Letters of John Ruskin to Charles Eliot Norton*, ed. C.E. Norton, 2 vols (Boston and New York, Houghton Mifflin 1904).
(*RFL*) = *The Ruskin Family Letters (1801-1843)*, ed. V.A. Burd, 2 vols (Ithaca and London, Cornell University Press 1973).
(*1845L*) = *Ruskin in Italy, Letters to his Parents 1845*, ed. H. Shapiro (Oxford, Clarendon Press 1972).
(*RLV*) = *Ruskin's Letters from Venice 1851-1852*, ed. J.L. Bradley (New Haven, Yale University Press 1955).
(*WL*) = *The Winnington Letters of John Ruskin*, ed. V.A. Burd (Cambridge, Massachusetts, Harvard University Press, and London, George Allen & Unwin 1969).
(*LMT*) = *The Letters of John Ruskin to Lord and Lady Mount-Temple*, ed. J.L. Bradley (Columbus, Ohio State University Press 1964).

A Note on the References

(RLPT) = *Reflections of a Friendship: John Ruskin's Letters
to Pauline Trevelyan 1848-1866*, ed V. Surtees
(London, George Allen & Unwin 1979).

A Note on the Contributors

Van Akin Burd is Distinguished Professor of English (Emeritus) at the State University of New York College at Cortland. He is the editor of *The Winnington Letters, The Ruskin Family Letters* and *John Ruskin and Rose La Touche*. He is currently working on an edition of a group of Ruskin's letters from Venice in 1876-7, which Ruskin titled *Christmas Story*.

Patrick Conner is Keeper of Fine Art at the Royal Pavilion Art Gallery and Museums, Brighton. He is the author of *Savage Ruskin*.

John Unrau is a lecturer in English Literature at York University, Toronto. He is the author of *Looking at Architecture with Ruskin*, and is currently writing a book about Ruskin and St Mark's, Venice.

Nick Shrimpton teaches English at Lady Margaret Hall, Oxford, and is currently working on an edition of Matthew Arnold's poetry.

Alan Lee taught history at the University of Hull. He contributed to several studies on newspaper history and wrote on conservatism in the British Labour Movement. He died just before this volume went to press.

George P. Landow is Professor of English at Brown University, Providence, Rhode Island. His two most recent books, both published by Routledge & Kegan Paul, are *Victorian Types, Victorian Shadows* and *Images of Crisis*.

John Hayman is an Associate Professor of the University of Victoria, British Columbia. He is currently preparing an edition of Ruskin's letters from the Continent in 1858.

John D. Rosenberg is Professor of English at Columbia University. His publications include *The Darkening Glass: A Portrait of Ruskin's Genius*, and *The Fall of Camelot*. He is currently completing a book on Carlyle and the historical imagination.

Dinah Birch is a Research Fellow at Merton College, Oxford. She is currently writing a study of Ruskin and Oxford.

David-Everett Blythe studied at the University of North Carolina at Chapel Hill, and was formerly Instructor of English at Randolph-Macon College. He has published on Shakespeare and Ruskin.

Jeffrey L. Spear is an assistant Professor at Princeton University. He is currently preparing a study of Ruskin as a literary critic to be titled *Ruskin Reading*.

Brian Maidment teaches English at Manchester Polytechnic. He is completing a study of social concerns in mid-Victorian popular fiction.

Robert Hewison is the author of *John Ruskin: The Argument of the Eye* and *Ruskin and Venice*. He is currently preparing a book on the Ruskin Art Collection at Oxford, for the Lion & Unicorn Press, Royal College of Art.

1

Ruskin's Testament of his Boyhood Faith:
Sermons on the Pentateuch

Van Akin Burd

INTRODUCTORY NOTE

I take pride in recalling that in 1954 I served the University of Illinois Press as a reader of Helen Gill Viljoen's manuscript, *Ruskin's Scottish Heritage*, and strongly urged its publication. In a review which I wrote later for the *Modern Language Quarterly*, I asserted that this book began a new era in Ruskin scholarship because Viljoen proved the danger in basing our view of Ruskin's life primarily on his autobiography *Praeterita* and the Introductions which Ruskin's editors, E.T. Cook and Alexander Wedderburn, prepared early in this century for the Library Edition of his works, documenting as they did Ruskin's own portrayal of the development of his mind. Viljoen intended this volume to serve not only as a study of Ruskin's parents and hence a prelude to a full-scale biography of Ruskin which her death in 1974 prevented her from completing, but also as a demonstration of the need to tell his story contemporaneously from the Ruskin manuscripts, many of which were – and still are – unpublished.

Not until I had sorted through the papers which Viljoen bequeathed to me did I realize that during the same years that she was completing the *Heritage*, she was also editing the sermons on the Pentateuch which Ruskin had written as a boy of twelve and thirteen. The five little booklets which he had made for his fair copies of these sermons had been generally unknown to scholars because of the failure of his editors to list them properly in their bibliography of Ruskin's manuscripts. W. G. Collingwood was familiar with at least one of the booklets, including in his *Ruskin Relics* (1903) a facsimile of a page from what we know now is the third volume of the set, a manuscript which had already been given to the Ruskin Museum in Coniston. Although Ruskin's editors refer in one place to the *books* of his sermons (35. lxxx), they include in their listing of Ruskin's notebooks only the one volume which Collingwood had used and which they now misdate 1827 (38.206). The other four volumes presumably were preserved at Brantwood, Ruskin's home near Coniston, until the final dispersal

of his papers in 1930 when these booklets made their way into the hands of the Rev. J.S. Ladd-Thomas, later the Dean of the School of Theology at Temple University, who acquired them as a gift from a friend living near Brantwood. After the death of Ladd-Thomas in 1959, Viljoen was given the booklets as a token of her friendship with the family. Combined with the volume in the Coniston Museum the five booklets made available to Viljoen the completed text of nineteen sermons and the rough draft of two more, constituting more than 40,000 words written on 94 leaves of manuscript. Viljoen left the four sermon books to the Pierpont Morgan Library where for the first time qualified scholars may study them. Unable to find a publisher for her edition of the sermons because of their specialized interest, she left with me her transcript of them and the Introduction, the latter consisting of 127 pages of typescript, which she had written for this work, hoping that I would share with readers of Ruskin her convictions about the importance of these sermons as a basis for understanding the growth of his religious thought.

The *Sermons on the Pentateuch* (as Helen Viljoen titles the series) provide the only contemporaneous record of the religious beliefs with which Ruskin had been indoctrinated during his boyhood and the quality of his response to this teaching. These sermons are not to be confused with the abstracts which he and his cousin Mary Richardson would compile of the sermons they had heard that morning in Beresford Chapel (35.72). Examinations of these abstracts in the homemade booklet of MS no. 11 of Ruskin's juvenilia at Yale University shows that they are little more than fragmentary notes.[1] Compared to the abstracts, these sermons show by their length and content a growth in Ruskin's power to sustain thought. They are written, not on a miscellany of topics such as one might expect to hear from the pulpit from Sunday to Sunday, but as a carefully organized commentary on events and characters in the Pentateuch and the laws which God gave to guide man's conduct then and now. Each sermon is worked out with regard for the traditional principles of rhetoric and for the larger theme of the sermons as a whole.

In central concept, Viljoen writes in her introduction to her unpublished edition, 'the *Sermons* develop the thesis that out of all-embracing knowledge, God gave laws and dealt with man in society antedating profane history so that instant needs were met by words and acts' foreshadowing future events and containing instruction timelessly immediate.[2]

She intended to present the sermons in four parts, the first to include the opening nine discourses which deal with the world before the flood, then the deluge and Noah's fathership of post-diluvian mankind and events recorded in sacred history. Sermons X through XIII, an interpretation of the ceremonial laws given in Leviticus, make up Part II. Sermons XIV through XIX, dealing with the moral law of the Commandments delivered to Moses, constitute Part III. The last section, sermons XX and the uncompleted XXI, begin Ruskin's analysis of the civil and judicial law of the Mosaic economy.[3]

In her study Viljoen corrects the errors of Ruskin's editors E.T. Cook and Alexander Wedderburn in misdating and misinterpreting his 'sermon-books' – another demonstration of the unreliability of the editorial apparatus in the Library Edition of Ruskin's *Works*. The contents of the *Sermons*, she agrees, may not seem to tell us more about the religion of Ruskin's youth than we knew from his autobiography *Praeterita*, that is, that Margaret Ruskin steeped her son's childhood in her own Evangelical faith. His mother, he declares on the opening page of his autobiography, had it 'deeply in her heart to make an evangelical clergyman of me' (35.13). His account of his daily study of the Bible and his list of the chapters he committed to memory are well known (35.40, 42). It was his mother's 'unquestioning evangelical faith in the literal truth of the Bible' that placed him as a boy 'in the presence of an unseen world', a faith which set his 'active analytic power early to work on the questions of conscience, free will, and responsibility' (35.128). But, precisely, what did he believe? From the tenets of Evangelicism and Ruskin's later statements, writers, including myself (*WL*.55-63), have conjectured answers. 'But there is a great difference between conjecture and genuine knowledge,' Viljoen reminds us; 'between the abstract and the concrete; between the hostile and mocking, yet nostalgic, memories, of a man who had suffered because of the indoctrination of his youth – and the living faith of a boy, eloquently spoken through his very script' (p. xi). The other notebooks of Ruskin's juvenilia show the interests of this lively adolescent in drawing, mineralogy, writing poetry, and his studies with his tutors. Viljoen sees the *Sermons* as one more occupation of his youth in which he would show the reasonableness of his religious faith 'without questioning his assumption that the whole truth of God was contained in his beliefs' (p.lvii).

3

In effect, these *Sermons* review what he had learned from his mother and pastors like Mr Burnet, and what he himself might some day preach as a Bishop - his father's vision of him in the future.

The first of the main ideas which Viljoen finds in Ruskin's *Sermons*, an analysis which I can only abstract here, adding some illustrations and comment from my own reading of the sermon books, is his belief in the truth and proper study of the Bible. A 'book of divine origin'[4] 'drawn by the pen of inspiration' (S1:5.13ᵛ), as he describes the Bible in the *Sermons*, each word is an expression of Divinity as represented by the Old Testament Jehovah. The 'signs and wonders' recorded in the Bible are there for our instruction (S2:8.13ᵛ). The study of the text should be conducted 'line upon line, and precept upon precept', as the guide which God gave us (S2:8.12ᵛ), 'the very ground of our faith' - to be 'unqualifiedly' accepted (S1:5.14ᵛ). The more we thus examine and meditate upon the Bible, 'the more we shall believe in the sanctity of its origin and the wisdom of its author' (S2:7.6ᵛ).

Although we must accept on faith those parts of the Bible 'placed above our comprehension' (S1:5.14ᵛ), the Old Testament provides evidence 'capable of proving the perfect truth of those statements' (S2:6.2ᵛ). God has shown himself when he repeated to Isaac the promise which he had first made to Abraham (S2:6.3ʳ); similarly he had assumed the form of man when he told Abraham of his proposal to destroy Sodom (S1:5.15ᵛ). His appearance to Moses in the fiery bush left 'no handle ... for unbelief' (S4:12.1ʳ). Further evidence comes from events in the lives of the patriarchs which serve as 'a lamp unto our feet and a light unto our path' (S2:6.5ʳ): the apparent choice of Moses, for example, as God's agent, since he never would have dared otherwise to deliver the Commandment against idolatry to 'that whole assembly of more than three millions' of his idol-loving followers if he had been 'an imposter' (S4:15.11ʳ). Miracles also testify to the Bible's truth because they could have been worked only through God's power (S2:8.10ʳ). It is 'the obstinacy of the human heart' which prevents men from recognizing the meaning of the Bible. If the young Ruskin doubted the truth of the Bible, he would consider himself worse than Pharaoh who refused to heed the miracles

performed by Moses. 'No, I know the nature of the God to whom the wonders recorded in the bible are ascribed, and if therefore I neglect to examine into them, my conduct is infinitely more reprehensible' ($S2:8.11^v$, 12^r).

The Bible is not only a source of truth but also a history of mankind not otherwise available, the annals of profane history, as in Herodotus, not beginning until 'nearly two thousand years later than the aera [*sic*] of the deluge' ($S1:2.5^r$). In the *Sermons*, this history begins after the Creation and Fall, a period of wickedness and violence brought about through the intermarriage of the sons of Cain (children of the world and hence the authors of the arts in whose origin 'we have no reason to be proud' ($S1:1.2^r$)), and the daughters of Seth (children of the church). Seeing no abatement of vice in their progeny, God gave them a probation period of 120 years followed by one more opportunity for reform, the warning contained in the building of the ark. Their rejection of this warning, Ruskin declares, 'is among the very strongest proofs on record, of the utter wickedness of the human soul' ($S1:2.3^r$). Ruskin closes his second sermon with a disposal of the 'infidel objections' which have been raised against belief in the actuality of the flood ($S1:2.4^r$-6^v).

Ruskin's account of this early history testifies to what he had called his early 'active analytic power' as he searches for answers to difficult questions. Words such as *cherubim* must be precisely defined. Exactly what is meant by saying that God *set a mark* on Cain ($S1:1.1^r$, 2^r)? Viljoen comments that the *how's* and *why's* seem incessant: how could Abraham have been a blessing to all nations when, under the dispensation, the blessing had been limited to one nation ($S1:5.15^v$); why should Cain have been judged *wicked* in offering God the first fruits of his husbandry ($S1:1.2^r$)? 'Thus the *Sermons* served to express and to satisfy his own inquiring mind,' Viljoen writes, 'perhaps too highly trained for his own good when he was, at most, thirteen' (p.lxii).

The third major theme which Viljoen finds in the *Sermons* is Ruskin's perception of God as Father and of the Son as sacrifice, deeply-felt beliefs which make the *Sermons* a new source of insight into Ruskin's later life. As a child he had already made the association between his Father on earth and the Father in heaven. 'In the first place,' he observes in his *Sermons*, approaching the Ten Commandments, 'children are to be taught to reverence their earthly parents, must they

5

not then much more be taught to reverence their heavenly parent. Nothing can be easier, than to lead the mind of the child from one to the other, . . . and fellowship will be found between the feelings of duty to the parent, and of duty towards God' (S4:14.7v). The deity of the *Sermons* is the Jehovah of the Pentateuch. Although 'a kind and faithful Creator' who always watches over the welfare of his people (S2:7.9r), nevertheless this Father can be a god of wrath and 'irresistible power' when 'obstinately braved' (S2:8.1r).

In the discourses devoted to the ceremonial laws set forth in Leviticus Ruskin stresses the law of sacrifice as the foundation of the Mosaic economy. The sacrifice of a lamb 'pure, . . . a male without blemish' on whose head the penitent places his hand 'in order to communicate the load of his sins and his wickedness to the animal' (S3:10.9v, 9r) is a harbinger of a later economy in which man may find atonement through God's sacrifice of Christ. The sacrifice, according to Mosaic law, must be appropriate. The highest of God's creations, man, would not have been appropriate for this later economy because the Almighty had created him, along with the other creatures of nature, by fiat (S3:10.11r). The only choice was the Father's only son who could make atonement for our sinfulness, not necessarily for any particular sin, but for 'the weakness of the carnality itself, which was continual and which required continual offering' (S3:11.14v).

The law of Moses, as Ruskin reads it, could not compel a man to bring his sacrifice to the altar, but disobedience is the sin which will sow the whirlwind of selfishness, pride, passion, and obstinacy which we see in transgressors. The young Ruskin, who took such pleasure in summer travels, recognizes that even the novelty of change of situation is no substitute for the satisfactions of obedience. 'It is true, that in this life, a monotonous succession of the same objects, and ideas would produce lassitude in the mind . . . and we find likewise that a change . . . will give a new spring to the nerves.' He reminds us, however, that throughout these changes of scene we carry our native depravity. 'No, there must not only be a new scene, but also a new eye to behold it' (S3:9.4v, 5r).

Ruskin's stress on the Law of Sacrifice makes the *Sermons* extraordinarily prophetic of his personal life. In the relationship with his immediate father, who was godlike in generosity to *his* son but as insistent as Jehovah in demanding attendance,

Viljoen comments, 'it is as though Ruskin lived out thoughts and attitudes which he had recorded as a boy. Emotionally he never outgrew the child in all that bound him to his parents' (p.lxiv). So destructive was this love that when John James died, Ruskin wrote to Henry Acland that he had lost a father who would have given his whole life for his son, 'and yet forced his son to sacrifice his life to him, and sacrifice it in vain' (36.471). Viljoen points out that in line with the Mosaic law some part of Ruskin's nature had led him to choose to sacrifice himself on the paternal altar; otherwise he could not have been forced to make this sacrifice. 'This phenomenon,' she writes, 'the *Sermons* help to make more comprehensible through their exposition of his early beliefs about man and God, and the role played by the Son' (p.lxiv).

The sermons on the Moral Law which analyse the Mosaic ideals of personal and social behaviour with an emphasis on obedience as an Ideal of Conduct, the fourth theme of Viljoen's analysis, are to her 'rewardingly suggestive to those concerned with Ruskin's childhood as the seed-bed from which came his later thought and vision' (p.lxvii). We find in these sermons his views on matters like truthfulness, lust, prayer, church attendance, observance of the Sabbath, war, benevolence *v.* selfishness as a social principle, the qualities of a nation's greatness. Those who know the development of Ruskin's ideas will recognize the persistence of these early convictions in his later years even after he had come to see Christianity as but one expression, as Viljoen describes this turn in his thought, of man's long search for moral values (p.lxviii).

Of all ideals in conduct, obedience receives the greatest attention in Ruskin's *Sermons*, and especially obedience to parents. When Moses delivered the Ten Commandments, he exempted neither man nor angel from 'obedience throughout all eternity' ($S3:9.4^v$). To only the Fifth Commandment does Ruskin devote a full sermon. God phrased this ordinance '*honour*' rather than '*obey* thy parents' inasmuch as godless parents might command ungodliness. This injunction 'tells, with increased power, upon those children who have Christian parents', Ruskin asserts. Unless these parents make a demand against right, which Ruskin finds 'almost impossible' to conceive, their children should obey them, 'not only to please them, but as an act of obedience to a higher parent; Such obedience is the foundation of all the harmony of

society' ($S4$:17.16r).

Parental obedience, Ruskin had maintained in an earlier sermon, includes submission on what a child thinks. When 'children first begin even to think, they generally begin to assert independence of judgment, this is a very strong example of human depravity and it must be checked at once' ($S4$:14.7v). These sermons, Viljoen reminds us, are themselves an exercise in reason, a constant temptation for an adolescent with this quality of mind to use 'independence of judgment'. The young Ruskin is fully aware of the dangers. In one of his many passages on the heinousness of doubt, he writes that in our search for the full meaning of Scripture we sometimes forget the faithful Creator, becoming 'as suspicious, as if we were moving in the country of an artful, and vigilant enemy, and where an ambush was laid for us in every thicket'. How different was Abraham who required no explanation when the Lord told him to leave his country for the land of Canaan ($S1$:4.11r, 13r). If children are to 'find their own pleasure and walk in their own ways,' Ruskin asks in his sermon on the Fifth Commandment, 'how can we expect those to be able to govern, who have never been governed?' No one can doubt, he concludes in this passage, 'that a constant submission to the parents' authority, would terminate in a better state of the nation' ($S4$:14.15v).

The rough drafts of Sermons XX and XXI show that Ruskin proposed to examine here the Mosaic judicial and civil law to argue 'that the law of Moses in every thing essential, is the same with the law of Christ' ($S5$:20.6r), and to deal with the central theme of his choice of texts, Deuteronomy 27-30 – the fruits of obedience as contrasted with the curses of disobedience. Confronted with the need to analyse the many penalties of disobedience, the fifth of the ideas which Viljoen identifies in the *Sermons*, the young Ruskin seems to lose heart and fails to develop his notes into a finished version.

In these chapters of Deuteronomy Moses is delivering his final charge to his followers who are about to enter the promised land without him. Setting before them the choice of life and death as blessing or curse, he urges them to 'choose life, that both thou and thy seed may live' (Deuteronomy 30:19). Viljoen rightly comments that read with any feeling of identification, Deuteronomy 27 and 28 can become terrifying chapters. As the people enter Jordan they will

hear two speakers, so Moses commands, one of whom is to remind them of the terrible consequences of disobedience. 'Cursed be the man that maketh any graven or molten image ... that setteth light by his father or his mother ... that removeth his neighbour's land-mark', and so on for another nine prohibitions in chapter 27. In the next chapter the curses mount from verses 15 through 68 with remorseless intensity. If you do not heed the Lord's commandments, Moses declares, 'all these curses shall come upon thee. . . : Cursed shalt thou be in the city, and cursed shalt thou be in the field The Lord shall send upon thee cursing, vexation, and rebuke, in all that thou settest thine hand unto for to do, until thou be destroyed.' On and on these curses come with a cumulative power, Viljoen believes, 'that can reach the core of conscience and of consciousness. One cannot know the immediate background against which the boy read these passages, or their immediate effect upon him' (p.lxxiii).

Ruskin's notes reveal his struggle to justify the details of the many restrictions of the Mosaic economy. 'Nothing left to the discretion of the people,' he writes of the civil law, 'or the whole system which God established might have been overturned.' The moral law is not so minute. 'But the ten commandments will be found to contain the prohibition of every sin' ($S5:20.6^r$). Of the privileges allotted to the priests, Ruskin asks, 'Now what is life, if all privileges be disallowed[?]' The distinction is for the benefit of the people. The wisdom of the Lord is also evident in the restrictions on property, that all land should be returned every fifty years to the original owners or their descendants ($S5:21.9^r$). Sermon XXI breaks off with Ruskin's effort to deal with the Mosaic prohibition of sexual intercourse between the Israelites and their heathen neighbours. 'First there was to be no intercourse of a close and intimate nature no marriage, that would have introduced idolatry. But they might deal slightly with nations around.' The boy's uncertainty shows in his deletions. 'It appears that it was the intention of God to mingle Life. . . . We should not permit ourselves to enter into any enterprise that is not connected with the gospel.' Viljoen thinks it not unmeaningful that a few lines later the *Sermons* come to an abrupt stop. With the Bible we are superior to the mightiest hero. 'How criminal if we do not take advantage of the Salvation held forth in this', so reads the last line to which he neglected to add terminal punctuation ($S5:21.11^r$).

A testament to his boyhood faith, the *Sermons* provide not only a fresh orientation to Ruskin's early religious views but another means of understanding his development in later years. In one of the sermons Ruskin stresses the need for belief as well as faith in the new life available to us through God's sacrifice of his Son. 'Yet faith merits nothing, without thus believing' (*S5*:20.5ʳ). This quality of belief which runs so deeply in the *Sermons* helps us understand why it took Ruskin nearly forty years to discover 'the falseness of the religious doctrines' in which he had been educated, as he would describe them in his autobiography (35.482). That moment in 1858 when he put away his Evangelical beliefs 'to be debated of no more' is well known in *Praeterita*. Now at age thirty-nine, he had won 'reluctant leave' from his father to spend the spring and summer without his parents in Switzerland and Italy. It was the contrast in Turin of a morning service in a Waldensian chapel in which the preacher ranted against the wickedness of the world and the afternoon visit to the Picture Gallery where, standing before the glowing colours of Veronese's *Queen of Sheba before Solomon*, he realized at last 'that things done delightfully and rightly were always done by the help and in the Spirit of God' (35.496).

In her notes Viljoen highlights the persistence of Ruskin's Evangelical convictions before that dramatic moment, two decades when his writings included most of *Modern Painters* and *The Stones of Venice*. When thirty-four years old he was still memorizing chapters of the Bible (12.lxxviii); and every day, true to his early training, he studied the Scripture. During the same period he continued to think of God as still the Jehovah of wrath who reserved the mercy of Christ's atonement for those whom he chose to save. The Rev. F.D. Maurice had shocked Ruskin in 1851 by insisting that redemption through Christ was 'not of us but of the whole world'. What could he mean by this, Ruskin had demanded of him in a letter. 'It would be . . . the beginning of another life to me, if you could justify those words' (12.565). The most significant change in Ruskin's religious attitudes is his outgrowing, by 1853, of much of the anti-Catholicism with which his parents had indoctrinated him. In *Praeterita* he recalls his pleasures with his first fourteenth-century missal and his discovery that all beautiful prayers were Catholic, those which he heard in church being only the debris of the

great Catholic collects (35.492). His purpose in *Notes on the Construction of Sheepfolds* (1851) was to argue that High and Low Churchmen and Scotch Presbyterians could be united within the Church of England, a conviction which shows that he was also outgrowing the sectarianism of his youth.

The books of his young manhood, as Viljoen observes, 'were always essentially religious in their drive but seldom marked . . . by beliefs which were distinctly Evangelical. From the first he must have felt that these books were a chief part of his service to God, *his* preaching as a layman who would appeal not primarily to those who haunted Evangelical chapels but, rather, to all who sought God in an England which was . . . religious in its Protestantism' (p.lxxxiv). The religious thought of *Modern Painters* Volume 1 (1843), she points out, does not reflect the *Sermons* so much as Carlyle's theory of the God-sent Hero which Ruskin adapted to his defence of Turner. In *Modern Painters* Volume 2, however, we do find direct expression of the doctrine of the *Sermons* in passages such as those on the depravity of human nature and the love of change as a symptom of the imperfection of human nature (4.176-7, 98-9).

One by one Ruskin set aside old beliefs, often with distress or reluctance which the *Sermons* can illuminate. In his daily scriptural investigations in the summer of 1858, mulling over the varying accounts of one of Christ's miracles, he cries out in his notes, 'Observe . . . the absurdity of claiming verbal accuracy for Scripture' (34.682). The American artist W.J. Stillman, amazed at Ruskin's strict observance of Sunday in 1860, convinced him that there was no authority either for the transference to Sunday of the Mosaic strictures against work on the seventh day of the week, or for the claim that Christ rose on the first day of the week, the basis for the Christian observance of Sunday in commemoration of the Resurrection. To all of this, according to Stillman, Ruskin exclaimed in desperation, 'If they have deceived me in this, they have probably deceived me in all.' Under the impression that Ruskin had never given any previous thoughts to these matters, Stillman was perplexed that he was unable to persuade Ruskin to respect the spirit rather than the letter of the Gospel.[5] The American would not have realized that years earlier his companion had explored these issues in his *Sermons*, satisfying himself that although God had com-

manded rest on the seventh day of the week in recognition of what whas then his greatest achievement, the Creation, he later set this aside for the 'greater marvel' through which he provided for man's salvation. Thus the authority for the observance of Sunday in memory of the Resurrection 'is the authority of God' (*S*4:16.13ᵛ).

His new love for the Evangelical child Rose La Touche did not save him from Bye-path Meadow, so he confesses to Charles Eliot Norton in the summer of 1861 (36.367). He writes to his father a few months later that he no longer believes in the Fall of Man except as 'every man is his own tumbler'.[6] Meanwhile to the children at Winnington Hall he was composing 'Sunday letters' whose overt purpose was to interpret key words of Christian doctrine such as *faith, holiness,* the *Atonement,* but on a deeper level to liberate his readers from Evangelical views. The *Sermons,* of course, are harbingers of these letters in structure, tone, and their passion for careful definition of difficult words. For the schoolmistress of Winnington he summarizes in 1861 the religious precepts of which he could then be certain: the need to attend to the health of the body, to be kind to others, to pursue our work with patience, and to disregard questions which God has left unanswered (*WL*.340-1).

By 1862 Ruskin was repudiating concepts which lay beyond merely Evangelical beliefs but were fundamental to all Christian thought. As Viljoen points out, these included 'his belief in God the Father who had sent his Son as a sacrifice; consequently, in the Divinity of Christ and in the miracle of the Resurrection; therefore in Personal Immortality' (p.ci). His letter to Elizabeth Barrett Browning, written in May 1861, shows the progress of his thoughts in this direction. He is stunned under the weight of discovering 'the myriad errors' that he had been taught; 'every reed that I have leant on shattering itself joint from joint I have that bitter verse pressing me, "I am a worm, and no man." What is a worm to hope for?' (36.364). He yearned for the poppy or mandragora, so he writes in 1863 to Miss Bell at Winnington, which would keep him from waking to face the loss of his faith in the Resurrection (*WL*.404). To his distressed father who had declared that he would give up half of his possessions if his son could recover the faith of his youth, Ruskin writes in 1861 that he must remain an iconoclast looking forward to some new form of Christianity (36.384).

'What think ye of Christ?' he asks Miss Bell in 1863 as the 'main question' (*WL*.397). The problem is to search the Scriptures for the historical figure of Jesus whom Ernest Renan was describing in his *Life of Jesus* as the most divinely great of all human beings. 'So glad I am about *Renan*', Ruskin writes to Miss Bell, as he hears of her interest in him (*WL*.355). Well acquainted now with the liberal theological opinions of *Essays and Reviews*, one of whose writers argues that Scripture must be interpreted like any other book, and the heretical Bishop John Colenso who accepts portions of the Old Testament as legendary, Ruskin is shifting to faith in a Supernal Spirit, incomprehensible to man, but not a 'senseless power', as Socrates had observed, so Ruskin writes Norton in 1861 (36.381). To live within this faith demanded of Ruskin what Viljoen terms the 'new ethics' splendidly proclaimed in *The Crown of Wild Olive* (1866) where he urges his readers to expect no jewelled circlet in heaven but 'only some few leaves of wild olive' here for having toiled for the peace of *this* world (18.398). Reviewing Ruskin's agonizing realization that he should rewrite all his earlier books because of the mistaken views under which they had been conceived, Viljoen is convincing in her belief that 'his very phrasing of this thought, expressed with hyperbolic intensity, connotes his memory of that fatal teaching - fatal because of its vitality - through which, he felt, his youth had been betrayed' (p.cix).

Elsewhere I have traced the steps of Ruskin's reconciliation with what he called a more Christian view of life, begun by his study of Giotto at Assisi in 1874 and intensified by experiences with spiritualists after the death of Rose La Touche in 1875 through which he regained his hope for personal immortality.[7] Viljoen sees the serious study of mythology which Ruskin had begun by 1865 as leading to this direction of his thinking. If the Resurrection was only a Christian myth, to comprehend the *nature* of mythology had become essential for Ruskin, she writes. He would say to Norton in 1870: 'My long training in Hebrew myths had at least the advantage of giving this habit of always looking for the under-thought' (37.20). An understanding of the myths of Greek literature and Egyptian art, he asserts in *The Queen of the Air* (1869), casts light upon 'the legends of our own sacred book', all great myths being the product of 'true imaginative vision' (19.298, 309) – by which he means know-

ledge gained through the intuitive apperception which he had described in *Modern Painters* Volume 2. The vision comes involuntarily 'as a dream sent to any of us by night when we dream clearest', emanating from that Spirit, as Ruskin cites Paul, in which all things live, and move, and have their being (19.309, 356). Thus in his lectures to his Oxford students in the 1870s Ruskin sees the Christian dogma of the *Sermons* as the formalization of a mythology which embodied vital truth expressing through imaginative insight the convictions of a people while Christianity was a living faith.

Viljoen shows that, in harmony with the training of his youth, until the end he held the Bible to be the essential book of education. In 1877 he tells the readers of his public letters in *Fors Clavigera* that in one of the Epistles we find repository 'of beliefs which, whether well or ill founded, have been at the foundation of all the good work that has been done, yet, in this Europe of ours' (29.109). Viljoen proves from Ruskin's unpublished correspondence with Henry Swan that in the schools of St George he wanted the Bible presented as a congeries of books with emphasis upon the different dates of their composition. For a pass children should know by memory at least five hundred lines of verse chosen from the Bible and selected poets (29.502-3).

In 1876, soon after a spiritualist had told Ruskin that she had seen the ghost of Rose standing beside him, Ruskin writes to Norton: 'I have no *new* faith, but am able to get some good out of my old one, not as being true, but as containing the quantity of truth that is wholesome for me. One must eat one's faith like one's meat, for what good's in it' (37.194). Dominantly, Viljoen writes of Ruskin's later years, 'he seems to have "*hoped*" that this promise of another life was among the "truths" of Christian "legend" ' (pp.cxxiv-v). Although he would jest that he was too wicked to go to heaven,[8] in 1888 he told Kathleen Olander (the reincarnation of his Rose) of his confidence in 'the immortal life opening to us both'.[9] Wordsworth was wrong in implying that heaven lies about us only in our infancy, he had remarked in *Fors* a few years earlier: 'if life be led under heaven's law, the sense of heaven's nearness only deepened with advancing years, and is assured in death' (29.457). By no means had Ruskin come full circle since the writing of the *Sermons*, but he had struck an arc on course with the faith of his youth. He disclaimed the honour of being the sheep who had returned to the fold,

he writes in his *Letters to the Clergy on the Lord's Prayer and the Church* (1879): 'The best I can be sure of, myself, is that I am no wolf.' In his later life, Viljoen suggests in her last note, Ruskin was enacting the faith he had described to these same clergymen when he assured them that among the Biblical confessions Paul's, in Acts 24:14 'is the one confession in which I can myself share: "After the way which they call heresy, so worship I the Lord God of my fathers" ' (34.216, 225).

NOTES

1 'Mary and I thought that we remembered a great deal,' Ruskin writes to his father in 1829 after one of these sermons (*RFL* 1.179), 'but when we came to write it down we found that we did not remember so much as we thought' – an impression confirmed in the abstracts of that year. Although the script of the *Sermons on the Pentateuch* is so small that it often requires magnification, the writing is almost all in ink composed in Ruskin's best boyhood hand, exhibiting the grace and legibility he would later expect of students in the schools of the Guild of St George (29.486). To each of the sermons he assigns a number and title.

2 Helen Gill Viljoen, 'Ruskin's *Sermons on the Pentateuch* and His Religious Life', typescript, p.xliii. Hereafter references to this typescript, in the possession of Van Akin Burd, will appear in the text by page numbers within parentheses.

3 Viljoen found it difficult to establish the degree of Ruskin's originality in these sermons. In the margin of the last page of the first volume of the sermons, Ruskin's mother has written 'J.R. written sermon of Mr. Burnetts', an ambiguous notation which could be understood to mean that one of the discourses was derived from a published ('written') sermon delivered around 1832 by the Reverend John Burnet of Camberwell Chapel. But none of Mr Burnet's sermons seems to have been printed before 1834. Margaret Ruskin may well have intended the note for a booklet containing some of her son's sermon abstracts. Viljoen, agreeing that it seems incredible for even a gifted boy of twelve to thirteen to conceive this body of material without outside help or inspiration, nevertheless believes that to some extent, at least, the *Sermons* are 'indubitably original' (p.xlvi). From the rough drafts of five of the sermons to be found in three of the Red Books of Ruskin's juvenilia at Yale, we may observe the care with which the boy develops the final sermons found in his fair copies. To what often begins as pedestrian prose, Ruskin adds the resonance and rhythms which would later characterize the style of the first volume of *Modern Painters*. 'If the rough draft represents

15

an abstract of the reasoning which the boy found in some source,'
Viljoen concludes, 'he must have felt thoroughly identified with the
content and authorship, through thus re-working the material, by
the time his fair copy was completed' (p.xlviii).

4 Sermon Book 4, Sermon 14, folio 6ᵛ, MS, The Pierpont Morgan
Library. Hereafter references to Ruskin's Sermon Books will appear
in the text within parentheses, the notation to begin with S and the
number of the sermon book; followed by the number of the sermon;
and (the leaves of the books being unnumbered) by the number of
the folio and abbreviation for *recto* or *verso*: as (S4:14.6ᵛ). The
holographs of Sermon Books 1, 2, 4, and 5 are located at the Morgan
Library; of Sermon Book 3 at the Ruskin Museum, Coniston. I am
indebted to the Trustees of the Morgan Library and Mr B.K. Bilton,
Curator of the Ruskin Museum, for permission to cite these books;
to Messrs George Allen & Unwin Ltd, the Literary Trustees of John
Ruskin, for permission to include these previously unpublished
passages from the writings of Ruskin.

5 William J. Stillman, *The Autobiography of a Journalist* (Boston and
New York, Houghton Mifflin 1901), I: 314-17.

6 Van Akin Burd (ed.), *John Ruskin and Rose La Touche: Her Un-
published Diaries of 1861 and 1867* (Oxford University Press 1979),
p. 60.

7 Ibid., pp. 134-41.
Sir Sidney Cockerell, *Friends of a Lifetime* (ed. V. Meynell)(London,
Cape 1940), p. 26: from letter of 1886.

9 Rayner Unwin (ed.), *The Gulf of Years: Letters from John Ruskin
to Kathleen Olander* (London, Allen & Unwin 1953), p. 60.

2

Ruskin and the 'Ancient Masters' in *Modern Painters*

Patrick Conner

The argument put forward in Ruskin's first major work is bold to the point of recklessness. *Modern Painters: Their Superiority in the Art of Landscape Painting to the Ancient Masters* is the startling title which appeared in 1843 on the boards of his first published volume. This was not the wording which Ruskin had suggested, and after the second edition it was shortened to *Modern Painters*, but the original title gives a fair indication of the theme of the initial volume.

At first sight it seems absurdly contumacious for an Englishman in the early years of Queen Victoria's reign to decry the 'ancient masters' in this way. One might forgive Giorgio Vasari, who had known Michelangelo and Titian, for asserting in 1550 that the artists of his own time exceeded all those who had gone before. But could John Ruskin seriously argue that his own English contemporaries – Turner, Clarkson Stanfield, Harding and Prout – were superior to the established masters of Italy, France and Holland, whose works were admired in the National Gallery by half a million visitors each year?

Ruskin's prefatory remarks prepare the ground for this daring venture. He will not seek to impugn the reputations of the great Italian artists of the High Renaissance, Raphael, Leonardo, Michelangelo and Titian (although by 1870 he had lost his reverence even for these illustrious figures). His targets, whom he lists candidly in an introductory chapter, are almost entirely of the seventeenth century: 'Claude, Gaspar Poussin, Salvator Rosa, Cuyp, Berghem, Both, Ruysdael, Hobbima, Teniers (in his landscapes), P. Potter, Canaletto, and the various Van somethings and Back some-

things, more especially and malignantly those who have libelled the sea' (3.85). Turning to the second volume of *Modern Painters*, we can add to Ruskin's rogues' gallery the Carracci, Guido Reni, Guercino, Domenichino and Caravaggio, all of whom were active in Bologna or Rome at the close of the sixteenth century or in the early years of the seventeenth.

Not all of these artists appeal strongly to modern tastes, and it is unlikely that more than one or two would appear on any artistic 'first eleven' selected in the twentieth century. But at the time when Ruskin wrote, all the artists listed above had a strong following. Among landscape artists Claude le Lorrain stood highest of all in the estimation of British collectors at the beginning of the nineteenth century. The sale in 1808 of the two 'Altieri' Claudes for 12,000 guineas set a long-standing price record, and thirty years later Gustav Waagen, Director of the new Royal Gallery in Berlin and an astute student of British tastes, could still describe Claude as the favourite painter of the English.[1]

Waagen made this comment in the course of a critique of the pictures displayed in the National Gallery which had just opened its doors in Trafalgar Square, and in which Claude was better represented than any other single foreign artist. But it would be a mistake to regard the national collection of this date as a faithful reflection of early Victorian tastes; the preponderance of Claude's work is more justly seen as indicating his reputation during the eighteenth century, during which his tranquil scenes had stood close to the heart of the English ideal of landscape. Forty years after his death Claude already appeared pre-eminent to Jonathan Richardson, who wrote in 1722 that 'of all the Landskip-Painters *Claude Lorrain* has the most Beautiful, and Pleasing Ideas; the most Rural, and of our own Times'.[2] Sir Joshua Reynolds, delivering his fourth Discourse in 1771, thought it indisputable that Claude's practice of eclectic composition 'is to be adopted by Landschape [*sic*] Painters'.[3] A number of English artists were indeed profitably occupied in satisfying the demand for landscapes in the manner of Claude and Gaspar Poussin; and, as the art of landscape gardening reached its peak in the third quarter of the century, Claude's scenes were invoked as models to be followed by the designers of landscaped parks.

But the early years of the nineteenth century saw the

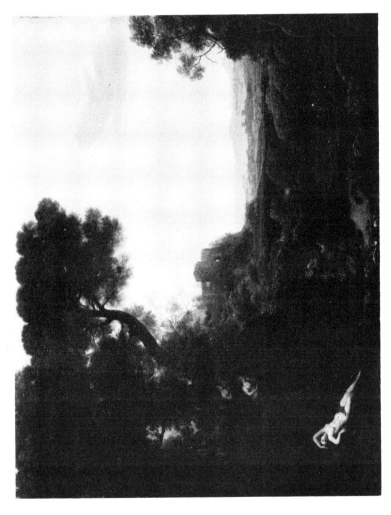

1 Claude le Lorrain, *Landscape with Narcissus and Echo*

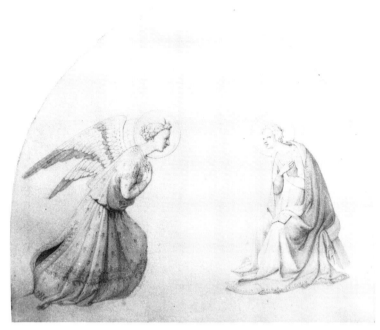

2 John Ruskin, study of the upper section of a reliquary by Fra Angelico, *The Annunciation, and Adoration of the Magi,* in the Convent of San Marco, Florence

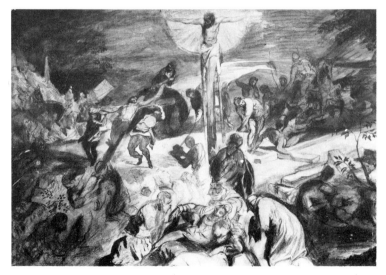

3 John Ruskin, study of the central portion of Tintoretto's *Crucifixion,* in the Scuola di San Rocco, Venice

decline of the Claudeian ideal in landscape painting. One of its last practitioners was the amateur artist Sir George Beaumont, patron of John Constable and possessor of a renowned collection of paintings by Claude. Constable was honoured to be invited to copy them, and certain of his early works show clearly the influence of Claude's art. But more significant in the present context is Constable's refusal to base his own painting on the Claudeian formal conventions and autumnal tones which Beaumont urged upon him.[4] Several of Constable's fellow artists shared his interest in a more immediate representation of unidealized nature. To them the gravel-pits of Kensington on a cloudy day offered more inspiring subject-matter than did the arcadian glow of the Roman *campagna*. In the sphere of gardening, also, the fashion for spacious 'natural' landscapes was superseded in the early nineteenth century by a dozen alternative enthusiasms for flower-breeding, exotic imports, formal patterning, rock gardens or greenhouses. Here again, the Claudeian ideal had lost much of its potency by the end of the Georgian era. It remained only for a critic of sufficient self-confidence to attack the citadel: the art of Claude himself.

In the course of his first volume Ruskin argues that Claude's work is inferior to that of Turner (the supreme representative of 'modern painting') in most of those qualities traditionally sought in a painting: perspective, colouring, chiaroscuro, effects of distance and foreground, diversity and choice of incidental subject-matter. But his most telling line of attack is to set specific passages of Claude's drawing against the standard of nature – nature, that is, as observed in precise detail by Ruskin, but described in such a way that his readers could verify the truth of his observation for themselves. Ruskin's dismissal of Claude's *Landscape with Narcissus and Echo* (plate 1) is typical of his method. The *Narcissus* had been regarded as one of the pearls of Beaumont's collection: Beaumont had imitated its composition in his painting,[5] and Constable relished his opportunity to breakfast in front of it: 'How enchanting and lovely it is, far very far surpassing any other landscape I ever yet beheld.'[6] Shortly afterwards Beaumont presented the picture to the national collection, where it was greatly admired even by Waagen, who had dared to suggest that two of Claude's 'seaports' in the National Gallery did not represent Claude at his most skilful.[7] But Ruskin drew his readers' attention to

19

the stem of the principal tree in the *Narcissus*: 'It is a very faithful portrait of a large boa constrictor, with a handsome tail; the kind of trunk which young ladies at fashionable boarding-schools represent with nosegays at the top of them by way of forest scenery' (3.578). His point is that boa constrictors taper without dividing, whereas trees are structured on the different principle of branching, according to which a trunk or bough becomes thinner only as it gives off shoots.

> Now observe the bough underneath the first bend of the great stem on Claude's *Narcissus*; it sends off four branches like the ribs of a leaf. The two lowest of these are both quite as thick as the parent stem, and the stem itself is much thicker after it has sent off the first one than it was before. (3.580)

One may reply that a few liberties of this kind do not detract from the atmospheric beauty and poetry of Claude's pictures. But Ruskin weakens the reader's defences by repeatedly drawing his attention to the conventional elements in Claude's scenes, such as the architectural background of *The Mill* (also known as the *Marriage of Isaac and Rebekah*), also in the National Gallery: 'I do not remember ever having met with either a city or a fortress *entirely* composed of round towers of various heights and sizes, all facsimiles of each other, and absolutely agreeing in the number of battlements' (3.331). Ruskin was perhaps emboldened to mock *The Mill* by his belief that it was a 'villainous and unpalliated' copy of an original in the Palazzo Doria-Pamphilj in Rome (3.348). Today, however, the version in London is generally accepted as the original, mainly because it corresponds more closely in several details to Claude's drawing in the *Liber Veritatis*, but also on the grounds that the quality of its painting is at least as high as that of the Doria picture.[8] Ruskin's opinion is not so extraordinary, given that it had already been voiced by other authorities, but it does lead us to ask how far the twenty-four-year-old Ruskin had progressed in his study of the seventeenth-century artists whom he condemned so violently. Most of the examples of their work to which he alluded were (and still are) on view in the National Gallery and in the picture-gallery of Dulwich College, near the Ruskin family home at Herne Hill. This circumstance was genuinely useful to Ruskin's readers, or at

least those who lived in or near London, since they could go
and decide for themselves whether Ruskin's criticisms were
just. But the obvious usefulness of referring to accessible
pictures obscures the fact that Ruskin's detailed knowledge
of 'old masters' hardly extended beyond those two galleries.

As a boy he had seen the picture collections of several
great country houses, while he accompanied his father on his
annual round of country clients for the sale of his sherry, but
it is doubtful whether the splendid ranks of portraits by Van
Dyck and Reynolds, Dutch genre pictures and Biblical
subjects by the Bolognese masters, all revealed briefly to him
by courtesy of the housekeeper, left any profound impression
on the small tourist. Later, the Ruskins began to make regular
travels abroad. In 1833 and 1835 the family reached
northern Italy, and Ruskin delighted in the mountains,
rivers and skies of the Alps; there was no suggestion as yet
that the study of pictures should play a major part in his life.
On his third excursion to Italy in 1840-1, a prolonged visit
intended to restore Ruskin's health, he admired those works
of art which the visitor was expected to admire – the paint-
ings of Raphael at Florence, and the sculptures of the
Vatican. On those occasions when he failed to make the
orthodox response, he was inclined to put it down to his
lack of experience: 'Michael Angelo's [figures] I could not
like; must try again tomorrow' (*D*1.108). Throughout this
long tour natural scenery and geology seem to have remained
his principal preoccupations. A few of the entries in his
diaries hint at some of his future concerns: in Venice the
ornament of the Ducal Palace aroused his curiosity, and at
Padua he admired for the first time the faces in the frescoes
of Giotto (*D*1.187-8, 190).

In 1844 the Ruskins' continental tour touched on Italy,
but brought them no further south than the Alps. In the
course of this year Ruskin became conscious that despite
four visits to Italy he had scarcely looked at the artistic
treasures which had been within his reach. Returning to
England via Paris in August 1844 he visited the Louvre, and
was impressed by the paintings of Perugino, Pintoricchio
and Giovanni Bellini; Alexis-François Rio's book *De la
Poésie Chrétienne* had already encouraged him to look more
closely at the works of these early Italian artists. Reviews of
his first volume of *Modern Painters* were generally favourable,
and as the author of that volume he wrote to *The Times*

21

criticizing the conservative buying policy of the National Gallery. Few readers of his letter could have guessed, from its tones of authority and self-confidence, that the writer had made no serious study of Italian art.

The newly appointed Keeper of the National Gallery at this time was Charles Eastlake, and it may be interesting to compare his previous experience with Ruskin's. Fifty years old when he took up the post in November 1843, Eastlake had spent half his adult life on the Continent. He was familiar with the collections and galleries of Germany and the Low Countries as well as those of France and Italy, and he had looked closely at the works of Memlinc and the van Eycks, Giotto, Fra Angelico and Giovanni Bellini, at a time when such artists of the fourteenth and fifteenth centuries were dismissed by all but a very few critics as 'primitive' and 'dry'. Eastlake's knowledge, and his published writing, was based on a detailed scrutiny of thousands of paintings and painters. Ruskin had not yet met Eastlake, but he had only to look, for example, at Eastlake's edition of Franz Kugler's *Hand-Book of the Italian Schools of Painting* (1842) to realize how limited was his own grasp of the stylistic development of painting of the characteristics of individual artists. On his travels Eastlake conscientiously noted the mannerisms of the artists whose works he examined – the consistency of their paint, their colouring and line drawing, their methods of painting flesh, or facial features, or drapery, or vegetation; his was a study designed to enable him to make reliable attributions from stylistic evidence, especially in the field of Italian painting.

In this aim Eastlake very largely succeeded. Until his death in 1865 no Englishman could match his expertise. But Ruskin did not try to emulate Eastlake, for his talents led him on a different course. In March 1845 he left England to study Italian art at first hand. In Tuscany he was captivated by the paintings and frescoes of the fourteenth and fifteenth centuries, and especially the works of Giotto, Masaccio, Perugino, Fra Angelico (above all), and the artists of the Campo Santo at Pisa. Comparing his notebooks with Eastlake's we can see the different attitudes of the two men.[9] Where Eastlake would allocate a few minutes to each of many pictures in a gallery, Ruskin would sweep past the majority and devote an entire morning to one or two paintings. Eastlake drew thumbnail sketches as *aides-mémoires*; Ruskin

copied details of pictures with laborious care, devoting hours to an attempt to recapture the wing or the face of an angel, and often repeating a small passage many times before retiring in despair. In this way he would immerse himself in a painting until he could feel that he understood the mind and soul of its author.

In the twentieth century it is still possible to distinguish, although not always sharply, between two broad approaches to the history of art. One is concerned primarily with interpretation – that is, with explaining the significance of a work of art in terms of the artist's intentions or the civilisation in which he worked. The other is concerned primarily with attribution, and requires a specialized knowledge both of the work of certain artists operating within a given period, and of such contemporary circumstances as the availability of pigments or potential sources of patronage. In the middle years of the nineteenth century Ruskin and Eastlake represented each of these two tendencies in an extreme form. Following the lead of his German colleagues, Eastlake made a systematic collection of observable data, both technical and stylistic, related to the early development of oil painting; in this respect he deserves to be regarded as the first British 'art historian'. But he excluded personal enthusiasm and evaluations from his writing, to an even greater extent than did Kugler and Waagen. At the opposite pole Ruskin revelled in interpretation. He greatly extended (often far beyond the bounds of credibility) the range of phenomena from which conclusions could be drawn about the mind and motives of the artist and his culture.

A clash between these two orientations can be found in Ruskin's cautious review for the *Quarterly* of Eastlake's scholarly and modestly-titled *Materials for a History of Oil Painting* (1847). Ruskin made an effort to match Eastlake's scholarship, quoting the latest French research and the recent translations into English of Theophilus and Cennini. But he was clearly impatient at Eastlake's reluctance to draw conclusions from his array of factual material. Eastlake had described at length the techniques (tempera, fresco and oil) of the early masters; Ruskin could not resist adding his own speculations on how these media affected the 'mental habits' of the artists who employed them (12.270-84).

In the years 1840-50 British tourists began to appreciate the masterpieces of early Italian art. Small groups of artists

and connoisseurs had admired these works in preceding decades, but their interests had not spread beyond specialist circles. An indication of the tastes of the generation before Ruskin's can be found in what was probably the best-known guide-book of the first third of the nineteenth century, Mariana Starke's *Letters from Italy*, rewritten and expanded in 1820 as *Travels on the Continent*. The author used a system of exclamation marks, equivalent to the asterisks of the twentieth-century *Guides Michelin*, to denote the merit of each work of art. Michelangelo's *Last Judgement* was the only painting to receive five exclamation marks; four were awarded to one or more works by Raphael, the Carracci, Correggio, Domenichino, Claude, Nicolas Poussin, Pietro da Cortona and Guido Reni. All these artists flourished in the sixteenth and seventeenth centuries. Works of the fifteenth century were practically ignored: only Ghirlandaio's frescoes in the chancel of Santa Maria Novella, which date from the last years of that century, were allowed a single exclamation mark.

The guide-books of the 1840s were more thorough and serious-minded, and the series published by John Murray was especially influential. Murray's *Hand-book for Travellers in Northern Italy* (1842) was compiled by Francis Palgrave, who anticipated several of Ruskin's predilections. He admired the frescoes of the Campo Santo, and described them at length; in Lucca he noticed the great sensitivity and breadth of style of Ilaria's tomb; in Venice he regarded Carpaccio's St Ursula cycle as 'particularly worthy of attention', and in Florence he was so struck by the paintings of Fra Angelico at the Convent of San Marco that he advised the traveller to 'consider the building as one of the main objects for which he visits Florence'.[10]

This last piece of advice was subsequently withdrawn from the guide-book, thereby illustrating the embarrassment felt by English Protestants over the fact that early Italian art was popularly associated with Roman Catholicism, through the writings of Rio (amongst others) and the neo-purist art of the German Nazarenes in Rome. Several admirers of Rio's artistic tastes felt obliged to dissociate themselves from his Roman Catholicism. When Ruskin came to commend the early Italian masters in the second volume of *Modern Painters* (1846), he tried to exploit their association with the church of Rome by blaming the more bloodthirsty scenes of Giotto

and Angelico on the morbid tendencies of Romanism (4.202). The 1847 edition of Murray's *Northern Italy* included short contributions from Ruskin on early Italian art, including the work of Fra Angelico at San Marco which Ruskin had adored above all else in Florence. But, perversely enough, the appreciation of these pictures given in the 1847 edition is actually less enthusiastic than that in Palgrave's version of 1842. The description of Angelico's painting as 'the highest type of "Catholic art" ' has been removed. Angelico's *Crucifixion*, previously described as his great masterpiece, now receives a lukewarm comment from Ruskin, and the reader is warned that Angelico's work, having suffered from neglect for three centuries, now suffered equally from the undue reverence of the modern German school and their sympathizers.[11]

If Ruskin resented the presence of Catholic propagandists in the rapidly growing cult of the early Italians, he must have found the response of naïve and over-susceptible tourists hardly more welcome.[12] He may have shared Eastlake's view, expressed to a parliamentary Select Committee in June 1853, that a rage for early works of art had grown up among people who lacked taste or sensitivity to the essential elements of painting.[13] But fundamentally Ruskin's attitude was at odds with Eastlake's. For thirty years Eastlake had taken a close interest in the styles and techniques of the early Italians – as precursors of the acknowledged masters. His concern remained very largely historical. Ruskin came relatively late to an appreciation of the quattrocentists, but he was quickly convinced that these artists expressed aesthetic merits in their own right, merits which were different in kind to those displayed by their successors of the 'High Renaissance'.

A contemporary observer might perhaps have predicted that Ruskin would return from Italy in 1845 under the spell of these early artists, who offered a new range of weapons with which to attack the conventions of seventeenth-century painting. Like-minded travellers had undergone this experience before him, and even before leaving for Italy Ruskin had begun to see the potentialities of the paintings he planned to study. But no observer would have anticipated the second revelation which Ruskin experienced in the same year. This occurred in Venice towards the end of Ruskin's tour. His declared purpose in going to Venice was to look at the

pictures of Giovanni Bellini and Titian (*1845L.*167), and his initial fortnight in the city followed the pattern of his visits to Pisa and Florence, for he found more to admire in the first great representatives of the Venetian school, Gentile and Giovanni Bellini, than in their better-known successors. Even Titian disappointed him. Then on 23 September Ruskin visited the Scuola di San Rocco and found himself overwhelmed by the work of Tintoretto – an artist whose vast and violent canvasses were far removed from the calm precision of Angelico and the brothers Bellini. Inventive, rapid and prolific, Tintoretto gambled with abnormal lighting effects and unprecedented notions of composition. The sheer scale of his operations was astounding: after he had been back to the Scuola next day, Ruskin calculated in a letter to his father that he had seen more than sixty of Tintoretto's pictures in Venice, of which three alone measured over 4,000 square feet, all 'covered with mind'. He wrote:

> I have had a draught of pictures today enough to drown me. I never was so utterly crushed to the earth before any human intellect as I was today, before Tintoret. Just be so good as to take my list of painters, & put him in the School of Art at the top, top, top of everything. (*1845L.*211-12)

This episode is surely one of the most remarkable of Ruskin's life. He had just begun to accept the idea that the sixteenth century was a period of decadence in Italian culture; and now he was embracing an artist who belonged both in fact and in spirit to that very period. It is certainly true that Tintoretto seemed to Ruskin to possess some of the imaginative powers which he had already discerned in Turner. Nevertheless Ruskin's ability to commit himself to two conceptions of art so dissimilar as Angelico's and Tintoretto's demonstrates a degree of flexibility which he could rarely command in later life. When he returned to Italy with his parents in the following year, this time visiting Florence immediately after Venice, he wrote of the difficulty of encompassing such diverse experiences (36.65), and a passage in *Modern Painters* must allude to the same problem: 'Severe would be the shock and painful the contrast, if we could pass in an instant from that pure vision to the wild thought of Tintoret' (4.264). Ruskin's reference here to the pain and repugnance experienced by a hypothetical spectator no

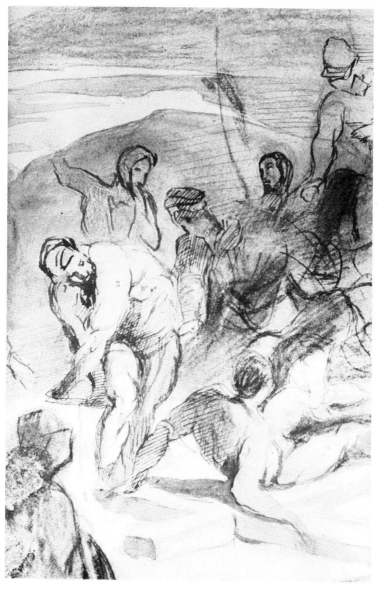

4 John Ruskin, detail of Plate 3

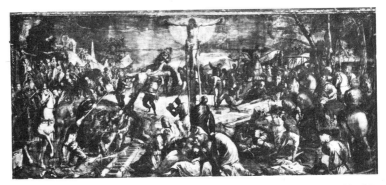

5 Tintoretto (Jacopo Robusti), *Crucifixion*, in the Scuola di San Rocco, Venice

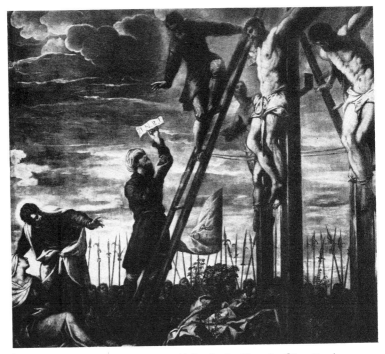

6 Tintoretto (Jacopo Robusti), *Crucifixion*, in the Church of San Cassiano, Venice

doubt springs from his own initial resistance to Tintoretto's cataclysmic art.

Ruskin's drawings of this period give an indication of his conflicting states of mind. If we compare his copy (plate 2) of Angelico's *Annunciation* in the Convent of San Marco with his copy (plate 3) of the central part of Tintoretto's *Crucifixion* in the Scuola di San Rocco, drawn four months later, we can see a spectacular difference in approach. The first is a close copy, precise but tentative, with each line deliberately drawn and redrawn, and the degrees of shadows in the folds of the robes carefully calculated. The second seems to be by quite another hand. The detail of Ruskin's drawing reproduced here (plate 4) shows one of the thieves lying on his cross, while an executioner bores a hole in its transverse beam with his auger. Ruskin has tried to capture the fluency of Tintoretto by the use of rapid wash-strokes and dashing lines of movement. He has smudged or omitted several of the faces, and made little attempt to follow the details of the original (plate 5): the men occupied in tying down the thief are hardly distinguishable from each other, and the shaft of the banner behind them, which is rigid in Tintoretto's painting, appears as a curving flick of Ruskin's brush.

Other connoisseurs of *quattrocento* quietitude seem to have found it impossible to appreciate the art of Tintoretto. Lord Lindsay, for example, as he travelled in Italy in the years 1838-42, became devoted to the frescoes at the Campo Santo, the Francias at Bologna, the Angelicos at Florence and the Carpaccios in Venice. Like Ruskin he planned a weighty disquisition on these artists; like Ruskin he admired the simplicity of Torcello and the oriental richness of St Mark's Cathedral. But in this frame of mind he could not accept the quite different offerings of the sixteenth-century Venetians, Tintoretto, Veronese and Jacopo Bassano. Visiting Venice in 1842, Lindsay wrote of Tintoretto's 'simple copyism of vulgar nature; in short he is the vulgarest of the school except Bassano, with whom indeed he has some strong sympathies.'[14]

Lindsay's attitude may have been influenced by Franz Kugler, whose guide to the Italian schools had just been published in English translation. Kugler noted Tintoretto's talent and felicity, but found these outweighed by faults in his composition and execution. (Later editions of this handbook retained these observations, but added in a footnote that Tintoretto's works were now better appreciated in

England, 'principally through the eloquent writings of Mr. Ruskin'.)[15] In 1842, again, Mrs Shelley was travelling in Italy, having met Rio in Dresden. When she reached Florence, she could record her 'extreme delight' in the works of Angelico, Ghirlandaio and their contemporaries. But this broadening of Mrs Shelley's tastes did not extend to Tintoretto, whom she scarcely mentioned in her travel-book; for her the art of Venice meant Titian and, to a lesser extent, Veronese.[16] Like St Mark's, the work of Tintoretto was generally regarded as a sightseers' curiosity rather than an artistic achievement. Tintoretto's *Paradiso* in the Doges' Palace enjoyed the reputation of being the largest canvas in the world, and the *Crucifixion* in the Scuola di San Rocco (plate 5), already considered by many to be the artist's *chef-d'oeuvre*, amazed visitors by its sheer size. But even this picture was felt by Palgrave to be 'more extraordinary than agreeable'.[17]

The second volume of *Modern Painters*, unlike the first, offered an appreciative interpretation of 'old masters' – the early Italians, that is, and Tintoretto. Paradoxically, Ruskin's denigration of Claude in the previous volume was less vulnerable to critical censure than his praise of Tintoretto, since the latter left greater scope for counter-interpretation. After Ruskin had reinforced his message in the 'Venetian Index' of *The Stones of Venice*, the *Art Journal* devoted successive leading articles to an uncompromising onslaught on his 'thoroughly unhealthy inflammation about Tintoretto'.[18] Taking issue with almost every aspect of Ruskin's criticism, the *Art Journal* concluded in effect that Tintoretto was an ingenious but superficial artist, and that Ruskin was an ingenious but superficial critic. The reviewer referred repeatedly to Tintoretto's figures, finding them coarse, vulgar and expressionless, whether they represented shepherds, or apostles, or the Virgin of the *Annunciation* in the Scuola di San Rocco. The essence of the *Art Journal*'s argument is that Tintoretto failed to supply what we should expect in a great painter – namely, 'the direct expression of thought, passion, and character, beauty and dignity, *as shown in the bodily form and countenance of men and things.*' By this standard the celebrated *Crucifixion*, relying little on the expression of emotion in the individuals portrayed, was a 'merely scenic notion' which could not rank as great art.[19]

This is a strong line of attack on Ruskin, for it appeals to

the very principle which he had followed in evaluating the early Italian artists. It was Ruskin who, above all others, had insisted on the significance of facial expression in art; but this insistence became an embarrassment when he came to describe, for example, the face of Christ in the Scuola di San Rocco *Crucifixion*, which is foreshortened and obscured by shadow. In another *Crucifixion* (plate 6), which hangs in the church of San Cassiano near the Rialto Bridge, the spectator is offered a worm's-eye view of brambles and Roman pikes, with three crosses angled away at the extreme right, and two executioners placed in the principal positions; if the artist had not been Tintoretto, this reversal of priorities might well have incurred Ruskin's disapproval, but at San Cassiano he seems to have relished the purely pictorial effects of the picture, and seen its unorthodox composition as evidence that Tintoretto painted it for his own pleasure(11.366).[20]

In this issue most modern admirers of Tintoretto would, I suspect, take Ruskin's part against that of the *Art Journal*, despite the latter's Ruskinian premise. But on the question of symbolism we should perhaps adopt the view of the *Art Journal*, which believed that the value of Tintoretto's *Annunciation*, for example, scarcely depended on whether (as Ruskin proposed) its crumbling masonry was intended to represent the supersession of the Jewish dispensation by the Christian. Holman Hunt accepted Ruskin's interpretation as a young man, and was further convinced when he visited the Scuola di San Rocco with Ruskin in 1869.[21] On the other hand when Henry James toured Venice later in the same year, with Ruskin's 'Venetian Index' as his guide, he decided that Tintoretto was the greatest of artists, for his painterly qualities rather than his symbolism: 'He seems to me to have seen into painting to a distance unsuspected by any of his fellows. I don't mean into its sentimental virtues or didactic properties, but into its simple pictorial capacity.'[22]

Henry James was able to admire Tintoretto's inventiveness, his exploitation of colour and the animation of his tableaux, while disregarding that aspect of Ruskin's critique – the supposed evidence of Tintoretto's 'profound thought' – which had most impressed Hunt. Significantly, the work which James ranked highest of all was the unorthodox *Crucifixion* at San Cassiano.

In the course of the 1850s Ruskin maintained his confidence in Tintoretto, but he grew ever more doubtful about the qualities of the early Italian masters. He developed a distinction between 'Purist' or 'Christian' art, typified by Fra Angelico, and 'Naturalist' art; and he drew this distinction increasingly to the advantage of the latter group, particularly as he began to involve himself in the social issues of his own day. In the fifth and final volume of *Modern Painters* (1860) he considered Angelico's art as a form of escapism, which took no account of those realities of the world at which men should 'look stoutly', and which erred 'in its denial of the animal nature of man' (7.264-7). New terms of esteem – 'realist', 'boldly animal', 'splendidly passionate' – entered his vocabulary, and his new idols were Titian, Veronese, Giorgione, Velasquez and Reynolds.

Ruskin's critical priorities were to undergo further adjustments. But he never quite resolved the problem which first arose on his tour of 1845 – the problem of accommodating within a single scheme both the devotional art of Florence in the fifteenth century and the tempestuous display of Venice in the sixteenth. The quandary re-emerges in his famous (or notorious) Oxford lecture of June 1871, 'The Relation between Michael Angelo and Tintoret'. This lecture might as well have been titled 'The Relation of the early Italian masters to Tintoret', for it goes some way towards reconciling his attitudes towards those two parties. Ruskin argued (or, rather, stated as an unquestionable fact) that Michelangelo, abetted by Raphael and Titian, brought about a catastrophic change in art between the years 1480 and 1520. Their pernicious policy was to introduce violent gestures and actions into their painting, and to make the body the centre of interest, rather than the spirit as manifested in the face, which had been crucial (Ruskin believed) to the century of Fra Angelico and Giovanni Bellini.

With the case viewed thus, there was no denying that Tintoretto inherited the unspiritual concerns of Michelangelo; that his *Last Judgment* was a wild and violent scene; that he paraded the various postures of the human body, and neglected individual character as indicated by facial expression. Ruskin insisted that Tintoretto was immeasurably superior to Michelangelo, and made every excuse for the Venetian artist, observing for example that in his *Last Judgment* the wicked were depicted as 'in ruin', but not actually

suffering physical pain (22.94). But in Ruskin's theme lies the implicit concession that Tintoretto fought a losing battle against the decadence of his age; he 'persisted . . . calamitously' in the disastrous innovations of Michelangelo (22.85). By these unsatisfactory means Ruskin achieved a measure of consistency – at the cost of disparaging not only Michelangelo, whom he had once respected, but also Tintoretto, whom he had revered.

NOTES

1 G.F. Waagen, *Works of Art and Artists in England*, (transl.) H.E. Lloyd, 3 vols (London, 1838), I:211.

2 J. Richardson, *An Account of some of the Statues, Bas-reliefs, Drawings and Pictures in Italy, etc., With Remarks* (London, 1722), pp. 186-7.

3 J. Reynolds, *Discourses on Art*, (ed.) R.R. Wark (San Marino, The Huntington Library 1959), p. 70.

4 See C.R. Leslie, *Memoirs of the Life of John Constable*, (ed.) J. Mayne (London, Phaidon 1951), pp. 113-14. Turner, too, was a close student of Claude; yet even his most Claudeian paintings, of the second decade of the century, have a turbulence and extravagance which are foreign to Claude's work.

5 A *Castel Gandolfo* attributed to Beaumont, which follows the composition of the *Narcissus*, is in the collection of Brighton Art Gallery.

6 Letter from Coleorton Hall, October 1823, in *John Constable's Correspondence*, (ed.) R.B. Beckett, 12 vols (Ipswich, Suffolk Records Society 1962-8), II (1964): 294.

7 Waagen, *Works of Art . . .*, op. cit., I: 212-14.

8 See Martin Davies, *French School* (National Gallery text catalogue, 1957), pp. 35-42, and Marcel Rothlisberger, *Claude Lorrain, The Paintings*, 2 vols (New Haven, Yale University Press and London, A. Zwemmer 1961), I: 281-3.

9 Ruskin's notebooks ('5A' and '5B') are in the Ruskin Galleries, Bembridge School, Isle of Wight; the Bodleian Library, Oxford, holds a typed transcript copy (MS Eng. Misc. C.213). Eastlake's notebooks are in the archives of the National Gallery.

10 *Hand-book for Travellers in Northern Italy* (London, John Murray 1842), pp. 458-68, 416, 369, 533.

11 *Hand-book for Travellers in Northern Italy*, 3rd edn. (1847), pp. 517-18; compare pp. 531-3 in the first edition. Lord Lindsay's *History of Christian Art*, also published by Murray in 1847, points to Rio as a source of ill-judged praise for Fra Angelico, III: 188.

12 For instance the Reverend Michael Hobart Seymour's *A Pilgrimage*

to Rome (London, 1848), pp. 129-44.

13 *British Parliamentary Papers,* Irish University Press Series, vol. Education: Fine Arts 4, para. 6466.

14 Letter to Anne Lindsay, 19 June 1842 (MS in the Crawford Family Papers), quoted in full as appendix 7 of Hugh Brigstocke, 'Lord Lindsay and James Dennistoun: Two Scottish Art Historians and Collectors of Early Italian Art', unpublished PhD thesis, Edinburgh University, 1976.

15 Kugler, *A Hand-book of the History of Painting,* (ed.) C.L. Eastlake (London, 1842), p. 376ff; 5th edn (1887), II: 612, quoted (4.lxvi).

16 See Mrs Mary Wollstonecraft Shelley, *Rambles in Germany and Italy in 1840, 1842 and 1843,* 2 vols (London, 1844), I: 245; II: 90ff, 141ff.

17 *Hand-book for Travellers in Northern Italy* (1842), op. cit., p. 362. For other opinions of Tintoretto see Waagen, *Works of Art . . . ,* op. cit., I: 333-4; Antoine Claude Pasquin, *Valery's Historical, Literary and Artistical Travels in Italy* (Paris, 1842), p. 168ff; Anna Jameson, *Memoirs of the Early Italian Painters,* 2 vols (London, 1845), II: 250-61.

18 *Art Journal* (September and October 1857), pp. 265-70 and pp. 297-301. In May 1857 the same journal carried an essay (pp. 145-7) which approved strongly of Ruskin's treatment of Tintoretto.

19 *Art Journal* (October 1857), p. 298, column b (italics in the original).

20 In 1852 Ruskin proposed to negotiate the purchase of the San Cassiano *Crucifixion,* together with three other Tintorettos, on behalf of the National Gallery: see David Robertson, *Sir Charles Eastlake and the Victorian Art World* (London, 1978), pp. 126-8.

21 William Holman Hunt, *Pre-Raphaelitism and the Pre-Raphaelite Brotherhood,* 2 vols (London, Macmillan 1905), II: 260ff, and see I: 90. For a sympathetic view of Ruskin's use of 'typological symbolism' and its influence on Holman Hunt, see George P. Landow, *William Holman Hunt and Typological Symbolism* (New Haven and London, Yale University Press 1979).

22 Letter to William James, 25 September 1869, in *Henry James Letters,* Vol. I, 1843-75, (ed.) Leon Edel (London, Macmillan 1974), p. 138.

3

Ruskin, the Workman and the Savageness of Gothic

John Unrau

While 'The Nature of Gothic' has been widely praised as one of the greatest essays on art in the English language, there are powerful dissenters from such a view, especially among historians of Gothic architecture. Paul Frankl, for instance, dismisses the portion of the essay which deals with the 'mental tendencies of the builders' (paragraphs 4 to 78) as 'utter vagueness and dilettantism'.[1] Such contempt from a scholar as learned as Frankl suggests that there must be serious flaws, or at least annoyances, in Ruskin's famous essay. One important anomaly, that 'The Nature of Gothic' develops criteria for the appreciation of the Gothic of northern Europe in a book devoted to Venice, has been dealt with by Kristine Garrigan.[2] Patrick Conner has pointed out semantic ambiguities in Ruskin's terms for the six characteristics he attributes to Gothic.[3] Wendell Harris has studied the essay as an example of Ruskin's tendency to apply 'a veneer of system over a disorderly mass of perceptions'.[4]

There are other, and perhaps even stronger, grounds for unease. Examination of Ruskin's study of the 'Savageness or Rudeness' which he considers the most important characteristic of Gothic and its builders (paragraphs 7 to 25) reveals errors of historical fact, bias in presentation of supposedly scientific argument, suppression of a range of Ruskin's own aesthetic responses, an almost comical abandonment of common sense, and a rather vulgar condescension in attitude toward the 'workmen' (both medieval and Victorian) whom he is supposedly championing. Ruskin's attempt to deduce the life of the medieval labourer from Gothic 'savageness' provides readers with a perfect example of what Proust calls

33

'the kind of illusion produced on them, and on Ruskin himself, by his writings'.[5] While Proust is none the less right in regarding Ruskin as 'one of the greatest writers of all times and all countries',[6] and Frankl wrong to be contemptuous, the modern reader of 'The Nature of Gothic' can best appreciate the reasons for its lasting appeal after taking note of the kinds of perversity with which it and *The Stones of Venice* as a whole are so deeply flawed.

In isolating for analysis the chief tendencies of Gothic 'Mental Power or Expression', Ruskin asks his readers to join him in an exercise of introspection, 'tracing out this grey, shadowy, many-pinnacled image of the Gothic spirit within us'. His analysis, he promises, will be confined to 'the idea which I suppose already to exist in the reader's mind' (10.182). Now the one image of Gothic which Ruskin could safely assume most of his readers to share was that of the shattered, grisly, upward-soaring, bird-encircled sublimity of Romantic tradition. For the better part of a century, in works as diverse as Scott's novels and the excited doggerel (characteristically beginning: 'Thou Sublime and Venerable Pile!') which flooded the *Gentleman's Magazine* and other periodicals between the 1780s and Ruskin's day, images more or less evocative of Gothic 'savageness' or 'rudeness' had been disseminated. But Ruskin had even stronger reason to suppose such an image to exist in the reader's mind, for he had planted it there himself two chapters earlier in this description of a northern cathedral:

> we will go along the straight walk to the west front, and
> there stand for a time, looking up at its deep-pointed
> porches and the dark places between their pillars where
> there were statues once, and where the fragments, here
> and there, of a stately figure are still left . . . and so higher
> and higher up to the great mouldering wall of rugged
> sculpture and confused arcades, shattered, and grey, and
> grisly with heads of dragons and mocking fiends, worn by
> the rain and swirling winds into yet unseemlier shape,
> and coloured on their stony scales by the deep russet-
> orange lichen, melancholy gold; and so, higher still, to
> the bleak towers, so far above that the eye loses itself
> among the bosses of their traceries, though they are rude

and strong, and only sees like a drift of eddying black points, now closing, now scattering, and now settling suddenly into invisible places among the bosses and flowers, the crowd of restless birds that fill the whole square, with that strange clangour of theirs, so harsh and yet so soothing, like the cries of birds on a solitary coast between the cliffs and sea. (10.79)

With that impression of the 'grim cathedral of England' (10.84) still strong in his memory, the reader of 'The Nature of Gothic' is not perhaps as disposed as he should be to question Ruskin's assertion that it is 'greatly and deeply true, that the architecture of the North is rude and wild' (10.185), or to resist the verbal sorcery with which we are invited to enthuse over Gothic man as he

smites an uncouth animation out of the rocks which he has torn from among the moss of the moorland, and heaves into the darkened air the pile of iron buttress and rugged wall, instinct with work of an imagination as wild and wayward as the northern sea; creatures of ungainly shape and rigid limb, but full of wolfish life; fierce as the winds that beat, and changeful as the clouds that shade them. (10.187-8)

This is powerful writing, and no one who has approached Cologne, Laon or Salisbury on a stormy winter day, and in an appropriately unsettled state of mind, can fail to respond to Ruskin's imagery. All the same, one cannot help noticing that he relies upon an extremely selective vocabulary to establish the 'savageness' of Gothic, both in evocation of large-scale impression ('this look of mountain brotherhood between the cathedral and the Alp' - 10.188), and in enumeration of smaller details. The cathedral towers are 'bleak', the walls 'mouldering', the traceries 'rude and strong', the arcades 'confused', the sculpture 'rugged', 'uncouth', 'ungainly', and 'rigid', consisting of 'grisly' gargoyles, 'formless monsters', and 'stern statues, anatomiless and rigid' (10.193).
Effective as such words may be in evoking one mood in which Gothic architecture has often been enjoyed, they amount, in accumulated effect and as a generalized description of Gothic, to demonstrable falsehood. A Gothic cathedral

35

is not an 'uncouth animation' which has been 'heaved into the darkened air' by inspired savages, but one of the most ingenious, intricate, and deliberate of the works of man. The sophisticated geometrical manipulations used by Gothic masons to derive the elevation from the plan and to determine the complicated curvatures of high vaults for their buildings have not yet been fully explained by the most thorough of modern investigators.[7] A structural engineer has claimed recently that the Gothic masons made use of thin-shell constructions of a kind considered revolutionary in modern design,[8] and that their mastery of the problems of stone construction has 'never been surpassed, or indeed even closely approached, in any other period of the world's history, the present included'.[9] As for the ungainly rudeness of the carving of Ruskin's imaginary cathedral, one need take no more than a glance at the portal figures of Chartres, Rheims or Bamberg to be convinced of the injustice of such a generalized description.

What is especially puzzling about all this is that Ruskin was aware of the falsity of such notions himself. Near the beginning of 'The Nature of Gothic' he had praised the 'magnificent science' of Gothic structure (10.185). He had read the books of, and recently enjoyed architectural talks and excursions with, the two Cambridge scholars, Robert Willis and William Whewell, who had done so much to demonstrate that 'science' to English readers (8.xl).[10] Furthermore, here is Ruskin writing of the drapery of Gothic statues a few years earlier in *The Seven Lamps of Architecture*:

> the drapery gradually came to represent the spirit of repose as it before had of motion, repose saintly and severe. The wind had no power upon the garment, as the passion none upon the soul; and the motion of the figure only bent into a softer line the stillness of the falling veil, followed by it like a slow cloud by drooping rain: only in links of lighter undulation it followed the dances of the angels. (8.150-51).

In his Edinburgh lectures on architecture, delivered the same year (1853) that the 'Nature of Gothic' was published, Ruskin pleads:

> let me beg of you - as you have time & opportunity, to

pay your utmost attention to this branch of art – the
sculpture of the 13th & fourteenth centuries – I cannot
tell you how great – how wonderful it is – and that almost
everywhere.[11]

Savageness, indeed.

Perhaps even more troubling to the thoughtful reader is
the distortion which occurs in the magnificent passage in
which, linking Gothic savageness with climate, Ruskin
describes an imagined high altitude flight northward from the
'great peacefulness of light' of the Mediterranean to the 'wall
of ice' setting, 'deathlike, its white teeth against us out of
the polar twilight'. Claiming that there is a 'parallel change in
the belt of animal life', he enumerates as 'southern' animals
the 'striped zebras and spotted leopards, glistening serpents,
and birds arrayed in purple and scarlet'. Against such 'swift
and brilliant creatures' we are to set the 'frost-cramped
strength, and shaggy covering . . . of the northern tribes'
(bear, wolf, Shetland pony), and then,

> submissively acknowledging the great laws by which
> the earth and all that it bears are ruled throughout their
> being, let us not condemn, but rejoice in the expression
> by man of his own rest in the statutes of the lands that
> gave him birth (10.187).

Those 'laws' dictate that, in the north, man's 'fine finger-
touch was chilled away by the frosty wind, and the eye
dimmed by the moor-mist' (in the manuscript, now at the
Pierpont Morgan Library, Ruskin had at first written
'blinded by the sea mist'). From all this shivering discomfort
and eye trouble, he suggests, come those 'hard habits of the
arm and heart' which explain the rudeness of Gothic (10.188).

The validity of the argument can be judged in a moment
by substituting, for Ruskin's bestiary, such specimens of
southern swiftness and brilliance as the hippopotamus and
sloth (with the fox and weasel representing northern clumsi-
ness), and by attempting to explain how the dim eyes and
chilled fingers of the north produced the *Book of Kells*.
Anyone familiar with the careful diary entries Ruskin had
been making in his study of geology and botany during the
decade preceding publication of *The Stones of Venice* must
wonder what devil of rhetoric could have tempted him so

John Unrau

far from his hard-won competence as an observer of nature.

But the crowning irony is that Ruskin, when actually looking at Gothic work which strikes him as clumsy and rude, is almost invariably disgusted by it. In 1844 he criticizes the 'disjointed' west front of Amiens and its 'coarse' detail, concluding: 'We shall have no good architecture while such things are praised' (D1.314). At Salisbury in 1848, he finds the sculpture of the cathedral 'perfectly savage', like 'the carvings of an Indian's paddle'. There is no hint of admiration or even tolerance in this diary entry, which abounds in adjectives such as 'meagre', 'disagreeable', 'eminently harsh and mean', 'ugliest', 'paltry' (D2.367). The sculptured heads at Grantham church are, he writes in 1876, 'the most monstrous and loathsome . . . in clownish stupidities of leer, stare, squint and grin, as in a sea-sickness of a ship of fools, and diabolic swine dying of cholera, that ever I saw'. In the same entry, the 'hard, coarse and vile touch' of the animal sculpture at Southwell Minster is declared to be 'utterly gross and humiliating to one's English soul' (D3.895). All in all, the 'clumps and humps' of 'savage Norman or clumsy Northumbrian' (24.222) prove highly distasteful to Ruskin. His praise of the 'wildness of thought, and roughness of work' (10.188) of northern architecture in 'The Nature of Gothic' is clearly at variance with a good deal of his actual response to 'savageness' when he encounters it in northern examples.

Having persuaded himself, however, that Gothic can be generally characterized as a rude and wild architecture, and that it is to be admired on that account, Ruskin proceeds to argue that its savageness is also a proof of the 'liberty of every workman who struck the stone; a freedom of thought, and rank in scale of being, such as no laws, no charters, no charities can secure' (10.193-4). This generous indulgence is attributed to the influence of Christianity:

> to every spirit which Christianity summons to her service, her exhortation is: Do what you can, and confess frankly what you are unable to do; neither let your effort be shortened for fear of failure, nor your confession silenced for fear of shame. And it is, perhaps, the principal admirableness of the Gothic schools of architecture, that they thus receive the results of the labour of inferior

38

minds; and out of fragments full of imperfection, and
betraying that imperfection in every touch, indulgently
raise up a stately and unaccusable whole. (10.190)

This has proven, for many readers, an attractive notion;
but it bears little relation to the truth. The probable response
of a Gothic master mason to Ruskin's proposal that 'any
degree of unskilfulness should be admitted, so only that the
labourer's mind had room for expression' (10.202) is concisely
indicated in the following article from a medieval code of
masonry:

> yf hit befall tht any mason tht be perfyte and connyng
> come for to seche werke and fynde any vnperfit and
> vnkunnyng worchyng the master of the place shall receyue
> the perfite and do a wey the vnperfite to the profite of
> his lord.[12]

Even when there was no threat of immediate replacement
by a better man, the bungler could expect short shrift. A
London code of 1356 states, for example, that no mason
may undertake any assignment 'if he does not well and
perfectly know how to perform such work'. The penalty for
a first offence is to be 'one mark; and the second time, two
marks; and the third time, he shall forswear the trade, for
ever.'[13] An interesting custom of some continental lodges
indicates how far the masons themselves were from encourag-
ing Ruskinian 'unskilfulness' within their ranks:

> The journeymen exercised a private justice among them-
> selves whenever one of them had spoiled a stone block.
> The stone was laid upon a stretcher and carried to a pit
> called the 'charnel house'; the guilty one walked behind the
> 'corpse' as the chief mourner and all the others followed.
> Afterwards the guilty one was *gebrütscht*, that is, given a
> mock beating which was probably not always gentle.[14]

Ruskin's conception of the artistic 'liberty of the labourer'
(10.205) in Gothic times is pure fantasy. It appears that the
master masons, from about the twelfth century on, were
accustomed to provide drawings, not only for the general
plan of a building, but for a large proportion of its detail.[15]
While the finest sculptors (often including the master mason

39

himself) might assume a free hand within certain limits, the general rule was for the master to transmit those limits 'to the working craftsmen by means of templates cut precisely to shape on the profiles which he had drawn of every moulding or detail to full size'.[16] (Ruskin himself presupposes such control of bounding forms, by an architect continuously sensitive to large-scale and distant effects of mouldings and carved ornament as part of the total composition, in a good deal of his visual analysis of medieval architecture.)[17] If much of the ornamental carving, which occupied the most highly skilled and privileged of the Gothic freemasons, provided such restricted licence for uninhibited invention, what of the tasks performed by the 'roughmasons', 'hardhewers', and, below them, the diggers and transporters of stone and mortar? We can be sure that such men had no more opportunity for artistic self-expression than an assembly-line worker has today. Indeed, the evidence seems to suggest that the typical Gothic building project was 'more comparable to a modern factory than is commonly supposed', and that even 'the craftsmen employed approximated more nearly than did other medieval artificers to modern workmen, being mere wage-earners, paid for working on raw material owned by their employer'.[18]

To complete our disillusionment, we learn that the Gothic masons had a low life-expectancy because of constant breathing of stone-dust,[19] that they seem to have been engaged in frequent controversies concerning their wages,[20] and that the press-gang was commonly used to recruit them, and also labourers, for royal and ecclesiastical building projects (imprisonment being the penalty for refusal; but even then it was 'often difficult to keep such craftsmen from escaping').[21] Ruskin's fantasy of a gracious indulgence extended 'to every spirit which Christianity summons to her service' would have amused the Archbishop of Canterbury as he sent out the more efficient summons of a press-gang to recruit masons in 1396,[22] and the vision of universal co-operation between patrons and workers is difficult to reconcile with the many accounts that survive of squabbling and strife, including the

> free fight, in August 1324, between seven monks of Westminster and seven of their servants on the one side and a party of the king's masons . . . on the other. In the course of the fight Roger Alomaly, one of the masons, was

killed by Brother Robert de Kertlington.[23]

Ruskin's friend Charles Eliot Norton once described him as 'a kind of angel gone astray'. Meant for Gothic times, 'he got delayed on the way, and when he finally arrived was a white-winged anachronism.'[24] One wonders how contemporary he would have seemed to Brother Robert and the king's masons had he arrived on time.

Ruskin's notion that ornamental sculpture was created by 'labourers' is surprising when one considers the shrewdness of his speculation about the over-all management of work on Gothic buildings. He assumes that in all important medieval projects one man (Ruskin usually calls him either the 'architect' or 'builder') was in charge of design and supervision of the work. In large-scale layout, down to the scale at which design can no longer be 'mathematically defined' or determined 'by line and rule', the master's instructions must be executed with precision (10.200). But in planning finer detail, he is faced with an important choice. Ruskin believes (and modern scholars agree) that the Gothic master mason was himself usually an expert sculptor who, because of his training, understood all the difficulties involved in lesser aspects of design. Since, however, he

> cannot execute the whole with his own hands, he must either make slaves of his workmen . . . and level his work to a slave's capacities . . . or else he must take his workmen as he finds them, and let them show their weaknesses together with their strength, which will involve the Gothic imperfection, but render the whole work as noble as the intellect of the age can make it. (10.202)

Ruskin is surely right in supposing that a choice of the kind he poses is a decisive factor in determining the nature of the finished building. If the master mason is a nervous and self-centred perfectionist – a believer in total planning, down to the last dog-tooth, and of course in his own pre-eminent ability in design – we can be sure he will not only employ a more docile sculptor, but will impose much tighter supervision on him, than would the master who possessed the generous and fostering attitude, with its trust in the basic

41

rightness of his sculptors' impulses, which Ruskin considers typically Gothic. Where he makes his great error is in imagining that those sculptors – even when hired by the most autocratic of master masons – can ever have been anything less than trained artists, many of them on the way to becoming master masons themselves. As a sketch of the relations which may have existed between the master mason and his fellow artists on many a Gothic building project, Ruskin's picture of the supervisor's benevolence and tolerance makes good sense. But his assumption, throughout much of 'The Nature of Gothic' and the third volume of *The Stones of Venice*, that those sculptors were mere labourers, learning on the job, and encouraged in their bumbling efforts in order to make them happy, is sentimental nonsense.

Ruskin may have had some inklings of this himself. In the midst of a rhetoric which takes seriously the notion that the Gothic masons could be considered 'the hands of childhood' to the architect's 'mind of manhood', he launches abruptly into an assertion that the 'difference between the spirit of touch of the man who is inventing, and of the man who is obeying directions, is often all the difference between a great and a common work of art' (10.200). A similar eruption several paragraphs later declares that 'no great man ever stops working till he has reached his point of failure' (10.202-3). Both of these claims may well be valid: but what have 'great art' and the 'great man' to do with the fumbling labourer of Ruskin's imagination? It would appear that Ruskin's first-hand knowledge of the artistry displayed in much Gothic ornament – its perpetual variation, its subordination to ruling masses designed with a view to the total effect of the building seen from different viewpoints, the skill with which apparent imperfections are calculated to give it perfect articulation at varying range – has risen powerfully enough in the back of his mind to disrupt briefly the assumptions about its supposedly 'savage' creator which are fuelling the rhetoric. How did Ruskin manage to suppress that knowledge long enough to write the passages which temporarily confused himself, and persuaded generations of readers, into supposing such ornament to be the work of 'labourers' rather than men who were among the finest craftsmen of their times? A partial explanation may be gained through study of the expository method employed in the treatise on Gothic savageness.

The tone of collaborative introspection adopted by Ruskin works insidiously upon both writer and reader to produce a state of mind in which assumptions based upon mere prejudice take on an air of established truth. The progress of this self-hypnosis provides a sobering insight into Victorian class-consciousness.

Readers who accept Ruskin's invitation to join him in tracing the fellowship that exists between Gothic 'and our Northern hearts' soon find themselves airborne and watching indulgently with their eloquent pilot as the Gothic Grendel tears up his rocks and heaves them into cathedrals on the inhospitable lands below (10.187). It is not difficult for Ruskin to move his readers on from this eminent and culturally superior position to the point of view of a patronizing Christianity as it patiently 'receives' the 'labour of inferior minds' of the Gothic workmen (10.190).

Ruskin now abruptly, and from the standpoint of chronology and logic quite improperly, introduces the nineteenth-century labourer into his argument, and a powerful assumption immediately becomes operative. That labourer is 'our' (Ruskin's and the readers') labourer. Furthermore, it is taken as granted that the poor chap is a fallen creature, utterly dependent upon his superiors for any morsel of spiritual sustenance which might aid his regeneration:

> Now, in the make and nature of every man, however rude or simple, whom *we* employ in manual labour, there are some powers for better things; some tardy imagination, torpid capacity of emotion, tottering steps of thought But they cannot be strengthened, unless *we* are content to take them in their feebleness, and unless *we* prize and honour them in their imperfection And this is what *we* have to do with all *our labourers*.(10.191, my italics)

Then, perhaps a little uncomfortable at the group identity with which he has associated himself (the merchants and factory owners of Bradford and Manchester, soon to receive such stinging rebuke in Ruskin's lectures?), he modulates smoothly into: '*You* can teach a man *You* must either make a tool of *the creature*, or a man of him If *you* will make a man of *the working creature*, *you* cannot make a tool' (10.191-2, my italics). By this time the readers have been manipulated into a frame of mind – it must have been

43

irresistible to many of them – in which it is not only per-
missible, but their Christian duty, to luxuriate in the fantasy
of playing God to their inferiors. To them has been granted
the divine power of breathing the breath of artistic life into
the cloddish 'working creature', to 'make a man of him' who
'was only a machine before, an animated tool' (10.192).

The self-flattering condescension implicit in this attitude is
carried headlong by Ruskin into his remarks about the
Gothic sculptor, and before the enchanted reader can collect
his wits that sculptor – whom Ruskin, in other contexts,
presents as a master whom the nineteenth century must
despair of emulating – has been demoted to the status of a
labourer. His condition is compared with that of such
nineteenth-century drudges as the men who chop glass rods
into beads (10.197) and, not surprisingly, the comparison
favours the Middle Ages. Instead of soul-destroying Victorian
labour, the medieval workers were encouraged to carve away
at cathedrals to their heart's content: by merely looking at the
savage old Gothic façades, we may see the results of enlightened
patronage of the lower orders by those in authority (10.193-4).
The humble facts of the case – that the Gothic sculptors
were trained artists, and about as numerous in proportion as
the exhibitors at a modern gallery[25] – haven't a hope in the
deluge of social conscience with which Ruskin now drowns
his own and his readers' common sense. Ruskin's view of the
Gothic sculptor has been entirely engulfed by his attitudes
toward the nineteenth-century 'operative'.[26]

It is thus not surprising that the note of earnest charity
with which Ruskin talks of that sculptor in 'The Nature of
Gothic' should often become one of outright condescension
in the third volume of *The Stones of Venice*, where the 'rude-
ness' of Gothic is praised for 'showing that the workman did
not mind exposing his own ignorance if he could please
others' (11.74), and the clumsiness of northern ornament is
pronounced 'admirable, and most precious, as the fruits of
a rejoicing energy in uncultivated minds' (11.159). Ruskin
becomes so captivated by his fantasy that he even begins to
imagine that Gothic ornament was often knocked off by
medieval labourers as a kind of recreation 'in the languor of a
leisure hour' (11.167). He advises his readers to emulate
the soft-hearted Gothic architects by not expecting too much
from the lower beings who disported themselves thus in
medieval times:

44

however much we may find in it needing to be forgiven . . .
its delightfulness ought mainly to consist *in those very
imperfections* which mark it for work done in times of
rest. It is not its own merit so much as the enjoyment of
him who produced it, which is to be the source of the
spectator's pleasure. (11.158)

Good persons such as Ruskin and his readers, furthermore,
will often be forced to blush at the naughtiness of him who
produced it:

Nothing is more mysterious in the history of the human
mind than the manner in which gross and ludicrous images
are mingled with the most solemn subjects in the work of
the Middle Ages . . . in many instances they are clearly
the result of vice and sensuality. The general greatness or
seriousness of an age does not effect the restoration of
human nature; and it would be strange, if, in the midst of
the art even of the best periods, *when that art was
entrusted to myriads of workmen,* we found no mani-
festations of impiety, folly, or impurity. (11.189, my italics)

Difficult as it may be for virtuous readers to tolerate such
lapses, they should never lose sight, Ruskin urges, of the
'desirableness of employing the minds of inferior workmen,
and of the lower orders in general, in the production of
objects of art *of one kind or another*' (11.157, my italics).
Therefore, though the 'vulgar mind' and 'coarsest wit of the
workman' (11.172-3) will inevitably appear in much Gothic
carving, persons such as Ruskin and his readers should
bravely cultivate 'feeling and charity enough to join in the
rude sportiveness of hearts that have escaped out of prison'
(11.158). The tone of this is close to what we might expect
from a group of sentimental but squeamish matrons watching
the chimpanzees' tea-party at the zoo. It is difficult to
believe that such condescension is being lavished upon men
who created the sculpture which, in less expansive moments,
and with his formidable eye trained upon specific examples,
Ruskin has so often demonstrated to be decorative art of the
highest order.

Writing in *Fors Clavigera* almost twenty years later, and by
then a much more penetrating observer of the human con-
dition, Ruskin exposes with ferocious irony a number of

pretensions and prejudices which had influenced his view of the nineteenth-century labourer, and hence of the Gothic 'workman', in *The Stones of Venice*. After a day's sightseeing at Furness Abbey, he and a lady with two daughters encounter a group of drunken labourers at the railway station:

> we were all in a very virtuous and charitable temper: we had had an excellent dinner at the new inn, and had earned that portion of our daily bread by admiring the Abbey all the morning. So we pitied the poor workmen doubly – first, for being so wicked as to get drunk at four in the afternoon; and, secondly, for being employed in work so disgraceful as throwing up clods of earth into an embankment, instead of spending the day, like us, in admiring the Abbey: and I, who am always making myself a nuisance to people with my political economy, inquired timidly of my friend whether she thought it all quite right. And she said, certainly not; but what could be done? It was of no use trying to make such men admire the Abbey, or to keep them from getting drunk. They wouldn't do the one, and they would do the other – they were quite an unmanageable sort of people, and had been so for generations.
>
> Which, indeed, I knew to be partly the truth . . . here were not only the actual two or three dozen of unmanageable persons, with much taste for beer, and none for architecture; but these implied the existence of many unmanageable persons before and after them They were a Fallen Race, every way incapable, as I acutely felt, of appreciating the beauty of *Modern Painters*, or fathoming the significance of *Fors Clavigera*.
>
> But what they had done to deserve their fall, or what I had done to deserve the privilege of being the author of those valuable books, remained obscure to me. (27.183-4)

Such ironic and self-deprecating puzzlement was still beyond the capacity of the author of *The Stones of Venice*, and its absence helps explain some of the absurdities which mingle with the splendid architectural analysis to be found in that work. The reader intent on learning from the latter should take heart from Ruskin's advice, written in 1881 when he was sixty-two, to those who are upset by his 'tendency to moralise or sermonise'. Admitting that this weakness is in

part owing to 'the common vanity of a clerk', he concludes:

> whatever belongs to *it*, or has been dictated by it, may
> perfectly well by any reader whom it offends be skipped,
> or denied: the practical substance of my books, if he
> knows how to read, will remain for him exactly the same.
> (35.629)

Only a cold-blooded and doctrinaire reader could rest entirely content with such a conclusion. For Ruskin's treatise on Gothic savageness is at least as much a work of imagination as of scholarship or social thought, and its impact on most readers probably has little to do with the soundness of its argument or the nature of the social attitudes expressed by its author. Tolstoy defines art as

> a human activity consisting in this, that one man con-
> sciously by means of certain external signs, hands on to
> others feelings he has lived through, and that others are
> infected by these feelings and also experience them.[27]

On this definition 'The Nature of Gothic', especially as it evokes the condition of the factory workers in mid-nineteenth-century Britain, would appear to be powerful art indeed. The feelings it generates in paragraphs 12 to 16 –

> But to smother their souls within them, to blight and hew
> into rotting pollards the suckling branches of their human
> intelligence, to make the flesh and skin which, after the
> worm's work on it, is to see God, into leathern thongs to
> yoke machinery with, – this is to be slave-masters indeed.
> (10.193)

– have proven so infectious that Morris was speaking for more than his generation when he wrote: 'To some of us when we first read it . . . it seemed to point out a new road on which the world should travel' (10.460).

Ruskin's historically inaccurate view of the Gothic sculptor may well increase, rather than diminish, the emotional infectiousness of his writing. He has himself explained, in analysing the pathetic fallacy, how the expression of strong feelings may justify departures from a commonsense view of things:

however great a man may be, there are always some
subjects which *ought* to throw him off his balance; some,
by which his poor human capacity of thought should be
conquered, and brought into the inaccurate and vague
state of perception. (5.209)

Such unbalancing influence is clearly at work in 'The
Nature of Gothic'. Ruskin's perception of the sufferings
endured by the factory workers of his day, and his attractive
vision of what work could be if all were united in a fellow-
ship of free artistic endeavour, have cast a spell over his
conception of Gothic as a historical phenomenon. The free-
hand artistry which so delights him in his favourite (and
emphatically un-savage) Gothic carving has become for him
an ideal of what all human work could be. In his eagerness
to express this ideal – and strongly influenced by attitudes
which in the early 1850s still dominate his thought about
'the lower orders'[28] – he ignores facts about the medieval
sculptors which his knowledge of the visual sophistication
of their ornament should have made obvious to him (and
which the nineteenth-century sculptor O'Shea was later to
drive home with a vengeance at the Oxford Museum).[29] Such
suspension of critical thought, involving him even in the
temporary suppression of his loathing for Gothic carving
which struck him as genuinely crude and savage, is a measure
of the strength of feeling which caused it.

Here we encounter the dilemma facing every reader of
Ruskin: the difficulty of knowing when to respond to him
as artist, and when as scholar/thinker.[30] The very acuteness
with which he records architectural fact in much of *The
Stones of Venice* makes it that much more difficult for the
reader to make the instantaneous mental adjustments required
for keeping pace with his sudden flights into imaginative
expression. The critical frame of mind required in com-
prehending passages characteristic of what Mazzini called
the 'most analytic mind in Europe' (35.44) becomes a
powerful hindrance to appreciation of others which demand
a willing – indeed eager – suspension of disbelief. It is
impossible to determine the point at which the Gothic
sculptor ceases to be for Ruskin a thirteenth-century artist
and becomes instead a mythological figure sustaining a
vision of what all human labour might ideally become. Yet
because Ruskin seems to be grounding his claims so decisively

48

on historical and scientific argument, the reader is impelled
to rational scrutiny of those claims; a scrutiny which will
inevitably become at some stage as inappropriate as a bio-
grapher's objections to *Richard III* or a marine biologist's
scepticism about Melville's white whale. Such perplexities
will trouble many a reader of 'The Nature of Gothic', and
perhaps only a personality as sensitive, mobile and divided
as Ruskin's could resolve them completely. For Ruskin is,
in Tolstoy's words, 'one of the most remarkable men not
only of England and of our generation, but of all countries
and times' because he is 'one of those rare men who think
with their hearts'.[31]

NOTES

1 P. Frankl, *The Gothic: Literary Sources and Interpretations through Eight Centuries* (Princeton University Press 1960), p. 560.
2 K. Garrigan, *Ruskin on Architecture: His Thought and Influence* (Madison, University of Wisconsin Press 1973), p. 102.
3 P. Conner, *Savage Ruskin* (London, Macmillan 1979), pp. 98-100.
4 W. Harris, 'The Gothic Structure of Ruskin's Praise of Gothic', *University of Toronto Quarterly* (1971), p. 112.
5 M. Proust, *Marcel Proust: A Selection from his Miscellaneous Writings*, (ed.) Gerard Hopkins (London, Allan Wingate 1948), p. 84.
6 Ibid., p. 88.
7 F. Bucher, 'Medieval Architectural Design Methods, 800-1560', *Gesta*, 11, no. 2 (1972), pp. 37ff, especially p. 47.
8 J. Fitchen, *The Construction of Gothic Cathedrals: A Study of Medieval Vault Erection* (Oxford, Clarendon Press 1961), pp. 64-9.
9 Ibid., p. 3.
10 Whewell's *Architectural Notes on German Churches*, first published in Cambridge in 1830, had reached a third edition by 1842. Willis's *Remarks on the Architecture of the Middle Ages, Especially of Italy*, was published in Cambridge in 1835.
11 Reproduced by permission of the Huntington Library, San Marino, California, item HM 6099, MS for *Lectures on Architecture and Painting*, Lecture 2, p. 12.
12 D. Knoop and G.P. Jones, *The Medieval Mason*, 3rd edn (Manchester University Press 1967), p. 247.
13 Ibid., p. 225.
14 P. Frankl, *The Gothic*, op. cit., p. 132.
15 L.F. Salzman, *Building in England down to 1540* (Oxford, Clarendon Press 1952), p. 22.
16 J.H. Harvey, *The Medieval Architect* (London, Wayland 1972), p. 174. G.G. Coulton has claimed that: 'At a liberal computation

of all the working-hours spent upon the masonry of a church, scarcely one-hundredth were spent upon work where the mason had a free hand', *Art and the Reformation*, 2nd edn (Cambridge University Press 1953), p. 202.

17 See for example (9.296-303).
18 Knoop and Jones, *The Medieval Mason*, op. cit., p. 3.
19 Ibid., p. 81.
20 Salzman, *Building in England* . . . , op. cit., pp. 72-5.
21 Knoop and Jones, *The Medieval Mason*, op. cit., pp. 80-4.
22 Ibid., p. 84.
23 Salzman, *Building in England* . . . , op. cit., p. 56.
24 *Letters of Charles Eliot Norton*, (ed.) Sara Norton, 2 vols (Boston, Houghton Mifflin and London, Constable 1912), II: 292.
25 Coulton, *Art and the Reformation*, op. cit., p. 479.
26 This nasty pre-Orwellian term for the industrial workman, first occurring in that sense in 1827, is used several times by Ruskin in the section on 'Savageness' in 'The Nature of Gothic'.
27 L. Tolstoy, *What is Art? and Essays on Art*, (trans.) A. Maude (London, Oxford University Press 1930), p. 123.
28 The severe handicap imposed on Ruskin by the snobbery that attended his upbringing is made clear in many ironic passages of *Praeterita*. Some lines cancelled after being set up in type provide a concise insight into the workings of the Ruskin family heart. Of his 'Croydon cousin' Bridget (see. 35.88) he writes: 'she was always more or less a thorn in my mother's side; more might perhaps have been done for her, if we had cared more. At last she married a Mr Fox, of whom I saw little and remember nothing, of rank somewhat above a tradesman – just enough to be uncomfortable. They went out to Sydney . . .' (Beinecke Library, Yale University, corrected proof and MS for *Praeterita*). If Mr Fox and Bridget caused such qualms, it is no wonder the 'operatives' appeared to be a separate and fallen race.
29 See the 1877 lectures, 'Readings in *Modern Painters*' (22.525). In the MS (Beinecke Library, Yale University), Ruskin had first written that the 'liberty' he had claimed for the Gothic sculptors had in fact been given only to 'those who had inherited the nature and reverently observed the traditions of men teaching their craft and bequeathing their spirit through sixteen hundred years'. Some technical reasons for his disappointment with O'Shea's notoriously 'free' carving are discussed in my *Looking at Architecture with Ruskin* (London, Thames & Hudson 1978), pp. 131-4.
30 Rachel Trickett's description of Ruskin as an artist who never found a medium which was perfectly suited to his genius provides an intriguing perspective on the problem.
31 L. Tolstoy, 'An Introduction to Ruskin's Works' (1899), in *Recollections and Essays by Leo Tolstoy*, (trans.) A. Maude (London, Oxford University Press 1937), p. 188.

4

'Rust and Dust':
Ruskin's Pivotal Work

Nick Shrimpton

On 8 November 1877 Ruskin stood in an Oxford lecture room between two piles of books. On his left were the five sumptuously bound volumes of *Modern Painters*. On his right was the faded green cloth of a single copy of *Unto this last*. In the summer of 1860, he told his audience, pushing the five volumes from him as he spoke, he had 'given up his art work'. Instead, in the Valley of Chamouni, he had turned to a new subject. *Unto this last* was solemnly raised from the lectern. 'This little book', he declared, 'was the beginning of the days of reprobation' and 'the central work of my life'.[1]

The dramatic simplicity of this self-analysis has had a natural, but fatal, attraction for Ruskin's critics and biographers. In the 1850s, we are constantly told, Ruskin moved from art to social concern. *Unto this last* marks a decisive moment of change. Both claims, unfortunately, are incorrect. Ruskin's interests after 1860 would continue to be a mixture of art and politics, as they had been for more than twenty years. And if anything in his long development could be said to represent a change of emphasis it is certainly not *Unto this last*. Like so many of Ruskin's remarks about himself, the description of his career given in the 1877 Oxford lectures is at best a useful abbreviation of the truth, at worst downright misleading.

What does happen to Ruskin's writing in the 1850s? The answer is that what it undergoes is less a change of topic than a change of medium. He had, after all, been writing about society as early as 1838, when his excited description of the brick architecture of the south of England, so 'admirably suited for that country where all is change, and all

51

activity; where the working and money-making members of the community are perpetually succeeding and overpowering each other; enjoying, each in his turn, the reward of his industry', appeared in *The Poetry of Architecture* (1.141). Three years later his social attitudes were quite different but his eagerness to express them was undiminished. Northrop Frye is exaggerating only very slightly when he argues that the later treatment of wealth in Ruskin's explicitly economic works is 'essentially a commentary' on *The King of the Golden River*, the fairy story written in the autumn of 1841.[2]

The influence which transformed an early enthusiasm for change and competition into the beliefs expressed in *The King of the Golden River* also determined the form in which, for the next twelve years, those beliefs were to be expressed. Ruskin had been reading a particular kind of medievalist literature, a specialized genre initiated in 1771 by Goethe's play *Götz von Berlichingen*. Here the competitive individualism of modern life was for the first time disadvantageously compared with the hierarchical social system of the Middle Ages. Such historical comparisons rapidly became an established technique of political analysis. By 1838 Carlyle could declare that what he christened 'Götzism' was 'making the tour of all Europe'.[3] Ruskin was deeply affected by it. As a child he enjoyed the medievalist works of Kenelm Digby and Sir Walter Scott. Between 1841 and 1845 he read the three classic texts of what we may call English Götzism: Cobbett's *History of the Protestant Reformation*, Southey's *Colloquies on the Progress and Prospects of Society* and Carlyle's *Past and Present*. By the end of the decade he was himself at work on a fourth. *The Stones of Venice* is a book on architecture. But it is also a late flowering of this distinctive tradition of polemical literature, a form in which modern social, political and economic systems are compared with their medieval equivalents and thereby condemned.

Ruskin's literary problem in the 1850s was that by the time he completed his major work of Götzism (the final volume of *The Stones of Venice* was published in October 1853) the genre was already out of date. In the late 1840s a more immediate literary engagement with contemporary problems had begun to establish itself, especially in the social novel. Carlyle, the outstanding political medievalist of the decade, responded to the new mood very swiftly. Putting the Götzist tactics of *Past and Present* firmly behind him he

began, in the spring of 1850, to publish *Latter-Day Pamphlets*. Medieval comparisons were replaced by a direct and satirical onslaught on the failings of the age, and this change of method proved highly influential. Ruskin first expressed a nervous awareness that the medievalist approach might have its disadvantages in August 1851, in his pamphlet *Pre-Raphaelitism* (12.358). But he continued the publication of *The Stones of Venice*, and as late as the September of 1854 could still write to Lady Trevelyan that he planned to 'collect materials for a great work I mean to write on politics – founded on the Thirteenth Century' (*RLPT*.89). Such a work would have been obsolete before it was begun. Less than four years later he would himself inform a Bradford audience that 'We don't want either the life or the decorations of the thirteenth century back again' (16.341).

But if the Götzist tradition, to which Ruskin had made so significant a contribution, would no longer serve, what was the alternative? How could he continue to express those social interests which had been an integral part of his work from the very beginning? One answer was to echo Carlyle's comic and combative manner, and Ruskin was not the only writer to sense this possibility. Clough's 'The Latest Decalogue' ('Thou shalt not covet; but tradition/Approves all forms of competition') and Tennyson's *Maud* display, respectively, the satirical and denunciatory styles of the new decade.[4] In theory Ruskin should have been well prepared for this shift of method. He had imitated the verbal technique as well as the intellectual procedure of *Past and Present* in *The Stones of Venice*, and he describes in another of his 1877 Oxford lectures how he corrected the weaknesses of his early prose style by reading Carlyle and 'succeeded in catching something of his rhythm' (22.509). But *Latter-Day Pamphlets* introduced a new dimension to Carlyle's social criticism. In this book he passed beyond his familiar effects of rhetoric and imagery into a vein of satire more violent even than that used in *Sartor Resartus*. The climax of the final pamphlet, for example, is a savage parody of utilitarianism, and of the moral assumptions which underlie classical economics. 'Pig Philosophy' is what Carlyle calls the predominant ethic of his age, and one does not have to share his judgments to enjoy the deadly wit with which he assembles its parodic propositions.

Writing like this is easy to admire but difficult to imitate,

and the development of a satirical voice was something which Ruskin would not find easy. At times in his later work the endeavour would lead to a strange effect of swamping, the Ruskinian note disappearing entirely beneath a tide of Carlylese. *The Crown of Wild Olive*, a group of lectures delivered between 1864 and 1869, is a particularly striking example of this tendency. The Appendix (added in 1873), a commentary on selected passages from Carlyle's *Frederick the Great*, is conducted in a prose often indistinguishable from the quotations. The fourth lecture, 'The Future of England', is similarly overwhelmed by its nakedly derivative manner.[5] But in the first two lectures of the volume we see the positive effects of the influence. 'Work' and 'Traffic' successfully combine Carlyle's satirical sparkle with some more distinctively Ruskinian effects, thereby producing two of the most satisfying pieces in the entire Ruskin canon.

Ruskin's social writing of the late 1850s likewise derives, at least in part, from the endeavour to absorb the example of Carlyle. In so far as the style is spare and sardonic its roots lie in *Latter-Day Pamphlets,* and Ruskin was quick to acknowledge his indebtedness. In the third of his 'Addresses on Decorative Colour', given at the Architectural Museum in December 1854, he declared that he owed more to Carlyle than to any other living writer (12.507). A month later he was writing personally to Carlyle to ask him 'when you come, as you must sometimes, on bits that look like bits of yourself spoiled' not to think 'that I have been mean enough to borrow from you knowingly, and without acknowledgement' (36.184). And in the third volume of *Modern Painters*, published in January 1856, Ruskin praised (along with Wordsworth) both Carlyle and a rather feebler contemporary writer of discursive social argument, Arthur (later Sir Arthur) Helps:

> to whom (with Dante and George Herbert, in olden time) I owe more than to any other writers; – most of all, perhaps, to Carlyle, whom I read so constantly, that, without wilfully setting myself to imitate him, I find myself perpetually falling into his modes of expression, and saying many things in a 'quite other,' and, I hope, stronger, way, than I should have adopted some years ago; as also there are things which I hope are said more clearly and simply than before, owing to the influence

upon me of the beautiful *quiet* English of Helps. (5.427)

Ruskin plunders some phrases and adapts some ideas from Helps, and uses him as a model for the plain style of sections of his later social writing. From Carlyle, Ruskin derives the satirical manner of other passages of that same work. But these influences alone do not explain the new mode of political literature which Ruskin develops as a replacement for Götzism. His writings of the late 1850s and 1860s are not merely Carlylean. Rather, they combine the influence of Helps and Carlyle with another, and more individual, technique.

Ruskin's sense of the need to achieve such a blend is suggested, I think, by the enthusiasm which he expressed in 1856 and 1857 for Elizabeth Barrett Browning's verse novel, *Aurora Leigh*. His remarkable declaration, in a letter to Robert Browning, that this is 'the greatest *poem* in the English language' might seem merely the partiality of a friend (36.247). But he repeated, indeed enlarged, the claim in cold print in an Appendix to *The Elements of Drawing* (15.227). The poem was important because its central event, a marriage between a poet (Aurora) and a social reformer (Romney Leigh), enacted a process which Ruskin was himself desperately trying to achieve. Mrs Browning's symbolic point is that a literature unconcerned with society and a political theory devoid of aesthetic power are each individually inadequate. A successful union between them is what will promote 'New churches, new oeconomies, new laws'. Medievalist writing is specifically dismissed (Ruskin commented to Robert Browning, 'poor Scott! and the sellers of old armour in Wardour St.!')(36.248). But the new political literature which replaces it will enable poets to 'get directlier at the soul/Than any of your oeconomists'.[6]

Ruskin agreed whole-heartedly. The problem of how he was to achieve this desirable conjunction, however, remained unsolved. In the mid-1850s his social thought, particularly about work, was developing rapidly. But what was the poetic element, the Aurora, which he could marry to his political enthusiasms? *The Political Economy of Art*, first delivered as lectures in the July of 1857, shows him casting about for an answer and not finding it. The jocular attempt to discuss art in the language of economics is a superficial device rather than a penetrating metaphor. The social thought is scattered and incoherent. Satire and plain speaking, the influences of

Carlyle and Helps, do not in themselves suffice.

In fact, by the summer of 1857, the first glimmerings of a solution had already appeared. On 3 April he spoke to the St Martin's School of Art on 'The Value of Drawing'. The lecture, which survives only in a report printed by the *Building News*, is a rambling discussion of what drawing can do for the art student. But towards the end, as Ruskin explains the chemical properties of artists' materials, the address suddenly acquires an unexpected profundity. He had spoken in passing, in *Modern Painters* Volume 4, of the social implications of chemistry and geology (6.132). Now he seizes upon them as the dominant motif of the second half of his lecture. What, he asks, is the physical origin of the colours black and yellow? The answer is that these pigments, like all 'good' and 'kindly' things, spring from a union of earth and air. Nature takes her most indispensable element, iron, mixes it with the atmosphere, and thereby produces colour. 'They had', Ruskin declares, 'all been troubled about rust as being an emblem of decay, but it was not only an emblem of decay - it was an emblem of resurrection as well' (16.443). With this 'true gold of the earth' Nature colours the landscape.

These arguments are already more than merely technical. But the next step takes Ruskin into a new dimension. What, he asks, is the most precious red pigment in the world? The answer, of course, is blood, and its colour too derives from iron. 'The iron entered into the soul,' Ruskin declares, making witty use of the Book of Job, 'in a different sense from that commonly received' (16.445). He promptly transforms this perception into a political argument:

> All men had iron as they had life in them; it was essential
> to the blood of the earth - it was a necessary element.
> That great colouring substance was used by Nature, and he
> hoped they might use it also, in another way than they
> ever used it - in the highest kind of painting; and the
> kind of painting they most wanted in London was
> painting cheeks red with health.

Ruskin had spoken in rather similar terms in *Modern Painters* Volume 2, when he told another audience of artists (imaginary in that case) that among the features 'pinched by poverty, shadowed by sorrow' and 'branded with remorse', and the bodies 'consumed with sloth, broken down by labour'

and 'tortured by disease' they had work to do:

> Herein there is at last something, and too much for that
> short-stopping intelligence and dull perception of ours to
> accomplish, whether in earnest fact, or in the seeking for
> the outward image of beauty: – to undo the devil's work;
> to restore to the body the grace and the power which
> inherited disease has destroyed; to restore to the spirit the
> purity, and to the intellect the grasp, that they had in
> Paradise. (4.176-7)

But three changes had taken place between 1846 and 1857. First, even through the lagging shorthand of the *Building News* reporter, one can sense how much Ruskin's prose has benefited from the chastening influence of Helps and Carlyle. Second, his emphasis has shifted. In *Modern Painters*, though he makes a gesture to 'earnest fact', he is really concerned with restoring the human frame on canvas. The painter, by observation and selection, can substitute a perfect image for the imperfect images with which he is surrounded. 'Painting cheeks red with health' in 'The Value of Drawing' means something rather different. This enhanced social emphasis is not in the end, however, what really matters about Ruskin's address to the St Martin's School of Art on 3 April 1857. The third, and crucial, change in this lecture is that in the course of it Ruskin stumbles upon the final component of the new medium in which he is to produce his later social writing. The word 'emblem', in the sentence about rust as a symbol of both resurrection and decay, provides the clue. He had often written about symbolism in the work of other artists. Now he begins to realize that he can exploit it himself, to provide the shape and system of a new form of political literature.

Less than a year later Ruskin re-used the material of the second half of 'The Value of Drawing' to create the work which has a better claim than any other to mark a decisive transition in his literary career. On 16 February 1858, he spoke at Tunbridge Wells on 'The Work of Iron, in Nature, Art, and Policy'. The lecture is the first work in which Ruskin successfully combines the new polemical manner, drawn from Helps and Carlyle, with an effective contribution of his own. *Unto this last*, though it makes more detailed reference to the work of contemporary political economists,

is simply a later exercise in the same imaginative mode.

Symbolism is actually present in 'The Work of Iron' (later published in *The Two Paths*) in two quite different senses. Ruskin reads the natural world symbolically, in very much the manner recommended by the chapters on Typical Beauty in *Modern Painters* Volume 2, to discover social lessons in geological and botanical details. And, second, he uses symbolism as a rhetorical technique, deploying it to attract and persuade his readers. The medieval analogy which had given shape to his political writing up to 1853 is replaced by a less reliable, but far more exciting, form of literary invention.

'The Work of Iron' begins with the rust which had been so important to 'The Value of Drawing'. The 'saffron stain' in the basin of the Tunbridge Wells spring is produced by 'iron in a state of rust'. This is not a defect of the metal. On the contrary, 'iron rusted is Living; but when pure or polished, Dead'. That death is dramatically illustrated:

> how would you like the world, if all your meadows,
> instead of grass, grew nothing but iron wire - if all your
> arable ground, instead of being made of sand and clay,
> were suddenly turned into flat surfaces of steel - if the
> whole earth, instead of its green and glowing sphere, rich
> with forest and flower, showed nothing but the image of
> the vast furnace of a ghastly engine - a globe of black,
> lifeless, excoriated metal? (16.378)

Ruskin's point is the romantic version of a physiocratic distinction between true, vegetable wealth and false, commercial riches which he had first expressed in *The King of the Golden River*. The 'rusting' of various metals into sand, lime and clay enables food to be grown. The same combinations of iron and oxygen ('the breath of life') puts colour into the landscape. Is there not, Ruskin asks, 'something striking in this fact, considered largely as one of the types, or lessons, furnished by the inanimate creation?' (16.377). The 'noblest colour ever seen on this earth' is the crimson of blood, and that pigment is 'connected, of course, with its vitality, and that vitality with the existence of iron as one of its substantial elements' (16.384).

Hitherto 'The Work of Iron' has essentially been a more elaborate version of 'The Value of Drawing', and the next step of Ruskin's argument also seems familiar. In the earlier

lecture he had used the union of iron with air as a symbol of the qualities for which his audience of art students should strive, 'strength and perseverance, with soul' (16.446). A similar procedure carries him into the second section of 'The Work of Iron', his account of iron in art. The best art combines body and soul, 'craftsmanship' and 'work of the heart' (16.385). From this point onwards, however, the lecture parts company with its predecessor. In 'The Value of Drawing' Ruskin wished to include a social appeal, but did not know how to integrate it with the rest of his argument. Though the students were urged to paint cheeks red with health, the political principles on which they should proceed to do so were indicated only by a digressive analogy between artistic composition and social order. In 'The Work of Iron' the imaginative fabric is much more tightly knit. First Ruskin uses decorative ironwork, in the form of fences, as an image of social division. Then (and a rejected passage, in the manuscript, indicates how carefully he is holding back the full political implications of his argument) (16.391) he proceeds to a directly symbolic use of the artefacts made from iron.

The political action of iron, Ruskin argues, may be 'simply typified' by 'three great instruments', the Plough, the Fetter, and the Sword (16.395). The image of the plough enables Ruskin to solve a problem which had defeated him in *The Political Economy of Art*. Arguing there for a 'fatherly authority' in society, that is for a highly interventionist state which corrects economic inequality in the same way as it punishes crime, he had failed to establish a convincing parallel between the two activities (16.25; 105-9). Now his symbol provides him with an answer. He starts with the very Biblical version of the Labour Theory of Value which he had developed in *Modern Painters* Volume 3 (5.380). According to the curse of man in Genesis, everybody owes Nature a certain amount of unfulfilling labour in return for sustenance. If we evade this law we are 'taking our hands off the Plough-handle, and binding another's upon it' (16.402). As so often happens, an anticipation of this thought can be found in *Modern Painters* Volume 2 (revising the latter work, in 1883, Ruskin was himself moved to comment that he 'had no memory . . . that it was anywise so pregnant with design of subsequent works') (4.211n). But the image of taking one's hand from the plough 'while men are perishing round about us' was there simply an account of devoting oneself to art

rather than to social action (4.217-18). Here it is a much
more general metaphor for the enjoyment of economic
advantages, and it is strengthened by the idea that unfulfilling
labour is a form of death. Stealing another man's labour,
Ruskin now argues, involves inflicting death upon him, and
'the choice given to every man born into this world is, simply,
whether he will be a labourer or an assassin . . . whosoever
has not his hand on the Stilt of the plough, has it on the Hilt
of the dagger' (16.406). Seen in these terms, exploiters
should be punished like murderers.

With this argument for draconian state intervention in
economic affairs firmly established, Ruskin is free to suggest
the characteristics which that state should possess. Once
again his ferrous imagery is to the fore. The Fetter is the
second political 'type' of iron, and a nation's 'second power'
consists in knowing how to wear it (16.408). This is a logical
development of Ruskin's hostility to laissez-faire economics.
An interventionist state is a state which restricts liberty. 'The
power and glory of all creatures, and all matter,' Ruskin
insists, 'consist in their obedience, not in their freedom'
(16.408). The third iron symbol, the Sword, leads on from
this very naturally. Military discipline and military self-
sacrifice, which in a medievalist work would have been
referred to as 'chivalry', are the ideal model of social
organization.

As this last point makes clear, the arguments advanced are
not unlike those of Götzism. The medium in which they are
presented, however, is entirely new. Ruskin combines a
Carlylean vein of satire and denunciation ('we differ from
Front de Boeuf, or Dick Turpin,' he tells his respectable
audience, 'merely in being less dexterous, more cowardly,
and more cruel') (16.402) with a complex yet coherent
network of imagery and allusion. Having located iron in our
heart's blood, and thus established its significance, he
proceeds to derive from it a series of imaginative meanings.
It is not, of course, a rational process. Ruskin is assembling
a poetic pattern of hints and suggestions. But one does not
have to share his opinions (I personally find them deplorable)
to admire the remarkable literary skill with which the lecture
is constructed.

'The Work of Iron' begins a new era in Ruskin's work, an
era which embraces the final sections of *Modern Painters*
Volume 5, *Unto this last, Munera Pulveris, The Crown of*

Wild Olive, Sesame and Lilies and *Time and Tide*. The balance between satire and symbolism in these books is not, of course, uniform. From 1858 onwards Ruskin has a new manner, but uses it in both rich and plain versions. In the final sections of *Modern Painters* Volume 5, for example, the symbolism predominates. *Unto this last* reasserts the plain style, but is none the less built on a framework of imagery and allusion. *Munera Pulveris* oscillates violently between an unprecedentedly sparse prosaic manner and a uniquely dense tangle of imagery. But once the basic procedure is established it persists, and it determines the form of Ruskin's second major group of political writings.

What prompted the choice of this symbolic method as the final component of a new political art? Did it simply arise from Ruskin's critical interest in painterly and poetic symbolism, expressed for instance in the 'Grotesque Renaissance' chapter of *The Stones of Venice*? Certainly he draws on such traditional models as Dante and Spenser, the Bible and the classics to inform and enrich his chosen images. Or did it, like the satirical and polemical manner, have a specific contemporary source? Carlyle, of course, was as much an inspiration for symbolism as he was for satire, and Ruskin was undoubtedly familiar with the advocacy of symbols in *Sartor Resartus*. But a much more suggestive parallel with Ruskin's actual practice in this area is offered by the work of an imaginative writer more nearly his contemporary, Charles Dickens. This example, more than any other, seems to me likely to have encouraged Ruskin in his endeavour to find emblems for contemporary life and thought.

Dickens is rarely advanced as an influence upon Ruskin, for the good and simple reason that the latter's comments on him seem so dismissive. Though both were disciples of Carlyle, their social views were far from identical (Dickens, very sensibly, found much more to say for the market economy) and Ruskin's valedictory comment, in a letter to Charles Eliot Norton on the novelist's death, was that while 'the literary loss is infinite – the political one I care less for than you do'. The letter goes on to give Ruskin's grounds for this view:

Dickens was a pure modernist – a leader of the steam-whistle party *par excellence* His Christmas meant mistletoe and pudding – neither resurrection from dead,

nor rising of new stars, nor teaching of wise men, nor shepherds. His hero is essentially the ironmaster; in spite of *Hard Times*, he has advanced by his influence every principle that makes them harder – the love of excitement, in all classes, and the fury of business competition, and the distrust both of nobility and clergy. (37.7)

In *Praeterita* Ruskin was still more explicit. Much as he loved the novels, Dickens 'never became an educational element of my life, but only one of its chief comforts and restoratives' (35.303).

The fact remains that the two men, in the 1850s, were engaged on very much the same inquiry. Both were seeking a new literary medium for the expression of political thought. In Dickens's case, of course, this was not because he needed a replacement for Götzism. He had never had anything but contempt for medievalists, and produced some of the most telling satire ever written about them. But, from the late 1840s onwards, he clearly wished to augment his long-established criticism of individual abuses with some more general, and more searching, vision of the body politic. Once again it was Carlyle who prompted the ambition and, in this case, it was certainly Carlyle who suggested symbolism as a means with which to achieve it. The extent to which *Dombey and Son* is shaped by the emblem of the sea, *Bleak House* by the fog and the law-court, or *Little Dorrit* by the prison, is now a commonplace.

But the parallel with Ruskin is not that of these grand, organizing symbols which serve to give coherence to an entire book. The link between the two men is, instead, to be found in Dickens's descriptions, above all in the moralized landscapes of his later work. The particular, local symbols of this writing, for which there is no precise equivalent in Carlyle, show striking similarities with Ruskin's emblems. Take, for example, the iron oxide of the Tunbridge Wells lecture. Iron had been a persistent minor symbol in *Bleak House*, where it was, indeed, associated with the 'ironmaster' whom Ruskin remembered in 1870 as the novelist's essential hero. Of course, the notion of the nineteenth century as an 'iron age' did not originate with Dickens. Matthew Arnold gave the idea its most famous formulation in 1850, in his elegy for Wordsworth. But Dickens's vision of a landscape of iron is, without being geological, far closer to Ruskin's

conception than any single phrase can be:

> He comes to a gateway in the brick wall, looks in, and
> sees a great perplexity of iron lying about, in every stage,
> and in a vast variety of shapes; in bars, in wedges, in sheets;
> in tanks, in boilers, in axles, in wheels, in cogs, in cranks,
> in rails; twisted and wrenched into eccentric and perverse
> forms, as separate parts of machinery; mountains of it
> broken up, and rusty in its age; distant furnaces of it
> glowing and bubbling in its youth; bright fireworks of it
> showering about, under the blows of a steam-hammer;
> red-hot iron, white-hot iron, cold-black iron; an iron taste,
> an iron smell, and a Babel of iron sounds He is left
> alone with the gentleman in the office, who sits at a table
> with account-books before him, and some sheets of paper,
> blotted with hosts of figures and drawings of cunning
> shapes. It is a bare office, with bare windows, looking on
> the iron view below. Tumbled together on the table are
> some pieces of iron, purposely broken to be tested, at
> various periods of their service, in various capacities.
> There is iron-dust on everything; and the smoke is seen,
> through the windows, rolling heavily out of the tall
> chimneys, to mingle with the smoke from a vaporous
> Babylon of other chimneys.
> 'I am at your service, Mr Steel,' says the gentleman,
> when his visitor has taken a rusty chair. [7]

Dickens's idea of iron as a living creature, and his sense of
an 'iron view', are perhaps less analytical than Ruskin's.
But the two visions spring from a very similar imaginative
process (Dickens has an underlying imagery here of steel as
a symbol of military organization, and of iron as an emblem
of commerce) and the closeness between the writers is even
more marked when they use iron railings as a symbol of
social division. Metal establishes the character of Sir
Leicester Deadlock's town house as firmly as water defines
the meaning of Chesney Wold:

> Complicated garnish of iron-work entwines itself over the
> flights of steps in this awful street; and, from these petri-
> fied bowers, extinguishers for obsolete flambeaux gasp at
> the upstart gas. Here and there a weak little iron hoop,
> through which bold boys aspire to throw their friends'

caps (its only present use), retains its place among the rusty foliage, sacred to the memory of departed oil.[8]

The core of Ruskin's long discussion of such features in 'The Work of Iron' is a similar, if more explicit, assertion that 'the uncomfortable and unprincipled parts of a country would be the parts where people lived among iron railings, and the comfortable and principled parts where they had none' (16.388). It is an intriguing thought that one of the alternative titles considered for *Hard Times*, the Dickens novel which Ruskin admired above all others, was 'Rust and Dust'.[9]

Do we, however, have any evidence that Ruskin admired Dickens's landscapes? His appendix on 'Plagiarism', in *Modern Painters* Volume 3, pays tribute to the novelist as a model merely of wit and humour (5.428). But elsewhere Ruskin does express profound enthusiasm for Dickens the descriptive writer. In *Modern Painters* Volume 1 he compares a perception of the sky in *American Notes* with Wordsworth and Turner (3.347), in *Frondes Agrestes* he declares that 'there is nothing in sea-description, detailed, like Dickens's storm at the death of Ham, in *David Copperfield*' (3.570n), and in Letter 19 of *Fors Clavigera* he declares that Dickens's description of a thunder-shower in a letter printed in Forster's *Life* 'will give you a better idea of the kind of thing than I can, for my forte is really not description, but political economy' (27.324-5). And though none of this praise is for the special kind of socially significant landscape which I have been discussing, there are repeated parallels between the symbolism developed in this context by Dickens and Ruskin's later political typology.

Iron, though interesting because it is the dominant image of a pivotal work, is actually a comparatively minor example. Much more important are two linked symbols which for Dickens became conspicuous in *Dombey and Son*, dirt and dragons. The soiled world of Stagg's Gardens, as the new railway is driven through, is an outstanding example of a frequent Dickensian effect:

> There were frowzy fields, and cow-houses, and dunghills, and dustheaps, and ditches, and gardens, and summer-houses, and carpet-beating grounds, at the very door of the Railway. Little tumuli of oyster shells in the oyster

season, and of lobster shells in the lobster season, and of broken crockery and faded cabbage leaves in all seasons, encroached upon its high places. Posts, and rails, and old cautions to trespassers, and backs of mean houses, and patches of wretched vegetation stared it out of countenance.[10]

When Ruskin was attempting to create a similar picture of squalor in his description of the approach to St Mark's in *The Stones of Venice*, his father wrote from England to criticize him for writing too much 'after Dickens'. On that occasion he replaced the sordid particularity of jars of pickles, strings of onions and a number of 'disbanded vinegar cruets' with an elegant periphrasis: 'certain ambrosial morsels of a nature too ambiguous to be defined or enumerated' (10.81).[11] But the moral symbolism of dirt and decay was something to which he responded very readily. In *Modern Painters* Volume 2 he wrote of purity as a type of Divine energy, expressing 'vital and energetic connection among its particles; as that of foulness is essentially connected with dissolution and death' (4.132). By the final volume of *Modern Painters* this has become a social principle. The internal organization of a crystal demonstrates the need for social order, a contention which Ruskin illustrates by taking 'an ounce or two of the blackest slime of a beaten footpath on a rainy day, near a large manufacturing town' (7.207). The clay, soot, sand and water are all competing with each other. But allow their natural organization to prevail and 'for the ounce of slime which we had by political economy of competition, we have by political economy of co-operation, a sapphire, an opal, and a diamond, set in the midst of a star of snow' (7.208). Even when Ruskin turns against Dickens, in the late and peculiar 'Fiction – Fair and Foul', he begins his attack with a highly Dickensian description of the squalor of Croxted Lane (34.266-7).

The railway which causes the defilement of Stagg's Gardens is equally fascinating. The trains glide 'like tame dragons' into their allotted sidings and, only five chapters later, are seen as 'a type of the triumphant monster, Death'.[12] By the time of Carker's death upon the rails, the devilish and deadly associations of this serpentine railway are overwhelming. In *Hard Times* we see dirt and dragons associated still more closely, as emblems of industrial society, and the passages

which present them are as full of Ruskinian parallels as they are quintessentially Dickensian:

> The day grew strong, and showed itself outside, even against the flaming lights within. The lights were turned out, and the work went on. The rain fell, and the Smoke-serpents, submissive to the curse of all that tribe, trailed themselves upon the earth. In the waste-yard outside, the steam from the escape pipe, the litter of barrels and old iron, the shining heaps of coals, the ashes everywhere, were shrouded in a veil of mist and rain.[13]

Clouds are a Ruskinian image of modern faithlessness, just as dirt is an emblem of modern competitive individualism (he writes in *Modern Painters* Volume 3 that our 'cloud-worship' expresses 'easily encouraged doubt, easily excited curiosity, habitual agitation, and delight in the changing and the marvellous, as opposed to the old quiet serenity of social custom and religious faith') (5.318). Serpents or dragons occur as 'snake-like shadows' in *The King of the Golden River* (1.338), are identified as an instance of 'malignity' in *Modern Painters* Volume 2 (4.158), and grow steadily in symbolic importance during the 1850s. By *Modern Painters* Volume 5 the dragon has become a central symbol, first of covetousness and then of death. 'Yes, Albert of Nuremberg,' declares Ruskin at the end of 'The Nereid's Guard', 'another nation has arisen in the strength of its Black anger; and another hand has portrayed the spirit of its toil. Crowned with fire, and with the wings of the bat' (7.408).

The two writers, in other words, both in the 1850s endeavouring to develop a new kind of political literature, share not just a general taste for symbolism but also a surprising number of particular symbols. Iron and dirt, clouds and dragons are a common imaginative currency. This is not a question of simple imitation. Ruskin's dragons, to take only one example, derive more immediately from Dante, Greek myth and the Bible than they do from Dickens. But it would be very surprising if Ruskin had not been encouraged by the example of his great contemporary. Kathleen Tillotson, in *Novels of the Eighteen-Forties*, speaks of the way in which, after Carlyle, 'the poetic, prophetic, and visionary possibilities of the novel are fully awakened'.[14] These possibilities, so vividly demonstrated by the later fiction of Dickens, are also

possibilities for non-fictional prose. In the new phase of his career which opens with 'The Work of Iron, In Nature, Art, and Policy', the poetic, the prophetic and the visionary are precisely the qualities to which Ruskin's work aspires.

NOTES

1 E.T. Cook's recollection of the occasion, given in his *Life of Ruskin*, 2 vols (London, George Allen 1911), II: 1-2. The phraseology in the notes for these lectures, printed in the Library Edition, is slightly different (22.511-13). Ruskin's words are here 'that central book of my life', and they occur in the next lecture, on 10 November 1877 (22.514).

2 Northrop Frye, *Anatomy of Criticism* (Princeton University Press 1957), p. 198.

3 Thomas Carlyle, 'Sir Walter Scott', *Works* ('Centenary Edition'), (ed.) H.D. Traill, 30 vols (London, Chapman and Hall 1896-9, and New York, Scribner 1896-1901), XXIX: 58.

4 *Maud* was first published in 1855. The precise date of 'The Latest Decalogue' is not known, and since Clough was expressing a similar idea in a letter to *The Balance* on 6 February 1846 its composition may pre-date the 1850s. Both poems are, however, heavily influenced by Carlyle.

5 Ruskin confessed as much when he wrote to Arthur Helps about this lecture on 16 January 1870: 'You can't think', he declares, 'what a mere faint echo of Carlyle – and coarse echo of you, I seem to myself – when I read either of you, now.' See J.R. DeBrun, 'John Ruskin and Sir Arthur Helps', *Bulletin of the John Rylands Library*, 59 (1976-7): 303.

6 Elizabeth Barret-Browning, *Aurora Leigh* (London, 1857), pp. 399, 343.

7 Charles Dickens, *Bleak House*, The Oxford Illustrated Dickens (London and New York, Oxford University Press 1948), pp. 846-7.

8 Ibid., p. 653.

9 See the memorandum, or working plans, for *Hard Times*, reproduced in Charles Dickens, *Hard Times*, (eds.) G. Ford and S. Monod (New York, Norton 1966), p. 233.

10 Charles Dickens, *Dombey and Son*, The Oxford Illustrated Dickens (London and New York, Oxford University Press 1950), p. 63.

11 Ruskin Galleries, Bembridge School, Isle of Wight, John James Ruskin, letters of 1-2 December 1851 and 6-7 January 1852 (BEM MS L4). I am indebted for this reference to Robert Hewison.

12 Dickens, *Dombey and Son*, op. cit., pp. 219, 280.

13 Charles Dickens, *Hard Times*, The Oxford Illustrated Dickens (London and New York, Oxford University Press 1955), p. 69.

14 Kathleen Tillotson, *Novels of the Eighteen-Forties* (Oxford, Clarendon Press 1954), p. 154.

5

Ruskin and Political Economy: *Unto this last*

Alan Lee

No one now reads Ruskin for his economics. He has had virtually no place in the recent renaissance in the study of the history of economic thought, and there has been no suggestion that the omission is a grave one.[1] Yet he spent a good half of his life writing about political economy, directly or tangentially. Although the customary view that he experienced something like a change of life in the late 1850s, moving from art to social criticism, has been replaced by a more plausible and accurate one in which the transition was nothing like so sudden or unpresaged, it must be admitted that there was a marked change of emphasis which centred upon the two semi-serialized works *Unto this last* (1860) and *Munera Pulveris* (1862). The former was the first and most memorable of Ruskin's attempts to grapple with orthodox political economy, and arguably it was the storm of hostile criticism which greeted it that led him to devote so much of the remainder of his life to social criticism and theory, and which in turn brought him the fame attaching to a Victorian sage.

Such fame, however, was not necessarily conducive to the understanding of his meaning and significance. The numerous studies of Ruskin's social thought, which began to flow well before his death, have each tended to present the reader with a different Ruskin: Ruskin the Socialist, the Social Reformer, the New Liberal, the Medievalist and later the Technocrat and Institutionalist. Whilst not wishing to dismiss these versions out of hand, it may be suggested that there is another, less commonly found, but more authentic Ruskin, Ruskin the Tory, which fits the development and nature of his

thought rather better than any of these, though it may diminish his relevance for later generations and sever the cord between Ruskin and, at its most absurd, Harold Wilson.[2]

Any such discussion of Ruskin's economic thought must be accompanied by an examination of the institutional background of the political economy of his day, and be seen in the context of the reception accorded him as one of the three wise men of Victorian society, with Carlyle and Arnold. People drank Ruskin in increasingly large draughts from the 1880s on, yet it is not entirely clear what they were drinking, or what they thought Ruskin was giving them. If, as is so often claimed, it made them into socialists and revolutionaries, it is legitimate to ask what sort of socialists and revolutionaries it could have made them into. As *Unto this last* was the chief vehicle of his social and economic thought any analysis of it must be made with this in mind.

If, however, we try immediately to look at Ruskin's political economy as set out in that book, we encounter the major difficulty that Ruskin was not a systematic thinker. His mind worked primarily in terms of visual perception, not verbal analysis, and he deliberately eschewed logic, hypothesis and system (11.115-20). His writing was aphoristic, thickly larded with allusions to the Bible and, increasingly as he grew older and less mentally stable, with usually dubious etymological digressions. His role tended to be, as one of his most astute contemporary critics put it, 'a brilliant partisan in a random guerilla warfare'.[3] So the concepts he used were rarely those of political economy: honour, justice, honesty and above all life and death. When he came to discuss wealth, value, utility, demand or labour it was only in terms of his own list of fundamentals. Nowhere do we find the painstaking logical analysis which characterized the economics of his day, and, indeed, of ours. He had received no training in the subject and his reading in it was not wide. Moreover, after the hostile reception of *Unto this last* he seems to have read less modern work than before, to have preferred Fawcett's popularization of Mill to the original, and to have been content in the main with second-hand accounts and reviews.[4]

The peculiarity of Ruskin's approach is made even plainer if we look first at the 'orthodox' political economy against which he railed.

Although in *Unto this last* he referred to political economy as 'the science of darkness; probably a bastard science' (17.92), he had little formal knowledge of it, nor it of him. His name had been made as the precocious author of *Modern Painters*, the last volume of which was published just two months before the first essay of *Unto this last* appeared in the new *Cornhill Magazine*. He was not yet the sage of later years; his name was not yet yoked with that of Carlyle. His strongest point was possibly his command of English style, but this was itself a grave drawback in the eyes of some economists. While Adam Smith and David Hume had certainly written well, though not 'finely', their arguments were usually lucid and analytical. David Ricardo, the acknowledged master of the science from the 1820s to the 1870s, had tightened up the arguments considerably, draining the colour from Smith, but presenting the science as a system of deduction from initial premises, simplifying where necessary, making many *ceteris paribus* assumptions for the sake of the general theory. This had lent him and his followers, the Mills and J.R. McCulloch, a powerful weapon against even formidable opponents like Thomas Malthus, himself no mean exponent of logical argument. They were also helped by the fact that their critics tended to be disunited and muted. Finally, the Ricardians were helped by the still primitive state of academic economics at the time. The Drummond Chair at Oxford had been established only in 1825, although both Oxford and Cambridge had provided some teaching in the subject previously. McCulloch obtained the chair at the new Benthamite establishment at University College London – and King's London, and later Dublin, were to establish chairs, but there remained considerable academic hostility to the subject right up to the 1860s.

To summarize the content of Ricardianism is, inevitably, to distort, but in essence its doctrinal bases were a labour (embodied) theory of value; an equilibrium theory of production and distribution, ruling out general overproduction; a differential theory of rent coupled neatly with the Malthusian population theory, and supporting a subsistence theory of wages (expressed in the term 'natural wage', the abandonment of which opened up the theoretical possibilities of social reform after 1870); and a residual theory of profits, squeezed by rents on one side and wages on the other. This meant that wages and capital were held to be reciprocally

related, the so-called 'wages-fund' theory, to be abandoned, precipitately thought some, by Mill in 1869. In the long term, and the Ricardian theory was essentially a series of long-term propositions, the rate of profit would fall, discouraging further saving and investment, the reason why Carlyle dubbed it 'the Dismal Science'.[5] By the 1860s the possibilities of exploiting new lands and resources were beginning to be seen as a way out, and this together with the admission by Mill and Cairnes that the assumptions of the uniformity of labour and of perfect competition were unreal, prepared the way for the demise of the classical Ricardian edifice.[6]

Ricardianism, however, had also exposed the roots of social conflict, between landlord and capitalist, and, from Ricardo's admission that machinery could at least in the short-term displace labour, between labour and capital. These were openings, of course, which the 'Ricardian socialists' and Marx himself seized eagerly upon. They were also implications which made economists particularly sensitive as to the way in which such 'truths' were presented to the working class, a sensitivity of some significance when considering the reception of Ruskin's works.

Even when looked at purely theoretically there were many flaws and unresolved questions. The theory of value, *pace* Mill, was a constant source of dispute, with some like Samuel Bailey and Nassau Senior groping their way towards a utility theory; the doctrine of the impossibility of general overproduction was questioned both by underconsumptionists and some monetary writers; the 'wages-fund' theory was regarded sceptically by spokesmen for the wage-earners who knew from practical experience that wages were not derived from a fixed stock of capital.[7] Nevertheless, few as the true 'Ricardians' were, their theory was in 1860 effectively established not only as a body of conventional science, but of conventional popular wisdom, and understandably the two were often confused.[8]

It was a confusion in part due to the coincidence of the Ricardian domination of theory and the triumph of political laissez-faire, between a scientific theory and a moral faith. Positivism and evolutionism later both, in different ways, made it difficult to maintain such distinctions, but had hardly begun to do so in 1860, and the 'neutral' stance was often misunderstood. As John Lalor, influenced by Carlyle,

pointed out in 1852, 99 per cent of people did regard political economy as a moral code, despite the protestations of Senior and Mill.[9] Ruskin's pupil Arnold Toynbee later explained that

> the laws of Political Economy are converted into rules
> by sheer force of necessity, and . . . the maintenance of
> . . . neutrality is practically impossible. Some answer
> must be given to the pressing questions of the day, and if
> Political Economy did not lay down the rules and become
> a practical science, journalism would.[10]

The more subtle point that political economists were willing to advise on policy, but that their theories were themselves not to be regarded as policy precepts, was a difficult one to get across, and it was always one which Ruskin rejected.

If the economists themselves were willing to admit that 'anarchy' prevailed, like De Quincey in 1844, or Jevons in 1876, public opinion was not. Henry Sidgwick later noted, almost with despair, a passage in the *Edinburgh Review* for 1861 which claimed for political economy the status of a set of established truths; Mill himself found it necessary to challenge Robert Lowe in the House of Commons on this point in 1868, and such attitudes undoubtedly prepared the response to Ruskin in 1860.[11] In the 1870s a certain disenchantment set in, provoking Walter Bagehot's famous remark that English political economy 'lies rather dead in the public mind'. Even at the academic level it lacked appeal.[12] Yet at a more popular level the rather crude propagandizing which had characterized the generation from the 1830s continued, and it was not until the 1890s that it was scornfully dismissed by Alfred Marshall: 'never again will a Mrs Trimmer, a Mrs Marcet or a Miss Martineau earn a goodly reputation by throwing [the teachings of political economy] into the form of a catechism or of simple tales by aid of which any intelligent governess might make clear to the children nestling around her where lies economic truth'.[13] In the 1860s this work was not held in such low esteem, nor was it the exclusive province of women as Marshall insinuated. Jevons, who did most to bring Ricardianism to its knees, used to refer pupil-teachers at the Owens College to Miss Martineau's 'admirable tales', admitting that he had first learnt political

economy from Whately's *Easy Lessons*.[14]

Indeed, political economy had, since at least the early 1830s, been considered an essential part of the instruction of the lower orders. Whately had produced the manual referred to above precisely for this purpose. By 1848 the subject was in the curriculum of the National Schools, although rarely as a separate subject. From 1863 to 1885 it was a compulsory subject in the curriculum of men's training colleges, and was only withdrawn under pressure from the payment by results system. Others had been equally keen on its educational value, McCulloch, the SPCK and the SDUK, Francis Place and the Birkbeck Institute, and William Ellis, who devoted his life to the elementary teaching of the subject in schools.[15] So Ruskin was up against, not only a powerful 'scientific' establishment, but also the widespread ideological use of the science which he attacked.

The institutional context of the appearance of *Unto this last* in 1860, then, was not auspicious. The Ricardians were still entrenched, and their opponents not in good voice. There was seemingly a huge confidence in the science in the public mind, which would only ebb in the following decade. It was not to be expected that he would find much support from the ranks of either the economists or of their publicists in 1860; for that he would have to wait until the 1880s.

How now did Ruskin come to the point of writing *Unto this last*? He may have begun his study of political economy in the late 1840s, although the reference in *Praeterita* (35.429) is very vague. He possessed a rather meagerly annotated first edition of Mill's *Principles*; his unpublished letters to *The Times* date from 1852; and he explained to Jane Carlyle in 1855 that 'my studies of political economy have induced me to think . . . that nobody knows anything about that, and I am at present engaged in an investigation, on independent principles, of the Natures of Money, Rent, and Taxes, in an abstract form, which sometimes keeps me awake all night' (5.l).

Although his boast in 1857 not to have read any political economy since Adam Smith twenty years previously (16.10) smacked of *épater les économistes*, it was not so far from the mark. He liked to think that he had had some experience of commerce in the family firm (36.340) but it is not clear

that this was so, or if it were, how he had benefited from it. As to his reading there is a similar uncertainty. His sermon-izing style left few clues as to sources, and most of these occur after 1860.[16] His Diaries have a few references to his 'doing Pol. Econ.' in the 1860s, but they appear to refer mainly to his own musings whilst reading Plato's *Laws* and Xenophon's *Economist*. An earlier reference in the Diary urges the importance for the political economy of Jeremiah 23, which is, perhaps revealingly, concerned exclusively with prophecy![17] There is no indication that he was familiar with Senior or Malthus. Sherburne has shown the affinity of his ideas with romanticism, especially regarding economics as a moral science, but there is no positive evidence of him being aware of the relevant writings of, say, Burke or Coleridge, Mill may have led him to De Quincey, but it is 'The Dialogue of the Three Templars' which he cites in *Unto this last*, and not the later and more substantial *Logic of Political Economy*, and in any case De Quincey was more or less a Ricardian who held a poor opinion of Coleridge's economic dabblings.[18] Sismondi, with whose ideas Ruskin's undoubtedly have much in common, seems only to have been read as an historian, and then to have been taken for more of a republican than he was. Furthermore, it was precisely the underconsumptionist thread in his writings that Ruskin referred to as 'monstrous' when reading Mill's critique of it.[19] Nor, finally, was Ruskin a reader of Comte, whom Frederic Harrison claimed shared much common ground with him in economics (28.15).[20] Given this paucity of economic study, orthodox or otherwise, it is scarcely surprising that Ruskin's own political economy differed radically from the mainstream teaching of his day. Much of it sprang from his own fertile mind, but there were two major sources essential to its understanding, the Bible and Carlyle.

Knowing much of the Bible by heart, Ruskin naturally drew freely upon it whatever his subject. Much of his criticism of the objects and methodology of political economy, as he understood it, was based, even in his 'unconverted' period, on the teaching of the good Book. However, this need not have put him outside the pale of respectable political economists. His Evangelicalism was shared with Henry Thornton who was responsible for persuading Mill to abandon the 'wages-fund' doctrine, and many of his academic audience, because they were academics, were clergymen; Whately, Whewell, Adam

Sedgwick, Thomas Arnold, even John Newman wrote on economics. It would, therefore, be unwise to assume that the biblical patina with which Ruskin's arguments were served up, provided too great an obstacle in themselves to his contemporaries. He may, indeed, be seen as sharing in the long Catholic tradition of social teaching, a lineage he would have loathed to admit and probably knew little of, but which at very many points closely touched his own thinking.[21]

But it was to Carlyle that he turned most often after the Bible. He kneeled at the feet of his 'master' (34.355) both intellectually and literally,[22] 'the greatest of our English thinkers', 'our one quite clear-sighted teacher' (18.468, 498). Carlyle it was who damned political economy as 'the dismal science', had attacked 'the cash-payment as the sole nexus', had sacramentalized work, had spoken of the true mastership of governing and of the chivalry of work, had, in fact, made virtually all the bricks with which Ruskin was to construct his own economic edifice.[23] Ruskin had *Past and Present* off by heart (27.179 n.1), and advised his readers to do likewise, later claiming that 'all has been said' in *Sartor, Past and Present* and the *Latter-Day Pamphlets* 'that needs to be said' (17.287). It is only in the shadow of this debt that the peculiar language and concerns of Ruskin's economics can be understood, and that debt itself must be set in the context of Ruskin's own Toryism.

There are ample indications that Ruskin was, as he claimed, 'by nature and instinct Conservative'.[24] 'I am,' he confessed in *Fors*, 'and my father was before me, a violent Tory of the old school' (27.167). It was from his father in Edinburgh that he first learnt his Toryism, which consisted in part of a distrust of 'liberty', still associated with the terrors of the French Revolution.[25] But it consisted of more than this. The parallel between fifteenth-century Venice and nineteenth-century England was only too obvious in the first volume of *Stones*, and the moral interpretation of history there provided was also the interpretation he gave to contemporary society. In place of 'Liberty' and 'anarchy' was set order, hierarchy, obedience and place. 'All anarchy is the forerunner of poverty, and all prosperity begins in obedience' (18.495). He shared the medievalist fashion of the times in locating these virtues in pre-Renaissance Europe, but more importantly the concept of an organic, status-based society, founded on legitimate authority, gave him a platform from which he

could launch into contemporary liberalism, the chief ideological prop of which was, as he rightly perceived, political economy. Not least of the errors of Adam Smith, in Ruskin's eyes, was his delineation of 'a system of natural liberty'.

As he wrote to the Social Democrat Sidney Cockerell in 1886, 'of course I am a Socialist – of the most stern sort – but I am also a Tory of the sternest sort'.[26] Discipline, not liberty, still less equality, was the common factor here. Bernard Shaw, so often an idiosyncratic and unreliable source, was surely right in this instance in linking Ruskin, Toryism and Bolshevism: 'The Tory is a man who believes that those who are qualified by nature and training for public work, and who are naturally a minority, have to govern a mass of the people',[27] and what consciousness would do for the Bolsheviks, education would do for Ruskin. 'Educate, or govern, they are one and the same word' (18.502). His confessions to socialism or communism were, though widely quoted, few in number, and it was only if one defined socialism in some such terms as his disciple J.A. Hobson did, namely the belief 'that industry should be directed by the motive of social good, not individual gain', could Ruskin easily be shepherded into the Socialist fold.[28] That he figured so prominently in the culture of the English labour movement is something we must return to later. For now it is sufficient to note that his claim to be 'a Communist of the old school' (27.116-17) rested on a decidedly paternalistic version of 'old communism', not inaccurate in itself, but likely, even in his own time, to mislead. What he certainly did not mean was the abolition of private property, which was the commonly understood characteristic of communist ideas. 'Men, and their property, must both be produced together – not one to the loss of the other' (19.401). The division of property would mean its destruction (17.106 n.), and he claimed that without the protection of private property the worker would effectively forfeit his right to the produce of his labour (17.192-3). Whatever similarities his later bureaucratic versions of Utopia might have had with later 'socialisms', Ruskin eschewed both the name and the thing as soulless and futile (12.556). It was a moral change that was called for, and he thought socialism did not provide that (17.144). The socialist would disable the rich in the name of justice, Ruskin would educate them (17.106 n.).

For Ruskin 'the impossibility of Equality' (17.74) was the

premise upon which his paternalistic society was to be built. In his early examination of political economy, *A Joy For Ever* (1857), he claimed that poverty was the result of 'wilfulness, when there should have been subordination', and he consequently urged the necessity of 'paternity, or fatherhood' in the nation (16.19, 24). In *The Stones of Venice* Volume 1 he emphasized that architecture was the expression *'of the mind of manhood by the hands of child-hood'* (9.290); in the 'Nature of Gothic', the supposed *locus classicus* of his 'socialism', he looked forward to the time 'when men will see that to obey another man, to labour for him, yield reverence to him or to his place, is not slavery. It is often the best kind of liberty – liberty from care' (10.194). All this appears again in *Unto this last* where he urged 'the advisability of appointing such [eternally superior] person or persons to guide, to lead, or on occasion even to compel and subdue, their inferiors according to their own better knowledge or wiser will' (17.74), perhaps one of his most Rousseavian passages.

He saw no injustice in a society ordered on such principles, the basis of what he termed 'mastership', and his theory of work is central here. He thought it essential to avoid reducing men to the numerical equivalents of each other (which was the way which political economy would shortly turn). He noted, in relation to Sismondi, '(as if any man consenting to obey another had not a nobler will in obeying than in rebelling)',[29] and in *Unto this last* the logical conclusion is drawn that death is the only real freedom possible to us.

Neither liberty nor equality was Ruskin goal, but Justice, which required the care, not the exploitation, of fools, honesty, honour and work, and all this would result in wealth (16.100-02). These were the central concerns of *Unto this last*. It was not so much the internal weaknesses of orthodox economy with which Ruskin was concerned, as its ideological and moral associations with liberalism and industrialism, and in this sense his was a real 'Tory' view.

Unto this last was, however, rather untypical of Ruskin's economic writings, in that whilst all that had gone before had focused upon 'work' and 'art' there is practically no discussion of these subjects in the book, an indication, perhaps, of how deliberately he had set out to deal directly

with 'the bastard science'. The book was, of course, no finished treatise, having been cut short in the *Cornhill*, and it must remain doubtful whether Ruskin was capable of such a work in any case, but it was intended to be a serious and rigorous piece of criticism.

The first essay, 'The Roots of Honour', derived its force of argument from its attack on the methodology of political economy, especially the practice of looking merely to individual self-interest, and the model of the 'economic man'. Ruskin insisted that this was misconceived, for 'the disturbing elements in the social problem . . . alter the essence of the creature under examination' (17.26). To imagine otherwise was as if to try to understand man by examining his skeleton alone, 'the ossifant theory of progress' (17.26). Whilst this was to exaggerate the classical position,[30] it did serve Ruskin's purpose of arguing that political economy was thus made impotent to deal with 'the first vital problem which [it] has to deal with (the relation between employer and employed)' (17.27). Labour relations could not be deduced from the mere play of interests; God had made life too complex for strategies of that sort to work. Instead, the only publicly discernible criterion was Justice, wherein lay 'the roots of honour' (17.28). Affection had to replace self-interest, and co-operation competition (17.30).

He was, however, under no delusion that the affective motives would triumph on their own; they were all too easily smothered by competition. Therefore, wages had to be fixed justly, as he thought those in the professions were so fixed.[31] It is important not to misconstrue this as a plea for a 'living wage', or a fixed remuneration for all, even in the same job; rather it was to call for a fixed payment for work of a certain grade. The bad workman would not be able to undercut the good one; he would not be able to work at that job at all (17.34).[32] This assumed a high degree of fluidity in the supply of labour, and seemed to imply that the aggregate demand for labour was fixed. It is difficult to see here, as some have done, the glimmer of a dynamic analysis.

Indeed, it was not part of Ruskin's purpose to provide such an analysis. When he spoke of the professions he touched the heart of the matter. It was important, for example, to exclude the merchant from the professions, because there self-interest had replaced self-sacrifice, the true mark of the profession. If gentlemen were to take again to trade, or, in

somewhat more alarming fashion, if the merchant were to learn to die in providing his service, and become a father to his employees, or the captain of his ship, things might improve (17.39, 41-2). What promised to be a new analysis of economic behaviour, then, turns out to be a homily for merchants, a tribute to the professions.

The second essay, however, returned to the more usual ground of political economy, the subject of 'wealth'. Ruskin was unhappy about the way in which orthodox economics treated wealth as a given, rather than a subject for further study. He, therefore, distinguished between political economy proper and 'mercantile economy', the science of 'getting rich' (17.43, 61-2). If such claims were tendentious, and many of his jibes, particularly against Smith, were unfair, Ruskin can be said to have made a valuable point, namely that 'Riches are a power', and entail, so he said, an equivalent poverty on the part of those over whom they exercise power (17.44). Such an argument had a long and distinguished lineage, including at the time Ruskin was writing, Marx, but it was obviously an unwelcome message to the readers of the *Cornhill*, who liked to think that wealth remedied, but did not entail poverty (17.46).

Ruskin, however, was no egalitarian, and he accepted that inequalities properly directed, and the accumulation of riches properly spent, would benefit society, as long as it did not lead to a permanent rift between rich and poor, workers and idlers (17.49-50). Contemporaries accused him, rightly, of confusing national and individual wealth,[33] but this was a necessary consequence of his 'moral' approach. He may have had an organic view of society, but he rejected the heart of the classical conception, namely a self-righting and self-sustaining *system*, in which individual self-interest would ensure harmony. Thus, he could never accept the primacy of exchange in the classical theory, for that was not real wealth. The activities of the middle-man were barren (17.51ff). There was no virtue in the cheapness of exchange. What was the *cost* of buying cheap, of selling dear? It could only be resolved by each man's innate knowledge of what was just (17.53-4). The failure of modern wealth to command the authority due to it indicated that modern society had not elevated but diminished those over whom it had power, and, thereby, diminished wealth itself (17.54-5).

The third essay continued this moral critique, and the issue

79

of 'robbing the poor because he is poor' (17.58), for all riches sprang firstly from the labour of the poor. Certain conflicts of interest, Ruskin agreed, were inevitable, but they had no need to be as destructive as they were, the laws of political economy could be managed so as to accord more closely with justice (17.61, 63 n.). While he did spend some time on the concept of 'utility', there can be no doubt that at the heart of his economics there was a labour theory of value: 'the just price is the [price] of the productive labour of mankind' (17.64 and n.). He was critical of the Ricardian labour embodied theory (17.83 n.), but he rejected the view that it was merely value in exchange that had to be measured.[34] Money, he argued, was the payment in general for specific labour services, and the value of these would vary with the variability of labour, an admission, of course, which was to prove fatal to the Ricardian theory. Ruskin did not see this (and Ricardo had chosen to ignore it). He persisted in arguing that underlying all such exchanges of labour were units of work which had 'a worth, just as fixed and real as the specific gravity of a substance' (17.68), what he elsewhere referred to as 'intrinsic value' (17.134-5). While he clearly thought that there was positive worth attaching to labour, and justice was the equitable exchange of such worths, he never managed to show how it was possible to know, and to compare, these worths. Later he grappled with the problem in another way, but it is reasonably clear what the implication here was, namely, that it was inconceivable that men did not in fact know the difference between push-pin and poetry, and that Bentham's suggestion that they did not, or that it did not matter, was self-evidently rubbish; justice, like taste in art, was held to be self-evident for those who would see.

The pricing of labour also entailed the distribution of power. Cheap labour concentrated employment and, therefore, power, in few hands and hindered social mobility; justly rewarded labour, on the other hand, would encourage employees to employ others, spread wealth more evenly and multiply it at the same time (17.71-3). The germ of a dynamic model of production and distribution may be detected here, but there is no real indication as to what the relationship between them is, not enough even to put him amongst the ranks of the underconsumptionists, of whom he disapproved anyway.[35] One of the most striking lacunae in Ruskin's

economic writings, in fact, is the lack of coherent discussion of capital.

The fourth essay had perforce to be something of a port-manteau, but dealt in the main with value, price and wealth (17.77). Here we come to a central piece of his political economy, the notion of 'unproductive labour', that is labour (or capital, for Ruskin seems to have treated capital as stored-up labour) spent on things which themselves did not aid future production, one of Mill's 'fundamental propositions on capital'. Ruskin rejected it, but not on the grounds that velvet and iron were equally items of consumption – he adopted his own distinction between goods and what he once termed 'bads' (19.405). In *A Joy For Ever* he had strenuously denied the proposition that *any* and *all* expenditure could produce employment and wealth, and in *The Two Paths* he took the socialist view that the rich actually robbed the poor by their expenditure, by using their labour on luxuries instead of necessities (16.19, 48-52, 123-5, 405-6). What concerned Ruskin was not the aggregate of demand but the worth of what was produced, or the use to which it was put, and, whereas he later admitted that all consumption contributed to demand, he insisted on distinguishing between the con-sumption of the labourer and that of the warmonger, black-mailer or thief (18.390). His attack on Mill's admittedly untenable version of the 'wages-fund' doctrine, that 'a demand for commodities is not a demand for labour', was vitiated by his insistence that the demand for some commo-dities was not, indeed, a demand for labour (17.77ff, 102ff).

He did, however, try to sort out the problem of value and price, unresolved at the time, and in doing so some have argued that he presaged future marginalist theories. Yet this must be based on the view that he rejected the labour theory of value, conceiving of all value as the relation between demand (or use) and supply.[36] However, he was prevented from adopting such a position because his initial premise was that all value in exchange was founded upon real, 'intrinsic' worth (17.81ff). He was thus left in the realm of meta-physics (17.94), in which, some would say necessarily, the theory of value had consistently dwelt. For Ruskin 'value' was a matter of the giving of life (17.85). Mill had said that wealth was a matter of possession and use, but Ruskin countered by arguing that with the former had to go the power to use, and that the latter depended on the capacity

of the user; so not 'everything to every man, but . . . the right thing to the right man' (17.87-8).

Ruskin thought exchange irrelevant to this. Like the eighteenth-century Physiocrats he denied that there could be gain in exchange *per se* (17.92), but as he also held that individuals were qualitatively different, and not equal, he could not logically dismiss the possibility of any net advantages from exchange. For the economists the market would decide, but Ruskin had little faith in that (17.94, 67). Instead he turned again to 'labour'; exchange which resulted in a net addition to 'good' or 'vital' labour was an addition to wealth (17.94-6). The distinction hinged on consumption, 'the end, crown, and perfection of production' (17.98). Understandably this has attracted much praise from later critics who rightly point to a neglect of the subject in classical theory, but again one must not assume that Ruskin was defending consumption as the motor of a dynamic economy. Like Marx and some contemporary German historicists he questioned the desirability of accumulation without end, and in the distinction he made between 'Production for the Ground, and for the Mouth' (17.101-2) was not only a moral critique of capitalism, but the hint that capitalism might undermine itself. Typically, however, it remained a hint, and we are led away again to the realm of moral evaluation and the famous phrase summarizing all of Ruskin's economics, 'THERE IS NO WEALTH BUT LIFE' (17.105).

After this climax there followed a handful of notes on various subjects, most importantly on population, which, although without direct reference to Malthus, adhered in some respects quite closely to his views. Rejecting colonization as a temporary palliative, he advocated restraint in reproduction and in consumption (17.111ff). Luxury now could intensify misery, though in a future society he allowed that might be avoided (17.114). He, therefore, called for individual moral regeneration, not social revolution; 'true felicity of the human race must be by individual, not public effort' (17.111).

The practical sections of the book, on trade unions and wages, Ruskin dismissed as its least important parts (17.18), and although there is a plea for 'forethought' and a sketch of what might be termed a mixed economy (17.60, 21-2) *Unto this last* did not discuss the role of the State. It had been prominent in *A Joy For Ever* and the more totalitarian

aspects of Ruskin's vision came out in *Time and Tide*, but it is clear that such policy conclusions were implied by the book, based as it was on a concept of commutative justice.

Whilst this essay is not a brief for Ruskin's modernity or relevance, it is necessary to say something of what contemporaries and disciples made of his economics, especially as in *Unto this last*, partly because the essence is there – William Morris deliberately refrained from reading the post-1862 works[37] – partly because it was the chief vehicle of his economic ideas after the 1870s.

This was, like much of Ruskin's intellectual history, not without irony, for *Unto this last* fell almost stillborn from the press. Fewer than a thousand copies were sold in ten years; seventeen years passed before a second edition, another five before a third, and yet in the 1880s, with the emergence of what Beatrice Webb dubbed 'a new consciousness of sin', it sold over two thousand copies a year, and by 1910 in various editions it had probably topped the 100,000 mark (17.5-11). Add to this the 75,000 each for *A Joy For Ever* and *The Two Paths,* 35-50,000 each for *Munera Pulveris* and *Time and Tide,* not to mention *Fors Clavigera*, there is no doubt that Ruskin was a best-seller by virtue of his 'economic' works alone. A survey of some London public libraries showed that Ruskin was 'the most popular author who deals with political economy and sociology', and that the chief work in question was *Unto this last.*[38] Cook made much of the prominence of Ruskin in the reading of the Labour MPs of 1906; seventeen of forty-five mentioned him, six *Unto this last* by name.[39] However, a closer look at this source suggests in what ways he was read. Of those who put special emphasis upon him, Bell, Clynes, Crooks and Jowett were leading, but older, members of the Labour movement, but Hardie and some of the younger lights, Snowden, Henderson and the young MacDonald, did not even mention him. Of the twelve who mentioned Carlyle, only four also mentioned Ruskin, so there may have been overlapping there, but more significant is the fact that nine mentioned J.S. Mill and three Alfred Marshall's *Economics of Industry.* Five of the former and one of the latter also referred to Ruskin. We do not know whether they all, like Burns, reacted against Mill in favour of Ruskin, but presumably not, for Mill was regarded as an

important precursor of collectivism and was integral to the positivist influence on British socialism. There were also less respectable competitors. Henry George's *Progress and Poverty* was only just pipped by *Unto this last* as the most mentioned title, five to six, and George had been received much more sympathetically by economists than had Ruskin.[40]

All this would seem to suggest that Ruskin was read in a different way from Mill, Marshall or even George, although the latter's moral appeal was very strong. It is difficult to believe that even those steeped in the Bible, as many older socialists were, could have gleaned much of an understanding of economics from Ruskin, still less, it might be added, of 'socialism'. It is unclear what Thomas Burt derived from reading the *Cornhill* articles; Tom Mann seems to have gained mainly in rhetorical strength; Morris respected Ruskin rather as a moral teacher and the creator of an aesthetic, and turned to Marx for his economics; Blatchford recommended Ruskin to readers of *Merrie England*, but not to the extent that some claimed; and his 'influence' was perhaps most strong on the aesthetic-cum-idealist socialism of Edward Carpenter.[41] Works which recommended Ruskin as an economist were not conspicuously successful,[42] and the point about the general rather than the specific impact of *Unto this last* can be made by reference to Thomas Barclay's popularization, *The Rights of Labour according to John Ruskin* (1887) which ran through eight editions, plus an Italian one, by 1906. This sixteen page pamphlet was thought by Ruskin to be 'the best abstract of all the most important pieces of my teaching that has yet been done', but it is significant that the order of the original was entirely lost.[43] As a résumé of Ruskin's ideas it may have been adequate, but if so it implies that the original was perhaps not. Ruskin had prided himself on its language (*WL*.371), but his friend Rossetti had asked 'who *could* read it, or anything about such bosh'.[44] Evidently some initial sympathy was required; would that have been forthcoming from even the working-class autodidact, had there not been some additional attraction?

There can be little doubt that the added ingredient was style. 'He who has something to assert will go as far in power of style as its momentousness and his conviction will carry him. Disprove his assertion after it is made, yet its style remains. Darwin has no more destroyed the style of Job or Handel than Martin Luther destroyed the style of Giotto.'[45]

It was Ruskin the admirer of Spurgeon who told men what they wanted to hear, who appealed to a burgeoning Labour movement, at a time when, as Meier has remarked, there were few serious socialist rivals in Britain.[46]

Ruskin's followers, of course, were not all socialists. There were radical individualists like Auberon Herbert and W.H. Mallock, and economists who, though ultimately rejecting his 'economics', were suitably impressed by his moral message, William Smart, J.B. Clark, and P.H. Wicksteed, and arguably that complex man Alfred Marshall was nearer to Ruskin's position than either would have cared to admit (27.234).[47] In America his following tended to be amongst the institutionalists, Ely, and especially Veblen.[48] That he did not find a specifically 'Tory' following, was surely because he was writing in the twilight of 'Toryism' proper, and thus became a quarry for other 'isms'.

It has not been possible to do justice to the whole of Ruskin's 'economics', but it is not unfair to conclude that Ruskin was no political economist, and that he will not be read as one. Misconceived, ill-informed and often unfair as his onslaught on political economy was, weak as his understanding of it, confused as his own arguments often were, he did manage to confront the science with a stiff moral challenge. In scope and methodology particularly he found weak spots, and in his insistence upon the social relations which were consequent upon the distribution of wealth, he sought to make more concrete an abstract logical discipline; but it was his call to justice not his claim to have set the science of political economy on a new footing that appealed to his readers, at a time when 'social justice' was becoming the common change of political debate.

NOTES

1 Ruskin is not even mentioned in the enticingly titled *Moral Revolution and Economic Science*, Ellen F. Paul (New York, Greenwood 1979). J.T. Fain, *Ruskin and the Economists* (Nashville, Vanderbilt University Press 1956), was a rare attempt to treat his economics seriously, and J. Sherburne, *John Ruskin or the Ambiguities of Abundance* (Cambridge, Massachusetts, Harvard University Press 1972), an exceptional *tour de force* in attempting to plot influences and traditions.

2 Sherburne, *Ambiguities of Abundance*, op. cit., stresses the 'welfare

state' lineage, but for Harold Wilson see P. Bétirac, 'Justice et économique politique: *Unto this last* de John Ruskin', *Cahiers de L'Institut de Science Économique Appliquée* (Paris, 1966), p. 216.

3 L. Stephen, 'Mr Ruskin's Recent Writings', *Fraser's Magazine* (New Series), 9 (1874): 692.

4 Caution is advised in taking Ruskin's citations as evidence for his reading. It is obvious, for example, that his references to Bastiat and others, after 1860, were taken from Whewell's useful compilation of 1862, *Six Lectures on Political Economy*, which he had sent Ruskin (17.271n.3), and his dismissal of Jevons's *Theory of Political Economy* was clearly based on a review in the *Pall Mall Gazette* (27.246-7).

5 Mark Blaug, *Ricardian Economics* (New Haven, Yale University Press 1958); Thomas Carlyle, *Latter-Day Pamphlets* (1850), *Works* ('Centenary Edition'), 30 vols (London, Chapman & Hall 1896-9, and New York, 1896-1901), XX: 43.

6 T.W. Hutchison, *On Revolutions and Progress in Economic Knowledge* (Cambridge University Press 1978), p. 67.

7 J.S. Mill, *Principles of Political Economy*, (ed.) W. Ashley (London, Longmans 1909), 1920 edn, p. 436.

8 Hutchison, *On Revolutions . . .* , op. cit., p. 280ff.

9 J. Lalor, *Money and Morals* (London, J. Chapman 1852), p. 129ff; on Carlyle see J.K. Ingram, *A History of Political Economy* (London, Black 1888), p. 216 n.1. On the general issue see T.W. Hutchison, *'Positive' Economics and Policy Objectives* (London, Macmillan 1964).

10 A. Toynbee, *Lectures on the Industrial Revolution* (London, Rivingtons 1884), 1908 edn, pp. 160-1.

11 T. De Quincy, *Works*, 16 vols (Edinburgh, A. & C. Black 1862-84), XIII: 235; W. S. Jevons, *Principles of Economics* (1871) (New York, Kelly 1965 edn), pp. 190-1; H. Sidgwick, *Principles of Political Economy* (1883) (London, Macmillan 1901 edn), p. 3; House of Commons Debates, 3rd series, 12 March 1868, cols 1525-6.

12 W. Bagehot, *Economic Studies*, (ed.) R.H. Hutton (London, Longmans Green 1880), 2nd edn (1888), p. 73.

13 *Memorials of Alfred Marshall*, (ed.) A.C. Pigou (London, Macmillan 1925), p. 296.

14 W.S. Jevons, *Political Economy*, Science Primers, (ed.) T.H. Huxley and others (London, Macmillan 1878), p. 5.

15 J. Goldstrom, 'Richard Whately and Political Economy in School Books, 1833-1880', *Irish Historical Studies*, 15 (1966): 131-46.

16 Ruskin 'judged Political Economy rather by what he supposed it to be than from first-hand knowledge', W. Smart, *Second Thoughts of an Economist* (London, Macmillan 1916), p. 4. In respect of this, however, he was no worse than Smith himself. But Collingwood observed after Ruskin's death that the library at Brantwood had virtually no Art or Political Economy, 'Ruskin's Library',

Good Words, 44 (1903): 120-4.

17 Bodleian Library, Oxford, typed transcript of Ruskin's Diary (MS Eng. Misc. C222, folio 100v).

18 W.F. Kennedy, *Humanist versus Economist* (Berkeley, California University Press 1958), p. 24ff.

19 The British Library, London, Ruskin's annotated copy of Mill's *Principles* (C.60.1.10), II: 89.

20 It is not without point that Mill, otherwise so appreciative of Comte, thought that he wrote political economy 'like an arrant driveller', *Mill on Bentham and Coleridge*, (ed.) F.R. Leavis (London, Chatto & Windus 1950), p. 155.

21 For the Thomist tradition see S. Worland, *Scholasticism and Welfare Economics* (Indiana, University of Notre Dame Press 1967), although there are probably closer resemblances in Augustine.

22 E.T. Cook, *The Life of Ruskin*, 2 vols (London, George Allen 1911), 1: 475-6

23 Ruskin claimed to have been embarrassed by the similarities, ibid., I: 477.

24 Ibid., I: 473.

25 H.G. Viljoen, *Ruskin's Scottish Heritage: a Prelude* (Urbana, University of Illinois Press 1956), pp. 27, 28ff, 95ff.

26 Quoted in P. Meier, *William Morris, Marxist Dreamer* (Hassocks, Harvester Press 1978), p. 155.

27 G.B. Shaw, *Ruskin's Politics* (London, Christophers 1921), p. 30. Clearly Ruskin's sentence can be read in two ways, but also that he meant to give priority to government.

28 J.A. Hobson, 'Ruskin as Political Economist', *Ruskin the Prophet* (ed.) J.H. Whitehouse (London, Allen & Unwin 1920), p. 92.

29 Bodleian Library, Oxford, typed transcript of Ruskin's Diary (MS Eng. Misc. C219, folio 8).

30 The term 'economic man' was not widely used by leading economists, but the grounds of the method were stated by J.S. Mill, *Collected Works*, (ed.) F.E.L. Priestley (Toronto University Press 1963 –), IV (1967): 236; later Alfred Marshall was careful to disown it in *Principles of Economics* (1890), 8th edn (London, Macmillan 1920), pp. 26-7. For the 'mythology' surrounding the concept see L. Robbins, *The Nature and Significance of Economic Science*, 2nd edn (London, Macmillan 1935), p. 94ff.

31 He did not elaborate what the practical side effects of this on the allocation of work would be in *Unto this last*, but later reaffirmed that order, obedience and duty were paramount, even if compulsion were necessary to elicit them (17.234ff; 27.234).

32 Even Mill defended 'fit and proper wages' which *'cannot'* be provided by competition, *Collected Works*, op. cit., VI: 447.

33 *Fraser's Magazine*, 62 (1860): 651-9.

34 Ruskin's copy of J.S. Mill's *Principle*, loc. cit., I: 516.

35 Ibid., II: 89.

36 Sherburne, *Ambiguities of Abundance*, op. cit., p. 135; Shaw, *Ruskin's Politics*, op. cit., p. 17; J.A. Hobson, *John Ruskin, Social Reformer* (London, Nisbet 1898), pp. 179-80; J. Robinson, *Economic Philosophy* (London, Penguin 1964), p. 47.

37 Meier, *William Morris*, op. cit., p. 123.

38 'What London Reads', *London*, 19 April 1894, p. 243.

39 Cook, *Life of Ruskin*, op. cit., II: 14; *Review of Reviews*, 33 (June 1906): 568-82.

40 W. Wolfe, *From Radicalism to Socialism, 1881-1889* (New Haven, Yale University Press 1975), especially chapters 2 and 6; B. Newton, 'The impact of Henry George on British economists', Ps I-III, *American Journal of Economics and Sociology*, 30 (1971): 179-86, 317-27; 31 (1972): 87-102.

41 D. Torr, *Tom Mann and his Times* (London, Lawrence & Wishart 1956), p. 79ff; Meier, *William Morris*, op. cit., pp. 122, 127 n.34; E. Carpenter, *Civilization: its causes and cure* (London, Swan Sonnenschein 1889), 1908 edn, p. 79.

42 P. Geddes, *John Ruskin, Economist* (Edinburgh, William Brown 1884); W. Smart, *A Disciple of Plato* (Glasgow, Wilson and McCormick 1883); and idem., *John Ruskin: his life and work* (Manchester and Glasgow, Heywoods 1880); H. Rose, *The New Political Economy* (London, J. Spiers 1891); Hobson, *Ruskin, Social Reformer*, op. cit.

43 Thomas Barclay, *The Rights of Labour according to John Ruskin* (London, W. Reeves 1887). Ruskin's approval is stated on the first page.

44 *Letters of D.G. Rossetti*, (ed.) O. Doughty and J.R. Wahl, 4 vols (Oxford, Clarendon Press 1965), I: 371.

45 G.B. Shaw, *Man and Superman*, with an introduction and notes by A.C. Ward (London and New York, Longman Green 1956), p. 26.

46 Meier, *William Morris*, op. cit., p. 149.

47 W.G. Collingwood, *Life of John Ruskin* (London, Methuen 1893), P.H. Wicksteed, *The Common Sense of Political Economy*, (ed.) L. Robbins, 2 vols (London, Routledge 1933), II: 827.

48 J. Dorfman, *Veblen and his America* (New York, Viking Press 1934), p. 35.

6
Ruskin as Victorian Sage: The Example of 'Traffic'

George P. Landow

Like Thomas Carlyle and Matthew Arnold, John Ruskin frequently tries to win the assent of his audience by assuming the tone and techniques of the Victorian sage. Although John Holloway did not include the author of *Modern Painters* in his pioneering study of this characteristically Victorian literary mode, Ruskin is in fact one of its greatest practitioners.[1] Holloway, who considers both writers of fiction and nonfiction to be sages, correctly observes that works in this mode do not attempt to convince primarily by means of rational, logical argumentation and that they instead employ indirect, poetical, or rhetorical means. Holloway and subsequent critics who have studied these Victorians in terms of their literary methods have made valuable contributions to the understanding of nineteenth-century prose, but to perceive the defining characteristics of what I take to be an identifiable nonfictional genre, one must analyse more precisely the structures, methods, and manner of proceeding that create the nonfiction characteristic of the Victorian secular prophet.

In particular, by examining Ruskin's strategies in 'Traffic', a neglected masterpiece of this kind of nonfiction, one can perceive the attributes of a literary form that continues to attract major writers down to the present day.[2] As the discussion of 'Traffic' will demonstrate, one may take the following as a useful working definition of the kind of literature created by the Victorian sage: it is a form of nonfiction that adapts the techniques of the Victorian sermon, neoclassical satire, classical rhetoric, and Old Testament prophecy to create credibility for the interpretations of

contemporary phenomena made by a figure, the sage, who stands apart from his audience and society.

The Victorian sage is, above all else, an interpreter, an exegete, one who can read the Signs of the Times. His essential, defining claim is that he understands matters that others do not – and that his understanding is of crucial value to those who see with duller eyes. Indeed, Ruskin, Carlyle, and Arnold are sages or secular prophets precisely because they perceive the central fact that the phenomena they choose to interpret *demand* interpretation. Many of the phenomena they urge upon us as instances of significant fact seem the natural and obvious materials to command the attention of one who would speak or write as a sage. Carlyle's *Chartism* fulfils our expectations when it urges upon the reader the crucial need of understanding the 'bitter discontent of the Working Classes', and Arnold similarly introduces an important subject when *Culture and Anarchy* opens the question of how England approaches the disestablishment of the Irish Church.[3] Ruskin's many discussions of truth, morality, and greatness in art, like his examinations of the labour question and fundamental problems of political economics, likewise strike one as precisely the kind of question to which the would-be sage must direct his supposedly higher vision. However, one of the factors that distinguishes the pronouncements of the Victorian sage from ordinary political speeches, essays, and other discussions of such subjects is that the sage also frequently draws our attention to apparently trivial phenomena, to facts that only he at first perceives can embody meanings important to his listeners. Carlyle thus explains the significance of the 'amphibious Pope' and 'that great Hat seven-feet high, which now perambulates London Streets' in *Past and Present*, while in 'The Function of Criticism at the Present Time' Arnold similarly draws our attention to Wragg's murder of her illegitimate child and to 'the natural growth amongst us of such hideous names, – Higginbottom, Stiggins, Bugg!'[4] In his introduction to *The Crown of Wild Olive* Ruskin similarly urges upon us the crucial significance embodied in the way a wrought-iron fence outside a newly built pub has affected its surroundings. In fact, the characterizing procedure of Carlyle, Ruskin, Arnold and other sages, such as Thoreau, is this identification and subsequent interpretation of trivial phenomena as the embodiments of essential truth. This procedure necessarily

entails grave rhetorical risks, since the writer can thus easily lose the confidence of his audience, but it also ensures that, when successful, the writer will have established his unique claims to authority and credibility - claims that are essential in an age of transition and shaken belief. By showing the members of his audience that truth resides in unexpected places and that he, and only he, can reveal it to them, the sage convinces them to give a hearing to his views of man, society, and culture that might at first seem eccentric and even insane.

In 'Traffic', as so often throughout his career, Ruskin self-consciously dons the mantle of the Victorian prophet to support his interpretations of contemporary phenomena. Therefore, perhaps the most effective way to begin a critical analysis of his manner of proceeding as a Victorian sage would be first to examine what portions of that method derive from the prophetic books of the Old Testament. Once one has determined how Ruskin draws upon this aspect of his religious heritage, one can observe where he diverges from it. Ruskin ends 'Traffic', a lecture he delivered in Bradford on 21 April 1864, with one of those familiar passages of height-ened prose with which he generally closes brief works and sections or chapters of longer ones. Like a great many such Ruskinian closing flourishes, this one is set in a visionary mode and draws heavily upon biblical rhetoric, structure, and image.

Ruskin, who is engaged to convince his listeners that they must change their society if they wish to improve its archi-tecture, sets his social, political, and aesthetic pronounce-ments within the context of the prophetic scriptures of the Old Testament, both by alluding to specific texts and by employing the patterns of those who gave warning to both the children and enemies of God. After charging England with worshipping the Goddess of Getting-on, he points out that both pagan and Hebrew wisdom warn of the inevitable consequences of such a false religion. He cites the *Critias*, a dialogue Plato left incomplete, and then quotes at length the judgment of the Olympian Gods upon the inhabitants of Atlantis, who had fallen from godlike love of virtue to an all-too-human worship of power and material wealth. Plato's condemnation of such blind devotion to worldly success forms, says Ruskin, the:

Last words of the chief wisdom of the heathen, spoken of
this idol of riches; this idol of yours; this golden image,
high by measureless cubits, set up where your green
fields of England are furnace-burnt into the likeness of the
plain of Dura: this idol, forbidden to us, first of all idols,
by our own Master and faith; forbidden to us also by
every human lip that has ever, in any age or people, been
accounted of as able to speak according to the purposes of
God. (18.457-8)

Having criticized, harangued, and mocked his listeners
previously in this lecture for their devotion to the Goddess of
Getting-on, Ruskin calls upon the testimony of the ages to
emphasize that he follows eternal, not transitory, standards.
Zeus's pointed condemnation of the Atlanteans also serves
to indict Victorian England, and Ruskin makes clear that he
takes the mythical Atlantis, as he had earlier in his career
taken Tyre and Venice, to be a type of his own nation. Then,
having established that even the pagans realized that such
spiritual blindness inevitably brings a nation to destruction,
he turns to the Bible and likens England now to Nebuchad-
nezzar's Babylon. The allusion to the third chapter of Daniel,
in which Nebuchadnezzar erects an idol on the plains of Dura,
reduces the inhabitants of Bradford to the moral and spiritual
stature of the inhabitants of Babylon. Next, he alludes
briefly to Christ's warning that cupidity – or the worship of
the Goddess of Getting-on – is the root of all evil, after
which he emphasizes that all men, whether pagan, Hebrew, or
Christian, have always recognized that such worship is for-
bidden. Ruskin thus employs the first part of the familiar
tripartite pattern of Old Testament prophecy – an initial
reminder of the nature of divine law which the prophet's
listeners have either forgotten or consciously disobeyed.

Next, he proceeds to the traditional second part of pro-
phetic structure, the warning that continued deviation from
the true path leads directly to horrible punishment and
destruction. 'Continue to make that forbidden deity your
principal one,' he warns his audience, 'and soon no more art,
no more science, no more pleasure will be possible. Catas-
trophe will come; or, worse than catastrophe, slow
mouldering and withering into Hades' (18.458). Having
already alluded to the fates of Atlantis and Babylon, Ruskin
has anticipated the final terrible destruction of any nation

that lives as England is living. Specifically, he warns that his nation's end can come in the form of catastrophe or a slow mouldering into hell – either as a bang or a whimper – but since he has already charged that his listeners have turned the once 'green fields of England . . . furnace-burnt into the likeness of the plain of Dura', itself a type of hell, he suggests that England is already well on the way to destruction. Ruskin, one must observe, warns about more than the final destruction of England as a nation and civilization, for like so many modern prophets, such as Lawrence and Mailer, he is also speaking about the death of pleasure, of *all* pleasure, of that which gives one joy and will to live. As he warns that soon there will be no more 'art, no more science, no more pleasure', he descends through the Ruskinian hierarchy of human faculties, for he is warning about the death of imagination and emotions that produce art, the intellect that produces science, and the bodily affections that are the seat of pleasure.[5] His prophet's curse upon the people, succinct as it is, is complete and pronounced with care.

Then, again following the tripartite pattern of biblical prophecy, Ruskin attempts to inspirit his listeners with a vision of that good which will come from returning to the ways of God and nature, for having expounded the law and stated the prophet's warning, he reassures them:

> But if you can fix some conception of a true human state of life to be striven for – life, good for all men, as for yourselves; if you can determine some honest and simple order of existence; following those trodden ways of wisdom, which are pleasantness, and seeking her quiet and withdrawn paths, which are peace; – then, and so sanctifying wealth into 'common wealth,' all your art, your literature, your daily labours, your domestic affection, and citizen's duty, will join and increase into one magnificent harmony. You will know then how to build, well enough; you will build with stone well, but with flesh better; temples not made with hands, but riveted of hearts; and that kind of marble, crimson-veined, is indeed eternal. (18.458)

Alluding to Proverbs 3:17, a text which employs the full pattern of Old Testament prophecy, Ruskin offers his listeners a vision of life-giving harmony if they return to

divine law. Then, rather than build commercial exchanges, they will build places of truer 'exchange' – places of community and commonwealth, rather than edifices to house competition and the worship of the Goddess of Getting-on. Rather than traffic in the Temple, they will worship there and elsewhere correctly, vitally, pleasurably.

As he employs each of the three stages of this prophetic structure Ruskin also follows another manner of proceeding learned from Daniel, Jeremiah, Isaiah, and other Hebrew prophets, for like them he adroitly positions himself in relation to his audience. Only once – when he mentions that such worship of golden idols or idolized gold is forbidden to 'us' – does Ruskin place himself in the same position as his listeners. Only then does he permit them to take him as a man like them. This employment of the first-person-plural pronoun, however, serves as his only gesture of community and commonality during this closing section of 'Traffic'. On the other hand, gestures of opposition, rhetorical strategies that place him at a distance from his listeners, occur frequently in the course of his attack upon his audience and what he terms 'this idol of yours' (18.457), and this opposition of speaker (or writer) and audience in fact characterizes the pronouncements of the Victorian sage. Such risky rhetorical strategies both set off this genre from most other literary forms and inevitably require special techniques to avoid alienating the sage's intended audience. In other words, the crucial difficulty in thus positioning the prophetic voice outside and above the society of the prophet's intended listeners is that he must find a way to be superior to them, and to convince them that he is superior to them, without alienating them. Or, to state this fundamental problem in slightly different terms: the Victorian audience is only willing to pay attention to someone extraordinary and set apart from the majority of men, but any claim that one possesses special insight threatens to drive it away.

This characteristic positioning of himself as sage in relation to his listeners appears earlier in 'Traffic' when Ruskin first instructs them that England will inevitably pass away and then, moving to solace his listeners, he reassures them that they have come to such a dilemma only because they have been deluded by those Others, by the false prophets of *Laissez faire* capitalist economics. Ruskin opens this attack by forcing his listeners to realize that worshipping material

success inevitably impoverishes a large portion of English
society, after which he anticipates his audience's objections,
openly admitting its hostility to him and his revelation: 'you
will tell me I need not preach against these things, for I
cannot mend them. No, good friends, I cannot; but you can,
and you will; or something else can and will. Even good
things have no abiding power – and shall these evil things
persist in victorious evil?' (18.455). After characterizing his
audience's inadequate spiritual and political understanding
by the fact that they mistakenly take the words of the sage
to be mere preaching – a ploy he adopts elsewhere in this
lecture – Ruskin then once again demonstrates his credentials,
his credibility as sage. He is not simply haranguing against a
phenomenon he finds wrong. Rather he is undertaking some-
thing far more serious, for he shows, in a manner typical of
the sage's whole enterprise, that England's worship of worldly
success has a precise, identifiable, interpretative significance.
This worship exists within a decipherable system of signifying
elements, and its meaning can be read to all who will listen,
for that meaning is clear to the sage. That meaning appears in
history, since 'All history shows' that 'change *must* come;
but it is ours to determine whether change of growth, or
change of death' (18.455). Having briefly joined with his
listeners when he tells them that they can choose their own
destinies, he immediately draws apart from them as, again
striking the prophet's stance, he places contemporary pheno-
mena within the context of eternity. 'Shall the Parthenon,'
he asks, 'be in the ruins on its rock, and Bolton priory in its
meadow, but these mills of yours be the consummation of
the buildings of the earth, and their wheels be as the wheels
of eternity?' (18.455).

Having first complimented his listeners when he joined
with them in the promise that they could choose their own
fates, he withdraws from them to place the signs of the times
within the context of ancient history and eternity. Imme-
diately after thus reducing the importance of present English
architecture (such as this planned exchange) by placing it
within the context of eternity, Ruskin again draws close to
his audience by partially absolving them of responsibility for
the present Condition of England:

I know that none of this wrong is done with deliberate
purpose. I know, on the contrary, that you wish your

workmen well; that you do much for them, and that
you desire to do more for them, if you saw your way to
such benevolence safely. I know that even all this wrong
and misery are brought about by a warped sense of duty
.... And all our hearts have been betrayed by the
plausible impiety of the modern economist, telling us that
'To do the best for ourselves, is finally to do the best for
others'. Friends, our great Master said not so; and most
absolutely we shall find this world is not made so. (18.455-6)

Exchanging the second for the first-person pronoun,
Ruskin tries to loosen his audience's allegiance to utilitarian
economics, for one way that the sage gains the assent of his
listeners is to compliment them or promise them hope after
having revealed their present perilous condition. However,
it is primarily by means of his unexpectedly convincing
interpretations that the sage justifies his superiority to his
audience.

In fact, Ruskin makes the inability of his contemporaries
to understand supposedly clear phenomena to be a significant
sign or symptom of their need for him. In order to emphasize
that architecture is the product of an entire society and not
merely of its architects or clergy, Ruskin insists: 'It is not the
monopoly of a clerical company – it is not the exponent of a
theological dogma – it is not the hieroglyphic writing of an
initiated priesthood; it is the manly language of a people
inspired by resolute common purpose, and rendering resolute
and common fidelity to the legible laws of an undoubted
God' (18.444). Briefly taking a tack opposite to the one he
usually adopts as a sage, Ruskin urges that all his listeners
should be able to comprehend the significance of a nation's
architecture. That they cannot and therefore they need his
assistance implies that they have a beclouded spiritual con-
dition that has darkened their understanding of all important
issues. Of course, in thus urging that architecture, particularly
Gothic architecture, is not the monopoly of a 'clerical com-
pany', not the 'exponent of a theological dogma', he is also
continuing his long campaign against High Anglican and
Roman Catholic proponents of Gothic architecture, for in
attempting to appeal to an England whose worshippers
were largely Evangelical Anglicans and dissenters, he had
long attempted to convince his audiences that Gothic archi-
tecture was a people's architecture and not the possession of

96

a church hierarchy. Ironically, Ruskin, who is here arguing against the High Church assumptions of a division between laity and priesthood, attempts to win from his listeners the admission that he possesses a priestly, prophetic stature, precisely because he can, in the High Church manner, understand mysteries which they do not.

Although the Victorian sage's separation of himself from his audience derives from the prophetic books of the Old Testament, his habitual practice of establishing credibility by interpretive virtuosity does not. Old Testament prophetic figures also frequently authenticate their claims to prophetic status by acts of interpretation, such as Daniel performs for Nebuchadnezzar, but the Victorian sage's acts of interpretation derive from the Victorian sermon, in which the preacher typically undertakes to set forth unexpected but essential meanings of scriptural word and event. Taking an announced biblical passage, the preacher frequently leads his congregation through a hermeneutic exercise, pausing along the way to define key terms, such as 'type', 'nature', 'sacrifice', and 'atonement'.[6] These related strategies of interpretation and definition, which are derived from the homiletic tradition, furnish the sage with some of his most characteristic rhetorical patterns.

In 'Traffic', after Ruskin has finally begun to fulfil his audience's initial expectations by speaking directly to the supposed point of his lecture – the architectural styles suitable for an exchange – he first performs an act of interpretation and then follows it by an exercise in definition. First, he urges that a nation's architecture necessarily exists in a signifying relation to its beliefs and conduct. Architecture, he insists, inevitably records and thus expresses a people's essential nature. He explains the kind of building created by the Greek worship of wisdom, the medieval worship of spiritual comfort and consolation, and the post-medieval worship of pleasure, after which he inquires, 'Now, lastly, will you tell me what *we* worship, and what *we* build?' (18.447). Displaying his characteristic alternation of familiar plain style with a rhetorically embellished one, Ruskin confides in his audience, as if he needs to get closer to its members and make them more vulnerable before he can strip them of their blindness and false understanding: 'You know we are speaking always of the real, active, continual national worship; that by which men act, while they live; not that which they talk of, when

they die' (18.447). Ruskin thereupon makes two claims characteristic of the sage: first, that he knows the true meaning of words, and, second, that he can restore language to a kind of ideal power, purity, and relevance. With this act of definition, the sage adopts the central homiletic device of defining key terms of a discourse in such a way as to seize control of the discussion and thereby make his audience dependent upon him.

The sage's devices of definition, redefinition, and satirical redefinition allow him to restore language to its true meaning by placing the word in proper relation to the thing or idea it represents. Definition thus allows one to function truthfully and well, since it enables one to exist in a proper relation to the truths of nature, man, and God, rather than in disjunction with them. Ruskin, like other sages, therefore usually begins by rejecting – and hence redefining – common words that we all use so casually, or else he hands down a pronouncement about a basic term. Characteristically, the sage thus asserts his control over the act of discourse by imposing his understanding of crucial terms upon the reader, for he rejects and often mocks his audience's usual understanding of such terms and their assumptions about them. Thereby, once again, the sage both demonstrates to his audience his essential superiority and places it in a relation dependent upon him. Thus, Carlyle's definitions of 'mechanical', 'symbol', or 'clothing', like Arnold's of 'culture', 'criticism', and 'poetry', seize control of the discourses in which they appear, and throughout his career as critic of art and society, Ruskin himself placed the greatest importance upon his definition and redefinition of key terms. In *Modern Painters*, for instance, he defines, among many other terms, 'imagination', 'beauty', 'sublimity', 'imitation', 'greatness in art', 'poetry', 'proportion', and 'ideas of relation' (or composition), while his socio-political writings similarly offer the true meanings of 'value', 'wealth', and 'justice'.

'Traffic', which continually redefines the notions of traffic and exchange, also expounds the true meaning of 'taste', 'architecture', and other terms. When in this same lecture Ruskin comes to define religion and emphasizes that he seeks an essential, not a superficial, meaning, he draws upon William Wilberforce's popular Evangelical devotional work *Practical Christianity* in making a distinction between nominal and practical religion. According to Ruskin, 'we have, indeed,

a nominal religion, to which we pay tithes of property and sevenths of time; but we have also a practical and earnest religion, to which we devote nine-tenths of our property, and six-sevenths of our time. And we dispute a great deal about the nominal religion: but we are all unanimous about this practical one; of which I think you will admit that the ruling goddess may be best generally described as the "Goddess of Getting-on", or "Britannia of the Market" ' (18.447-8). Having revealed the true meaning of a central term, a word upon which the entire argument rests, Ruskin once again withdraws from his listeners, placing them at that moral distance which signifies their unimproved, fallen, dependent state. As he makes this transition in emotional and moral distance, he also changes style and tone and employs elaborate parallels and rhetorical flourishes to emphasize that Victorian England possesses its own architectural style which too accurately expresses the nature of the country's practical religion:

> It is long since you built a great cathedral; and how you
> would laugh at me if I proposed building a cathedral on
> the top of one of these hills of yours, to make it an
> Acropolis! But your railroad mounds, vaster than the
> walls of Babylon; your railroad stations, vaster than the
> temple of Ephesus, and innumerable; your chimneys, how
> much more mighty and costly than cathedral spires!
> your harbour-piers; your warehouses; your exchanges!
> – all these are built to your great Goddess of 'Getting-on';
> and she has formed, and will continue to form, your
> architecture, as long as you worship her; and it is quite
> vain to ask me to tell you how to build to *her*; you know
> far better than I. (18.448)

As Ruskin's redefinition of religion suggests, the Victorian sage's attempts to impose the meanings of key terms upon his audience often function as satiric sallies against the cloudy understandings of its members. Like other sages, Ruskin not only thus adopts the rhetorical patterns, tone, and ideas of both the biblical prophet and the contemporary preacher of the gospel but he also adds major elements of satire to these techniques. Drawing upon a wide range of satiric methods, Ruskin, like Carlyle and Arnold, attacks both his audience's understanding and its actions. Here the Victorian sage differs

from neoclassical satirists, such as Swift, who had a profound influence upon their methods and ideas, for the secular prophet frequently makes his listeners the direct targets of attack. Swift wrote that satire is a glass in which we see everyone's face except our own, but Ruskin characteristically undertakes the grave rhetorical risk of attacking his audience directly and thus forcing its members to see their faces in the mirror. This kind of satire requires consolatory and other techniques to retain one's listeners. Such an approach to chastening one's listeners owes much to the homiletic tradition, since the social and spiritual situation of the sermon requires that the congregation recognize its inferiority to the preacher. Unlike the prophets Jeremiah or Isaiah, who speak as men removed from their contemporaries, the preacher is accepted by his listeners from the beginning of his discourse as one existing, however briefly, on a higher, more spiritual plane.

A second point at which the sages' applications of satire differ from those neoclassical masters of the form who so importantly influenced them is that in these Victorian works satire provides only a part of tone and structure, since the creations of the sage characteristically alternate between satirical attack and visionary solace and encouragement.

Ruskin employs satiric thrusts right from the beginning of his lecture when he informs the members of his audience in his opening paragraph that he will not tell them what they have come to hear because, in truth, they don't care about the subject. According to him, the total cost of such an exchange is to them, collectively, nothing, and, in fact, buying a new coat is a more important financial outlay to him than erecting this planned building will be to them.

> But you think you may as well have the right thing for your money. You know that there are a great many odd styles of architecture about; you don't want to do anything ridiculous; you hear of me, among others, as a respectable architectural man-milliner; and you send for me, that I may tell you the leading fashion; and what is, in our shops, for the moment, the newest and sweetest thing in pinnacles. (18.434)

By reducing his enterprise as a critic of architecture to the level of a milliner, he mocks himself for receiving so

little of his audience's respect, and in this way he makes some small amends for the abrasive opening of 'Traffic'. But, of course, drawing such an analogy between himself and the female milliner not only points out how little respect his listeners have for him as man and thinker, it tells far more harshly upon them, since this analogy implies that they perceive little more in a matter crucial to their society than transitory fashion. (Paradoxically, like many satirical analogies that cut at least two ways, this one begins to take on an unexpected validity by the close of the lecture, for as the audience gradually recognizes that architecture does indeed clothe and body forth a nation's inner self, one also perceives that Ruskin's initial satire has a Carlylean application and truth. Like Teufelsdröckh, the fictional author of Carlyle's Clothes Philosophy, Ruskin has shown that buildings are in a sense clothes, symbols of spiritual facts that they embody.)

In addition to his deployments of satiric analogy and definition, Ruskin also makes fine use of what he himself termed symbolical grotesques – set pieces in which his initial conceit takes the form of an allegorical image, emblem, or fable.[7] For instance, after explaining the relation between the various religious faiths that have pervaded European culture since the days of classical Greece, Ruskin tells his listeners that if they based their society on a true religion and made modern labour a matter of heroism and not drudgery, he could then

carve something for you on your exchange worth looking at. But I can only at present suggest decorating its frieze with pendant purses; and making its pillars broad at the base, for the sticking of bills. And in the innermost chambers of it there might be a statue of Britannia of the Market, who may have, perhaps advisably, a partridge for her crest, typical at once of her courage in fighting for noble ideas, and of her interest in game; and on her shield, instead of St. George's Cross, the Milanese boar, semi-fleeced, with the town of Gennesaret proper, in the field; and the legend, 'In the best market,' and her corslet, of leather, folded over her heart in the shape of a purse, with thirty slits in it, for a piece of money to go in it, on each day of the month. And I doubt not but that people would come to see your exchange, and its goddess, with applause. (18.450-51)

Employing a version of the old satiric convention known as 'Advice to a Painter', Ruskin creates a fictional work of art that functions as a satiric emblem mocking the spiritual Condition of England. The first details mentioned strike a comparatively light note, for they attack little more than the nation's tastelessness, but, as his entire lecture thus far has tried to demonstrate, such a condition represents a fearful inner state. Ruskin's allusions to his nation's abandonment of the way of St George, like his reference to the Gennesaret pigs and to Judas's thirty pieces of silver, make clear his belief that such faith in worldly success is essentially satanic. Therefore his detailing the goddess's attributes becomes a means of charging that Victorian England has abandoned its earlier Christian beliefs, allowed itself to become possessed like the Gennesaret swine, and finally betrayed Christ Himself. This fittingly grotesque assemblage of a nation's sins in visual form, like his parable of two householders and his parody of the capitalist's vision of earthly paradise (18.438-9, 453), permits him to make a harsh, detailed analysis of the state of England without assuming the tone or harangue of the moral preacher, which he can then reserve for special points of emphasis and instruction. Furthermore, the elements of indirection contained in such elaborate satirical images provide an economical means of stating truths which might otherwise appear too overtly hostile to his listeners.

In addition to thus making use of these satiric devices, Ruskin also employs a naïve observer whose ingenuous observations reveal a disparity between the way things are supposed to be and the way they in fact are. For example, when introducing the connection between a nation's architecture and its beliefs, he assumes this pose. The posture of the alien is in part natural to the Victorian sage since he addresses his audience so frequently from outside his society's usual points of view; but whereas he speaks then with unusual authority, the naïve satiric persona, such as Goldsmith's Chinese citizen of the world, fails to understand and hence speaks with an unusual lack of authority. 'I notice', Ruskin tells his Bradford audience, 'that among the new buildings which cover your once wild hills, churches and schools are mixed in due, that is to say, in large proportion, with your mills and mansions' (18.440). Ruskin, having adopted this persona, begins with an implicit compliment to

his listeners, for he points out that they have not stinted on churches or schools but have provided them in proper proportion to the mills which provide the economic strength of the region. In concluding this same sentence, however, Ruskin as a naïve observer raises what proves to be an important question. Like Goldsmith's foreigner observing an odd custom, Ruskin tells his audience that he has noticed that 'the churches and schools are almost always Gothic, and the mansions and mills are never Gothic. May I ask the meaning of this?' (18.440). Using the device of the alien or naïve observer to set common things in a novel light, Ruskin draws his listeners' attention to their architectural eclecticism. At this point he abruptly abandons the mask of the naïf, since he points out, as only a knowledgeable authority could, that such assignment of different styles to different building types 'is a peculiarly modern phenomenon' (18.440), and that when medieval Gothic cathedrals were constructed the builders' homes and town halls took the same form.

Returning to this pose of the naïf, he provides an unexpected interpretation of these apparently neutral facts. Earlier men built all their structures in the same style, 'but now you live under one school of architecture, and worship under another. What do you mean by doing this?' (18.440). Satirists frequently derive conceits from plays upon the ontological status of things and ideas, often taking idiomatic expressions as if they were objects and moving something from the status of an idea to an object, or from an object to an idea – as Swift does so effectively when he rings changes on the ideas of afflatus, flatulence, inspiration, and wind in *The Tale of a Tub*. Ruskin similarly plays upon the ideas of 'living under' a particular architectural style, intentionally running together the idiom's various usages to suggest both the physical act of living beneath a structure erected in a particular style and also the notion of granting allegiance to an abstract doctrine. Still assuming the pose of the naïve observer, Ruskin thereupon confronts his audience as if they were fully conscious of what their manner of building implies about the nature of their religious belief. Asking the embarrassing questions permitted to outsiders, children, and fools, he inquires, 'Am I to understand that you are thinking of changing your architecture back to Gothic; and that you treat your churches experimentally, because it does not matter what mistakes you make in a church?' (18.440). Then, as do all good satirists, skilfully

varying his tone and point of attack, Ruskin then asks another disturbing question: 'Or am I to understand that you consider Gothic a pre-eminently sacred and beautiful mode of building, which, you think, should be mixed for the tabernacle only, and reserved for your religious services?' (18.440).

Such a conclusion at first seems quite complimentary to his audience, particularly if one recalls that it bears resemblances to Ruskin's own arguments in the first chapter of *The Seven Lamps of Architecture* for lavishing expense upon ecclesiastical buildings. But Ruskin's statements on architecture demonstrate that although he wished churches built in more lavish style than other structures, he did not accept that Gothic was a style set apart for ecclesiastical applications. In fact, having apparently set the division of architectural styles in a favourable light with his suggestion, Ruskin springs a rhetorical trap upon his audience, for abruptly abandoning the pose and tone of the naïf, he again speaks as a sage, pronouncing the full implications of such phenomena: 'For if this be the feeling, though it may seem at first as if it were graceful and reverent, at the root of the matter, it signifies neither more nor less than that you have separated your religion from your life' (18.440).

Immediately after he has claimed that his listeners have 'separated your religion from your life' – a charge he will refine upon when he later argues that they are six-sevenths pagan – Ruskin assumes the preacher's voice. In order to prove to his audience that religion cannot be isolated from other human affairs, he begins, as he so frequently does at crucial stages in an argument, by citing scripture in the manner of the Evangelical propounder of the Gospel. Ruskin had made elaborate use of scripture to argue for the importance of lavishing expenditure upon church architecture in *The Seven Lamps* and for the sacred nature of colour in the fifth volume of *Modern Painters*, and now, alluding to Jacob's dream of a ladder joining earth and heaven in Genesis 28:12-17, he argues that God must be worshipped everywhere and not only in buildings set aside for that purpose.[8] Ruskin's procedure, adopted in part surely because it answered to the experience and expectations of many in his audience, demands comment, because other evidence reveals that he was no longer a believing Christian at this point in his career, though within a decade he was to become one again. Like Carlyle, a master of such techniques of accommodation,

Ruskin frequently employs the language, images, and rhythms of the Bible to suggest to an aggressively Protestant audience that he had more in common with its fundamental beliefs than he in fact did. With Carlyle such accommodation most commonly takes the form of redefining Christian terminology until it takes on his own meaning, and Ruskin also occasionally makes such uses of it. Here, however, he merely cites the source of that text found above so many dissenting chapels – 'This is the house of God and this is the gate of heaven' (Genesis 28:17) – and sets forth its original meaning. His combined act of interpretation and restorative definition has a cutting edge, because, whether or not Ruskin accepts Christian belief, he can use it to reveal that, judged by their own supposed faith, his listeners have separated their religion from their lives.

As this example of Ruskin's methods as a Victorian sage suggests, he derives many techniques from Victorian homiletics, eighteenth-century satire, and Old Testament prophecy. Setting 'Traffic' within the context of such contemporary and earlier traditions of discourse emphasizes how necessary it was for the sage to adjust certain older techniques if they were to be used effectively in this new kind of prose. For instance, although Ruskin and other sages use the structural patterns, tone, and language of the jeremiad, they had to make major adjustments before they could apply such biblical materials to contemporary political and aesthetic issues. Because neither Ruskin nor other Victorians were literally prophets inspired by God, as had been Daniel and Isaiah, they could not deliver their predecessors' message to their contemporaries. At the very least, Ruskin and his fellow secular prophets had to demonstrate the way the old familiar points of faith lay hidden in their newer statements of them. Similarly, although Ruskin, Carlyle, and others use the tropes and procedures of the Victorian preacher, they never begin a discourse with their audiences in the same friendly, even acquiescent position as are those of the minister of Christ. Therefore, the sage must demonstrate his superiority, his greater vision, to the audience before he can hope to win its assent. Similarly, although the Victorian sages possess fine skill as satirists, they never remain satisfied with the satirist's goals of chastening foolish humanity for its specific foibles and general flaws. Rather, after using satire as merely the opening move in a complex attack upon erring thought and

action, the Victorian sages move on to provide replacements for those positions they have scorned.

Although Ruskin, like all practitioners of this form of non-fiction from Thomas Carlyle to Norman Mailer, makes elaborate and expert application of devices borrowed from other modes of discourse, the enterprise of the sage cannot be defined solely in terms of these earlier modes or traditions. But by placing 'Traffic' and similar writings, such as *Culture and Anarchy* and *Chartism*, in the context of traditional rhetorical theory one can observe what distinguishes this form of writing from those others it draws upon. According to classical rhetoricians, argumentation occurs in three basic modes, those of *logos, pathos,* and *ethos*. *Logos*, or the appeal to reason, includes citations of authority, testimony, statistics, and syllogisms, while *pathos*, the appeal to emotions, includes any devices that allow the speaker to stimulate the audience's feelings on his behalf. *Ethos*, the appeal to credibility, founds all its attempts to convince on the implicit statement 'I am someone worth listening to, I can be trusted'. Of course, virtually all rhetorical techniques to some extent achieve *ethos*, and when any writer or speaker successfully demonstrates that he can use the tools of reason, his accomplishment obviously makes him more believable. Basing an argument entirely upon *ethos*, however, implies that neither intellectual nor emotional appeals can win an audience's attention and allegiance. The dominant role of *ethos* in the writings of the Victorian sage indicates quite clearly that this form of discourse arose as a response to the political, spiritual, and aesthetic situation of England in an age of changing beliefs. The sage's appeal to credibility, in other words, particularly well suits not only romantic conceptions of the artist-seer and Carlylean views of the Hero but also the needs of an audience which finds all received opinion has been cast into doubt.

As one might expect, the techniques and structures thus far observed in 'Traffic' all contribute to the creation of this essential *ethos*. Ruskin's practice of definition and redefinition, which forces the audience to depend upon him because it makes him the possessor and creator of its words, obviously establishes him as one who speaks with authority. Similarly, his characteristic acts of interpretation repeatedly establish his sage's claim that he understands matters his listeners do not. Even Ruskin's satiric devices, which risk alienating his

audience, finally establish his credibility, since as soon as his listeners accept that his satire is correct, they find themselves in the position of people who need guidance. Their old ideas have been attacked and they need others to replace them.

In addition to these devices, the Victorian sage employs several directly related to the creation of *ethos*. The careful positioning and adjustment of the sage's relation to his audience represents one such device. Another frequently employed is the use of self-denigration or confession of weakness to convince his hearers that he can be trusted. Such devices can take the form of the speaker's admission that he does not have the full respect of his audience, or they can appear in a form (used at the opening of 'Traffic') of the claim that circumstances beyond his control force the sage to utter unpleasant truths. Both forms of self-denigration, which appear to derive ultimately from Montaigne, ingratiate the speaker with his listeners, for they imply that the sage, like the listener, has human weaknesses. More important, such admissions of weakness further imply that the speaker has courageously revealed all his flaws, all his weaknesses, and that the rest is strength. The speaker implies, 'You can believe anyone who would so sincerely confess such embarrassing weakness in the interests of truth'. Ruskin's characteristic layering of footnotes, which often turns portions of *Modern Painters* into a palimpsest, exemplify such confessions of weakness, for they clearly, almost aggressively, suggest that so much of what Ruskin has written is valid that he can willingly admit his few errors.

The sage's citations of personal experience are closely related to these devices derived from romantic emphases on sincerity. The presence of major autobiographical elements in so many nonautobiographical works of Victorian prose, which David J. DeLaura has observed, derives largely from this need to create *ethos* by suggesting to the reader that the conclusions presented have in fact been tested upon the writer's own pulse.[9] Much of Ruskin's most important work – though not 'Traffic' – functions in a manner analogous to *In Memoriam*, making the claim: 'Reader, I was *there*, I experienced it myself', for many of his major writings, like Tennyson's great poem, use ideas, experiences, and even patterns of argument, not to convince the reader by intellectual means, but rather to allow him to re-experience what the author has felt. Tennyson begins with a fundamental

epistemological scepticism, one which holds that all faith is essentially subjective, and he proceeds by allowing his reader to enter his past experiences – to enter his subjectivity. This manner of proceeding, which implies that except in the poem's closing sections no single argument or experience can be cited as 'Tennyson's', permits the poet to create that kind of work Ruskin argued for in *Modern Painters* when he held that the great artist-poet had to permit his audience to share his feelings and imagination and so perceive truths and states otherwise inacessible to them. Unlike Tennyson, however, Ruskin generally employs 'fables of experience' whose validity is not cast into doubt when they are abstracted from their original context.[10] Furthermore, unlike Tennyson, Ruskin the sage also uses such experiences directly for purposes of satire and argumentation. Throughout the first volume of *Modern Painters* he thus frequently juxtaposes his experience of a landscape to a painting of it by an artist, such as Claude, whom he wishes to attack. In this manner Ruskin can demonstrate, not only his expertise at word-painting (which itself tends to win the audience's approval), but also his greater sensitivity to visual fact and visual beauty.[11]

Ruskin employs his proto-cinematic presentation of particularized landscapes without satirical intent in *The Stones of Venice* to enable his reader to experience them as he has done, and he also uses it in other places for caustic analyses of false notions of art and life. For example, in the last volume of *Modern Painters* he demolishes theories of the picturesque by moving the reader closer to a 'picturesque' scene in the Highlands, until he has revealed the suffering which underlies an aesthetic that treats people as mere visual objects (7.268-9).

Such rhetorical applications of essentially romantic experience appear to have carried us far from Ruskin the satirical sage and nineteenth-century prophet, but they merely emphasize what a wide range of techniques for creating *ethos* he can deploy. When he wishes to communicate his experience of landscape or of a painting in his art criticism, he employs his visual style. On the other hand, when he has no visual fact whose experience he wishes to communicate – as is the case in 'Traffic' – his set pieces tend to be visionary rather than visual; which is to say that he employs elaborate symbolical grotesques for satiric allegory and parable. Unlike the visual set pieces of *Modern Painters*

and *The Stones of Venice*, these satirical images no longer have the primary function of creating *ethos*, and therefore Ruskin had to develop the wide range of devices which make his audience give credence to the utterance of the Victorian sage.

NOTES

1 J. Holloway, *The Victorian Sage: Studies in Argument* (London, Macmillan 1953).

2 As I perceive the history of this putative genre, it first achieves full development in the works of Carlyle, who draws upon Montaigne, Swift, Coleridge, and many others for certain aspects of its characteristic techniques. Ruskin, Arnold, Newman, and (in America) Thoreau are its other great Victorian practitioners, while Lawrence, both in his travel books and *The Fantasia of the Unconscious*, carries on this prose form in the early twentieth century. Norman Mailer (*Of a Fire on the Moon*), Tom Wolfe (*The Pump House Gang*), Peter Matthiessen (*The Snow Leopard*), and E.M. Cioran (*The Fall into Time*) exemplify recent American and French contributions in this mode.

3 Thomas Carlyle, 'Chartism', *Works* ('Centenary Edition'), (ed.) H.D. Traill, 30 vols (London, Chapman & Hall 1896-9, and New York, Scribner 1896-1901), XXIX; Matthew Arnold, *Culture and Anarchy*, *Complete Prose Works*, (ed.) R.H. Super, 11 vols (Ann Arbor, University of Michigan Press 1965), V: 192.

4 Carlyle, *Past and Present, Works* ('Centenary Edition'), X: 138-41; Arnold, 'The Function of Criticism at the Present Time', *Complete Prose Works*, III: 273.

5 For Ruskin's version of the ancient hierarchy of the faculties, see (16.294), which is discussed in my *The Aesthetic and Critical Theories of John Ruskin* (Princeton University Press and Oxford University Press 1971), pp. 51-3.

6 For a detailed examination of the kind of sermons which had such great influence on Ruskin, see the first chapter of my volume, *Victorian Types, Victorian Shadows: Biblical Typology in Victorian Literature, Art, and Thought* (London, Routledge & Kegan Paul 1981).

7 Ruskin's notions of the Symbolical Grotesque, which are the nexus of his theories of allegory, artist and imagination, appear in the third volume of *Modern Painters* (5.130-32), and *The Stones of Venice* (11.181-2). *The Aesthetic and Critical Theories*, op. cit., pp. 370-99 provides an introduction to these Ruskinian theories of allegorical imagery and their relation to his conceptions of art and artist.

8 Ruskin's arguments for the sacredness of colour, which appear in (10.174-5) and (7.417-18), are discussed in the context of his applications of biblical typology to the enterprise of the sage in my *Victorian Types, Victorian Shadows.*

9 D.J. DeLaura, 'The Allegory of Life: The Autobiographical Impulse in Victorian Prose', *Approaches to Victorian Autobiography,* (ed.) G.P. Landow (Athens, Ohio University Press 1979), pp. 333-54.

10 The phrase 'fables of perception' is taken from Richard L. Stein, *The Ritual of Interpretation: The Fine Arts as Literature in Ruskin, Rossetti, and Pater* (Cambridge, Massachusetts, Harvard University Press 1975), p. 53, which contains many fine insights into the literary strategies of Ruskin's art of criticism.

11 For an extended analysis of Ruskin's use of such word-painting as a satirical device in his criticism of Claude's *The Mill* (3.41-3), see my 'There Began to be a Great Talking about the Fine Arts', *The Mind and Art of Victorian England,* (ed.) J.L. Altholz (Minneapolis, University of Minnesota Press 1976), pp. 139-43.

7
Towards the Labyrinth: Ruskin's Lectures as Slade Professor of Art

John Hayman

When Ruskin received news of his appointment as Slade Professor of Art at Oxford in August 1869, he was in a retrospective mood. He had passed the summer mainly at Verona, and had frequently thought about his earlier work on Venice. To Henry Acland, who sent him word of the appointment, he wrote: 'The main gist of what I have written seventeen years ago is entirely right, and the things I then declared to be admirable, *more* admirable, *in the sense I meant*, than even I then thought them' (20.xx). The remark reflects Ruskin's interest at this time in fixing his earlier positions securely. His Oxford lectures were to be his final words. To Acland again, he wrote: 'Remember, whatever I now do or say, I do or say as a man does on his deathbed. Not the worse for that I hope – nor the less gaily, sometimes' (36.593).

This concern to review and restate his position once and for all culminated in the final set of lectures during his first period as Professor (1869-78), when he provided readings from *Modern Painters* rather than entirely new lectures. As he remarked: '*Modern Painters* itself is a lecture with no conclusion, and I have now to put the conclusion upon it' (22.511). But Ruskin also recognized that he would at some points disagree with his earlier opinions, and he supposed that 'the little corrections of this and that, as I come across errors, will keep the life in one's talk'.[1] To come to terms with any of the Oxford lectures one must therefore consider the degree to which they are repetitions or revisions. Are they, in short, to be thought of as summations – or as tentative gropings in new directions? As journeys on the old road – or as other versions of the new road Ruskin actually attempted to build at Hinksey?

111

Certainly, there are many indications of Ruskin's attempt to
draw his ideas together and present complex but unified
assessments. The very titles of some of the lectures show
this intent. In *Lectures on Art* (1870), for example, there are
'The Relation of Art to Religion', 'The Relation of Art to
Morals', and 'The Relation of Art to Use'. Similarly, in *The
Eagle's Nest* (1872), there are 'The Relation of Wise Art to
Wise Science', 'The Relation of Art to the Science of Light',
'The Relation of Art to the Sciences of Inorganic Form', etc.
Even in such eccentric ventures as *Love's Meinie* (1873) – an
attempt to present 'the cream of forty volumes of scientific
ornithology' (25.13) – he aims to connect the various interests
of art, botany, and mythology. Moreover, it was not only in
the lectures that he tried to draw his diverse interests and
attitudes together. He considered his drawing classes to be an
essential part of his task, and he lamented that so few students
made the connection between theory and practice (22.301).
Similarly with his attempt to involve undergraduates in road
building at Hinksey. The connection between the project and
his lectures was clear enough – at least to Ruskin. 'I am
resolved now,' he wrote to Acland, 'to let the men under-
stand what I mean by useful art. I have waited patiently for
five years to see if any good comes of lecturing. None does,
and I will go at it now otherwise.'[2]

Ruskin's attempts to define clear distinctions reflect
especially well his urge for finality as well as the difficulty of
achieving this. There are, for example, his accounts at
different times of the artistic traditions he variously referred
to as purist and naturalist, colourist and chiaroscurist, Gothic
and Greek.

These distinctions are sketchily foreshadowed, first of all,
by the remarks on Angelico and Tintoretto in *Modern
Painters* Volume 2 (1846). Angelico is seen here as the
exponent of a traditional religious faith; Tintoretto, of a
humanistic faith ('the Art of Man in its full majesty' (4.354)).
Angelico is associated with 'typical beauty', since the qualities
that typify God, such as 'unity' and 'repose', are to be found
in his art; Tintoretto is associated with 'vital beauty' – the
imaginative rendering of human life. Occasionally the two
artists are connected by references to specific paintings. Of
Angelico's *Last Judgment*, for example, Ruskin writes: 'the
treatment is purely typical; a long Campo Santo, composed
of two lines of graves, stretches away into the distance;

on the left side of it rise the condemned; on the right the just' (4.275). The depiction has therefore the stillness, the symmetry, and the temperateness that are characteristic of typical beauty. Tintoretto's *Last Judgment*, on the other hand, is dramatic, energetic, and imaginative. The artist has 'grappled with [the event] in its Verity; not typically nor symbolically, but as they may see it who shall not sleep but be changed' (4.276). In *Modern Painters* Volume 2 these comparisons are not made for the purpose of diminishing either artist. On the contrary, Ruskin writes here with exceptional generosity and range of appreciation.

In *Modern Painters* Volume 3, however, a related distinction between the purist and the naturalist is accompanied by some explicit evaluation. The purist is associated with early Christian (or Angelican) art, in his 'endeavour to create . . . an imaginary state, in which pain and imperfection either do not exist, or exist in some edgeless and enfeebled condition' (5.104). The appeal of such art is readily acknowledged; its concern with innocence is morally commendable. But it is also a 'childish' form of art. 'For all firm aid, and steady use, we must look to harder realities' (5.105-6), Ruskin sternly concludes – and consequently the purist is urged 'to extend his delicate narrowness towards the great naturalist ideal' (5.109). As for the naturalist, it is his primary merit that he 'concerns [himself] simply with things as they ARE, and accepts, in all of them, alike the evil and the good' (5.111).

In the Oxford lectures Ruskin's position is more complicated, even while he also aims for final clarification. There are, for example, some notes entitled 'For first Lecture on Distinction of Schools' in an unpublished section of his diary:

The Great Division of Perceivers of Darkness – and
Dreamers in colour – of Mortality and of Life to come
associated secondly with Naturalism against fantasy.
Greek work is essentially to make everything reasonable
and human – Reasonable against ⟨imaginative⟩ fanciful [;]
human against monstrous.
 Trust always in the natural fact, that the best will be
the rendering of that – yet it must be beheld from the
imaginative side.
 Take Carpaccio's viper – compare it with one of
Flaxman's – its power is in its reality –

113

Compare it with one of my Hindoo speckled drawings
- its power is in its unreality.
(Con[fer] - illustratively - writhe of Turners Python.)
Nature - but nature beheld with a great soul.[3]

Subsequently, Ruskin attempts to clarify these distinctions
with a diagram:

There is thus one good and
one bad element in each
school. The shade being bad
as opposed to colour - the
fancy bad, as opposed to
naturalism. Yet both natur-
alism getting vile, if separate
from imaginative, and colour
mean, if separated from
shadow.

Such dialectical arrangements are to be found throughout
Ruskin's writings, but the control which they had once
assured him has become difficult to maintain.[4] This is clear
from the lectures that are related to these notes - *Lectures on
Art* (1870). Here the tradition that Ruskin referred to as
'Gothic' is equated with colour; the 'Greek' with light (and
darkness). The Gothic is 'full of comfort and peace'; the
Greek is 'full of sorrow' (20.140). In themselves these distinc-
tions pose problems, since elsewhere Ruskin sees the Greek
achievement as consummate - 'the origin, not only of all
broad, mighty, and calm conception, but of all that is
divided, delicate, and tremulous' (20.350). But a more acute
difficulty occurs subsequently in his comments on the
development of the Gothic colourists. 'In their early days',
Ruskin writes, 'the colourists are separated from other
schools by their contentment with tranquil cheerfulness of
light; by their never wanting to be dazzled' (20.169). Then,
towards the close of the fifteenth century, they were drawn
to actual light (and shadow). The scheme of values set out in
Modern Painters Volume 3 prepares us for Ruskin's approval
of this evolution to 'the great Naturalist ideal'. But that is
not what happens:

The complete painters, we find, have brought dimness and
mystery into their method of colouring. That means that
the world all round them has resolved to dream, or to

believe, no more; but to know, and to see. And instantly
all knowledge and sight are given, no more as in the
Gothic times, through a window of glass, brightly, but as
through a telescope-glass, darkly. Your cathedral window
shut you from the true sky, and illumined you with a
vision; your telescope leads you to the sky, but darkens
its light, and reveals nebula beyond nebula, far and farther,
and to no conceivable farthest – unresolvable. This is
what the mystery means. (20.171)

Earlier, Ruskin had viewed the painter's sense of mystery
as a religious recognition; now he views it as a matter of con-
fusion and uncertainty. His inclination for the lost paradise
of the purists is clear enough. And yet paradoxically he
finally allies himself with the other camp:

> If you want to paint . . . in the Greek School, the school
> of Leonardo, Correggio, and Turner, you cannot design
> coloured windows, nor Angelican paradises. If, on the
> other hand, you choose to live in the peace of paradise,
> you cannot share in the gloomy triumphs of the earth
> For my own part, with what poor gift and skill is in me, I
> belong wholly to the chiaroscurist school. (20.174-5)

To suppose that one can choose to live in paradise is a
quaint notion – akin to Ruskin's supposition that he could
avoid terrible dreams by restricting himself to a single serving
of pudding. And, finally, this rather surprising commitment
to the chiaroscurist position – following as it does so ominous
an account of the school – seems itself a sign of Ruskin's
vexed position.

Ruskin attempted repeatedly to distinguish between these
schools or traditions, perhaps because of the difficulty he
experienced in settling his attitude towards them. In *Lectures
on Landscape* (1871), for example, a divided attitude is again
apparent. Initially, Ruskin shows here an inclination to
detain his young pupils in the pre-lapsarian state that he
associates with the 'entirely cheerful' 'pure Gothic school of
colour' (22.56). 'As long as I can possibly keep you among
them, there you shall stay – among the almond and apple blos-
som' (22.61). But he is also aware that ultimately it is necessary
to venture into a fallen world – and he concludes that it is
Turner's especial distinction that he has done this. 'The

115

master insists upon the ancient curse of the earth – "Thorns also and Thistles shall it bring forth to thee" ' (22.68). In Turner's paintings 'the neglected agricultural poor' have their place as well as Arcadian shepherds. Ruskin himself seems intent on emulating Turner by again attending to both mountain gloom and mountain glory – despite the appeal of a glory that seemed to offer freedom from perplexity and suffering.

The complication of earlier attitudes may be illustrated further by two of the more rewarding lecture series: *Aratra Pentelici* (1870) on sculpture and *Ariadne Florentina* (1872) on engraving.

Both series exhibit a vivid interest in strictly aesthetic properties that is rarely to be found in Ruskin's earlier work. In *Aratra Pentelici* the term 'aesthetic' is itself said to be concerned with 'abstract relations and inherent pleasantnesses, whether in space, number, or time, and whether of colours or sounds' (20.207), and clearly there is no concern here with the mimetic or moral qualities of art. On the contrary, Ruskin advances the following propositions: '(i) that sculpture is essentially the production of a pleasant bossiness or roundness of surface; (ii) that the pleasantness of that bossy condition to the eye is irrespective of imitation on one side, and of structure on the other' (20.214). As an illustration, Ruskin offers a Greek coin depicting the 'Arethusa of Syracuse':

> That these intricately modulated masses present some resemblance to a girl's face, such as the Syracusans imagined that of the water-goddess Arethusa, is entirely a secondary matter; the primary condition is that the masses shall be beautifully rounded and disposed with due discretion and order. (20.215)

It is a remark that Whistler might have wished he had made. This same preoccupation with the technical and formal aspects of art is apparent as well from a comment on engraving in *Ariadne Florentina*. 'The first requirement in the Florentine work,' Ruskin remarks, 'is that it shall be a lovely arrangement of lines; a pretty thing upon a page To engrave well is to ornament a surface well, not to create a

realistic impression' (22.380). Related to this interest in such formal properties is an interest in the materials of artistic production. 'In oil painting,' he remarks, 'its unctuous quality is to be delighted in; in fresco, its chalky quality; in glass, its transparency; in wood, its grain; in marble, its softness; in porphyry, its hardness; in iron, its toughness' (20.307). Such delight in the materials themselves goes considerably beyond the earlier argument in *Seven Lamps of Architecture* (1849) that the artist and architect should not falsify the true nature of the materials employed.

It would be inaccurate, however, to conclude from this that Ruskin is setting up a programme for those who were to insist on 'the absolutely satisfying value of beautiful workmanship' and the importance of a 'love of art for art's sake'.[5] For he is just as insistent on the truth of artistic representation as he had been earlier – indeed, he extends beyond the earlier position, as he himself is aware:

> The object of the great Resemblant Arts is, and always has been, to resemble; and to resemble as closely as possible. It is the function of a good portrait to set the man before you in habit as he lived, and I would we had a few more that did so. It is the function of a good landscape to set the scene before you in its reality; to make you, if it may be, think the clouds are flying, and the streams foaming....
> You think all that very wrong. So did I, once, but it was I that was wrong. (20.282-3)

The reference to an earlier, erroneous position is presumably to that in *Modern Painters* Volume 1, where such 'resemblant art' was considered morally reprehensible and related to 'the sensation of trickery and deception' (3.101). In *Aratra Pentelici* the term 'deception' is itself given a new status. In an analysis of Turner's *The Falls of Terni*, Ruskin remarks:

> the painter has strained his skill to the utmost to give an actually deceptive resemblance of the iris, dawning and fading among the foam. So far as he has not actually deceived you, it is not because he would not have done so if he could; but only because his colours and science have fallen short of his desire. (20.285)[6]

Such reversals of earlier positions are the more difficult to grasp since the positions advanced in the Oxford lectures are not entirely consistent. The urge for definiteness has apparently led to the statement of extreme positions, and an earlier pose of different realizations has consequently been upset.

It is possible all the same to find coherence in Ruskin's attitude at this time. To do so one must attend to the thread of imagery and allusion in his lectures rather than to a line of abstract thought. This reliance on visual reference in particular is most apparent from the wealth of drawings, engravings, and photographs that he brought to his lectures. On occasion he also produced the very item that he wished to talk about rather than an artistic representation of it. At such points a pervasive nineteenth-century concern with 'the object as in itself it really is'[7] reached its ultimate conclusion – but with Ruskin the object has also a symbolic import. There is, for example, the ploughshare that he placed on the table at the opening lecture of *Aratra Pentelici*. Initially it served to introduce a reference to the Franco-Prussian War, as Ruskin reiterated his social watchword: 'Soldiers of the Ploughshare, instead of Soldiers of the Sword' (20.200). Subsequently, it illustrated more deliberately his central notion about 'the essential unity of the arts' (22.337). A ploughshare and an architectural structure are first related in this account:

> The placing of the timbers in a ship's stem, and the laying of the stones in a bridge buttress, are similar in art to the construction of the ploughshare, differing in no essential point, either in that they deal with other materials, or because, of the three things produced, one has to divide the earth by advancing through it, another to divide water by advancing through it, and the third to divide water which advances against it. And again, the buttress of a bridge differs only from that of a cathedral in having less weight to sustain, and more to resist. (20.202-3)

This realization of the visual imagination is finally sustained by a characteristic assertion of analysis. Abruptly closing the paragraph, Ruskin declares: 'We can find no term in the

gradation, from the ploughshare to the cathedral buttress, at which we can set a logical distinction.' It is partly this engagement of both rational consideration and intuitive grasp that makes the connections here so vivid. But the passage is also enhanced by social and economic considerations, for Ruskin continues: 'by . . . division of labour, you ruin all the arts at once' (20.203).

Subsequently the unity of man's endeavour is suggested by more specific connections between ploughing and the arts of sculpture and engraving. In *Aratra Pentelici*, for example, Ruskin urges that the 'great mythical expression of the conquest of the earth-clay and brute-force by vital human energy, will become yet more interesting to you when you reflect what enchantment has been cut, on white clay, by the tracing of finer furrows; – what the delicate and consummate arts of man have done by the ploughing of marble, and granite, and iron' (20.329). Similarly in *Ariadne Florentina*, the instrument for engraving is said to be 'a solid ploughshare, which, instead of throwing the earth aside, throws it up and out' (22.348). 'A ploughed field is the purest type of such art; and is, on hilly land, an exquisite piece of decoration' (22.322). For Ruskin, then, it is one of the happier workings of *Fors* that Holbein should have produced a woodcut of a ploughman in his series *The Dance of Death*, since 'the central syllable' of the word 'engraving' is closely associated with death (22.306). Moreover, this particular woodcut illustrates especially well Ruskin's account of engraving procedures, in that the medium itself is eminently suited to the depiction of an 'old and gaunt husbandman [who] has passed his days, . . . in pressing the iron into the ground' (22.355). A kinship between the physical action and the effect of the sculptor's chisel, the engraver's burin, and the ploughman's share – it is on the basis of this visual recognition that Ruskin's imagination constructs a coherent, if fragile, world in which art and the most basic of agricultural activities are at one.

Such recognitions of the visual imagination are not of course new in Ruskin's writings. He had much earlier formulated a science of aspects',[8] but his dismay at the increasing dominance of an alien scientific approach provoked him to some forceful reiteration in the Oxford lectures. Abruptly he now declares that 'art has nothing to do with structures, causes, or absolute facts; but only with appearances' (22.222). This preoccupation with appearance is sometimes reflected in

notes that apparently defied more articulate formulation – in the remarks entitled 'Recognition of Order', for example, that Ruskin jotted down while preparing 'Studies in the *Discourses* of Sir Joshua Reynolds':

> To see design and trace it, the great human faculty.
> Beginning of order is breaking into waves – Vibration: fall
> of cataract. This order of the peacock's feather is the
> finest possible of vibrations – lustrous waves fastened
> for ever – a golden glacier, with musically measured
> crevasses, a cascade of perpetual fire. (22.506)

This apprehension of a living order – an order that includes and transcends dissolution – is a fine stroke, rendered vivid by Ruskin's display of a drawing. The observation is akin to many in Gerard Manley Hopkins's notebooks, and inherent in it is Hopkins's later concept of instress and inscape. Sometimes Ruskin's recognitions are less exalted. While working on some lectures concerned with fish, he reported to Acland that they were 'not to have any jests, but to be real work all through' (22.xxvi). But his subsequent connection between a drawing of a fish and a caricature of a self-made man must leave one wondering. 'If we were to take the hat off,' Ruskin assures us, 'you see how nearly the profile corresponds with that of the typical fish' (20.293).

A further distinction of Ruskin's later concern with the visible relates to the specific visual forms that preoccupy him. In particular, it is possible to mark his movement from the curve to the labyrinth as a central point of reference. His earlier preoccupation with curvature is as evident in his own drawings as in his analyses in *Modern Painters* of such natural phenomena as mountains, waves, and the growth of trees.[9] In the Oxford lectures, the form is also remarked on, as in his suggestion that by drawing an outline of the cup of Dionysus, one will learn 'all the practical geometry of nature; the ellipses of her sea-bays in perspective, the parabolas of her waterfalls and fountains in profile; the catenary curves of their falling festoons in front; the infinite variety of accelerated or retarded curvature in every condition of mountain débris' (22.217). But other linear movements also now fascinate Ruskin – for example, the 'spiral form' (21.92). His own drawings of shells where he found this form are numerous – more than twenty are listed in the 'Catalogue of

Drawings' (38.282) – and he also set related 'Exercises' for his Oxford drawing class and gave further instruction in drawing snail shells in *Fors Clavigera* Letter 62 (February 1876) (28.524-7). In addition, he contemplated some lectures on shells, and his notebooks contain again some preliminary material:

> For introduction. Spiral line. Waves curling. – Winds. Nineveh water. Harpies. – Rams Horn – Spirals of plants – connection of Horns with vegetation With the Ground. Serpent strength. Volumen. Volute. Ends of leaves. Ends of Ferns – Corinthian capital.[10]

The wealth of illustration is ominous here; 'the world's multitudinousness'[11] that threatened Ruskin and so many other nineteenth-century artists seems scarcely controllable within a spiral line. Not surprisingly, then, we arrive at a related motif, the labyrinth itself – an image that seems deliberately to invoke the complexity with the intent of triumphing over it.

Daedalus, the classical figure associated with the labyrinth, has, for Ruskin, a twofold significance. First, he is 'the master of minute and precious decorative work . . . the head of the deliciousness & daintiness of art'.[12] As such, his dominion is wide; it extends from the 'exquisiteness of finish' in Attic culture to the intricate inlaying of Tuscan architecture – indeed, 'from the tomb of . . . Edward the Confessor, to the farthest shore of the opposite Arabian and Indian world' (20.352-3). The influence of Daedalus' concern with intricate appearance and mechanical dexterity has its danger, Ruskin is ready to admit. But this baleful influence is counteracted by Daedalus' further merit. For he is, secondly, 'the giver of motion and life: and this in the deepest sense; the giver of soul'.[13] Viewed fully, then, Daedalus is one whose devotion to art has finally been life-giving. Ruskin's wary acceptance of him as a guide at this time suggests that he knew he might himself be drawn into narrow aesthetic considerations – into the labyrinthine lettering of medieval manuscripts, for instance. Like other misled disciples of Daedalus he might then 'love the gilding of the missal more than its words' (20.353). He must instead remain aware of both the 'peril of the influence of Daedalus' and the ideal that he may point towards – just as he must accept the danger and the exhilarating challenge of the labyrinth itself.

References to labyrinths are present in Ruskin's earlier writings - in *The Stones of Venice,* for example, where Ruskin finds in the appeal of 'braided or woven ornament' 'the joy that the human mind has in contemplating any kind of maze or entanglement, so long as it can discern, through its confusion, any guiding clue or connecting plan' (10.163). The same notion is advanced in *Ariadne Florentina,* where Botticelli's engravings are related to 'the instincts . . . for the arrangement of pure line, in labyrinthine intricacy, through which the grace of order may give continual clue' (22.451). But there is a new urgency about the later remark, for Ruskin now maintains that the instinct appealed to by a labyrinthine line has been lost from modern consciousness - 'the influence of modern naturalistic imitation being too strong to be conquered' (22.451). Furthermore, Ruskin invokes the labyrinthine with almost obsessive frequency in his later years, and he attaches an extraordinary significance to the form.

In *Praeterita,* for example, the labyrinth is at one point an image of the continuity and coherence of his life:

> My runs with cousin Mary in the maze, (once, as in
> Dantesque alleys of lucent verdure in the Moon, with
> Adèle and Elise,) always had something of an enchanted
> and Faery-Queen glamour in them: and I went on
> designing more and more complicated mazes in the blank
> leaves of my lesson books - wasting, I suppose, nearly
> as much time that way as in the trisection of the angle.
> Howbeit, afterwards, the coins of Cnossus, and characters
> of Daedalus, Theseus, and the Minotaur, became intelligble
> to me as to few. (35.247)

Even here the idyllic memory of childhood is complicated by the recollection of a more exotic experience with two precocious young ladies from France, but the labyrinth is seen none the less as informing his life in a valuable way. From this it is a far cry to the lament in *Ariadne Florentina* that 'the labyrinth of life itself, and its more interwoven occupation, becomes too manifold, and too difficult for me' (22.452). The labyrinth has now become a symbol for hell - a way of representing Dante's depiction of the inferno. In outlining this in *Fors Clavigera* Letter 23, Ruskin writes of his own familiarity with the region. 'In my poor and faltering path,' he remarks, 'I have myself been taken far enough down

among the diminished circles to see this nether hell' (27.412). Granted such experience, Ruskin's attempt at road building near Oxford is the more poignant.

Inevitably, Ruskin sometimes loses his way within the labyrinth that he calls into being. At such moments, the labyrinth becomes a model for his own procedure as a writer, and a reader feels lost by the false starts, wayward digressions ('by the way'), and returns to a starting point. But the image of a labyrinth also produces some compelling insights. In 'The Flamboyant Architecture of the Somme' (1869), for example, the labyrinthine line is seen as nothing less than a clue to universal art of the highest order:

> In all living art this love of involved and recurrent line exists, – and exists essentially – it exists just as much in music as in sculpture, and the continually lost and re-covered threads and streams of melody in a perfect fugue, correspond precisely in their sweet science of bewildering succession, to the loveliest traceries over the gold of an early missal, or to . . . fantasies of . . . stone work. (19.259)

At such a moment, the labyrinth is no longer associated with the tortuous. It offers instead a triumphant image of the unity of man's endeavours. First and last, Ruskin's Oxford lectures aimed to communicate this complex unity.

NOTES

1 Bodleian Library, Oxford, MS Acland d. 73, folio 129V (no date). Letter to Henry Acland.
2 Bodleian Library, Oxford, MS Acland d. 73, folio 106V (no date). Letter to Henry Acland. A penetrating analysis of this venture is provided by Tim Hilton in 'Road Digging and Aestheticism 1875', *Studio International*, 188 (December 1974), pp. 226-9.
3 The diary is at the Ruskin Galleries, Bembridge School, Isle of Wight (BEM MS L16); the notes follow an entry of 23 June 1870. Carpaccio's viper is a detail in *St George Killing the Dragon* (Scuola di San Giorgio degli Schiavoni, Venice), copied by Ruskin 'for the schools of Oxford as a Natural History study' (24.241-3). Ruskin considered it to be a distinguishing feature of 'Hindoo' (or Indian) art that '*it never represents a natural fact*' (16.265).
 Turner's python is analysed in *Modern Painters* Volume Five (7, chapter 11).

4 I have attempted to show this in 'Ruskin and the Art of System-Making', *The Yearbook of English Studies*, 4 (1974): 197-202.

5 Oscar Wilde, 'L'Envoi' in James Rennell Rodd's *Rose-Leaf and Apple-Leaf* (Philadelphia, J.M. Stoddart 1882), p. 10. Wilde wrote of this *Envoi* that it was 'most important, signifying my new departure from Mr Ruskin and the Pre-Raphaelites and marks an era in the aesthetic movement', *The Letters of Oscar Wilde*, (ed.) Rupert Hart-Davis (London, Rupert Hart-Davis, and New York, Harcourt Brace 1962), p. 96.

6 An unpublished diary entry on this topic suggests that Ruskin is daringly playing with the term 'deception' here. 'No question exists as to the manner or degree of the realization. It should be as complete as it can be – deception – if deception were compatible with the highest truth' (Ruskin Galleries, Bembridge School, BEM MS L16, p. 8).

7 'On Translating Homer' (1861), in *The Complete Prose Works of Matthew Arnold*, (ed.) R.H. Super, 11 vols (Ann Arbor, University of Michigan Press 1960), I: 140. Arnold quoted this passage in 'The Function of Criticism at the Present Time' (1865), *Complete Prose Works*, III.

8 See Patricia M. Ball, *The Science of Aspects* (London, Athlone Press 1972), chapter 2, 'Ruskin and "The Pure Fact"'.

9 Paul H. Walton, *The Drawings of John Ruskin* (Oxford University Press 1972), pp. 78-81.

10 Beinecke Library, Yale University, Cash Book Ledger (MS Vault, Section 14, Drawer 2), p. 322.

11 *The Letters of Matthew Arnold to Arthur Hugh Clough*, (ed.) H.F. Lowry (London and New York, Oxford University Press 1932), p. 97.

12 Beinecke Library, Yale University, Day Book Ledger (MS Vault, Section 14, Drawer 1), p. 38.

13 Ibid.

8

Ruskin's Benediction: A Reading of *Fors Clavigera*

John D. Rosenberg

The August 1872 issue of *Fors Clavigera* opens with a beautifully crisp frontispiece captioned, all in one long line, 'Part of the Chapel of St. Mary of the Thorn, PISA, as it was 27 years ago.' Centred directly below the line and completing the caption in almost pained brevity stand the words: 'Now in Ruins.' Drawing and caption are emblems of what is to come in the body of this most remarkable of the ninety-six public letters that comprise *Fors Clavigera*.

Ruskin's drawing of the chapel, done in his mid-twenties, depicts a Gothic idyll in stone, a delicate filigree of pinnacles and sculptured arcades, rose-windows and shaded gables all bathed in brilliant morning light. Frontispiece, caption, and ensuing text trace a continuous arc from felicity to enraged despair, the letter ending as Ruskin stares in incredulous horror while a Pisan stonemason sets to work demolishing the chapel. 'Now in Ruins' is Ruskin's summary judgment upon the fall of a Gothic paradise and the rise in its stead of the aggressively secular, industrialized Europe he detested. But the caption also carries a more private significance. For the long course of years between Ruskin's first drawing the chapel and witnessing its destruction[1] also saw the wreckage of his own hopes of ever gaining mastery over his disordered life. His books were becoming increasingly fragmentary and idiosyncratic. To the distress of his friends he had begun to write in *Fors* of the ominous 'storm-cloud of the nineteenth century' that was polluting the clear skies he had known in his childhood. The English public, he believed, had ignored or rejected his 'message', and Rose La Touche, whom he had loved obsessively for over a decade, had refused his offer of

marriage and was daily drifting further into unreason. The ruin of which Ruskin writes so movingly in Letter 20 is of himself as well as of 'St. Mary of the Thorn'.

The letter opens casually, with Ruskin drawing his reader into the attentive circle of 'My Friends' and picking up, as friends will, the threads of interrupted conversation. He had been spending the summer of 1872 in Venice, his rooms at the Hotel Danieli only a moment's walk from the quay of the Ducal Palace and almost in earshot of Mass at San Marco. In *Fors* of the previous month he had complained angrily of the 'accursed whistling' (27.328) of the Lido steamer boarding passengers at the quay. Now, resuming where he had left off and seeking to reassure his readers of his equanimity, indeed of his sanity, he justifies his characterization of the steamer as 'accursed'. Ruskin's struggle to keep hold of himself and in touch with his readers forms the inner drama of *Fors*, the writing of which served both to focus and release his 'chronic fury'.[2] The measured pace of his opening phrases –

> I never wrote more considerately [than in the last *Fors*] ;
> using the longer and weaker word 'accursed' instead of
> the simple and proper one, 'cursed,' to take away, as far
> as I could, the appearance of unseemly haste – [3]

contrasts starkly with the cry of pain and rage soon to come. From its title of 'Benediction'[4] onwards the letter is about, and itself dramatically enacts, the contrary states of accursedness and blessedness that Ruskin sets out to define. In form it combines sermon and letter into a uniquely Ruskinian 'Epistle'. As archaic in origin as the verses from the Epistle of James that Ruskin takes as his main text, 'Benediction' is also as contemporary and intimate as 'the beating of one's heart in a nightmare'.[5] The biblical allusions threaded throughout the letter remind one that Ruskin's mother 'devoted him to God' before he was born and that his first recorded words, preached from an improvised pulpit of sofa pillows, were 'People, be good' (35.24-6). The homiletic child was father of the socially-conscious adult who, one year after his inauguration at Oxford as Slade Professor of Fine Art, began writing *Fors Clavigera* 'to quiet my conscience' (28.485) and founded the St George's Guild. The Guild's achievements were modest compared to Ruskin's

ambitious plans for slaying, almost single-handedly, the
dragon of industrial capitalism and converting England into
pastoral communities of disciples, 'none wretched but the
sick; none idle but the dead'.[6] Yet many of the letters
directly address the affairs of this small band of followers,
giving the series a distinct if unnoticed kinship to the
'pastoral' Epistles of the New Testament. Travelling widely
over western Europe and the Mediterranean, proselytizing
for the Guild in the pages of *Fors* and preaching his message
of co-operation and compassion, addressing the members as
their 'Master' and expounding on virtually every verse in the
Bible, Ruskin writes like a quixotic St Paul who stayed in
all the best hotels. Often the letters reach beyond the small
community of St George's Guild to a diaspora of kindred
spirits spread over the English-speaking world. It is this
wider, invisible congregation that Ruskin summons through
the monthly readership of *Fors* and greets, at the start of
'Benediction', with the salutation 'My Friends'.

The voice that speaks to us so easily and personally in
the first few words of 'Benediction' quickly takes on a more
formal, episcopal air. Within a dozen lines our picture of
Ruskin in his elegant Venetian rooms fades and instead we
begin to hear a graver voice, Ruskin the exegete of Scripture
intoning as if from some unseen pulpit these verses from the
Epistle of James on the unruliness of our tongues: 'There-
with bless we God, and therewith curse we men; out of the
same mouth proceedeth blessing and cursing. My brethren,
these things ought not so to be.'

Overtly and covertly this text controls the letter and
shapes even its seemingly wildest digressions, which in
reality are not digressions at all but vivid exempla of Ruskin's
sermon on the 'accursedness' of modern civilization and its
assault upon his own sanity. That assault first manifests itself
in the return of the Lido steamer as it abruptly invades
Ruskin's main text and disrupts his exegesis of James. Like
Ruskin, the reader is wrenched without transition from the
measured commentary on blessing and cursing to the noise
outside the hotel window:

Now, there is a little screw steamer just passing . . .; she
is not twelve yards long, yet the beating of her screw has
been so loud across the lagoon for the last five minutes,
that I . . . left my work to go and look.

127

There follows a passage of startling immediacy in which Ruskin seems to step through the frame of his own narrative and enter the quayside scene he had been observing from his window the instant before. His Biblical commentary, first displaced by the screw steamer, further recedes as he recounts an incident set grammatically in the past but charged with the psychological urgency of the immediate present:

> Before I had finished writing that last sentence, the cry
> of a boy selling something black out of a basket on the
> quay became so sharply distinguished above the voices of
> the always debating gondoliers, that I must needs stop
> again, and go down to the quay to see what he had got to
> sell. They were half-rotten figs, shaken down, untimely, by
> the midsummer storms: his cry of 'Fighiaie' scarcely ceased,
> being delivered, as I observed, just as clearly between his
> legs, when he was stooping to find an eatable portion of
> the black mess to serve a customer with, as when he was
> standing up. His face brought the tears into my eyes, so
> open, and sweet, and capable it was; and so sad. I gave him
> three very small halfpence, but took no figs, to his
> surprise: he little thought how cheap the sight of him and
> his basket was to me, at the money; nor what this fruit
> 'that could not be eaten, it was so evil,' sold cheap before
> the palace of the Dukes of Venice, meant, to any one
> who could read signs, either in earth, or her heaven and sea.

The reader is caught up in the urgency of the narrative, with its absolute fidelity to perceived detail,[7] yet is detained and puzzled by a suggestion of significance far in excess of any explicit statement. The boy, the Palace, the rotten fruit, the well-dressed Englishman in tears – these are signs of the times that Ruskin entreats us to read. They form part of the parable-like 'autobiographical myth'[8] that parallels and illuminates the biblical commentary on the letter's surface.

Twenty years earlier, in *The Stones of Venice*, Ruskin had written of the Ducal Palace as the centre of the most sacred complex of civic and ecclesiastical architecture in the world (9.38). He had especially praised the carving, on the south-west corner of the Palace, of Adam and Eve fathering fruit beneath a fig-tree (10.359). And in one of the letters of *Fors* he transcribed the verse from Micah carved on the corner-

stone of the Palace, as if in promise of earthly plenty for all
who live in the city: 'Every man shall dwell under his vine
and under his fig-trees' (29.34). Ruskin had educated a whole
generation of readers in biblical typology and in the icono-
graphy of Christian art, especially the art and architecture of
Venice. 'Benediction' is part of this larger exegetical enter-
prise, and if the modern reader now falters over Ruskin's
many scriptural allusions, his contemporaries could virtually
read them as they ran. The sad-faced boy bent over his
blighted figs, in front of the deserted Palace and beneath a
statue of Adam and Eve, themselves gathering figs, is an
animate image of the Fall. The latent obscenity of the cry
shouted from between the boy's legs[9] clashes with the open
innocence of his features. Rising and stooping, half-fallen
and half-risen, he is scarcely redeemed by Ruskin's 'three
very small halfpence'. Yet the boy is seen through com-
passionate eyes: Ruskin's gesture of bestowing the pennies
but taking nothing in return suggests a furtive blessing.
Like the city whose corrupt splendour surrounds him, the
boy retains a kind of faded sanctity, marked on his face by
its mixture of sadness and sweetness. He is a doomed angel
who has fallen into an accursed world where, even on the
steps of its grandest palace, the fruit 'could not be eaten, it
was so evil'.[10]

The writing of 'Benediction' occupied Ruskin during odd
intervals on three successive days. The dates of *3rd, 4th*, and
5th July placed at the head of each of the sections suggest
the spontaneity of a journal or diary, a spontaneity shared
by all the letters despite their being addressed to a general
audience on a wide range of issues. No quality of *Fors* is
more remarkable than its disregard of the conventional
boundaries separating the public from the private. The first
section moves from biblical exegesis to the seeming digression
of the figs. The second section also opens with literary
analysis but ends – or rather abruptly aborts itself – in a
nightmare of private pain.

Accuracy of language, like clarity of sight, was for Ruskin
at bottom a moral faculty, and in opening the second section
of 'Benediction' by drawing a precise distinction between
swearing and cursing he again takes up the larger labour or
exegesis which opened the letter and which lies at the heart

of all his writings. But his extreme exactitude of articulation suggests an element of stress, like the hyper-enunciation of someone about to fall into a rage. In a sharply pointed contrast Ruskin observes that swearing is 'invoking the witness of a Spirit to an assertion you wish to make', whereas cursing is

> invoking the assistance of a Spirit, in a mischief you wish to inflict. When ill-educated and ill-tempered people clamorously confuse the two invocations, they are not, in reality, either cursing or swearing; but merely vomiting empty words indecently.

In the final phrases Ruskin manages to refine raw anger into wit. When still in control, the invective in *Fors* must have given Ruskin as much pleasure to write as it gives us to read, as in his comparison of the expanding British Empire to a 'slimy polype, multiplying by involuntary vivisection, and dropping half-putrid pieces of itself wherever it crawls or contracts' (27.451). Elsewhere, as in much of 'Benediction' and in the great Christmas Letter of 1874, the pleasures of the invective pale before our sense of Ruskin's increasing isolation and pain, standing alone

> in the midst of this yelping, carnivorous crowd, mad for money and lust, tearing each other to pieces, and starving each other to death, and leaving heaps of their dung and ponds of their spittle on every palace floor and altar stone.[11]

As Paul Sawyer observes, in passages such as these 'Ruskin's invective becomes itself a kind of curse'.[12] The description applies perfectly to the second section of 'Benediction', which culminates in a curse upon modern civilization and assaults the reader like a shriek of pain.

Ruskin prepares for that assault by examining the two principal forms of malediction in English: the curse upon the spirit – 'God damn your soul!' – and the curse upon the bodily members – 'God damn your eyes and limbs!' What do we in fact mean when we call down upon someone the blinding of an eye or the crippling of a limb? In the final third of the letter Ruskin will portray a living illustration of his text, two spiritually blind and palsied girls riding beside him in a closed railway carriage. But here he is intent upon

understanding the malediction on the eyes and limbs, and in order to do so he contrasts the act of cursing with its scriptural opposite, blessing, as in Christ's 'Blessed are the eyes which see the things that ye see', or Isaiah's promise that in Zion the lame man shall 'leap as an hart, and the tongue of the dumb sing'.[13] At this point the reader comes upon a violently disjointed paragraph that itself embodies the contrary states of blessedness and cursedness that have all along been Ruskin's central subject:

Again, with regard to the limbs, or general powers of the body. Do you suppose that when it is promised that 'the lame man shall leap as an hart, and the tongue of the dumb sing' - (Steam-whistle interrupts me from the *Capo d'Istria*, which is lying in front of my window with her black nose pointed at the red nose of another steamer at the next pier. There are nine large ones at this instant, - half-past six, morning, 4th July, - lying between the Church of the Redeemer and the Canal of the Arsenal; one of them an ironclad, five smoking fiercely, and the biggest, - English and half a quarter of a mile long, - blowing steam from all manner of pipes in her sides, and with such a roar through her funnel - whistle number two from *Capo d'Istria* - that I could not make any one hear me speak in this room without an effort), do you suppose, I say, that such a form of benediction is just the same as saying that the lame man shall leap as a lion, and the tongue of the dumb mourn? Not so, but a special manner or action of the members is meant in both cases: (whistle number three from *Capo d'Istria*; I am writing on, steadily, so that you will be able to form an accurate idea, from this page, of the intervals of time in modern music. The roaring from the English boat goes on all the while, for bass to the *Capo d'Istria*'s treble, and a tenth steamer comes in sight round the Armenian Monastery) - a particular kind of activity is meant, I repeat, in both cases. The lame man is to leap, (whistle fourth from *Capo d'Istria*, this time at high pressure, going through my head like a knife) as an innocent and joyful creature leaps, and the lips of the dumb to move melodiously: they are to be blest, so; may not be unblest even in silence; but are the absolute contrary of blest, in evil utterance. (Fifth whistle, a double one, from *Capo d'Istria*, and it is

131

seven o'clock, nearly; and here's my coffee, and I must
stop writing. Sixth whistle – the *Capo d'Istria* is off, with
her crew of morning bathers. Seventh, – from I don't
know which of the boats outside – and I count no more.)

The verses from James that opened the letter – 'out of the
same mouth proceedeth blessing and cursing' – here come to
life as two antiphonal voices issuing simultaneously out of
Ruskin's own mouth. With absolute spontaneity yet absolute
mastery, he achieves a poetry of controlled cacophony:
Ruskin 'scores' the paragraph as a duet of divided conscious-
ness in which the lips of his 'blessed', episcopal self 'move
melodiously' outside the parentheses while his 'accursed'
self rages discordantly within the parentheses, outshouting
the steam-whistles that mark, as he bitterly says, 'the inter-
vals of time in modern music'.

The paragraph is intentionally unintelligible if read in
line-by-line sequence down the page. Its 'meaning' is precisely
the violent fragmentation of meaning in the modern world,
a fragmentation Ruskin directly induces in the reader.
Throughout *Fors* he portrays not only the passing scene out-
side his window but the inmost movements of his own mind
as it is shaped – and threatened – by that scene. As vital as
the act of seeing always was for Ruskin – 'To see clearly is
poetry, prophecy, and religion, – all in one' (5.333) – his
ultimate subject in *Fors* is not sight but insight, his own
distraught consciousness as it engages the world. Through
lightning transitions, allusions, backtrackings, shifts in tone,
tense, and voice he all but obliterates the gap between self
and scene, proximate and distant, present and past. The
Capo d'Istria paragraph amplifies all these effects through the
abrupt shifts from main text to parentheses and back again.
The movement in and out of the parentheses locates us in
two worlds, two times, two states of consciousness at once,
resulting in a dizzying immediacy akin to 'zooming' in photo-
graphy. Earlier in the letter Ruskin had achieved a similar
effect by telescoping the time between his observing and
recording the same event: 'Before I had finished writing that
last sentence . . . I must needs stop again, and go down to the
quay.'[14] Here words so closely trail the things they describe
they seem to overtake the depicted actuality.

The reader feels an uncanny closeness to the events
described in *Fors*, a proximity that in 'Benediction' becomes

progressively menacing. In the opening section the threatened intrusion appeared in the form of the little screw steamer first heard at some distance across the lagoon. In the *Capo d'Istria* paragraph the intrusion intensifies into assault. Outside the parentheses the quiet cadences of the biblical exegesis serve as a neutral ground offsetting the infernal treble of the steam-whistles within the parentheses. The reader follows the melodious tones of the main text with the gratified half-attention one gives to a voice from a distant pulpit; the phrases are long, the content familiar and intentionally untaxing, the elegant episcopal voice poised in the middle of a question and intoning the word *sing* when the first whistle cuts the text in two. In the inferno inside the parentheses, where the blessed do not sing but the damned shriek, the nine ships are spread out – like symbolic markers charting the distance dividing salvation from destruction – between the Church of the Redeemer and the Canal of the Arsenal. The significance of the location is obscured by the headlong rush of the paragraph and, for the modern reader, is likely to register only subliminally, if at all. But the positioning is *not* fortuitous. As always Ruskin is topographically exact: seen from the angle of his window the ships were stationed exactly as described. Yet Ruskin could have oriented the reader in a thousand other ways, choosing instead, in the instant it took him to pen the line, the two most symbolically resonant landmarks available to his purpose in all of Venice.[15]

The speed with which Ruskin wrote *Fors Clavigera*, the seemingly anarchic spontaneity of most of the letters and the extreme stress of some, especially of 'Benediction', may make the assertion of their underlying order appear unconvincing indeed. Yet their unity is not illusory, their spontaneity not affected. *Fors* is the inspired metamorphosis of chance into design. The first word of the title means *chance* or *accident*, but the full title, drawn primarily from Horace's *Odes* and suggesting 'Implacable Fate, the Nail-bearer', is heavy with the sense of fatality underlying all chance. Sheer chance, perhaps, determined that the *Capo d'Istria* should blast off in the middle of Ruskin's exegesis of Isaiah, but only the synthesizing genius of his imagination could so contrive a sentence that the first cacophonous blast falls on the word *sing*. So too the blessed lame man, as if cued into motion by the word *leap*, himself leaps in a perfect arc over

133

the third parenthesis – the steam-whistle meanwhile slicing through Ruskin's head like a knife – and lands in innocent joy on the far side of Ruskin's agony.

Time-keeping in the paragraph began at 'half-past six, morning, 4th July' and ends at 'seven o'clock, nearly; and here's my coffee, and I must stop writing'. The modulations in tone have been extraordinary – from Isaiah's vision of the blessed, to the *Inferno*, to the Prufrockian end ('and here's my coffee') in only a few lines. Like the sounding of the seven trumpets in Revelation, the count of the steam-whistles stops with the seventh blast, and by the final sentence the biblical exegesis has been wholly displaced by the parenthetical intrusion, from which there is no return to the main body of the letter. As if enclosed within his own parenthesis, Ruskin ends on a perfect ambiguity: he has ceased to enumerate the whistles and, in the midst of the annihilating din, he has ceased to matter: ' – and I count no more.)'

A wide margin of white space follows 'these broken sentences', and after a day's interruption Ruskin resumes the letter as if awakened from a bad dream. He steps back from the excruciating scene at his window and describes instead, in minute and loving detail, the painting of a sleeping princess he had first seen in Venice three years earlier. Carpaccio's *Dream of St Ursula* figures in 'Benediction' as Ruskin's ideal pictorial representation of blessedness. His description is charged with an intensity and felicity that seem to arise from his deepest experience. For Ruskin had begun to see in the legend of St Ursula, which he retold at length in *Forṣ*, parallels with the life of Rose La Touche; and in the exquisite, deathlike repose of the dreaming princess, whose hair and eyes and lips he drew on countless studies, he saw mirrored the type of beauty that most touched him in Rose. A few months before Rose died, feverish and insane, Ruskin sketched her in profile, head down-tilted, eyes almost closed as if in sleep or death. He caught the same serenely still, self-reflective expression in his sketches of Carpaccio's dreaming princess and in his remarkable watercolour of Jacopo della Quercia's tomb of the young Ilaria di Caretto, whose head rests lightly on a marble pillow as she lies in a sleep too deep for life and too self-possessed for death.[16] Ruskin's description of Ursula's sunlit bedroom, her clothing, her features, is quite

literally a labour of love, a protracted exegetical ecstasy in which not a tuft of fabric or tone of flesh is left without commentary. In the unbending line of her body and bed-clothes Ruskin sees a prefiguration of her grave:

> The young girl lies straight, bending neither at waist nor knee, the sheet rising and falling over her in a narrow un-broken wave, like the shape of the coverlid of the last sleep, when the turf scarcely rises. She is some seventeen or eighteen years old, her head is turned towards us on the pillow, the cheek resting on her hand, as if she were thinking, yet utterly calm in sleep, and almost colourless.

An angel enters Ursula's room bearing a martyr's palm in his right hand and in his left, a shroud. He is the Angel of Death, and as Ruskin describes him, coming into the room without haste, his small body casting a shadow as if he were mortal, we realize that Ursula has dreamed him into being, foreseeing as she sleeps her own martyrdom and marriage to Christ, who is to be her only spouse. A month after writing 'Benediction' Ruskin saw Rose on the estate of mutual friends. 'His last words to me were a blessing', she wrote:

> I felt too dumb with pain to answer him When we see 'face to face' in that Kingdom where love will be perfected and yet there will be no marrying or giving in marriage we shall understand one another. Meantime God cannot have meant nothing but pain to grow out of the strange link of love that still unites us.[17]

Among its many public and private meanings, 'Benediction' is a veiled tribute to Rose, a tribute darkened by forebodings of her death. Soon after she died Ruskin wrote in *Fors* that Carpaccio's 'lesson' in the St Ursula series is that no bride-groom on earth rejoices over his bride 'as they rejoice who marry not, nor are given in marriage, but are as the angels of God, in Heaven' (28.746). Ruskin here alludes to the same verse in Matthew that Rose had echoed in refusing him.[18] And the very last letter of *Fors* is a thinly disguised requiem for Rose, opening and closing with her name.

Ruskin's image of the sleeping Rose-Ursula comes at the mid-point of 'Benediction', the still centre of the letter

where the princess 'dreams . . . with blessed eyes that need no earthly dawn'. Her bedroom is portrayed as a tomb, a marriage-chamber, a shrine. The scene abruptly shifts to another enclosed space, this time not a paradise but a comic inferno, as Ruskin leaves Venice and Carpaccio's painting for an afternoon's train-ride to Verona. The two miserable American girls with whom he shares a closed carriage in stony silence are emblems of purest mortality. Travelling with the comfort and wealth of the modern world at their command, passing through an exquisite landscape of vine-clad hills, undeceived by any 'superstition' and undegraded by any constraints, they are in Ruskin's appalled eyes parodic incarnations of the biblical texts that underlie the letter: 'accursed' limbs once whole but now palsied and lame, unblessed eyes that cannot 'see the things that ye see', tongues grown sullen and dumb. The sleeping Ursula is portrayed in regal control over her sacred life; Ruskin's hyperactive carriage-mates writhe in an indolent dance of death. The stigma of their mortality clings to them as do 'the flies and the dust', and like the novels they tear apart page by page, they seem themselves to be in some slow process of decomposition:

> By infinite self-indulgence, they had reduced themselves simply to two pieces of white putty that could feel pain. The flies and the dust stuck to them as to clay, and they perceived, between Venice and Verona, nothing but the flies and the dust. They pulled down the blinds the moment they entered the carriage, and then sprawled, and writhed, and tossed among the cushions of it, in vain contest, during the whole fifty miles, with every miserable sensation of bodily affliction that could make time intolerable. They were dressed in thin white frocks, coming vaguely open at the backs as they stretched or wriggled; they had French novels, lemons, and lumps of sugar, to beguile their state with; the novels hanging together by the ends of string that had once stitched them, or adhering at the corners in densely bruised dog's-ears, out of which the girls, wetting their fingers, occasionally extricated a gluey leaf. From time to time they cut a lemon open, ground a lump of sugar backwards and forwards over it till every fibre was in a treacly pulp; then sucked the pulp, and gnawed the white skin into leathery

strings for the sake of its bitter. Only one sentence was exchanged in the fifty miles, on the subject of things outside the carriage (the Alps being once visible from a station where they had drawn up the blinds).

'Don't those snow-caps make you cool?'

'No – I wish they did.'

And so they went their way, with sealed eyes and tormented limbs, their numbered miles of pain.

There are the two states for you, in clearest opposition; Blessed, and Accursed.

One final image of accursedness remains – the smashing of the marble cross atop Santa Maria della Spina – and with that annihilating act Ruskin closes 'Benediction'. For over six centuries, he writes, the chapel had stood on the banks of the Arno, housing a relic from the crown of thorns and receiving the prayers of sailors as they headed for the open sea. Ruskin was drawing the cross for his Slade lectures at Oxford when he saw 'the workman's ashamed face, as he struck the old marble cross to pieces. Stolidly and languidly he dealt the blows, – down-looking.' The face of the fig-boy was sad but 'open and sweet' – half-fallen and half-graced – but the stonemason's face is wholly unredeemed, except for its marks of shame, and the consequences of his work are wholly irremediable.

The dehumanizing effect of work in the modern world is one of Ruskin's great themes in *Fors*, and two of his chief aims in founding the St George's Guild were to end industry's assault upon the environment, natural and urban, and to make work fulfilling rather than crippling for the individual labourer. The pain Ruskin conveys at the destruction of the chapel is not an antiquarian's regret over the loss of a landmark but outrage at the profitability of labour that, under the guise of public works, is intrinsically brutalizing and destructive of the human past. The many strands of 'Benediction' all draw together in these closing sentences: the startling curse upon the eyes and limbs in the previous section has now been twice embodied in the action of the letter, first in 'the sealed eyes and tormented limbs' of the writhing girls and finally in the downcast eyes of the guilty stonemason, his 'pair of human arms out of employ' because 'now in 1872' the world rows by steam (a reference back to the *Capo d'Istria*), digs by steam, and worships steam.

Like Paul in concluding his Epistles, Ruskin ends Letter 20 with a benediction. The complimentary close – 'Believe me, faithfully yours' – is at once conventionally valedictory and distinctly liturgical in tone. We can take the redoubled close as an elegant variation on *sincerely yours*; or we can find ourselves compelled by the force of the immediately preceding words to hear the Pauline plea for belief in *believe me* and for faith in *faithfully yours*. Of Ruskin's many voices in 'Benediction' – preacher, social critic, elegist, exegete, art critic, diarist, tourist, Master of St George's Guild – none carries more authority than the voice that blesses us at the very end. The child who began his ministry with 'People, be good' here speaks in the name of his heavenly Father; and it is the mark of Ruskin's greatness that he *can* so speak and still strike us as triumphantly sane:

A costly kind of stone-breaking, this, for Italian parishes to set paupers on! Are there not rocks enough of Apennine, think you, they could break down instead? For truly, the God of their Fathers, and of their land, would rather see them mar His own work, than his children's.
<div align="center">Believe me, faithfully yours,</div>
<div align="right">JOHN RUSKIN</div>

NOTES

1 Ruskin first drew Santa Maria della Spina, with the Arno in the background, in 1840 (4. plate 4). The close-up drawing used as the frontispiece of Letter 20 is of the eastern end of the chapel and was made from a daguerreotype he took in 1845. In the Library Edition Cook and Wedderburn shift the drawing to the end of the letter, where it faces Ruskin's description of the destruction of the chapel. They also delete, perhaps distressed by what they took to be hyperbole, Ruskin's dramatic 'Now in Ruins'. The chapel survives, or rather in its stead now stands a meticulous but chilling replica of the early-thirteenth- and fourteenth-century church Ruskin saw knocked to pieces, stone by stone, in 1872. Centuries of neglect, followed by severe flooding, led to the 'restoration' of the chapel, along with raising it three feet and shifting it from its ancient position overhanging the buttressed banks of the Arno. Letter 20 records Ruskin's appalled witness to the early stages of this reconstruction, with its needless destruction of many of the old stones (38.274). In reading the letter we should

recall that Ruskin was an early advocate of architectural *preser-vation*, arguing that 'restoration' was a lie often more devastating, because more subtle in its obliteration of the past, than outright destruction. Two years after the reconstruction of Santa Maria della Spina he wrote to Sir Gilbert Scott, President of the Royal Institute of Architects, declining the award of its Gold Medal. While Europe's architectural heritage was being devastated, as at Pisa, through neglect and ruinous restoration, he wrote, we must not 'play at adjudging medals to each other' (34.514). Today the visitor to Pisa reads in the guides of this 'gem of Pisan-Gothic architecture' and is given no clue – other than the strange lifeless-ness of the chapel itself – that he is gazing at a late nineteenth-century replica.

2 'I don't *anger* my soul,' he wrote to a reader of *Fors*, 'I relieve it, by all violent language I *live* in chronic fury . . . only to be at all relieved in its bad fits by studied expression' (37.371).

3 All citations of Letter 20 are from the Library Edition (27.334-51).

4 The letters were originally issued without titles until Letter 90 of July 1882. The title 'Benediction' was first affixed to Letter 20 in the third edition of November 1883 (27.xci-xcvi; 29.423).

5 The striking phrase is Cardinal Manning's (see 36.lxxxvi).

6 See Letter 5 (27.95-7). For a fuller discussion of the Guild's aims and its limited success, see my *The Darkening Glass* (New York, Columbia University Press, and London, Routledge & Kegan Paul 1961), pp. 188, 195-9.

7 Ruskin so narrates the event that the reader's perception of it exactly mirrors the successive stages of Ruskin's own experience. Hence, while still stationed at the window in the first sentence, Ruskin cannot see, nor does he permit the reader to realize, that the boy is selling figs. Rather he describes only the figure of a boy 'selling something black' from a basket; only when on the quay in the second sentence can he (or we) distinctly hear the cry of 'Fighiaie' or clearly see the half-rotten figs. Similarly, the syn-tactically acrobatic account of the boy bending and rising as he cries 'Fighiaie' mimics the action it describes.

8 Paul Sawyer uses the phrase to characterize the confessional elements of *Fors* through which Ruskin 'records a private quest for a lost Eden, a "Paradise within",' and contrasts it to the related but more public myth of St George, through which Ruskin seeks the spiritual rescue and rebirth of England. See 'Ruskin and St. George: The Dragon-Killing Myth in *Fors Clavigera*', *Victorian Studies*, 23 (Autumn 1979), pp. 7, 15. Sawyer's essay is one of the very few important studies of *Fors*.

9 The thumbing gesture of 'giving the figs' would of course have been familiar to Ruskin from the streets of Italy and from Dante, whom he explicates throughout *Fors*. The fig-gesture serves Dante as a supremely shocking instance of blasphemy at the start of

John D. Rosenberg

Canto XXV of the *Inferno*, where Vanni Fucci directs it at God
Himself. For Ruskin's insistent invective against the obscene
shoutings and gesturings he had witnessed in the streets of Venice
and Florence, see *The Darkening Glass*, pp. 181-5.

10 At the end of the paragraph Ruskin appends this footnote: ' "And
the stars of heaven fell unto the earth, even as a fig-tree casteth her
untimely figs, when she is shaken of a mighty wind." – Rev. vi. 13;
compare Jerem. xxiv. 8, and Amos viii. 1 and 2.' The reader who
wishes to follow further this intricate maze of allusion might also
look at Jeremiah 24: 3; Micah 4: 4; and Letter 74 of *Fors Clavi-
gera*, in which Ruskin discusses the fig-passage in Letter 20 and
cites ancient Venetian laws prohibiting the sale of imperfect or
unripe fruit.

11 (28.207). The force of this excerpt cannot be appreciated apart
from its context in 'Advent Collect', one of the most moving
letters in all of *Fors*. The autograph manuscript, owned by the
Pierpont Morgan Library (MA 2285), has relatively few revisions
and is written in a rapid, even hand, as are the other draft letters
of *Fors* for 1874 bound in the same notebook. One is astonished
that under such stress Ruskin could compose with such apparent
ease.

12 P. Sawyer, 'Ruskin and St. George', op. cit., p. 9. Throughout *Fors*
Ruskin's angry indictments of the modern world are very much in
the ancient tradition of the 'invective-threats' or curses of the Old
Testament prophets.

13 Luke 10: 23; Isaiah 35: 6.

14 Jay Fellows has brilliantly analysed such sentences as well as
Ruskin's use of parentheses in *The Failing Distance* (Baltimore,
The Johns Hopkins University Press 1975). See 'The Syntax of
Consciousness: Broken Sentences', pp. 99-126.

15 The regular reader of *Fors* would be unlikely to miss the symbo-
lism. The Venetian Arsenal figures very prominently in the June
1872 issue of *Fors*, published only a few weeks before 'Benediction'.
In a long passage of analysis Ruskin translates Canto XXI of the
Inferno, with its hideously graphic description of sinners plunged
into a lake of pitch that boils 'as, in the Venetian Arsenal, the pitch
boils in the winter time' (27.313). Scarcely a phrase in the *Capo
d'Istria* paragraph is without similar allusive force. For example,
the fiercely-smoking English warship is a kind of iron-clad Levia-
than clearly akin to the flaming monster in Job 41: 19-21. I am
indebted to Thomas Southwick for pointing out the monstrous
kinship.

16 One of Ruskin's copies of the *Dream of St Ursula* is reproduced
in 27. plate 8, and faces his analysis of the painting in 'Benediction'.
In Letters 72 and 72 of *Fors* he transcribes at length the legend of
St Ursula and further analyses Carpaccio's painting. For the profile
sketch of Rose and the drawing of the head of Ilaria di Caretto,

140

see 35. plate C, and 23. plate 19. The family resemblance among Ruskin's 'sleeping beauties' is striking. For the importance he attached to Jacopo della Quercia's tomb of Ilaria di Caretto in his aesthetic development, see 35.347, 349, and 4.122, 347. For a fuller account of his association of Rose with St Ursula, see Derrick Leon, *Ruskin: The Great Victorian* (London, Routledge & Kegan Paul 1949), pp. 507-10, and *The Darkening Glass*, op. cit., pp. 204-6.

17 Leon, op. cit., p. 496.

18 'For in the resurrection they neither marry, nor are given in marriage, but are as the angels of God in heaven' (Matthew 22:30).

9

Ruskin and the Science of *Proserpina*

Dinah Birch

I take . . . Wordsworth's single line,
 'We live by admiration, hope, and love,'
for my literal guide, in all education. My final object,
with every child born on St. George's estate, will be to
teach it what to admire, what to hope for, and what to
love: but how far do you suppose the steps necessary to
such an ultimate aim are immediately consistent with what
Messrs. Huxley and Co. call 'Secular education'? (28.255)[1]

This question appeared in *Fors Clavigera* in February 1875.
Ruskin was about to publish the first part of a study of
botany which was to provide a far-reaching and bitter answer.
Proserpina (1875-86) shares in an inclusive scheme of edu-
cation designed to demonstrate that the truth of Wordsworth's
axiom is unchanged by the claims of progressive science. The
work is aggressively idiosyncratic. Yet Ruskin did not include
controversy among his aims in *Proserpina*. Like *Love's
Meinie* (1873-81) and *Deucalion* (1875-83), *Proserpina* was
first intended to be a grammar, based on unquestioned
precepts, the simplest tool of the teacher. Ruskin wrote of
the three works in 1876: 'In especial, I have set myself to
write three grammars – of geology, botany, and zoology, –
which will contain nothing but indisputable facts in those
three branches of proper human learning; and which, if I
live a little longer, will embrace as many facts as any ordinary
schoolboy or schoolgirl needs to be taught' (28.647). The
emphasis on fact is characteristic, and misleading. Ruskin's
studies of botany, ornithology, and geology were meant for
textbooks, but have more to do with the principles of a

moral vision than with the practice of observational science. Art, history, and mythology have equal place with measured scientific data. A priestly philosophy subverts the accepted methods of empirical research, for Ruskin constantly repudiates the 'vile industries and vicious curiosities of modern science' (25.56). He believed that materialism had mortally degraded a discipline which had become little more than the inquisitive rapacity of self-interest. The enduring value of Ruskin's rival venture into scientific writing lies in its dissent.

Ruskin's botanical book voices his anger more directly than the works on ornithology or geology. Though these texts are each part of a larger educational plan, they differ in scope and origin. The study of birds in *Love's Meinie* did not advance far beyond the three lectures which were its point of departure.[2] *Deucalion* is weightier. But *Proserpina* is the most adventurous of Ruskin's attempts to provide an alternative definition of science, and the most interesting. *Deucalion* acknowledges a closer relation to conventional methods of study. In part, this was because Ruskin knew far more about geology than floral botany. He had studied rocks with intermittent enthusiasm since his earliest years. John James Ruskin said of his son: 'From Boyhood he has been an artist, but he has been a geologist from Infancy' (26.xxvi). In his introduction to *Deucalion*, Ruskin wrote that it had been 'the summit of my earthly ambition' to become President of the Geological Society (26.97). No doubt this is hyperbole, a wry memory of the eager aspiration with which he had become a Fellow of the Society in 1840. Yet Ruskin's contributions to the science were substantial. The geological chapters of *Modern Painters* had an extensive audience, and he added to his reputation as a geologist with an impressively technical series of articles published in the *Geological Magazine* in the 1860s.[3] Ruskin frankly admitted that no such accumulation of learning lies behind *Proserpina*. He describes his work on flowers as 'being merely tentative, much to be modified by future students, and therefore quite different from that of *Deucalion*, which is authoritative as far as it reaches, and will stand out like a quartz dyke, as the sandy speculations of modern gossiping geologists get washed away' (25.413). Ruskin saw *Proserpina* as a work of exploration. For this reason, it is a more personal book than *Deucalion*.

Like *Modern Painters*, in which it has its source, *Proserpina* is conceived on a large, open-ended scale. It refers to the perception of the natural world as it is transformed by the pressure of the imagination, and its disparity with traditionally objective science is therefore ineradicable. *Proserpina* is not concerned with investigative natural history. This is perhaps why Ruskin saw firmer prospects for his relatively orthodox 'life of stones'. As he wrote to Charles Eliot Norton in 1875, '*Proserpina* is liked, and *Deucalion*, which will have all my geology swept up in it, is liking to myself' (37.170). *Proserpina* has not lost its first appeal. It is a generous work, for in carrying his cardinal argument to a troubled conclusion Ruskin was not afraid to risk failure. His book on botany is pre-eminent among his final acts of defiance.

Ruskin's interest in plants was almost as longstanding as his love of rocks, though his study was less comprehensive. His curiosity was first inspired by the Alpine tours of his early twenties, when it showed itself in drawings rather than botanical notes. Thirty years later Ruskin looked back on the origins of his botany, recalling how he had begun 'by making a careful drawing of wood-sorrel at Chamouni; and bitterly sorry I am, now, that the work was interrupted. For I drew, then, very delicately; and should have made a pretty book if I could have got peace' (25.204). When he first came to project a botanical book in the 1850s, it was in terms of colour that the plants were to be classified.[4] Flowers were not, however, predominant in Ruskin's early view of botany. The science of plants had been important in the fifth volume of *Modern Painters* (1860), but references to flowers are surprisingly rare. Ruskin explained why they have no real interest for the artist. Flowers have 'no sublimity' (7.119). 'They fall forgotten from the great workmen's and soldiers' hands. Such men will take, in thankfulness, crowns of leaves, or crowns of thorns – not crowns of flowers' (7.120). Ruskin's feelings on this question changed. When, in 1866, he once more took up the idea of a work on botany, his design was for a book on flowers. It was to be based on his study of Alpine botany, and was largely intended for children. In *Time and Tide* (1867), he noted that he was writing 'a book on botany just now, for young people, chiefly on wild flowers' (17.413).

The idea grew slowly. Discussions of flowers begin to appear in other works of this period, notably in *The Ethics*

of the Dust (1866) and *The Queen of the Air* (1869). Soon after *The Queen of the Air* was published, Ruskin wrote to Charles Eliot Norton of his plans. They included the immediate publication of a work on botany, to be called '*Cora Nivalis* 'Snowy Proserpine': an introduction for young people to the study of Alpine and Arctic wild flowers' (36.597). Cora, or Proserpina, was in Greek mythology the daughter of the goddess Demeter. She was captured by Hades while gathering flowers in Sicily, and became his consort in the underworld.[5] Ruskin's allusion to her in the proposed title of his book brings together the Northern scenes which had first prompted his examination of plants with the study of mythology that had absorbed him in the 1860s. Part of the characteristic energy of the work derives from this unexpected convergence.

Ruskin was appointed Slade Professor at Oxford in 1869, and his new duties may have delayed the book. The first part did not appear until 1875. It was entitled *Proserpina: Studies of Wayside Flowers, while the air was yet pure among the Alps, and in the Scotland and England which my Father knew.* The 'Alpine and Arctic' setting now included more familiar scenes; but Proserpina retained her jurisdiction over the work. The elegiac strain in this title is characteristic of the goddess. Her association with flowers was inseparable from her rule over the spirits of the dead. Ruskin's father had died in 1864, and Ruskin never ceased to mourn him. The book is in part a tribute to John James Ruskin, and a lament for the lost security of the family. But the myth of Proserpina had acquired a meaning still closer to Ruskin's emotions. He saw Proserpina as an image of Rose La Touche.[6] The course of his hapless love for the Irish girl had a pervasive effect on his botanical studies. When he began serious work on a book of botany in 1866, his life was dominated by his love for Rose. In the spring of that year he wrote to Burne-Jones: 'I'll come on Monday and then be steady, I hope, to every other day – Proserpine permitting. Did you see the gleam of sunshine yesterday afternoon? If you had only seen her in it, bareheaded, between *my* laurels and *my* primrose bank!' (36.504). Ruskin had long known of Proserpina's affinity for flowers. He was also conscious of the myth's reference to death. In 1861 botanical work undertaken for the final volume of *Modern Painters* had led to a lecture on 'Tree Twigs' at the Royal Institution. He spoke there of the Greek feeling for flowers:

That of the Greeks is set forth by the fable of the Rape of Proserpine. The Greeks had no goddess Flora correspondent to the Flora of the Romans. The Greek Flora is Persephone, the 'bringer of death', because they saw that the force and use of the flower was only in its death. For a few hours Proserpine plays in the Sicilian fields; but, snatched away by Pluto, her destiny is accomplished in the Shades, and she is crowned in the grave. (7.474)[7]

Rose La Touche died on 25 May 1875. Unaware that she was dead, Ruskin was studying the blossom of the hawthorn on that day. His grief became inextricably linked with his work on flowers.

A few months later, an account of the hawthorn blossom appeared in *Proserpina*. The passage bears the date of Rose's death; Ruskin's description of the flower describes Rose:

White, – yes, in a high degree; and pure, totally; but not at all dazzling in the white, nor pure in an insultingly rivalless manner, as snow would be; yet pure somehow, certainly; and white, absolutely, in spite of what might be thought failure, – imperfection – nay, even distress and loss in it. For every little rose of it has a green darkness in the centre – not even a pretty green; but a faded, yellowish, glutinous, unaccomplished green, and round that, all over the surface of the blossom, whose shell-like petals are themselves deep sunk, with grey shadows in the hollows of them – all above this already subdued brightness, are strewn the dark points of the dead stamens – manifest more and more, the longer one looks, as a kind of grey sand, sprinkled without sparing over what looked at first unspotted light. And in all the ways of it the lovely thing is more like the spring frock of some prudent little maid of fourteen, than a flower. (25.301)

Rose had become part of a world of spiritual guidance. She took many forms – not only that of Proserpina, but also of the medieval Saint Ursula, of the Greek heroine Ariadne, and of Dante's Beatrice. In 1880, Ruskin wrote in *Fors Clavigera*:

I myself am in the habit of thinking of the Greek Perse-
phone, the Latin Proserpina, and the Gothic St. Ursula, as
of the same living spirit; and so far regulating my conduct
by that idea as to dedicate my book on Botany to Proser-
pina; and to think, when I want to write anything pretty
about flowers, how St. Ursula would like it said. (29.385)

Among this company of ruling spirits stands the attendant
shade of Rose La Touche. Like Proserpina herself, Rose
represents both the ominous power of death and the inno-
cence of maidenhood. *Proserpina,* the book, combines the
two aspects of her nature. The consequent emphasis on the
virgin purity of flowers cannot be disregarded. Ruskin
declared that their sexual function was to form no part of
his study. 'You are fond of cherries, perhaps; and think that
the use of cherry blossom is to produce cherries. Not at all.
The use of cherries is to produce cherry blossom; just as the
use of bulbs is to produce hyacinths, – not of hyacinths to
produce bulbs' (25.250). Investigations of the reproductive
purpose of flowers were among what Ruskin termed the 'vile
curiosities' of modern science.

I observe, among the speculations of modern science,
several, lately, not uningenious, and highly industrious, on
the subject of the relation of colour in flowers, to insects –
to selective development, etc., etc. There *are* such relations,
of course. So also, the blush of a girl, when she first
perceives the faltering in her lover's step as he draws near,
is related essentially to the existing state of her stomach;
and to the state of it through all the years of her previous
existence. Nevertheless, neither love, chastity, nor blushing,
are merely exponents of digestion.
All these materialisms, in their unclean stupidity, are
essentially the work of human bats. (25.263)

This is the innocent Proserpina, and here Ruskin alludes to
the image of Rose's girlhood. Though he intended that all
three of his works on natural history should be used in
schools, his potential audience of children is much more in
his mind in *Proserpina* than in *Love's Meinie* or *Deucalion.*
This too may trouble the modern reader. The later parts of
Proserpina occasionally lapse into the language of the nursery.
Ruskin describes the flower of the thyme: ' – the whole

147

blossom being something like a dress provided at a fairy almshouse for slightly hump-backed old fairies, fond of gossip' (25.515). It is not reassuring to find that the shape of Ruskin's new system for the classification of flowers is decided with reference to children, taking a form which 'by simple lips, can be pleasantly said, or sung' (25.313). But simplicity may not, after all, be appropriate only to children. Ruskin's assumption of a child-like audience has a serious purpose: 'For indeed we are all of us yet but schoolboys, clumsily using alike our lips and brains; and with all our mastery of instruments and patience of attention, but few have reached, and those dimly, the first level of science, – wonder' (25.318).

Reverence, rather than speculation, is the proper response of the natural scientist. 'For the first instinct of the stem, – unnamed by us yet – unthought of, – the instinct of seeking light, as of the root to seek darkness, – what words can enough speak the wonder of it!' (25.318). Ruskin's scientific method inclines to devotion rather than analysis. The primary experience of wonder leads to the realization of spiritual government in the physical world. This was not a new concept in his work. Botanical exempla had previously illustrated the theme. In *The Queen of the Air*, he had used the image of the flower as a special manifestation of the life of the plant. 'The Spirit in the plant – that is to say, its power of gathering dead matter out of the wreck round it, and shaping it into its own chosen shape, – is of course strongest at the moment of its flowering, for it then not only gathers, but forms, with the greatest energy' (19.357). This power is here identified with Athena, in her function as 'the vital force in material organism' (19.351). Now named as Proserpina, the same spirit rules the flowers Ruskin describes in his book of botany. There is an element of dread in the wonder that her presence inspires. Her influence is not always benevolent: 'I am amazed and saddened, more than I care to say, by finding how much that is abominable may be discovered by an ill-taught curiosity, in the purest things that earth is allowed to produce for us' (25.391).

Horror, not timidity, led Ruskin to argue that the natural scientist should turn away from some of the secrets that flowers concealed. The classification of flowers in *Proserpina* rests on three basic divisions, whose family names have respectively masculine, feminine, and neuter forms. The

148

masculine form, ending in '-us', indicates qualities such as 'strength', 'dominant majesty', or 'stubbornness and enduring force' (25.344). The feminine form is reserved for more gentle associations, for 'no name terminating in "a" will be attached to a plant that is neither good nor pretty' (25.345). The names ending in '-um' have a heavier meaning: 'The neuter names terminating in "um" will always indicate some power either of active or suggestive evil (Conium, Solanum, Satyrium), or a relation, more or less definite, to death; but this relation to death may sometimes be noble, or pathetic, – "which today is, and tomorrow is cast into the oven," – Lilium' (25.345).[8] The 'dark kingdom of Kora' (25.481) claimed an unremitting tribute of awe, and of sorrow.

In his first detailed study of a particular flower, the poppy, Ruskin emphasizes the dual aspect of Proserpina. He explains that he had chosen the poppy to begin with 'on account of its simplicity of form and splendour of colour' (25.277). A deeper reason lies in the role of the flower in literature and mythology. The poppy is the special flower of Demeter, mother of Proserpina, for it grows in the corn over which Demeter rules. In its narcotic, sleep-inducing qualities it is connected with Proserpina herself. Ruskin found autobiographical meaning in the characteristics of the flower. He had first mentioned the poppy in *Proserpina*'s chapter on 'The Flower'. Remarking on its tendency to shed its protective calyx quickly, he noted that 'It is the finished picture of impatient and luxury-loving youth, – at first too severely restrained, then casting all restraint away – yet retaining to the end of life unseemly and illiberal signs of its once compelled submission to laws which were only pain, – not instruction' (25.260). In describing the conditions which afflict the flower in its youth, Ruskin also pictures what he had come to see as the cramped conditions of his own upbringing. The passage dates from the period of the irregular monthly account of his childhood in *Fors Clavigera*.[9] In the summer of 1875, immediately after Rose's death, Ruskin made a more extended study of the poppy. The terms of conventional botany are rejected. It is not enough to note with Sowerby's *Botany* that the petals of 'Papaver Rhoeas', the common wild poppy, are of 'bright scarlet'.[10] Ruskin points out that in describing them as 'robed in the purple of Caesars' he has fixed the moral quality of their colour; 'that the splendour

of it is proud, - almost insolently so' (25.267). For the
poppy is not an entirely innocent flower, any more than
Proserpina is an entirely innocent goddess.

Its beauty exists in alliance with hostile powers in nature.
In connection with the poppy, Ruskin asks his readers to
remember 'the cause of Proserpine's eternal captivity - her
having tasted a pomegranate seed, - the pomegranate being in
Greek mythology what the apple is in the Mosaic legend; and,
in the whole worship of Demeter, associated with the poppy
by a multitude of ideas which are not definitely expressed,
but can only be gathered out of Greek art and literature, as
we learn their symbolism' (25.277-8). Ruskin explores the
importance of the poppy-head, and other decorative forms
associated with it, in a 'vast range of art', suggesting that
these forms had predominated at the expense of 'flowers of
luxury' (25.279).

> And that the deeply underlying reason of this is in the
> relation of weeds to corn, or of the adverse powers of
> nature to the beneficent ones, expressed for us readers of
> the Jewish scriptures, centrally in the verse, 'thorns also,
> and thistles, shall it bring forth to thee; and thou shalt
> eat the herbs of the field' ($\chi\bar{o}\rho\tau o\varsigma$, grass or corn), and
> exquisitely symbolized throughout the fields of Europe by
> the presence of the purple 'corn-flag', or gladiolus, and
> 'corn-rose' (Gerarde's [sic] name for Papaver Rhoeas),
> in the midst of carelessly tended corn. (25.279)[11]

The 'adverse powers of nature' were not merely a figure of
speech for Ruskin. He demands a directly moral interpretation
of plants:

> Of which things you will find it good to consider also
> otherwise than botanically. For all these lower organisms
> suffer and perish, or are gladdened and flourish, under
> conditions which are in utter precision symbolical, and in
> utter fidelity representative, of the conditions which
> induce adversity and prosperity in the kingdoms of men:
> and the Eternal Demeter, - Mother, and Judge, -- brings
> forth, as the herb yielding seed, so also the thorn and the
> thistle, not to herself, but *to thee.* (25.294)

That Ruskin should express his sense of ethical meaning in

the physical world with reference to art, mythology, and the Bible is part of the design of *Proserpina.* The brief allusion to Gerard is also characteristic. John Gerard's *The Herball, or Generall Historie of Plantes* (1597) is, like Sowerby's *Botany,* an authority of the old-fashioned kind that Ruskin prefers to use in his work. Such texts suggest the persistent tradition of the gentleman amateur naturalist. Ruskin had no sympathy with the new professionalism in the study of natural science which had grown up since, as a boy, he had noted geological formations in the Alps and measured the blue of the sky with his home-made cyanometer.[12] He wrote of his distrust of the modern scientist's dependence on sophisticated instruments in *Deucalion:*

> And still, with increasingly evil results to all of us, the separation is every day widening between the man of science and the artist – in that, whether painter, sculptor, or musician, the latter is pre-eminently a person who sees with his Eyes, hears with his Ears, and labours with his Body, as God constructed them; and who, in using instruments, limits himself to those which convey or communicate his human power, while he rejects all that increase it. (26.116)

Ruskin usually excludes reference to botanists whose first instrument was the microscope. Citations of modern texts are therefore rare, and almost always to minor works. John Lindley's *Ladies' Botany* (1834-7), for instance, makes an occasional appearance in the pages of *Proserpina.* 'For without at all looking upon ladies as inferior beings, I dimly hope what Dr. Lindley considers likely to be intelligible to *them,* may also be clear to their very humble servant', Ruskin remarked (25.272). Despite the heavy humour here, his attack on the modern concept of scientific authority is seriously intended. A late chapter, 'Science in her Cells', published in 1885, recommends the purchase of Louis Figuier's *Histoire des Plantes* (1865):

> The botanists, indeed, tell me proudly, 'Figuier is no authority'. But who wants authority? Is there nothing known yet about plants, then, which can be taught to a boy or girl, without referring them to an 'authority'?
> I, for my own part, care only to gather what Figuier

can teach concerning things visible, to any boy or girl,
who live within reach of a bramble hedge, or hawthorn
thicket, and can find authority enough for what they
are told, in the sticks of them.

If only *he* would, or could, tell us clearly that much;
but like other doctors, though with better meaning than
most, he has learned mainly to look at things with a
microscope, – rarely with his eyes. (25.483-4)

Ruskin considered that authorities in the natural sciences
revealed their deficiencies particularly in the naming of
species. Names could only be permanent if they confessed
the immutable truths to which contemporary scientists
seemed blind. Ruskin accordingly arranged new systems of
nomenclature for birds and, more extensively, for plants.
Before the first part of *Proserpina* was published, he wrote to
Daniel Oliver, keeper of the herbarium and library at Kew.
Oliver must have been taken aback by his assertion that
'Modern botanical nomenclature is *absolutely* ephemeral. It
cannot last above ten years more – it is entirely unscholarly
– and it is founded on imperfect knowledge, hastily and com-
petitively fitted with names. It is in many ways disgusting
and cannot be translated to girls. In my Oxford schools I
introduce a terminology which is classical: graceful as far as
I can make it so, and founded on eternal facts.'[13]

Ruskin constantly saw 'eternal facts' as the substance of
his natural history. It is for this reason more than any other
that his most biting contumely was reserved for the work of
Charles Darwin. The idea of incessant flux in Darwin's
research on evolution was incompatible with Ruskin's para-
mount belief that the physical world expressed moral and
spiritual precepts that were irreducible and utterly unchanging.
He wrote in *Deucalion* that myths are

incomparably *truer* than the Darwinian – or, I will add,
any other conceivable materialistic theory – because they
are the instinctive products of the natural human mind,
conscious of certain facts relating to its fate and peace;
and as unerring in that instinct as all other living creatures
are in the discovery of what is necessary for their life:
while the materialistic theories have been from the
beginning products . . . of the '*half* wits of impertinent
multitudes'. (26.336)

Insisting that the term 'half-witted' should be taken literally, Ruskin explains that 'imaginative power' constitutes the missing half of Darwin's capacity (26.336). Competition and progress had obscured the perception that wisdom lies outside the scope of any single intelligence. Ruskin's arrogance rested on a belief in humility. He hoped to instil the scientific study of the world with a sense of the imaginative truths embodied in its culture. Only the imagination could distinguish between good and evil, health and disease, jealousy and love. Such distinctions were the foundation of art and mythology. It therefore seemed to Ruskin in no sense eccentric to urge that they should also become the basis of science. He defined his ruling principles in a late chapter on the 'Veronica', asking his readers

> whether the system be more rational, or in any human sense more scientific, which puts calceolaria and speedwell together, – and foxglove and euphrasy; and runs them on one side into the mints, and on the other into the nightshades; – naming them, meanwhile, some from diseases, some from vermin, some from blockheads, and the rest anyhow: – or the method I am pleading for, which teaches us, watchful of their seasonable return and chosen abiding places, to associate in our memory the flowers which truly resemble, or fondly companion, or, in time kept by the signs of Heaven, succeed, each other; and to name them in some historical connection with the loveliest fancies and most helpful faiths of the ancestral world – Proserpina be judge. (25.436)

Proserpina was never completed. It had become much more than the grammar Ruskin had first proposed. The new scheme of botanical nomenclature eventually came to confuse even its author. It is part of the nature of the work that it should be unfinished, for Ruskin was not interested in the limitation of suggestion. It may well have been the book's private meaning, never far from his mind, that eventually brought it to a close. Notes intended for a chapter on the cyclamen show how the mythology of flowers expressed personal distress. The chapter had been intended to demonstrate that the essential nature of the cyclamen lay in its circular habits of growth. In the fifth volume of *Modern*

Painters Ruskin had emphasized the importance of the spiral in the development of all plants. He saw in the cyclamen a link with Demeter, who ruled over the cycles of the seasons. The connection is supported by 'the subterranean stem, stooping flower, and buried, or at least hidden, front', all of which seemed to him to give 'ample reason for the dedication' (25.542). These were not the only reasons. 'There is a farther, though more subtle one, in its dark purple colour, which the Greeks always associated with death' (25.542). The legends of Demeter were interwoven with those of her daughter. The association with death could not but recall the loss of Ruskin's Proserpina, Rose La Touche. He had intended the main substance of the treatise to consist of an analysis of the 'mythic meaning of spirals – of the wheel of Fortune, and nine spheres of fate, which I hope the reader laments the loss of', and had planned to relate this study to the 'evil circles' in Aristophanes' *Frogs*.[14] The plan was not fulfilled. He noted that 'this only it is worth saying still, that the running round of the Dogs (Furies) in Aristophanes certainly means the tormenting recurrence of painful thoughts in a circle from which there is no escape' (25.542).

This was written in 1886. Little productive time remained to Ruskin. Yet he came to rediscover a more serene meaning in the mythology of plants. In 1888, only months before his work ended, the cyclamen was again in his thoughts. On his last journey to the Continent, he saw it growing on the rocks of Champagnole.

I write these lines (1st Sept., 1888) at my old home
of Champagnole, where but the day before yesterday I
had a walk in the pine wood, and on rocks glowing with
deep purple cyclamen above the glen of the Ain, which
might well have been in the Earthly Paradise after Christ's
Kingdom shall be come. And in the actual sound of
forests, and the murmur or whisper of the spring winds
through budding branches and setting blossoms, there is
a true Eolian song, addressed partly to the ear, but more
to the heart and to the true and creative imagination.
The fable of Apollo and Daphne, chief of those founded
on the humanity of trees, and the resultant acceptance
of the laurel crown as the purest reward of moral and
intellectual power used nobly in the service of man, has
yet a deeper symbolism in its expression of the true love

which may be felt, if we are taught by the Muses, for the beautiful earth-bound creatures that cherish and survive our own fleeting lives. (35.641)

NOTES

1 Ruskin is quoting *The Excursion*, iv, 763.

2 *Love's Meinie*, based on a series of lectures that Ruskin gave in Oxford in 1873, is by far the slightest of the three works. Lectures on the robin and the swallow formed the first two parts of the book. A further lecture, on the chough, was prepared and set in type. Then the work came to a standstill. Ruskin lamented in 1875 that his plans for *Love's Meinie* 'merely torment me in other work with the thousand things flitting in my mind, like sea-birds for which there are no sands to settle upon' (28.460). A rather prolix lecture on the dabchicks was published in 1881. But Ruskin had lost his heart for ornithology. He gave a final lecture on 'Birds, and how to paint them' at Oxford in 1884. It was reported in the *Pall Mall Gazette*: 'And I have actually been unable, from the mere distress and disgust of what I had to read of bird-slaughter, to go on with *Love's Meinie*' (33.528). Whether or not this was the reason for Ruskin's discouragement, nothing further was added to the book.

3 'Notes on the Shape and Structure of Some Parts of the Alps, with Reference to Denudation' appeared in the *Geological Magazine* for February and May 1865. 'On Banded and Brecciated Concretions' followed in seven parts, the first published in August 1867 and the last in January 1870. Ruskin also contributed to the *Geologist*, which published an abstract of his Royal Institution lecture 'On the Forms of the Stratified Alps of Savoy' in July 1863. Ruskin always felt that his geological work lacked due recognition. In 1884, he remarked bitterly to the Mineralogical Society, to which he also belonged, that 'though an old member of the Geological Society, my geological observations have always been as completely ignored by that Society, as my remarks on Political Economy by the Directors of the Bank of England' (26.373). Belatedly, the Geological Society publicly recognized Ruskin's work in a complimentary obituary by the President which appeared in the *Quarterly Journal of the Geological Society* for May 1900.

4 Ruskin wrote to Lady Trevelyan in 1853: 'I have not given up my idea of a Botanical-reference-book founded on colours' (*RLPT*53). Colour continued to be important in his classification of plants. He spoke of the 'twelve great families of cinquefoiled flowers, of which the first group of three is for the most part golden, the second, blue, the third, purple, and the fourth, red' (25.313).

5 For an invaluable account of the origins and early development of the myth of Persephone, see Günther Zuntz, *Persephone: Three*

Essays on Religion and Thought in Magna Graecia (London, Oxford University Press 1971).

6 Ruskin claimed to spell Proserpina to himself without the initial 'P' and the second 'r', leaving *Rosepina*. See *The Brantwood Diary of John Ruskin*, (ed.) H.G. Viljoen (New Haven and London, Yale University Press 1971), p. 110; also *LMT* 235.

7 Report from the *London Review*, 27 April 1861. The idea reappears in *The Queen of the Air* (1869): 'Proserpine plays in the fields of Sicily, and thence is torn away into darkness, and becomes the Queen of Fate – not merely of death, but of the darkness which closes over and ends, not beauty only, but sin' (19.304). Ruskin was not the only Victorian for whom the strange myth of Proserpina held a special fascination. For Swinburne, Proserpina was the supreme representative of the pagan ideal. His *Poems and Ballads* (1866) included 'The Garden of Proserpina', 'At Eleusis', and the notorious 'Hymn to Proserpina' – a poem which was important to Ruskin. In September 1866 Ruskin wrote to Edward Coleridge: 'I've got the original MS of the Hymn to Proserpine, and wouldn't part with it for much more than leaf gold', *The Swinburne Letters*, (ed.) C.Y. Lang, 6 vols (New Haven and London, Yale University Press and Oxford University Press 1959-62), I: 184. Rossetti began his brooding portrait of Jane Morris as Proserpine holding the pomegranate in 1872, and worked on successive versions of the picture until his death ten years later. Pater's evocative essay on 'The Myth of Demeter and Persephone' was published in 1876. Tennyson's 'Demeter and Persephone', which appeared in 1889, gave a Christian interpretation curiously at odds with the sombre tone of the myth.

8 Matthew 6: 30.

9 This account, the germ of *Praeterita*, had begun in October 1871. The last part appeared in May 1876 (27.167-71, 517-18, 617; 28.101-2, 170-1, 271-5, 296-8, 316-19, 343-53, 385-91, 546-9, 602-5).

10 The petals are so described in the third edition of Sowerby's great *English Botany*, (ed.) J.T.B. Syme, 12 vols (London, 1863-86) I: 88. The first edition, which Ruskin thought 'far the best' (25.441n.), pictures the flower more graphically: 'Petals large, broad, crumpled, of a deep vivid scarlet, and with a rich silky gloss.' J.E. Sowerby, *English Botany*, 36 vols (London, 1790-1814) IX: 645.

11 Ruskin quotes Genesis 3: 18.

12 A cyanometer is a device for measuring blueness in the sky or sea. Ruskin recalls shading his cyanometer with cobalt in *Praeterita* (35.152).

13 The Ruskin Galleries, Bembridge School, Isle of Wight (BEM MS T 30). The letter is dated 19 January 1875. Ruskin refers here to his drawing schools at Oxford, for he made little mention of botany in his lectures as Slade Professor.

14 Aristophanes, *Frogs*, 472.

156

10

A Stone of Ruskin's Venice

David-Everett Blythe

There is in Venice a sacramental stone I identify with Ruskin's name both for having been discovered by him in his tour of 1877, and for bearing a text which affirmed the heart of his teaching. This inscription by a Gothic stonecutter is found on the north gable of what is legendarily the oldest church[1] and centrepoint of the Venetian islands,[2] the San Giacomo di Rialto. Here, cut cruciform into Istrian limestone, are 'the first words', said Ruskin, 'that Venice ever speaks aloud' (33.442):

SIT CRUX VERA SALUS HUIC TUA CHRISTE LOCO,

And below the cross the supporting band continues:

HOC CIRCA TEMPLUM SIT IUS MERCANTIBUS AEQUUM
PONDERA NEC VERGANT NEC SIT CONVENTIO PRAVA.
(21.269)

For the renowned prosperity achieved by the later Venetian state, thus was revealed a seminal edict (30.312) having principal likeness to Ruskin's own economic thought. This correlation I propose to trace through his critical interpretation of *The Merchant of Venice* where the morality of a Venetian and Ruskinian commerce is exemplified much as if this drama were a parable of Gothic political economy. For Ruskin accounted the influence of Shakespeare 'as part of the great reality and infinity of the world itself, and its gradually unfolding history and law' (35.366). Of main interest was such 'law' as concerns commercial exchange: in

157

Munera Pulveris Ruskin declared that the 'ultimate lesson
which [Shakespeare] . . . meant to tell us in the tale of the
Merchant of Venice' is that 'all is lost' when commerce
hardens the heart (17.222-3). This is the truth of the San
Giacomo Stone.

Cook and Wedderburn first mention Ruskin's stone in his
letter from Venice of 7 March 1877:

> I've had a strange piece of good fortune to begin with,
> in discovering, on the Church of San Giacomo di Rialto
> (the first built in Venice, but supposed to have been
> entirely destroyed and rebuilt), an inscription of the ninth
> century which nobody knew of. It stared them in the face,
> if they looked up, under the church gable; but they never
> did, and the best antiquary in Venice, the Prefect Samedo
> of St. Mark's Library, accepted from me to-day, in amaze-
> ment, a photograph, clear in every letter, of the Merchants
> of Venice motto in the ninth century! - which not an
> historian of the literally hundreds who have written of
> Venice ever read. (24.xli)

The actual day of discovery, however, was first made
public by the Evans-Whitehouse *Diaries* for the entry 14
February 1877: 'Found out lovely Rialto inscription . . .
yesterday' (*D*3.937). Two months later appeared the first
published allusion to Ruskin's simmering thought on the
matter: 'I am now collating for you the Mother Laws of the
Trades of Venice' (29.86), and in the appended 'Notes and
Correspondence' for that *Fors Clavigera* he takes this Latin
maxim as a validation of those principles set forth in *Unto
this last, Time and Tide,* and *Munera Pulveris*:

> And now here has Fors reserved a strange piece of . . .
> good fortune for me; namely . . . to declare again in its
> full breadth the great command against usury, and to
> explain the intent of Shakespeare throughout the
> *Merchant of Venice* . . . , it should also have been reserved
> for me to discover the first recorded words of Venice
> herself, . . . on her first church, St. James of the Rialto;
> . . . When the church was restored in the sixteenth century,
> the inscription, no more to be obeyed, was yet . . . in
> reverence for the old writing, put on the gable at the back,
> where, . . . nobody noticed it any more till I came on it,

poking about in search of the picturesque And this is
the inscription on a St. George Cross, with a narrow band
of marble beneath – marble so good that the fine edges of
the letters might have been cut yesterday.

On the cross –

'Be thy Cross oh Christ, the true safety of this place . . .

On the band beneath it –

'Around this temple, let the merchant's law be just – his
weights true, and his agreements guileless.'

Those, so please you, are the first words of Venice to
the mercantile world. (29.98-9)

Of the concepts suggested by the stone, the moral bond
between marketplace and church is of special Ruskinian
meaning, for the spiritual invocation of the cross and the
economic decree of the band have an ideological kinship
corresponding to the physical adjacency of San Giacomo and
Ponte di Rialto 'where merchants most do congregate'.[3] The
twin ideals thus proclaimed may be likened to that union of
civil and religious law extolled in *The Stones of Venice* which
had 'no other aim', said Ruskin, 'than to show that the
Gothic architecture of Venice had arisen out of, and indicated
in all its features, a state of pure national faith, and of
domestic virtue; and that its Renaissance architecture had
arisen out of, and in all its features indicated, a state of
concealed national infidelity, and of domestic corruption'
(18.443). To the San Giacomo principle, the terms 'national'
and 'domestic' (or 'public' and 'private') are complementary,
and for Ruskin, it is these relationships which 'explain the
intent of' *The Merchant of Venice* whose kind merchant,
Antonio, acts publicly and religiously, and whose money-
lender, Shylock, acts privately and for temporal gain.

Just as 'Gothic' and 'Renaissance', 'public' and 'private',
'national' and 'domestic', are benchmarks in Ruskin's greater
view of Venetian history, they may also delimit the political-
economic poles of Shakespeare's play, for Ruskin saw the fall
of the Venetian state as a change 'from her days of religion
and gold ducats' (public, Gothic, Antonio) to 'her days of
infidelity, and paper notes' (24.232) (private, Renaissance,
Shylock). And since this ducat was itself of such golden
purity as to be, in Ruskin's words, 'a confession of faith
made universal' (9.31), it is a feature of commercial morality
linked with Shakespeare's credit theme discussed below. On

the basis of Ruskin's analysis these elements, taken together, may be simplified into schematic form: (a) pure faith and pure gold (mercantilism) marks the rise of Venice; (b) corrupt faith and paper credit (usury) marks her fall.

Here, then, is an instance of the acknowledged principle that a purity of coinage indicates economic condition: in general, gold signifies stability while paper currency is the usual exponent of a faltering commercial system (17.200). From Ruskin's point of view, the physical form of the money-document depends, like architecture, on social morality. This premise may be financially related to Gresham's Law (bad money drives out good), a phenomenon which involves more than debasement (or 'inflation') of money because the theorem logically includes all labour and all goods for which money is a documented claim and on whose 'non-violation' (according to Ruskin) 'all national soundness of commerce and peace of life depend' (19.404).

This crucial organic function of money as a 'title-deed' should be distinguished from the mechanical function of money as a so-called medium of exchange (17.487). To signify this relation between objects and the certificate for their claim, Ruskin elsewhere defines money as 'an order for goods' (29.554), an office also denoted by a near-contemporary of Shakespeare, Dr Thomas Wilson, who calls money 'a measure and a beame betwixte man and man'.[4] In so far, therefore, as goods and labour hold value commensurate with the integrity of their representative coinage, the implicit force of Gresham's Law accords with Ruskin's equation drawn above, but in his terms the scheme should thus appear: bad architecture (Renaissance) corrupts good architecture (Gothic), paper money drives out gold, and infidelity corrupts faith. In a wider universal sense this phenomenon is told in the proverb cited by Ruskin, *corruptio optima pessima* (the worst is corruption of the best) (17.222) whose moral and economic effect in *The Merchant of Venice* is manifest in the corruption of trade by moneylending and the premeditated destruction of Antonio by Shylock, counter-positions at even greater variance when Ruskin's Gothic political economy is compared to that of modern theorists.

Ruskin defined political economy as being no 'science; but a system of conduct and legislature, founded on the sciences, directing the arts, and impossible, except under certain conditions of moral culture' (17.147). Against this essentially

Platonic and Christian standpoint the 'pseudo-science' of political economy postulates a predatory 'economic man, from whom the social affections were eliminated' (17.lxxxiii) and is 'based on the idea that an advantageous code of social action may be determined irrespectively of the influence of social affection' (17.25). The emergent Renaisance mode, in other words, tends to establish a 'maximum inequality' between men (17.46) and sets personal competition against public co-operation. This antithesis is central to Ruskin's teaching and appears in a passage of *Modern Painters* which anticipates what his political economy would become:

> The highest and first law of the universe – and the other name of life is, therefore, 'help.' The other name of death is 'separation.' Government and co-operation are in all things and eternally, the laws of life. Anarchy and competition, eternally, and in all things, the laws of death. (7.207)

In Venetian terms, personal competition displaced government (co-operation) and established the competing private over the public good, an economic 'renaissance' whose causes and effects are the accessory phenomena to Ruskin's thesis of architectural decadence. This change began with the infiltration into Venice of the usurious contract which the 'nec sit conventio prava' of the Rialto stone implicitly forbad.

By challenging the equitable regulation of the non-usurious standard, the merchants of Augsburg started the practice of usury in Venice on their mart, or 'Fondaco'. Against them the merchants of Venice, in league with the compassionate order of Franciscans, founded the *Monte di Pieta* (Bank of Charity) (23.162-3) to lend without interest to those distressed. Now Antonio is a merchant of this kind, one who, in Shylock's scorn, 'lent money for a Christian curtsey' (3.1.45), while Shylock and Tubal, by syndicating their capital,[5] may suggest the joint-stock type of German merchants. Through Shylock's flint-hearted (4.1.31; 4.1.79) opposition to Antonio's compassionate heart, Shakespeare dramatizes the medieval controversy of enmity (usury) versus charity (mercy).[6] This key antagonism[7] Ruskin develops in *Ariadne Florentina*:

You perhaps have heard before of one Antonio, a

merchant of Venice, who persistently retained the then
obsolete practice of lending money gratis, and of the peril
it brought him into with the usurers. But you perhaps did
not before know why it was the flesh, or heart of flesh,
in him that they so hated. (22.439)

Shylock's usury-enmity, Ruskin elsewhere explains, has its
'symbolism literally carried out by being aimed straight at
the heart, and finally foiled by a literal appeal to the great
moral law that flesh and blood cannot be weighed' (17.223):

> The quality of mercy is not strained,
> It droppeth as the gentle rain from heaven
> Upon the place beneath. (4.1.181-3)

It is with special reference to unconstrainable mercy and
unweighable flesh that the abstraction – 'usury' – should be
considered together with its ancient life-negating associations.
In *Fors Clavigera* Ruskin defines usury as 'the taking of
money for the loan or use of anything (over and above what
pays for wear and tear), such use involving *no care or labour
on the part of the lender*. It includes all investments of
capital whatsoever, returning "dividends," as distinguished
from labour wages, or profits' (26.669). The distinction I
italicize is developed in Shakespeare between Antonio's
mercantile 'ventures' and Shylock's 'bond' which involves
on his part neither effort nor risk but is none the less a
certified pre-assurance of gain at the borrower's certified and
pre-assured loss. The operation of this kind of bond (or bank
loan) presumes, in effect, that in any given monetary system
the money-document itself has a generative virtue by dint
of the chimerical co-efficient, 'rate of interest', a computation
Dr Wilson condemns as 'against the nature of things, because
it is impossible by the order and course of nature that once
one should be twice one'.[8] Aristotle's objection to what is
effectually an arbitrary scaling of money's deed power
through usury is based on just this sort of inorganic genera-
tion,[9] which is the classical figure underlying Antonio's
challenge to Shylock, 'for when did friendship take / A breed
for barren metal of his friend' (1.3.130). Here 'barren metal'
suggests the documentary function of money whose title-
deed essence cannot legitimately vary. Through usury (*usura,
utor*, to use) Shylock *uses* money, not as a token of right, but

as a variable commodity, for in practice he uses money to use men as his material and his capital means. Without himself adding to the labour or goods represented he therefore effectually counterfeits the power of the document, the commercial result of which deception is much the same as if he had circulated bogus ducats representing neither effort nor thing.

In thus supposing furthermore that principal capital has in itself a capacity to accrue through 'interest', usury presupposes a currency greater than the per centum a formal revenue (or minting) system is calibrated to secure.[10] For even though goods and labour obviously vary, variation alters purchasing power only. The distinction between usury and true industry may be seen in Shylock's account of Jacob's sheep-breeding where is imaged an actual rather than a documentary *pecunia* (1.3.73-87).[11] But Antonio's challenge, 'is your gold and silver ewes and rams?' (1.3.93) divides the money-function (gold) from the thing gold documents (sheep), and is based on a fundamental difference Shylock cannot see: 'I cannot tell', he says, 'I make it breed as fast' (1.3.93). But in his reasoned objection to Shylock's personal interpretation of the Jacob story, Antonio is also separating the use of money (usury) from personal industry: Jacob's increase of Laban's flock accordingly, 'was a venture . . . served for' (1.3.88). And even though Jacob's increase was not a deception of nature,[12] – 'A thing not in his power to bring to pass, / But swayed and fashioned by the hand of heaven' (1.3.89-90) – it was nevertheless a deception of Laban. This 'thrift' the self-righteous Shylock concludes to be 'a blessing if men steal it not' (1.3.87). Yet Jacob and Shylock are both thieves differing only in technical class: Jacob by deception in real objects, Shylock by deception in symbolic ones.

In making money thus 'breed' fast as sheep, Shylock is not multiplying natural things (like lambs) but is multiplying a 'rate of interest' by an impossible calculus which inevitably debases the document standard and leads to general social debasement otherwise. In greater historical view, therefore, rising interest rates signify national declines, just as lower rates – perhaps the nearest non-usurious condition generally achievable[13] – signify a truly flourishing (uninflated) commerce.[14] Ruskin's scheme showing paper credit's ruination of the long-inviolable Venetian ducat standard arraigns usury,

then, as an inherently fraudulent and destructive contractual phenomenon which the San Giacomo stone outlawed and against which Shakespeare directed the entire moral thrust of his play.

It may now be seen what occupational opposites the principals are: Antonio is a 'royal merchant' (3.2.243) in Venetian sea-trade and a free-lender of money besides, while Shylock, in selling the documentary power of money,[15] defrauds both individuals and commonwealth. It is commonly believed that such a practice 'furthers' trade when in reality the usurer is simply taxing it (29.573). In an unregulated and demoralized Venice, therefore, Shylock's 'tribe' (1.3.54) gains financial domination similar in principle to the instituted force of modern banking groups. For according to Ruskin's definition of usury, the anonymous banker taxes all monies by gathering from one source to lend usuriously to another, just as the corporate stockholder 'lends' the workman his tools, and the landlord 'lends' (rents) shelter or (leases) farmland:

> all gain, increase, interest, or whatever else you call it or think it, to the lender of capital, is loss, decrease, and dis-interest to the borrower of capital. Every farthing we, who lend the tool, make, the borrower of the tool loses. And all the idiotical calculations of what money comes to, in so many years, simply ignore the debit side of the book, on which the Labourer's Deficit is precisely equal to the Capitalist's Efficit. (28.674)

The true Ruskinian profit which is derivable only from personal industry opposes this false profit whose single most insidious form is the 'national debt' through which the nameless corporate usurer, by financing the government, taxes the labouring classes to perpetuity (28.428, 640).

As contradistinguished from the usurer's, the merchant's ideal role is defined by Ruskin as providing for the commonwealth (17.40), a patriotism for which Venetian merchant princes, at their highest, furnish in action as well as in charter perhaps the noblest examples.[16] It is in this context Shylock is 'an alien' (4.1.346) among Venetians, for by following Ruskin's application of the Venetian Mother-Law to *The Merchant of Venice*, the active presence on the quay of the Hebrew moneylending organization presages a faltering society and a commerce verging on disintegration. Against

Rialto standards of just law, true weights, and fair contracts, Shylock, in typifying an unyielding conglomerate usury, insinuates among the islands that infidelity and paper credit which in Ruskin's view undermined Gothic Venice.

In his operation, however, the moneylender requires the two essential matrix elements of innocence and prodigality as provided by Antonio and Bassanio. The entrapment of an insolvent young nobleman (like Bassanio) by a dissimulating moneylender is a social archetype:[17] the sheer availability of borrowable monies is the initial lure for a 'loan' commonly notarized under a pretext to friendship much like Shylock's 'merry bond' (1.3.170). By the contract thus made, the usurer 'drives out' his debtor even after the impetus seen in Gresham's Law, a course Portia can intercept only by disarming Shylock of his (apparent) legal power to destroy. For the Adriatic seaport, however, the *Monte di Pieta*, to which Portia and her 'Belmont' very generally compare, was but quaint intercession against 'this newly risen demon' (22.439), an advancing and sanctioned Renaissance usury. This phase of Venetian history Ruskin saw as 'the Franciscan institution of the Mount of Pity' failing 'before the lust of Lombardy and the logic of Augsburg' (23.161-2). The 'lust' he means is the love of money and the 'logic' is the banker's computation that twice two is six (24.232).

The element of Ruskin-like Christianity (or selflessness) comes to Shakespeare's Venice in Portia's 'Mercy' whose unrestrained quality, said Ruskin, is not *misericordia*, but *gratia* (17.224). Portia's mercy is gratuitous – free and loving, generous and unobliging – and it is this *gratis* nature which characterizes Antonio's lending to Bassanio in the merchant's *Monte di Pieta* role: 'I have oft delivered from his [Shylock's] forfeitures / Many that have at times made moan to me' (3.3.24-5). To this Christian-Venetian behaviour the usurer-alien expresses incredulity and with an inverted logic appears to deny mercy because Antonio had granted it: 'tell me not of mercy – / This is the fool that lent out money gratis' (3.3.1-2). The non sequitur is in keeping with Shylock's profession and character, for as one motivated exclusively for personal gain, he cannot see the fundamental synonymity of lending gratis and unrestrained mercy, and his egotistical (and unsyllogistic) reflex triggers another self-serving misconstruction as earlier seen in his interpretation of Jacob's sheep-breeding connivance.

165

In further effect, Antonio's free-lending checks the moral and economic 'inflation', as it may be called, of Shylock's usury, a feature giving Antonio's role additional positive mercantile significance. And it is by this Christian generosity the moneylender's enmity is most deeply goaded: 'I hate him for he is a Christian / But more for that in low simplicity / He lends out money gratis, and brings down / The rate of usance here with us in Venice' (1.3.38-42). As Shylock is dispositionally unreceptive to the interrelated ideals of free lending and mercy, so here he forces a distinction between 'low simplicity' and Christianity which in the play betoken kindness: 'The Hebrew will turn Christian – he grows kind' (1.3.176). When Shylock is sentenced, therefore, so far from being 'converted', the only significant stipulation inferrable is that he desist from usury. Finally, Antonio's free lending role is representative of what Ruskin calls the 'main condition' of 'the system of Venice' (28.143n.) through which benign agency the merchant is a compassionate interceptor with an enormous unseen effect: 'He hath . . . hindered me,' mulls the usurer, 'half a million' (3.1.50).

In terms similar to Portia's, the Duke of Venice also hopes for an awakening in Shylock of 'human gentleness', 'love', and 'commiseration' (4.1.25 and 30), sympathetic modes noticeably consonant with Ruskin's premise in the opening sentence of *Unto this last* where 'social affection' is the only true economic motive power (17.25). On the actual Rialto, however, such 'affection' is provided for within the mercantile justice ('ius mercantibus aequum') of right measure ('pondera nec vergant') and fair contracts ('nec sit conventio prava'), whose essence Ruskin explains as a 'perfect and accurate exchange' which diminishes 'the power of wealth, first in acquisition of luxury, and secondly, in exercise of moral influence' (17.70). Under true justice, therefore, selfish enterprise cannot predominate, nor could a merely private commerce hold sway in the greater epochs of the Venetian Republic when citizenry and seigniory co-operated for public good. Historians have as yet no example to show of such a city having been raised by a cadre of usurers.

Just as Shakespeare's flesh-bond is therefore a dramaturgical figure for the deliberated malice inherent to usury, so the contract is emblematic of all capitalistic engagements wherein one party positions for advantage over another, so as, in Shylock's phrase, to 'catch him once upon the hip'

(1.3.43). For it is solely on this presumption of advantage (28.516) that either moneylenders offer loans or brokers take pawns: this is the flesh-eating (27.xlvi) code which, in Marxian phrase, runs crimson with the blood of the indebted worker.[18] That such 'advantage' means taking for pawn the human heart is the subject-theme of the play, and, according to the parable, the opportunistic Shylock premeditates manslaughter and is thus reckoned by the sentencing Portia: 'Thou hast contrived against the very life / Of the defendant' (4.1.356-7).

That usurers thrive on their debtors' blood, and are in Portia's sense criminally monstrous, is reinforced by attributes Venetians give Shylock: 'bloody creditor', 'inhuman', 'keen and greedy', and 'wolvish' (among others) all partake of medieval *avaritia* lore as does the vicious and self-indicting 'I will feed fat the ancient grudge I bear him' (1.3.44) and 'I'll go in hate to feed upon / The prodigal Christian' (2.4.14-15). The tenor of this last, which Portia's climactic ruling is intended to counter, reflects the ancient similitude implicit (for example) in Cato's proverb: 'Ab hoc usuram exige, quem non sit crimen occidere.' (Exact usury of him whom it is not unlawful to kill.)[19] In view of the power the usurer legally assumes over his victim, such life-rending figures are less metaphorical than at first they seem, for, like *usura*, the older connotations got denotatively fixed, as in the Hebrew term for usury, *neshek*, 'cruel biting', the Greek *pleonasmos*, 'painful travailing', and the Latin *foenus*, 'unnatural brood',[20] each of which is relatable to Ruskin's definition of the sin of usury 'as of the same unnatural class as Cannibalism' (29.590). For 'the readist waye surely to undoe any man livynge,' says Wilson, is to 'byte him, yea and eate hym out with usurie'.[21] In these rather literal terms Shylock intends execution of his bond to the full Latin extent of *exaction* (*ex* + *agere*, to drive out) and *forfeiture* (*foris* + *facere*, to put out) (1.3.161) which, in so doing, the usurer 'taketh mens hartes (as I might saye) out of their bodies'.[22] When therefore Shylock's property is apportioned by the state, with what telling irony the usurer is made the improbable definer of usury for the occasion of the play – and beyond: 'you take my life, / When you take the means whereby I live' (4.1.372-3).

There remains to consider the Rialto creed in so far as a

topical counterpart may be said to exist in Antonio's
impersonal recognition of due Venetian process:

> The duke cannot deny the course of law:
> For the commodity that strangers have
> With us in Venice, if it be denied,
> Will much impeach the justice of the state,
> Since that the trade and profit of the city
> Consisteth of all nations. (3.3.26-31)

For the intent Ruskin saw in the Venetian inscription this
passage may be read as a kind of voucher in that lawful
'trade and profit' causally depend on 'the justice of the state'.
Antonio's reasoned espousal of the law is thus in contrast to
the characteristic personal insistence of his adversary's
interpretation of 'justice', as first described by Salerio: 'He
[Shylock] plies the duke at morning and at night, / And doth
impeach the freedom of the state, / If they deny him justice'
(3.2.278-80), and then by Shylock himself: 'I purpose . . . /
To have the due and forfeit of my bond. / If you deny it, let
the danger light / Upon your charter and your city's freedom!'
(4.1.35-9). Whereas Antonio regards the ideal of justice,
Shylock reduces law to the first person: 'The pound of flesh,
which I demand of him / Is dearly bought, 'tis mine, and I will
have it: /If you deny me, fie upon your law!' (4.1.99-101).[23]
 In further opposition to Antonio's impersonal civic view,
Shylock invokes 'freedom', not as political desideratum, but
as a kind of banker's laissez-faire to seek immeasurably more
than the recovery of his loan: he rejects Bassanio's 'ten times
o'er' (4.1.208) and Portia's 'thrice thy money' (4.1.224),
and Jessica declares her father 'would rather have Antonio's
flesh / Than twenty times the value of the sum' (3.2.287-8).
In that Shylock's usurious contract predicates the annihila-
tion of Antonio – 'for were he out of Venice I can make what
merchandise I will' (3.1.119-20) – Shakespeare ratifies the
classical precept that usury ultimately destroys life itself.
And nowhere is Shylock's municipal role as an economically
and morally alienated non-Venetian so apparent as in his
clamour for a freedom he would use to undermine the city's
founding Mother-Law. The sense of 'alien' (4.1.345) now
applies to Shylock in the same way the prejudicial Deutero-
nomic usury-sanction makes foreigners eligible victims:
'Unto a stranger thou mayest lend upon usury, but unto thy

brother thou shalt not lend upon usury' (Deuteronomy
23: 20). On one side Antonio is a free-lender to any man;
on the other, Shylock and Tubal are incorporated to lend
usuriously to Venetian Gentiles. This is but the racial
entrenchment of Ruskin's 'Competition or Evil Commerce'
(17.210) which 'makes all men strangers' (17.183n.).

By the terms of the Rialto maxim, then, and by Ruskin's
interpretation, no bona fide Venetian could lapse into
Shylock's idiom of legal hysteria as in 'I crave the law / The
penalty and forfeit of my bond' (4.1.203-5), or in the raving
fusion – 'Justice! the law! my ducats, and my daughter!'
(2.8.17). Of this exploitation it is instructive to notice that
elsewhere in Shakespeare an entrenched usury determines
law, which is the import of Lear's 'the usurer hangs the
cozener' (4.6.160).[24] That would be to say in modern
political economy, it is the financier who decides what is
legal, a more current expression of which status quo is given
by a German playwright whose cozening protagonist asks,
'what is robbing a bank compared to founding one?'[25]

In Shakespeare's Venice the divergencies of race and
economics are in the legal realm of claim on property.
Humanity has been debased to that numerical tie which in
spirit with Ruskin (and Marx) Carlyle epitomizes as the 'cash
nexus'.[26] For this arithmetical relation an express figurative
parallel is given when Bassanio rejects the silver casket, '[I
will none of thee thou pale and common drudge / 'Tween
man and man' (3.2.103-4) which image suggests the two
directions of a city-state racially and economically divided.

In the first place, ''Tween man and man' implies the
spiritual ghetto as men lose their human reason and become
to each other mercantile integers. This is Shylock's founda-
tional capitalism: 'I will buy with you, sell with you, . . . but
I will not eat with you, drink with you' (1.3.34-5). It is not
just that Shylock isolates himself from social affection: there
is no social disaffection so universally ill-meant as a hospitality
which courts the statistical but denies the essential spirit of
men. But the nature of the mammon-worshipping mind has
obvious bearing beyond Shylock's typically avaricious
personality: among Elizabethan tractarians, especially, the
pivotal idiom ''tween man & man' occurs with such frequency
as to express incredulity concerning the usury-nexus between
men, when heretofore lending had been understood,
according to Wilson, as a kind of *mutum*, 'that is to say, mine,

thine',[27] a mode exemplified by Antonio's offer to Bassanio: 'be assured / My purse, my person, my extremest means, / Lie all unlocked to your occasions' (1.1.137-9). The charity of *mu-tual* (or co-operative) good, however, is corrupted by a Shylockean self-assertion, for while 'interest' (L. *interesse*) implies 'going between', *mutuum* explains Antonio's free lending: *'ex meo tuum'* (from me to thee).[28] The apparent moral slant of these Roman terms may be compared to the pejorative *usura* and *foenus* already mentioned.

On the other side, 'drudge' answers the medieval type of lucre as the unclean separator between men, and, in the psychomachia of the Shylockean soul,[29] between a man's higher and lower natures. Shylock's homicidal-creditorial design, therefore, is spiritually self-destructive, just as in late Judaic prophecy the usurer is said to die in his own blood (Ezekiel 18: 13) while he who refrains from usury – in an idiom resounding in Shakespeare - 'executes true judgement between man and man' (Ezekiel 18: 8). Bassanio's rejection of the corruptible 'ornamental' power of gold and silver may be seen, then, as a rejection of the falseness, the enmity, and the injustice of usury, just as his choosing the lead may depend, I suggest, not only on its utility, but also, in a bye-sense, on its old connotations for plumbness (L. *plumbum*, lead).[30] As against 'gawdy gold' and 'pale drudge', therefore, lead is the agent ore for true weights ('nec pondera vergant') and the undebaseable reckoner of impartial measure. In thus winning Portia[31] by choosing justly, Bassanio judges true use (*utilitas*-utility) over false use (*usura*-usury) which decisive separation is sustained by another Shakespearean simile, 'like a usurer abound'st in all / And uses none in that true use indeed' (*Romeo and Juliet*, 3.3.123). In thus thoroughly penetrating false use and apprehending true, Bassanio anticipates Portia's law and recalls Antonio's thematic assessment of Shylock, 'O, what a goodly outside falsehood hath!' (1.3.99).

I have been tracing out Ruskin's economic analysis of the fall of Venice – her decline from religion and gold ducats to infidelity and paper credit - as relatable to Shakespeare's portrayal of that fall principally evident in the actions of Antonio and Shylock. The better-day Venice of faith and justice to which Ruskin's San Giacomo stone is a monument of unusual historical importance, and the better-day Venice of order and generosity recognized in Belmont, afford per-

spective by which to gauge the city's historical inner corruption. For Shakespeare and Ruskin, in essence, Venice became commercially demoralized when her Mother-Law of 'contracts fair' was violated, which subversion takes form in *The Merchant of Venice* as a contractualized personal enmity whereby men are merely ledgered as creditors or debtors. Ruskin's leading ideas of currency and conduct also illuminate Portia's ordered reinstatement of Venetian law, an ideal correction of the interrelated impurities of money and men.

With reference, finally, to the famed Rialto integrity, magnificent Venice, in her best Gothic aspect, immortalizes the essentially public enterprise of a merchant and princely society whose religious faith and commercial probity, in their force, were as indivisible as the Christian invocation and commercial decree it was the pride of Ruskin's life to have found (32.100). For in her commerce, in her civil rule, in her arts, and in her architecture, *Venezia* was of all Eurasia the common-wealth nonpareil. In the 'Epilogue' to *The Fall* (volume 3 of *The Stones of Venice*) Ruskin speaks of her history as written in her ruins and says how servants of his kind 'think upon her stones' (11.231). How naturally these words from Psalms carry meaning set apart for him who revealed on the white marbles of San Giacomo di Rialto this ideological light by which we also may learn to mourn the fallen and think upon those stones which remain as Venice:

Be thy Cross, oh Christ, the true safety of this place.
Around this temple, let the merchants law be just – his
weights true, and his agreements guileless.

NOTES

1 Thomas Okey cites Sanudo: ' "in the year cccxi, [the traditional date for the founding of Venice] . . . the first stone of St. Giacomo di Rivoalta was laid by the Paduans" ', *The Story of Venice*, 8th edn (London, Dent 1931), p. 6.
2 Horatio F. Brown, *Studies in the History of Venice*, 2 vols (New York, E.P. Dutton and London, J. Murray 1907), I: 41; and Peter Lauritzen, *Venice* (New York, Atheneum and London, Weidenfeld and Nicolson 1978), p. 18.
3 *The Merchant of Venice* (1.3.46), in *The Works of Shakespeare*, (ed.) John Dover Wilson (Cambridge University Press 1968). All

171

references are to this edition, citing Act, Scene and line as here.

4 Thomas Wilson, *A Discourse Upon Usury* (London, 1572) reprinted and edited with an introduction by R.H. Tawney (London, G. Bell and New York, Harcourt Brace 1925), p. 313. In Shakespeare's time 'usury', according to Tawney, 'after the land question, was the most burning social problem of the day', ibid., p. 2.

5 Shylock is nonchalant and ever-certain of backing: 'what of that? / Tubal a wealthy Hebrew of my tribe / Will furnish me' (1.3.53-5).

6 Wilson, *Usury*, op. cit., pp. 201, 301.

7 John W. Draper, in agreement with H.W. Farnam, *Shakespeare's Economics* (New Haven, Yale University Press 1931), pp. 4-5, describes this difference: 'Race and religion, then, are not the main themes of the play; it is rather conflicting economic ideals' - 'Usury in *The Merchant of Venice*', *Modern Philology*, 33 (August 1935): 39.

8 Wilson, *Usury*, op. cit., p. 377. John Blaxton calls the calculation 'devilish Arithmeticke', *The English Usurer or Usury Condemned* (London, 1634, reprinted Amsterdam, Theatrum Orbis Terrarum 1974), p. 48.

9 'The trade of the petty usurer . . . is hated most, and with most reason: it makes a profit from currency itself, instead of making it from the process . . . which currency was meant to serve. Currency came into existence merely as a means of exchange; usury tries to make it increase [as though it were an end in itself]. This is the reason why usury is called by the word we commonly use [the word *tokos*, which in Greek also means "breed" or "offspring"] ; Hence we can understand why, of all modes of acquisition, usury is the most unnatural', *The Politics of Aristotle*, (transl.) Ernest Barker (Oxford, The Clarendon Press 1948), I, x: 4-5.

10 'Of Money', in *David Hume, Writings on Economics*, (ed.) Eugene Rotwein (Madison, University of Wisconsin Press 1970).

11 *Pecunia* (money) from *pecus* (cattle).

12 In Dante usurers sin not against man only, but against nature, that is, the 'celestial mind': 'But in another path / The usurer walks; and Nature in herself / And in her follower thus he sets at nought, / Placing elsewhere his hope', *The Vision of Dante: Hell*, (transl.) Henry Francis Cary, 3rd edn (1844, reprinted London, Frederick Warne 1892), XII: 113-16. 'The usurer,' Cary explains, 'despises nature directly because he does not avail himself of her means', p. 55.

13 This condition Bacon seems to allow for: 'I say this only, that usury is a *concessum propter duritiem cordis*' - 'Of Usury', *The Works of Francis Bacon*, (ed.) J. Spedding, R. Ellis and D. Heath, 15 vols (Boston, Brown and Taggard 1860-4), XII: 218.

14 'Nothing is esteemed a more certain sign of the flourishing condition of any nation than the lowness of interest', Hume, 'Of Interest', *Writings on Economics*, op. cit., p. 47.

15 'Money was not devised,' said Dr Wilson, 'to bee marchaundize',

Usury, op. cit., p. 313 (cf Aristotle above).

16 Ugo Tucci, 'The Psychology of the Venetian Merchant in the Sixteenth Century', in *Renaissance Venice*, (ed.) J.R. Hale (London, Faber & Faber, and Totowa, New Jersey, Rowan and Littlefield 1973), p. 358.

17 Draper, 'Usury in *The Merchant of Venice*', op. cit., p. 44.

18 John Bowle, *Politics and Opinion in the Nineteenth Century* (London and New York, Oxford University Press 1964), p. 339. Also: capitalism is 'a vampire . . . "sucking the blood" of living labour; it has a "were-wolf's hunger for surplus value" ', p. 334.

19 Blaxton, *The English Usurer*, op. cit., p. 29.

20 J.B.C. Murray, *The History of Usury* (Philadelphia, J.B. Lippincott 1866), p. 50.

21 Wilson, *Usury*, op. cit., pp. 256-7.

22 Ibid., p. 288.

23 Marx calls money the 'I am' power, *Karl Marx: Early Texts*, (transl.) and (ed.) David McLellan (New York, Barnes and Noble and Oxford, Blackwell 1971), p. 180.

24 Cf. 'edicts for usury, to support usurers', *Coriolanus*, 1.1.81.

25 Bertolt Brecht, *The Threepenny Opera*, (transl.) Hugh MacDiarmid (1955, reprinted, London, Methuen 1973), 3.1.11.

26 Bowie, *Politics and Opinion*, op. cit., p. 316. Benjamin Nelson in *The Idea of Usury*, 2nd edn (Chicago, University of Chicago Press 1969), describes the post-medieval 'bifurcation of human relations into distinct spheres: one, the world of friendship and free service; the other, the world of commercial intercourse and the economic calculus', p. 65.

27 Wilson, *Usury*, op. cit., p. 276.

28 Blaxton, *The English Usurer*, op. cit., p. 6.

29 Disaffection universally characterizes the moneylending disposition, but Shylock's capacity for human love and his greed of lucre seem to contend in the selfish but not unloving reference to the lost ring of his wife: 'I had it of Leah' (3.1.114).

30 *V.* 'plummet: A criterion of rectitude or truth' (OED).

31 Ruskin calls Portia 'portion' (17.223).

11

Political Questing: Ruskin, Morris and Romance

Jeffrey L. Spear

> In the habitation of dragons, where each lay, shall be grass with reeds and rushes.
>
> Isaiah 35: 7

'Romance', William Morris declared, 'is the capacity for a true conception of history, a power of making the past part of the present.'[1] Morris's definition implies a break in cultural continuity that must be overcome by an effort of historical imagination, whether in creation, criticism or appreciation. Like Carlyle and Ruskin whose tradition he transforms, Morris not only associates the break between past and present with the Renaissance and neo-classical aesthetics, but with the rise of modern commercial society and industrial capitalism. Since Ruskin and Morris thought of art as ultimately social expression, there is a logical progression in their careers from a focus upon the history or the creation of art to its political economy; from the desire to renew art to the effort to redeem a society and a landscape ravaged by industrialiam.

Morris addressed his definition of romance to the Society for the Preservation of Ancient Buildings, urging its members not to 'be ashamed of saying with John Ruskin that any old building is worth the ground it stands upon' – all the more so if it is a 'monument of beauty and romance'.[2] Buildings, like texts, are truly brought into the present by being read. Consequently they must be preserved, not restored. As Ruskin argued in 'The Nature of Gothic', for Morris his central work:

174

the criticism of the building is to be conducted precisely
on the same principles as that of a book; and it must
depend upon the knowledge, feeling, and not a little on
the industry and perseverance of the reader. (10.269)

Ruskin applied his six defining characteristics of Gothic
architecture to both builders and buildings. Thus, the reading
of a Gothic cathedral brings the critic (and by extension his
readers) into contact with the thought, faith and imagination
of the people who planned, built and decorated it. By an act
of critical imagination akin to that of the historical novelist,
Ruskin conveys to his readers through the analysis of archi-
tecture, and the arts subordinate to it, the experience of
another time to be set against their own. By contrast, restor-
ation is not preservation but defacement: the work of a Tate
writing his *King Lear* over the only text of Shakespeare's.

Ruskin advocated preservation as the precondition to a
revivial of broken traditions in the arts. Morris devoted him-
self to the revival itself in 'the lesser arts' and in literature.
But 'making the past part of the present' remains an isolated,
individual, artistic achievement unless the conditions that led
to the initial breakdown can be overthrown. Thus the Gothic
Revivalism of Ruskin and Morris implies a contemporary
political struggle. 'The capacity for a true conception of
history' when translated into action brings not only Morris's
own definition of romance, but the theme and structure of
romance as a literary genre, into the political realm.

Although the societies they hoped to see established
were antithetical in social structure, both Ruskin and Morris
saw the future as the perfected form of a lost 'Gothic Eden'.[3]
The regaining of the earthly paradise, argues Northrop Frye,
lies at the heart of romance representing 'a final reconciliation
with nature as something to be attained after the human com-
munity has been reordered'.[4] As Ruskin lost his childhood
faith, and with it hope of individual salvation, his imagination
turned to the paradise man might recover:

How have we ravaged the garden instead of kept it - . . .
are those gates that keep the way indeed passable no
more? or is it not rather that we no more desire to enter?
For what can we conceive of that first Eden which we
might not win back, if we chose? (7.13)

When secularized and read into history, the polarized conflicts between good and evil, knight and dragon, white magic and black that made romance an apt vehicle for Christian allegory have revolutionary implications. They remain latent in Ruskin's battle with the dragon of Mammonism, but become explicit in Morris's communism. Morris's progression from poet-craftsman-designer to revolutionary was not the 'earthly paradox' it seemed to most contemporaries, nor a simple substitution of the politics of hope for the literature of despair. It was rather the final extension of his literary and artistic imagination; the logical outcome of his Ruskinian habit of reading the structure of romance into the progress of history.

Both their common medievalism and their disparate hopes for the future reflect biases Ruskin and Morris carried forward from a lost paradise of childhood. Ruskin's memory of Eden differs most markedly from that of Morris in that he recalls himself as the only inhabitant. Life in Ruskin's garden was at once luxurious and severe. He may have been 'summarily whipped if I cried, did not do as I was bid, or tumbled on the stairs' (35.21), but his mother's accounts of young John's extraordinary good behaviour suggest that he rarely cried, disobeyed or tumbled.[5] The elder Ruskins may have seemed 'visible powers of nature to me, no more loved than the sun and the moon' (35.44); but it was he who absorbed their love, pride, solicitude and ambition, finding perfect happiness in obedience to their laws. It was only after experience made manifest the incongruities between the outside world and that in which he had been raised; after failure in marriage and in love; after the protracted ebbing away of his childhood faith, and the attendant clashes with his parents, that the Herne Hill garden came to seem an Eden in which '*all* the fruit was forbidden; and there were no companionable beasts' (35.36).

Like so many only children Ruskin bolted down parental expectations whole. The exercises in piety that pleased his mother, and the verbal, artistic and literary precociousness that filled his father with pride, set the pattern for a lifetime of commentary. In the passage of the tenth *Fors* that became the opening of *Praeterita*, Ruskin traced his political stance to the paternal and literary inheritance of his childhood: 'I am, and my father was before me, a violent Tory of the old school (Walter Scott's school, that is to say, and Homer's)'

(27.167). It was Scott's power to reanimate the past, to make
it a felt reality, that led Ruskin to link him with Shakespeare
as the 'only two real historians (to my thinking) since
Herodotus' (24.432), and to find in his work as in Homer's
true models of selfless heroism.

Whereas at nine years of age Ruskin was expressing his
enthusiasm for the *Seven Champions of Christendom* by
writing St George and the Dragon into 'A Puppet Show' for
his father featuring carefully printed verses and illustrations,
William Morris, in his child's suit of armour, was riding a
flesh and blood pony through Epping Forest. The contrast
is emblematic both of the imaginative world they shared and
the different ways of acting out their dreams. Morris was a
first son, but unlike the overprotected Ruskin, a third child.
He grew up with the companionship first of older sisters,
then of younger brothers, establishing a pattern of relation-
ships that persisted for life. Morris remained dependent
upon the encouragement and sympathy of women while
becoming a leader of men. Morris was particularly close to his
oldest sister, Emma, with whom he seems to have had one of
those intense Victorian sibling relationships, the lack of
which Ruskin so bitterly regretted in reviewing his own
childhood.[6]

In the relatively unspoiled countryside around Woodford
Hall, his Walthamstow home, Morris combined his love of
landscape with his appetite for literature of and about the
past, restoring in imagination the surviving monuments of
medieval England and the people who created and used
them. He knew all of the Waverley novels by the age of seven
and, like Ruskin, continued to think of Scott as a great
historian of the spirit, if not the factual details, of the pre-
industrial past. He accepted the 'horse's head couped argent'
from the coat of arms with which his father gilded his new
fortune as his own emblem, considering himself 'in some sense
a tribesman of the White Horse'.[7] As an adult he made regular
pilgrimages to the great White Horse of the Berkshire Downs
where as a boy he used to imagine himself contemplating that
ancient monument from the perspective of the *fourteenth*
century. The argent head became the weathervane atop Red
House; 'the foothills of the White Horse' the setting of the
fourteenth-century village in *A Dream of John Ball*.

'The days when I was a little chap' that Morris recalled
with such pleasure ended with a series of losses. First came

the death of his father in 1847; followed in 1848 by removal to a 'boy farm', Marlborough School, cutting him off from the regular companionship of his sisters and brothers. Then, in 1850, Emma married and Morris 'felt deserted'.[8] Morris has left no direct record of how the loss of his father at the age of thirteen affected him. There is, however, no more striking contrast between the social ideals of Ruskin and Morris than Ruskin's insistence upon, and Morris's rejection of, paternal authority. The central value running through Morris's work is that of a universal fellowship abolishing all barriers of class and sex.

Whereas Morris was effectively cast out of his Eden, Ruskin's gradually faded into the light of common day. Its central element, the adoring yet dictatorial attention of his parents, remained in place long after the internal contradictions of his upbringing and its failure to prepare him for the outside world had become painfully manifest. Ruskin's attempt to continue his old life in a new form through marriage ended in private failure and public humiliation. He made gardens wherever he lived, but only briefly, in one of the rare moments of peace in his tortuous devotion to Rose La Touche, did one of them become 'Eden land'. The failure of his religious faith went hand in hand with the failures of his personal life leaving Ruskin without a centre of stability. However luxurious his mode of travel as he traced and retraced the steps of Byron, Turner and the young John Ruskin over the Alps and into Italy, Ruskin felt himself a perpetual outcast within sight and memory of the walls of lost Eden.

Ruskin found the social equivalent of his own sense of loss and internal division in the contrast between the organic feudal society of the Middle Ages and the mechanistic modern one - terms powerfully set by Carlyle to whom Ruskin increasingly turned as an intellectual and even emotional father in the 1850s and 60s. But Carlyle looked to the Middle Ages for a model of government, for faith expressed as social organization, whereas Ruskin focused upon the expression of faith through art. Carlyle's model medieval man was Abbot Samson; Ruskin's the Gothic artisan. Carlyle concentrated upon the fact rather than the nature of labour ('all work, even cotton spinning is noble; work alone is noble');[9] Ruskin was equally concerned with its quality. Unlike the medieval craftsman whose soul was expressed and preserved in Gothic carving

and glass, the modern workman has become a function of the machinery he serves. His soul is exhaled in factory smoke. To Ruskin, Adam Smith's vaunted division of labour is in truth a division of men 'so that all the little piece of intelligence that is left in a man is not enough to make a pin, or a nail, but exhausts itself in making the point of a pin or the head of a nail' (10.196).

It was to the contrast between Gothic and modern labour that Morris traced the central theme of his life's work:

> For the lesson which Ruskin here teaches us, is that art is the expression of man's pleasure in labour; ... that unless man's work once again becomes a pleasure to him, the token of which change will be that beauty is once again a natural and necessary accompaniment of productive labour, all but the worthless must toil in pain, and therefore live in pain.[10]

Until his 'unconversion' in 1858 Ruskin clung to a belief in personal salvation that could temper his outrage over the degradation of the modern workman. But once he admitted that he had become a pagan, the lives of the exploited poor eking out their existence with only an illusion to comfort them struck him as a moral outrage of unexampled dimension. Ruskin vowed to do all in his power to end this sacrifice to Mammon by attacking the economic rationale of the industrial order, its effects upon people and nature, and by advancing, piecemeal, his concept of a natural social order. The primary unit of that order is a household in which the mutual devotion of the chivalric knight and lady has become permanent through marriage.

Ruskin announced his crusade in symbolic fashion in the fifth volume of *Modern Painters*, the central theme of which, as Robert Hewison points out, is life against death.[11] The plain of battle is this earth and its issue is not salvation or damnation in an afterlife, but reclamation of the earthly paradise from what is rapidly becoming an earthly hell. The fortitude for such a battle Ruskin finds exemplified in the Knight of Dürer's *Knight and Death* who has passed the type of sin by, and is keeping his eyes fixed steadfastly ahead, though the pale horse of death has hooked his bridle, making its bell 'toll as a passing bell' (7.311). The traditional enemy of the knight of romance, the dragon, Ruskin locates

in Turner's *Garden of the Hesperides* associating it with the dragons of Genesis, Hesiod, and Dante through a form of secularized typology.[12] Through Turner Ruskin shows us the assumption of the Dragon of Mammonism, for Ruskin as for Carlyle the false religion of the latter-day.

> No St. George any more to be heard of; no more dragon-slaying possible: this child, born on St. George's Day, can only make manifest the dragon, not slay him, sea-serpent as he is; whom the English Andromeda, not fearing, takes for her lord. (7.408)

Resuming his childhood identification with St George, Ruskin devoted much of the rest of his public life to combating the dragon that his masters, Turner and Carlyle, could only make manifest, and instructing the English Andromeda (and her proper lord) on the literal interpretation of chivalric manners and Christian morals in the context of modern commercial society.[13]

While 'the Don Quixote of Denmark Hill', as he came, with some bitterness, to call himself, was launching the crusade that was eventually to succumb under the double strain of external conflicts and battles with dragons of lust and wrath within,[14] Morris was coming to grips with the failure of his own attempt to create a private version of his restored Eden. Unlike Ruskin, Morris managed to find and marry the physical embodiment of his female ideal; but nevertheless, the central failure of his life was, like Ruskin's, a failure in love. It was also a failure to transcend the barriers of class. If marrying 'beneath him' was for Morris a romantic defiance of family and convention, for Jane Burden, the groom's daughter, marrying a gentleman and living in his Palace of Art, Red House, must have been the romantic fulfilment of a more conventional dream.

It was during his shortlived attempt to be a painter that Morris wrote to Cormell Price that he could not enter into 'politico-social subjects' having 'no power or vocation to set them right in ever so little a degree. My work is the embodiment of dreams in one form or another.'[15] If we give 'embodiment' a double meaning, the representation of dreams on the one hand, and the realization of dreams on the other, Morris's remark can indeed define his life's work, for Morris came to dream a 'politico-social' dream.

The Morris without the power to set things straight became the 'dreamer of dreams, born out of my due time' who narrates the Apology of *The Earthly Paradise*. Although Morris invokes Chaucer as his model for the telling of a cycle of tales, his narrative posture is Ruskinian. He sets the modern Dark Age 'overhung with smoke' against a bright medieval London, 'small and white and clean', and organically integrated. The pen that wrote *The Canterbury Tales* here 'moves over bills of lading'.[16]

The deluded wanderers of Morris's frame story, deliberately distanced from their creator in time and space, and in hopeless flight from death, invite contrast with Chaucer's pilgrims so solidly on their way to Canterbury in the interests of salvation. 'There's', wrote Ruskin to Joan Agnew, 'such lovely, lovely misery in this Paradise. In fact, I think it's – the other place – made pretty . . . ' (37. 3) – and so it is. *The Earthly Paradise* was a multiform escape from the consequences of the fall from Red House, a relief from Morris's bafflement in love and the concomitant temptation to brood on death. As craft, however, this work of the night created largely in the hours between shop work and sleep was one with the revivals carried on more vigorously in Morris's daytime work – the creation and creations of the Firm. Morris revived the art of retelling traditional tales as popular narrative verse just as he revived in modern form traditions of glass design, tapestry and dyeing, 'making the past part of the present'.

With the failure of his attempt to design and inhabit an independent private world on the basis of his unearned income, having no faith in or yearning for a disembodied immortality, Morris found personal salvation in art-labour, the work of hand and mind together, as Ruskin had prophesied in 'The Nature of Gothic'. But just as Ruskin when deprived of his faith in immortality was forced to confront and combat the misery in which most people were condemned to pass their one life, so Morris had to believe that the work in which he took such pleasure had a positive social function if he was to enjoy it in good conscience. As a young man he had justified the changes in his proposed occupation from the church, to architecture, to painting, to design and craft in terms of benefit to others as well as his own pleasure. After reading *The Stones of Venice* Morris declared himself a pagan with none of the anguish the same self-designation caused

Ruskin. But while he rejected Christianity he retained its millennial promise in the form of hopes for art to be realized first through his firm, then through socialism.

In 'The Nature of Gothic' and its extension, the lectures of the 1850s on art and industrial design (*A Joy Forever* and *The Two Paths*), Ruskin subsumed all the decorative arts from painting and sculpture down to what Morris called 'the lesser arts' of stained glass, furniture, interior decoration, pottery, glassware, metal work, jewellery, even, implicitly, cloth and clothing under the broad category of architecture. In the Ruskinian historical schema adopted by Morris, Gothic architecture and the arts subsidiary to it were the organic expression of the faith, values, and talents of the European peoples. This cultural unity was broken in the Renaissance and further fragmented by industrialism producing decadent architecture, and manufacture destructive to both the environment and the human nature of the worker. To initiate the process of recovery Ruskin called upon consumers to demand only goods produced without degradation of the workman, and upon manufacturers and architects to reform taste as they supply it. In Ruskin's ideal workshop goods would be made by men doing various, easy and lasting work (16.36). The workers would, in the terms of *Unto this last*, be both making and becoming wealth; that is, happy, healthy, human beings. Ruskin's pleas to producers and consumers became the italicized slogans of Morris's lecture on 'The Beauty of Life' (1880): *'Art made by the people and for the people, a joy to the maker and the user'* and *'Have nothing in your houses which you do not know to be useful, or believe to be beautiful'* (XXII. 51ff).

Much of Ruskin's programme was realized by Morris & Co. Morris himself became the embodiment of the Ruskinian designer, the master of every craft for which he created patterns. In keeping with Ruskin's belief that 'the workman ought often to be thinking, and the thinker often to be working, and both should be gentlemen, in the best sense' (10.201), he tried to revive not only medieval crafts but medieval men, whole men. Like Ruskin he saw the power to design and create as the product of general culture expressed in traditional skills. He complained to the Royal Commission on Technical Instruction of the *'general ignorance'* of the London workmen he employed not just their lack of specific training.[17] In his particular work he found himself trying to

renew through conscious effort skills that had once been passed down from generation to generation and absorbed, in Morris's view, almost unconsciously. His adult workmen were set in their ways, but some he took on as boys he was able to train in design. He encouraged men performing routine tasks to rotate assignments to counter the dulling effects of the division of labour.

The establishment of his Merton Abbey workshop in 1881 was, as Philip Henderson says, 'the realization of a Ruskinian dream',[18] with its watermill, orchards, garden and weatherworn buildings. It was also the promise of 'A Factory As It Might Be' if the general lot of the worker could be improved. Morris envisioned the factory as the centre of a vital community combining production, education, and relaxation with richly functional architecture in harmony with the natural surroundings. But the very success of his business brought home to Morris the internal contradictions of its Ruskinian premises.

In his first public lecture Morris addressed the members of The Trades Guild of Learning as people like himself 'engaged in the actual practice of the arts that are, *or ought to be*, popular' (XXII. 8, my italics). But goods produced for sale at a profit cannot be by and for the people. Indeed only the classes whose wealth Morris came to see as surplus value stolen (the rhetoric of Ruskin, Morris and Marx is at one here) from the working class could afford most of his goods. Moreover, such changes in taste as he inspired did not create a concomitant demand for more humane modes of labour. Rather it inspired cheap imitations manufactured by means he deplored. Neither Morris & Co., nor the arts and crafts movement it helped inspire, could make any significant improvement, either directly or through example, in the general lot of the working class. Morris was forced to the conclusion that social revolution was the prior condition to the modes of production and consumption necessary to fulfil human nature and bring it into harmony with the environment. Revolution was the only way to the factory that might be.

> I know that I had come to these [socialist] conclusions a good deal through reading John Ruskin's works, and that I focussed so to say his views on the matter of my work and my rising sense of injustice, probably more than he

intended, . . . [thus] I was quite ready for Socialism when I came across it in a definite form, as a political party with distinct aims for a revolution in society.[19]

The initial purpose of Ruskin's social crusade had been to persuade merchants of their duty to provide, governors to govern, and bishops truly to oversee. Failing in his purpose he determined to gather people of good will from all classes for the purpose of feeding people, dressing people, lodging people and 'pleasing people, with arts, or sciences, or any other subject of thought'. Only after these necessities are provided dare we say with St Paul: 'If any man will not work, neither should he eat' (18.182). *Fors Clavigera* was to rouse the faithful; his Guild of St George was to be their vehicle of action – a working model of Ruskin's ideal social order.

What Ruskin saw in Europe as he launched *Fors* was the distillation of all he opposed. The German bombardment of Paris was an expression of dehumanized, displeasing science devoted to dislodging, starving and killing people. He saw the rise and fall of the Paris Commune as the overt expression of what was implicit in England: a society broken into warring camps of capital and labour. The capitalists, having all power save that of numbers were operating as brigands rather than as soldierly providers, the role Ruskin had assigned them in *Unto this last*. That people should be blown into Elysium from a paved-over Champs Elysées; that the Tuileries should become another kind of potter's field; that the Grenier d'Abondance should be burned along with (as rumour had it) the Louvre – grain and art being his two chief examples of wealth – these were to Ruskin the signs of the times.

Ruskin's declaration of himself as 'a Communist of the old school – reddest also of the red' (27.116) was not an expression of momentary sympathy for the Communards checked by the threat to the Louvre and its art, but a play on words at once didactic and self-mocking in a manner peculiar to *Fors*. Communism of the old school proves to be that of Lycurgus, Theseus, Horace and Sir Thomas More; Ruskin's redness that of Dante's and Giotto's Charity. Ruskin's Communism, like the old communion, crosses class lines, but does not abolish them. It implies common wealth more splendid than 'singular' wealth; richly ornamented public buildings, simple private ones; common labour followed by common refreshment. The enemies of commonwealth are the capitalists:

people who live by percentages on the labour of others:
instead of by fair wages for their own. The *Real* war in
Europe, of which this fighting in Paris is the Inauguration,
is between these and the workman. (27.127)

Unlike Morris, who could freely accept the revolutionary
slogan of liberty, equality and fraternity, Ruskin could
endorse only fraternity, which always implied paternity,
benevolent authority (16.24). His enemy was not simply the
capitalist but the 'Lord of Decomposition, the old Dragon
himself', which in social terms is class warfare per se. Unable
to choose sides in the struggle he prophesied, Ruskin felt
condemned to wage a war for reconstruction he knew he
could not win. His 'definite dragon turned into indefinite
cuttlefish, vomiting black venom into the waters of [his] life'
(27.293). Written in double awareness of necessity and
impossibility and against the backdrop of personal anguish –
principally over Rose La Touche who was to be the Princess
Sabra to his St George - *Fors* emerged in two incompatible
modes: romance and irony. Ruskin's romance links the
potential redemption of England through what became the
Guild of St George to tales of heroes, saints, artists and
authors of the past. It sets what is against what was, and
what might be. His irony, however, generates contrasts with-
out the element of hope. When Ruskin turned his irony on
himself and measured his plans for the Guild against its real,
if limited, accomplishments, he perplexed potential contri-
butors and undercut his own call to action. From the first,
Fors was a brilliant but self-defeating performance, and after
the death of Rose La Touche in 1875 its social purpose was
increasingly enveloped in private myth and personal obsession.

Morris followed Ruskin's crusade, exclaiming in 1894:
'how deadly dull the world would have been twenty years
ago but for Ruskin! It was through him that I learned to
give form to my discontent' (XXIII. 279). Although Morris
never simply reiterated Ruskin in art or politics, his first
three steps in public action all bore a Ruskinian aspect and
began when Ruskin's friends feared for his health and stability.
First came the Eastern Question, which took the popular
form of a polarized moral issue to which Ruskin, Morris,
and Burne-Jones could all respond on the Ruskinian principle
that foreign policy, like private morality, should be based on
doing the just rather than the expedient thing. Burne-Jones

solicited Ruskin's name as a convener of the Eastern Question Association. He responded with a public call for England to act like St George in defence of the Christian populations being suppressed by the Turks (29.46), and with a private wish that Burne-Jones and Morris might 'never retire wholly again out of such spheres of effort'.[20] While still engaged in 'Anti-Turk' Morris began an even more Ruskinian project, 'Anti-Scrape': The Society for the Preservation of Ancient Buildings. Ruskin's opposition to restoration was vociferous but individual. In both 'Anti-Turk' and 'Anti-Scrape' Morris translated Ruskinian protests into organized opposition movements in which he took a leading role.

In December 1877 Morris took his third step into public action, giving the first of his public lectures linking art and social issues. Morris's lectures were a deliberate extension of the Ruskin tradition intended to make his audience 'uneasy, discontented, and *revolutionary*' (XXII. 140, my italics). In 'Art and the Beauty of the Earth' (1881), Morris insists it was 'the torch of the French Revolution' that led to the romantic revival, which led in turn to what Ruskin developed; the 'feeling for the romance of external nature, which is surely strong in us now' and the longing to know something of the real lives of those who have gone before us. Both find 'broadest expression in the pages of Sir Walter Scott' (XXII. 59). Morris links Scott's fusion of romance, history and land-scape with the rebellions of the Pre-Raphaelite Brotherhood and Ruskin himself whose words, he insists, 'I am echoing'. But the effect of this 'turning-point of the tide' in the direction of art is only that a few artists have 'caught up the golden chain dropped two hundred years ago' thereby leading culti-vated people into 'discontent with the ignoble ugliness that surrounds them' (XXII. 60). As yet Morris saw no way of linking the discontent of the cultivated few with that of the oppressed many; the means of revolution with the end of universal art-labour. Morris was still part of what he was to look back upon as 'the pessimistic revolt of the later end of this century led by John Ruskin against the philistinism of the triumphant bourgeois'.[21]

Marx resolved Morris's dilemma. In the historical sections of *Capital* Morris found a more hopeful version of the his-torical paradigm he had adapted from Ruskin's. The very forces that plunged the English working class 'from its golden into its iron age' at the end of the fifteenth century, causing

the slow death of art, contained within it seeds of its own destruction. The process of capitalist accumulation was effecting both the dispossession and the organization of the working class thus begetting 'with the inexorability of a law of Nature, its own negation'.[22]

Ruskin and Morris were selective admirers of each other's work; but not intimate friends, each being closer to the Burne-Joneses than they were to one another. Morris seized the occasion of a public lecture, 'Art Under a Plutocracy', given at University College, Oxford, in 1883 with Ruskin in the chair, to express to his early master the continuity he found between his work and that of Marx. Ruskin's great truth, 'ART IS MAN'S EXPRESSION OF HIS JOY IN LABOUR', implies that only the foolish would willingly consent to labour without pleasure, and that society is hideously unjust for forcing men to do so. Fresh from his reading of *Capital* Morris explains that industrial capitalism, while making this unhappiness of the workmen inevitable, at the same time 'has welded them into a great class' antagonistic to the capitalist class (XXIII. 187). Thus, paradoxically, it is only with the overthrow of capitalism and its class distinctions that the middle-class dream of a general revival of the arts can be possible, for only then can joy in labour be restored. Morris concluded by urging his academic audience in terms of romance to take the side of the workmen: 'organized brotherhood is that which must break the spell of anarchical Plutocracy' (XXIII. 191). Ruskin was forceful in defence of Morris's purpose and argument in the uproar that followed this political appeal, but chose to recall in print only Morris's opposition of Plutocratic Oxford to the Oxford of old (34. 383, 390).

Although his means were now radically different, Morris was still, like Ruskin, engaged in a double effort: to influence the perception of history and the course of events. Looking back on the Communards he celebrated them for 'elevating the mass of workers into heroism'.[23] He inaugurated *Commonweal* with a serial romance that turned unhappy lovers in the triangular situation that haunted his imagination into *Pilgrims of Hope* on the barricades of Paris inspiring: 'love of the past and the love of the day to be' (XXIV. 408). Thrust into the leadership of a workers' party, Morris discovered that his ability to communicate his vision of 'the day to be' to working-class audiences was circumscribed by the very

barrier of class he was striving to abolish ('I can't *talk* to them roughly and unaffectedly'),[24] and the question of ends often lost in wrangling over means. Both intractability of the opposition and the potential of palliative measures to forestall complete polarization of the classes and so blunt the commitment to revolutionary change were brought forcibly home to him. A gap opened between Morris's hopes and his expectations. But having chosen sides and found a sustaining ideology, Morris could keep action and vision working together as Ruskin could not. Though subject to disappointment, he did not despair. As Ruskin faced his failure to restore even a piece of English ground to its Edenic state, his crusade gave way to a review of his own life as a series of paradises lost and failed conversions.[25] The pictures of his early life that in *Fors* were background to his vision of the future became pure retrospection in *Praeterita*, and his plea for conversion of the adult world into a second childhood in which work and play would be as one (18.401ff) became a reversion to his own childhood. Morris faced the prospect of immediate failure by transforming the illusion of summer in December conjured up by the wizard in the Apology to *The Earthly Paradise* into Utopian romance. The poet's 'apology' for 'striving to build a shadowy isle of bliss' became an assertion of faith in social revolution that would ultimately change the urban winter of the present order into a pastoral summer.[26]

In a Marxist critique of Northrop Frye, Fredric Jameson locates the historical occasion of romance in transitional moments when society seems torn between past and future worlds rather than by internal divisions of class: 'The archaic character of the categories of romance (magic, good and evil, otherness) suggests that this genre expresses a nostalgia for a social order in the process of being undermined and destroyed by nascent capitalism '[27] Jameson's analysis goes to the heart of Ruskin's problem as a social critic. His critique of capitalism was based on the contradictions between the values of the past as expressed in the Bible, art and literature, values to which most Victorians gave formal allegiance, and their economic practices. Implicit in Ruskin's critique, however, was the class structure assumed by the tradition from which he took his values. Thus Ruskin's social crusade ended in the vain attempt to impose on the outer world an idiosyncratic version of the old order - first by argument, then by example. Unlike Ruskin, Morris believed that the social structure

of the Middle Ages was not essential to its art-labour. The one could be revived without the other. Consequently, he eludes Jameson's formulation and in his political romances actually transforms the opposition of past and future worlds into a contemporary class struggle while expressing what amounts to nostalgia for the future.

In his first vision of summer in January, *A Dream of John Ball*, Morris encounters his revolutionary progenitor in 'Gothic Eden'. Like Morris, Ball has transformed the communion of the church into one of fellowship, and hope of salvation into the longing for an earthly paradise. Because he and his audience are part of an organic community expressed in everything from architecture, art and idiom, down to clothing and cuisine, Ball can communicate his revolutionary message across class lines, causing the 'shame and fear' to fall from his listeners as Morris longed to do. The message Morris carries back to John Ball is a bitter one. The very movement Ball leads will 'free' the workman for wage slavery. In the ensuing class struggle, however, lies hope for the eventual 'Fellowship of Men'. Inspired by his forebear's courage and the imperfect commonwealth that was, Morris wakes from his dream of John Ball rededicated to John Ball's dream and to his own work, the model of the unalienated labour to be: 'my day's "work" as I call it, but which many a man besides John Ruskin (though not many in his position) would call "play" ' (XVI.288). In *Ball* Morris associates his revival of crafts not with the social structure of the Middle Ages, but with the revolt against it. In *News from Nowhere* he extends his romance formula by projecting the vital part of the past, all he means by Art, into the future. Frye calls romance the literary analogue of the wish fulfilment dream, the quest, 'for some kind of imaginative golden age in time or space'; 'the search of the libido or desiring self for a fulfilment that will deliver it from the anxieties of reality but will still contain that reality.'[28] *News from Nowhere* is the wish fulfilment of a desiring, political being. At the outset Morris is self-alienated, watching himself function as an angry faction of one, pitted against like factions, in a party of comrades. He emerges in the future as 'I', and awakens from his dream reintegrated. The forces that had divided him have been again objectified, and Morris's struggle against them justified, though he will never see the great rebellion he places on the centenary of his Oxford matricu-

lation and the writing of 'The Nature of Gothic'.

Morris thought all Utopias expressive 'of the temperament of the author',[29] and the crises and longings of Morris's personal life are surely worked out in Nowhere: the triangular love affair, the establishment of free companionship, the elimination of all paternal authority. Here too, stripped of the puritanism and paternalism he despised, is the vision he shared with Ruskin: the extension of family into communal values; the production and exchange by individuals, regions and countries of what each was suited by nature to produce; unalienated labour even (as Ruskin sought to demonstrate at Oxford) in road building. Above all, England has become a garden. Its people in various and lovely dress live and build in harmony with nature. 'I was having my fill,' says Guest, expressing the deepest longing Morris shared with Ruskin, 'of the pleasure of the eyes without any of that sense of incongruity, that dread of approaching ruin, which had always beset me hitherto when I had been amongst the beautiful works of art of the past . . .' (XVI. 141).

The way to this Utopia is opened by a revolution that is an ideological displacement of romance. Contrary to Jameson's formulation its central struggle is precisely the division between capital and labour imagined as a conflict between those with a common identity and 'otherness', between good and evil.[30] The failures and frustrations of Morris's political life are transformed as Bloody Sunday blends with accounts of the Commune to emerge as the first stage in a successful revolution. An intelligently led and well-disciplined working-class movement becomes the collective St George that slays the dragon of capital that lay waste the land. Marx and magic transform England into an earthly paradise. The distinction between nature and a separate human nature has become a bad memory. Men and women live as self-conscious social animals free to satisfy every instinctual need within the limits set by the needs of the community. The urge, not the necessity, of labour is free to express itself in art.

The only 'otherness' in Nowhere is that of Guest himself. The Utopian version of the communal trip up the Thames undertaken by Morris's family and friends comes to Kelmscott, the symbol of continuity between past and present in Morris's own life. As the journey ends, Guest is increasingly tempted to embrace Ellen, the perfected form of the female companion Morris had sought since the loss of Emma. With the

temptation to disclose his identity comes the dreamer's recognition of himself as the alien in his own vision. Morris wakes to his own place and function in history, labouring at the beginning of the change while spreading a vision of its end. Blending his own vocabulary, which stresses the tribe or people over the individual or family, with that of *Unto this last*, he foresees an England peopled with a 'happy and lovely folk, who had cast away riches and attained to wealth' (XVI. 200).

Morris's attempt to make the cause of art that of the people led to a theoretical breakthrough, but a practical failure.[31] The organization of the English working class generally proceeded on melioristic rather than revolutionary lines, stressing the material reward for labour over the question of its nature. Morris ended his socialist days in relative isolation, telling his story of how the change might come and what it could bring to meetings of the Hammersmith Socialist Society, an organization as much his own as the Guild of St George was Ruskin's. Like his own John Ball, Morris refused to compromise either his commitment to the working class or his millennial vision. Consequently Morris has become to his admirers not only, like Ruskin, a prophet, but a hero. 'So he still paces ahead of us, no longer "lonely" but still in the van – beckoning us forward to the measureless bounty of life.'[32]

NOTES

1 *William Morris: Artist, Writer, Socialist*, (ed.) May Morris, 2 vols (Oxford, Blackwell 1948), I: 148.
2 Ibid.
3 John D. Rosenberg, *The Darkening Glass* (New York, Columbia University Press and London, Routledge 1961), pp. 52-3.
4 N. Frye, *The Secular Scripture* (Cambridge, Massachusetts, Harvard University Press 1976), p. 173.
5 *The Ruskin Family Letters*, (ed.) Van Akin Burd, 2 vols (Ithaca and London, Cornell University Press 1973), I: *passim*.
6 In *Praeterita* Ruskin portrays his cousin, Jesse Richardson (1820-7), as the lost companion of his childhood. In 1859 he wrote to Margaret Bell: 'I've no sisters – no relations who had an idea in common with me – I *had* some nice ones, but all whom I used to care for are drowned – or married far away – or otherwise dead or departed' (*WL* 121).

191

7 J.W. Mackail, *Life of William Morris*, 2 vols (London and New York, Longmans 1899), I: 12.

8 Mackail's notebook quoted by Jack Lindsay, *William Morris* (London, Constable 1975), p. 29. Lindsay traces the motif of the triangular love affair that pervades Morris's literary work, and which he seemed doomed to act out like a latter-day Arthur, to the loss of Emma.

9 Thomas Carlyle, *Past and Present*, (ed.) Richard Altick (Boston, Houghton Mifflin 1965), p. 155.

10 Preface to the Kelmscott Press, *Nature of Gothic* reprinted (10.460).

11 R. Hewison, *John Ruskin: The Argument of the Eye* (London, Thames & Hudson and Princeton University Press 1976), p. 123.

12 For extended comment on the Turner of *Modern Painters* Volume 5 see George P. Landow, *The Aesthetic and Critical Theories of John Ruskin* (Princeton University Press and Oxford University Press 1971), p. 420ff, and Hewison, *The Argument of the Eye*, op. cit., pp. 81-4.

13 See Paul Sawyer, 'Ruskin and St. George: The Dragon-Killing Myth in *Fors Clavigera*', *Victorian Studies*, 23 (Autumn 1979), pp. 5-28.

14 'I have had a hard time of it and curious dragon battle, about Rosie. I was nearly beaten yesterday, - lance in worse splinters than Carpaccio's [in his *St. George*] and not at all so well through the back of the throat, but it holds, I am thankful to say.' Letter to Charles Eliot Norton, 23 February 1874, published by permission of the Houghton Library, Harvard University.

15 *The Letters of William Morris*, (ed.) Philip Henderson (London, Longmans Green 1950), p. 17.

16 *The Collected Works of William Morris*, (ed.) May Morris, 24 vols (London and New York, Longmans Green 1910-15), III: 3. Hereafter cited parenthetically in the text by volume in Roman numerals and page, thus (III. 3).

17 Mackail, *Morris*, op. cit., II: 52. Morris followed Ruskin in wishing to broadly educate all workmen and teach them drawing through studies of the human figure and natural objects (16. 329).

18 Philip Henderson, *William Morris: His Life, Work and Friends* (New York, McGraw-Hill 1967), p. 232.

19 'How Shall We Live Then', (ed.) Paul Meier, *International Review of Social History*, 16 (1971), Pt 2, pp. 255-6.

20 Letter from Venice, 8 December 1876. Already in the grip of the Venetian obsessions that foreshadowed his mental collapse, Ruskin followed his call to action by saying: 'But the great joy to me was the glimpse of hope of seeing you here in the spring' (24.xxxviii).

21 'Looking Backward', *Commonweal*, 22 June 1889.

22 Karl Marx, *Capital*, (transl.) S. Moore and E. Aveling, (ed.) Frederick Engels, 3 vols (New York, International Publishers 1967), pp. 719, 763. On the parallels Morris found between *Capital* and 'The Nature of Gothic', and the importance of the Eastern Question Association

and 'Anti-Scrape' in Morris's radicalization, see E.P. Thompson, *William Morris: Romantic to Revolutionary* (London, Merlin 1955, revised edn 1977), pp. 35-9, 206-42. Paul Meier denies that this progress amounts to a Ruskinian influence on Morris's socialism: *La Pensée Utopique de William Morris* (Paris, Editions Sociales 1972).

23 'Why We Celebrate the Commune of Paris', *Commonweal*, 19 March 1889.

24 *Letters of William Morris*, op. cit., p. 237.

25 See Elizabeth K. Helsinger, 'Ruskin and the Poets: Alterations in Autobiography', *Modern Philology*, 74 (November 1976), pp. 142-70.

26 John Goode's 'William Morris and the Dream of Revolution' in *Literature and Politics*, (ed.) John Lucas (London, Methuen 1971) presents an ideological defence of Morris's romances as 'a formal response to problems which are theoretically insoluble', p. 222.

27 'Magical Narratives: Romance as Genre', *New Literary History*, 7 (Autumn 1975), p. 159.

28 Northrop Frye, *Anatomy of Criticism* (Princeton University Press 1957), pp. 186, 193.

29 'Looking Backward', op. cit.

30 What Robert Tucker calls Marx's 'moralistic myth' of good and evil wherein 'Collective Worker wrests the world of alien wealth away from My Lord Capital, [and] the monster is thereby destroyed' would be in narrative form a romance. *Philosophy and Myth in Karl Marx* (Cambridge University Press 1961), p. 222.

31 Raymond Williams, *Culture and Society* (London, Chatto & Windus and New York, Columbia University Press 1958, postscript 1963), p. 153.

32 Thompson, *Romantic to Revolutionary*, op. cit., p. 730.

12
Ruskin, *Fors Clavigera* and Ruskinism, 1870-1900

Brian Maidment

One theme of Auden's poem 'In Memory of W.B. Yeats' is the way in which the death of the writer changes the social and intellectual impact of his writing. In Yeats's case, Auden tells us, 'the death of the poet was kept from the poems' and, more decisively, that Yeats 'became his admirers'.

> The words of a dead man
> Are modified in the guts of the living

For Ruskin, the separation of the writer from his work might be said to have taken place not only while the author was still alive, but actually to have spanned over twenty years of his life. After the first of his major illnesses in 1878 Ruskin continued to write, correspond, plan and lecture with what was well described in *Fors Clavigera* as a 'daily maddening rage' until 1889 when he withdrew finally from public life and remained in retirement at his Lake District house, Brantwood, until his death early in 1900. Yet throughout the whole period between 1878 and 1900 the impact which Ruskin's work was making on Victorian thought was no longer totally within the author's own control. While Ruskin sat in virtual seclusion at Brantwood, almost wordless, his works began to gain force and to focus discussion among the public from whom he had been forced to withdraw. The irony of the situation is too poignant to be passed over. One visitor to Brantwood in 1880, the wife of the Manchester Ruskin enthusiast T.C. Horsfall, described exactly and sympathetically her sense of the withdrawal of Ruskin's physical presence from the intellectual battles of late Victorian England:

He is a very small, gentle looking old man, who does not
look like a fighter at all. He has clear blue eyes with
shaggy eyebrows, and a nose with very wide nostrils.
He wears an old fashioned frock coat which seems to
enfold more clothes but nothing more substantial.[1]

Ruskin, it seems, had merged not only into his admirers
but even into his coat. After a life of relentless public self-
analysis, or polemical gestures seldom less than considered
but bordering on the absurd, Ruskin's social ideas only begin
to take shape in the public consciousness during the period
when Ruskin's personality was withdrawn from the attack.
It is this lack of apparent consistency between Ruskin's
highly personal and well-developed style of arguing and the
way in which his work finally did become an important
strand in English social thought which I wish to examine in
more detail. The extraordinary surge in sales figures for
Ruskin's books during the years between 1885 and 1900
consequent upon the introduction of a fairly cheap uniform
octavo edition of his works by George Allen[2] partly explains
Ruskin's new found influence, but publishing policy alone
can scarcely account for the importance of Ruskin in the
decades either side of 1900. The power of his followers, and
perhaps most of all the changing sense of the possibilities and
failures of industrialism and political economy, rendered
Ruskin's *work* appropriate to the time even as his prophet-
like *presence* became unnecessary. When Ruskin's publisher
George Allen recalled a visit to Ruskin in 1898, he especially
remarked that 'Ruskin says but little' – a tragic reversal for a
man whose voice had never been less than torrential. When
Allen tried to goad Ruskin into enthusiasm by saying how
much his books were appreciated, Ruskin replied 'in a low
kind of whisper that makes it rather difficult and painful to
listen' that 'people thought a great deal more about them
than he himself did'.[3] At one level this is advanced self-pity,
at another it was nothing less than the truth.

The book which most clearly defines the intentions of
Ruskin's late style, *Fors Clavigera,* is, in spite of its fragmentary
nature, both a crucial and a radical book in the Ruskin canon,
radical not so much in what it says but rather in the mode of
discourse which it adopts. This remains true even if the

boldly self-announced audience for *Fors* – 'the workmen and labourers of Great Britain' – was not the actual readership which the book had.[4] Indeed such evidence as we have – reminiscences by contemporary readers, the high price of individual copies, the refusal of Ruskin to use conventional sales outlets in the bookshops or railway bookstalls – all point to the extremely circumscribed and largely wealthy readership which *Fors* obtained. One working man, fully conscious of his own hard-won learning, may well have spoken for many of his contemporaries:

> In 1873 was founded a book society at St. Thomas's Square Chapel which was to influence strongly my intellectual life . . . in October 1874 I was made librarian Among the publications circulated was Ruskin's 'Fors Clavigera'. Only one man, so far as I could see, cared for Ruskin's 'Fors', and I was not that man. Well read as I certainly was, I was certainly a philistine in regard to Ruskin, and saw nothing then in what he said, and in this I undoubtedly expressed the feelings of the few – the very few – workmen who had read his books.[5]

Even the four volumes reprint of *Fors*, issued in 1896 by George Allen, was not cheap at 24*s*. In any case, this cheap edition, edited by W.G. Collingwood, was an entirely different *Fors* from the original part issue, omitting the sense of urgency, activity, and controversy which the monthly parts had created.[6]

Any failure of intention in *Fors*, any sense of its inadequacy as an effective dialogue between a benign author and the working classes of Great Britain, should not disguise the fact that the book marks a definite, and culminating, stage in the development of Ruskin's polemical style. This development may be crudely summarized as a movement away from regarding a writer's works as a series of objects towards a sense of books as possible *discourses* or centres of activity and argument. Such a statement may at first sight seem a strange one to readers reared on the thirty-nine volumes of Cook and Wedderburn's Library Edition or the grey paper, purple calf, and green cloth Allen editions. But very few of Ruskin's works were written for conventional volume publication. Only the great early trilogy of *Modern Painters*, *The Seven Lamps of Architecture*, and *The Stones of Venice* were

written initially in volume form, and of these *Modern Painters* exhibits many characteristics of rather extended and badly controlled serial publication. The vast bulk of Ruskin's work comprises groups of lecture texts,[7] either revised for publication or else written with the dual purpose of platform delivery and volume publication in mind, reprinted series of articles to magazines,[8] or idiosyncratic but none the less recognizable essays at established generic forms such as the popular guide book, the controversial pamphlet, the popular science handbook or even the fairy story.[9] To these should be added a few experimental genres which Ruskin himself developed, the most important of which is the self-created, self-dramatizing, didactic dialogues exploited in *The Ethics of the Dust* (1866), *Time and Tide* (1867) and, most notably, *Fors Clavigera.* Another way of approaching this unexpected variety and determination in the use of Victorian popular literary genres is to underline the fact that during the period I would call 'late Ruskin' (1870-1900) Ruskin was bringing out his new books almost entirely, if a little erratically, by monthly serial publication.

This practice may well be seen mainly as the result of a disintegrating sensibility, able to produce work sporadically and episodically, unable to maintain coherence and continuity. The *Diaries* and other evidence for this period clearly show psychological pressures towards a more improvised and fragmentary mode of publishing. Yet beyond the immediate needs of Ruskin's personal compulsions to serialization I think it is important to see his use of popular genres for his arguments as both self-conscious and, except perhaps in the case of *Fors,* successful in terms of both sales figures and literary effect. Serial publication creates for the author possibilities of accessibility, immediacy and cheapness while at the same time creating constant pressures of time and space on the writer which can lead him or her into episodic diversions or even total incoherence. While Ruskin used serial publication his work remained open to the constant influence of his readers' views, and his potential readership was extended both by the cheapness of the serial parts and by the excitement and unpredictability of the mode. In choosing to write and publish his books as he did, Ruskin was prepared to risk the loss of his early readers brought up on the well-organized and finished volume in order to find new readers, new forms, and new words for his

197

proposed discourse. To clarify these changes and their sig-
nificance it may be best to look back briefly at the shape of
Ruskin's literary output.

Ruskin's early books were written entirely without any
conception of readership, nor, indeed, thanks to John James
Ruskin's wealth, did they *need* any readers. The leisurely
examination of Ruskin's developing sensibility was able to
continue without any limitations of space, and without any
need to concede anything to the tastes or needs of his readers.
If Ruskin was writing for anyone at all, it was for his father
and his father's circle of cultured and indulgent friends.[10]
Ruskin's first major book on political economy, *Unto this
last* (serialized 1860, published in book form 1862), con-
fronted that group of readers in content, style, and mode –
the articles appeared in the mass-circulation early issues of
the *Cornhill Magazine*, were stopped under pressure from
readers and publisher alike by the editor, Thackeray, after
four issues, and Ruskin was reputed to have outraged most of
England with his views. But as important to Ruskin as the
public opposition which he raised was his father's private
response to his forty-year-old son's waywardness. Ruskin
gained the right to speak on different subjects, but equally
he had found the freedom to speak to different audiences,
and it was this latter freedom, as much as what he was
saying, which hurt his father so deeply. *Unto this last* rep-
resents Ruskin's first attempt at a kind of writing in which
the nature of the readership and the terms of the discussion
were decided by the author rather than by the author's
patrons, family, or publisher.

The first of what was to become a series of redefinitions of
readership, represented by *Unto this last*, was largely effected
by a deliberate change in the *content* of Ruskin's work.
But subsequent redefinitions of readership depended more
heavily upon changes in *mode*, changes clearly visible in the
adaptation of recognizable or traditional forms to Ruskin's
own purposes. Foremost among these is the public lecture,
but, as I have already suggested, Ruskin also strained such
well-established genres as the popular scientific textbook, the
guide book, the epistolary didactic work or the exhibition
catalogue to the limits of coherence and expressivity. Each of
these genres presupposed certain formal characteristics and

certain predetermined readerships, which Ruskin, in the full
confidence of his late style, treated as opportunities rather
than as constraints. His grasp of the range of Victorian pub-
lishing was acute enough for him to launch his own some-
what idealized 'Cottage Library' directly in the tradition of
popular publishing by such firms as Milner and Sowerby in
Halifax or Nicholson in Wakefield.[11] Yet Ruskin's intellectual
conflicts did not allow him to call this series anything other
than 'Bibliotheca Pastorum' nor to allow it to be published in
anything other than fragile grey boards at the price of 7s.6d.
per volume. At the same time as Ruskin launched his own
contradictory assault at a range of popular genres his work
also spilled over from books, lectures, and letters to the press,
into practical experiments like the Hincksey Diggings, the
Paddington Tea Shop, and the Guild of St George, all schemes
in which critical judgment has to balance doubtful practicality
against polemical effect and psychological compulsion.

Aspects of many of these modes of argument resurface in
Fors Clavigera, a work which steps beyond traditional literary
genres. The basic format is a kind of personal journal written
as a monthly series of letters, but by way of appendices, or
even in the body of the text, Ruskin incorporated letters
from readers, press cuttings, documents and accounts relating
to the St George's Guild. The seemingly casual or even
random movement of the argument is overlaid by biblical
and mythological analogies and by conscious or intuitive
imagistic structures. Yet every now and then a didactic
passage of blazing clarity and directness shines out. And
perhaps the most alarming feature of *Fors* is its sense of risk.
The author risks embarrassing his readers by his constant
vulnerability, his guilt-ridden anger and anxiety. Ruskin also
makes himself publicly accessible to the challenge of his
readers, and even invites their hostility. In all these senses
Fors represents the culmination of Ruskin's polemical
rhetoric. Ruskin has made a crucial shift from regarding
the book as a kind of internal monologue describing the
relationship between a sensibility and its external stimuli
to a notion of the book as the exploration of the relation-
ship between writer and reader. The exploitation of this
relationship, Ruskin sees, can also give formal and intellectual
impetus to the writer. Yet if this shift in Ruskin's thinking
is as important as I have claimed, obvious difficulties in
explaining Ruskin's popularity occur. Having perfected, in

Fors and elsewhere, modes of arguing which depended utterly on the continuing, if uncomfortable, polemical presence of the writer and on the accessibility of the writer to his readership, Ruskin disappeared from public view.

The immediate effect of Ruskin's disappearance was a total change in the presentation of Ruskin's work to the public. In 'becoming his admirers' the mediation of Ruskin's work into Victorian consciousness was revolutionized. This shift can partly be described in terms of changed circumstances, but it is largely a matter of style. A simple example may clarify my meaning.

Ruskin's books were not cheap in the 1870s and many correspondents wrote to tell Ruskin that they were interested in his work, but poor, and could not afford the considerable expense of *Fors*. Ruskin might have been expected to show sympathy for the earnestness and the desire for self-improvement revealed in these often moving letters. Here, however, is one such reply, reprinted in *Fors*, to a letter written in 1879 on behalf of a literary society in Bristol:

> My reason for making my books dear is, I think, almost enough explained by *S* 10, 13, & 32 of *Sesame*, in which, however, I have not said the hundredth part of what I feel about the mischief of cheap literature.
>
> But – if deadly in a thousand ways – it is at least, in *one* way, enough excuse for my obstinacy. If a 'poor student' can get a shilling Shakespeare, a sixpenny Bible, and any quantity of poetry or science at 4*d*. a pound, is there any pitiful necessity for having J.R. too, at such a price as will enable him to pack his groceries in my best paragraphs? . . .
>
> It may interest the Society to know a fact about *Unto this last*. A working man copied it all out, from this first word to that last. Somebody came to me pitying him very much. I answered that the poor man had only done once, easily, what I had done myself, three times over, with great difficulty, and that he would be very much the better for the business. (37.280)

An immediate response to this is that Ruskin's belief in the educative experience of writing out *Unto this last* is an

overemphatic piece of deliberate antagonism. But the strategy of the letter is more sophisticated than this. The opening reference to *Sesame and Lilies* establishes Ruskin's letter in the firm context of his economic work, and especially to his whole theory of value which is elaborated in the cited paragraphs. This necessary context gives Ruskin the freedom to turn his reply to rhetorical rather than intellectual purposes. Hence the play on words ('this first word to that last'), the imagery of consumption ('4*d.* a pound' linked emotively with groceries) and the anecdote with the shock conclusion. All these are permissible for a writer who has proved his seriousness elsewhere. But it is the wit and energy of the reply which strike most forcibly – Ruskin has given of his best, and this generosity robs the letter of its sting. The modulation by which the letter concludes confirms the good intentions behind the stylistic aggression: 'Surely it would be much better to read quietly *one* scene of Shakespeare's for the evening study – and take it line by line' (37.280). This letter can be usefully compared with an extract from an unpublished letter from J.E. Phythian, president of the Manchester Ruskin Society, written in July 1900 to T.C. Horsfall:

> I wrote to Severn, Ruskin's guardian to ask his help for a Ruskin exhibition at the Art Gallery, and received the following reply: 'We have no special interest in Manchester, and I should say it is the last place the Professor would have wished to see any of his drawings sent for Exn. We have had three or four applications from towns – chiefly I suppose with a view to making a nice profit.'[12]

What I think is important here, and I don't think the example too simple to carry the burden of my argument, is the changed response from Ruskin's guardians at Brantwood. Imagine what Ruskin himself would have made of this opportunity – his refusal to help the Exhibition (if indeed he had refused) might have been as absolute but in its style and sincerity it would at least have shown that Ruskin *cared* about Manchester, and was not patronizing and hostile in response to a correspondent who had worked for over twenty years to disseminate Ruskin's works and ideas. What this letter from Brantwood suggests then is that in taking over

the way in which Ruskin was presented to visitors, corres-
pondents, enthusiasts and applicants, his guardians the
Severns revealed their indifference, even incomprehension, as
to how Ruskin had worked and what he had meant as a
public figure. The change of style here between Severn's
reply and Ruskin's earlier response to the Bristol literary
society suggests one important consequence of Ruskin's
withdrawal from public life. Once the personal discourse had
been broken, Ruskin's presence and indeed his theories and
beliefs were free to be interpreted as others thought fit.

This argument inevitably raises questions about the role of
Ruskin's second cousin Joan Agnew and her husband Arthur
Severn in his life during the Brantwood years. Until recently
it was usual to regard Ruskin's declining years as a time when
nothing was happening, when Ruskin sat peacefully and
silently contemplating his life's work, lovingly attended
by the devoted Severns. Certainly, very little attention had
been paid to the manuscript material and letters which cover
this period of Ruskin's life. This was changed by the publi-
cation of several books, notably Sheila Birkenhead's
Illustrious Friends (1965), James Dearden's edition of
Arthur Severn's memoir of Ruskin *The Professor* (1967) and
Helen Viljoen's publication of *The Brantwood Diary* (1971).[13]
 The account of the Severn family in *Illustrious Friends*
draws on a vast mass of letters between Ruskin and Joan
Severn, many of them embarrassing or pathetic, and the
book does seem to offer a properly documented account of
Ruskin's illness and domestic life. The author established
important facts which had previously been either withheld
or tacitly understood – that Ruskin's illness had been violent
on occasions, that he had been frequently hard to control
and to look after, and that there had been serious disagree-
ments and even walkouts staged within the Brantwood house-
hold. Miss Birkenhead directed most of this evidence at
vindicating the role of the Severns and in offering tribute to
their care of the difficult old man. Unfortunately, this
vindication is all too successful, for the book is so concerned
with the Severns that it does Ruskin an injustice.
 To see Ruskin in a totally domestic context is to ignore his
carefully created and consciously sustained public role, his
presence as an important voice in English life. Miss Birkenhead

domesticates Ruskin even as she shatters the myth of the Brantwood idyll. Ruskin did not live at Brantwood alone. He lived widely in the lives and activities of his friends, followers and readers, and it is important to stress that as Miss Birkenhead ignores the Ruskin beyond Brantwood, so did the Severns themselves. They never understood his public life, and I say this while fully acknowledging Ruskin's physical and mental instability during this period. Ruskin became, both legally and emotionally, the Severns' property, and whatever debt Ruskin owed the Severns for their care, it is possible to argue that he paid for this by the distortion of his whole life's work. Miss Birkenhead's biographical account of Ruskin in his last years has to be balanced against the evidence of Ruskin's supporters, devotees, and business managers.

The extensive archives of the present George Allen & Unwin Ltd, now reproduced on microfilm, provide some of the detailed evidence to sustain this view of the Severns as uncomprehending and unsympathetic in their dealings with Ruskin's friends and supporters. The issues over which tension arose between Ruskin's devoted publisher and Brantwood are complicated. The central issues were a continuing conflict between the undoubted need for cheap and easily available editions of Ruskin's works, and the need to maintain Ruskin's oft-repeated wish for high standards of book production, with both impulses in a curious relationship to Ruskin's long and hard-fought attack on the booksellers, their discounts and advertisements. There were also constant rows about translation rights, about the use of extracts from Ruskin's works in anthologies, schoolbooks, or critical works, and about the publication of works by Ruskin's followers and interpreters. But the evidence I want to use here is again concerned more with a changed sense of Ruskin's presence than with the underlying causes of that change, which I have examined elsewhere.[14] Here are extracts from two of Allen's letters, the first dated 23 January 1896, the second 7 September 1893, which suggest how totally Allen, a former pupil of Ruskin's at the Working Men's College, a member of the St George's Guild, Ruskin's engraver, publisher, companion, and disciple, was excluded from contact with his master, contact which had shaped his life:

If Mr. Ruskin himself were allowed to listen to

explanations I have no doubt things would be on a
different footing. But as we both know (and alas! realize
only too well), not only is he quite unfit to be troubled
with business matters, but he is inaccessible for an
explanatory interview without an intermediary.

'Fors' is a good work and is not half appreciated
I often get very sad that the author is not more in
evidence personally – no one knows indeed how sad it
all is to me.

The inaccessibility of Ruskin to even his closest followers,
let alone to a wider readership, resulted in a total change in
the way his books were offered to and received by the public.
What we get, then, in the 1880s and 1890s is the creation
of an image of Ruskin as a tamed and silent oracle, who
lived only in his works. This process might be better des-
cribed as the creation of a canon of work in the place of an
active and unpredictable literary presence. This in turn led to
the continual restatement of theories, ideas and social gestures
which had once been radical and vivid but which by the end
of the century had often hardened into absurd or reactionary
prejudices. This is not to say that Ruskin's ideas had always
been in a direct relationship to trends in contemporary
thought, or that his thinking had always shifted in a con-
tinually progressive manner, but rather to say that his
chosen modes of discourse were continually alert to the
potentialities of various readerships and methods of publi-
cation. Ruskin's work, while he remained active, was too
elusive to become a canon, and any sustained exegetical
activity was soon forestalled by the variety and contrariness
of his writing. With the publication of the Cook and Wedder-
burn Library Edition of the *Works* which began in 1903, but
which had been unofficially planned since 1898, the estab-
lishment of Ruskin's books as 'objects, essentially fixed
and dead' was made evident. The compulsion towards
indexing Ruskin's works which dogged the early Ruskin
Societies, and the half-hearted George Allen 'Works' series,
were immediately obvious as symptoms of the need to turn
uncomfortable ideas and actions into texts. The exegesis of
Ruskin's books could proceed without the distraction of his
presence.

If the growing domesticity and social acceptability of the way in which Ruskin's ideas were expressed led to an enormous growth in the popularity of his work in the last thirty years of the nineteenth century, there were other, more simple, reasons for this popularity. Most important of these was the growing cheapness and availability of his books after 1880. Ruskin's publisher, George Allen, had the difficult task of balancing Ruskin's often stated demands for well-produced, durable books against his own knowledge of the developing, and profitable, mass market for serious books. Allen's own interest in cheap books and in the needs of a new artisan readership was further accelerated in Ruskin's case by the author's growing dependence on the income from his books as his main financial support.

Cautiously, and with many delays, Ruskin's works did become available in cheap form, and sold in large quantities. Some of his books had never been dear. *Unto this last,* for example, had never cost more than 3s. 6d., and *The Political Economy of Art* (1857) had actually appeared in a series called a 'new Cheap Series of Original and Standard Works of Information and General Interest' at 2s. 6d. Many other works had been cheaply serialized in their original form. But in spite of these exceptions, the prices of Ruskin's works did show a strong general downward movement towards the end of the century. For example, the cheapest available edition of *Modern Painters* in 1875 cost £8. 8s., in 1860 £6. 6s., in 1895 42s. *Fors Clavigera* cost 24s. for four volumes in 1896, as against 10d. a monthly issue in the late 1870s. Most striking of all is the dramatic publishing history of *Sesame and Lilies* which was published in 1865 at 3s. 6d., went up to 9s. 6d. and then 18s. in the 'Works' series in the 1870s, then down to a small 5s. edition in the early 1880s, and finally to a hugely popular, solid, 2s. 6d. green cloth edition. George Allen Ltd had been founded as one of Ruskin's idealistic gestures in 1870, but as Ruskin lost control of the development of the firm, his radical attack on publishing and bookselling practice gradually became subsumed into Allen's success as a publisher of fine illustrated books. Allen's move from rural Kent to London, his introduction of a fixed discount to booksellers, in short his conventional success as a publisher, did give Ruskin's works a new popularity in the new mass markets of the late nineteenth century, even if Allen had, in practice, largely modified Ruskin's own strongly held views on the book trade.

The most obvious way in which Ruskin's popularity and influence in the period 1870-1914 can be quantified is through an account of the Guild of St George, the Ruskin Societies, and the Ruskin Reading Guilds. Yet it is precisely here that quantification proves most difficult. Some of the Ruskin Societies had a few influential members and associates yet the majority of members seem to have been well-intentioned professional people with a scattering of cranks and a leaven of earnest or ambitious working people. At their strongest the Ruskin Societies had quite impressive memberships, but the overwhelming impression is that the initial distinctiveness of a *Ruskin* Society soon faded into a general wish for social awareness and concern in which Ruskin's works were at best used for general inspiration rather than as the genesis of specific theories. Ruskinian activities take us into a network of related concerns, some of which might have been sanctioned by Ruskin, but many of which might have been ridiculed or dismissed by him. Despite a very specific attempt to focus on Ruskin and his works, the slide into, on the one hand, social action, and, on the other, hagiology, characterizes both the Ruskin Societies and the Reading Guilds. A focus on Ruskin's works meant a focus on *books*, and yet the books, especially *Fors Clavigera*, insisted on social action. A literary society often proved to be an inappropriate mode of Ruskinian discourse.

The Guild of St George is something of a separate case, for the level of commitment demanded of Guildsmen precluded all but the dedicated and active. The Guild propounded a reactionary social programme based on subsistence agriculture or cottage industry. The aim was to provide pockets of resistance to industrial England in which the moral arts could be practised without hindrance. The regime was to be hierarchic, with a great stress on the inner life which was to be brought into focus by dignified labour and communal independence. In pursuit of these aims some land was bought or donated to the Guild, and several isolated communities struggled against overwhelming financial and social odds, as Ruskin became less and less capable of directing the affairs of the Guild. It is important not to see the Guild with retrospective cynicism, but to see it as one more way in which Ruskin's work led him beyond books – a product in fact of complex psychological and social pressures. But the inevitable conclusion is that the Guild was begun as a rheto-

rical flourish in *Fors*, and remained a better focus of argument and discussion than a practical mode of Utopian living. The committed and partisan Edith Hope Scott, in her account of the Guild, explains its inevitable failure as an attempt to create an a-historical, a-social reserve for Ruskin's kind of moral feudalism:

> There is nothing new in the Guild It might rather be called a Preserve or Sanctuary for the fundamental social relationships, and arts of life, which no revolution can ultimately destroy or reformation vitally change.[15]

The limits of Ruskin's anti-Victorianism are clear enough in this separation of moral life from history – a separation his early work had sought to deny.

The Ruskin Societies and Ruskin Reading Guilds show rather similar patterns of rapid expansion followed by a longer period in which the initial Ruskinian energy is diffused into unfocused or widely focused forms of social concern. The Manchester Ruskin Society was founded in 1879 and the other Societies were affiliated to it. Strong societies subsequently existed in Liverpool, Glasgow, and, in alliance with the Carlyle Society, in London. Fellow travellers might be found in many more or less ephemeral groups which were often called after Ruskin, but which were concerned with wide intellectual and social matters. The 'Sesame' Reading Club in Ayr in the late 1880s is one example. The Toynbee Ruskin Society, based in Toynbee Hall and under the persuasive influence of C.R. Ashbee, is another. The Reading Guilds were on the whole smaller and less institutional cells of Ruskinian activity, and they were both widespread and more productive. In the late 1880s Liverpool, Birmingham, Oxford, Bradford and Armagh had active Reading Guilds, and there were several branches in London. Scotland showed particular interest with Guilds in Glasgow, Edinburgh, Elgin, Arbroath and Dunfermline, and it was from Scotland that the impulse towards the first important Ruskinian magazine, *Igdrasil*, was drawn. *Igdrasil* began as a handwritten circular letter of the Arbroath Reading Guild in 1887, became a printed journal for all the Ruskin Reading Guilds in 1889, and emerged as a national periodical under the editorship of William Marwick and Kineton Parkes for two years (1890-2) before becoming a conventional literary magazine, *World-*

Literature, in 1892. The two Ruskinian phases of the magazine – small scale journal of co-operative endeavour and self education, and late Victorian magazine centred on, but by no means exclusively concerned with Ruskinian social, economic and educational interests – quickly give way under conventional business pressures.

A similar account might be made of the other important Ruskinian magazine, J.H. Whitehouse's *St George*, which began as the journal of the Birmingham Ruskin Society and moved on to become a magazine of general social concern. The contradiction implicit in *St George* between the superb layout and print work, Walter Crane title-page, bevelled boards and the earnest, concerned content with its eager desire for a wide readership typifies dilemmas faced by Ruskin himself throughout his life. But where Ruskin found either triumphant or uneasy solutions to the discrepancies between intention and effect, his organized supporters often found the contradictions between high cultural aspirations and immediate social problems totally insoluble. The 'network' of organized Ruskinian discipleship which grew up in the last twenty years of the nineteenth century was compounded of three mutually destructive tendencies: a wish to honour a great man, an attempt to focus on that man's written work (work which continually insisted on action rather than study), and an attempt to apply ideas which had been vivid, active, and relevant in the 1860s to the changed world of the 1880s and 1890s. It is not surprising that the span of organized, institutionalized Ruskinism was short and largely unproductive. None the less much material relating to local Ruskinian activities exist in local libraries, and a study of the Ruskin Societies and Guilds would be a worthwhile undertaking.[16]

A shift of focus from Ruskin's own works to more generalized social action which had been only adumbrated in those works is characteristic too of the careers of many of Ruskin's individual disciples like J.A. Hobson or William Morris. One might describe the process as Ruskinism by association. Rather than looking again at the career of a well-known disciple, I would like to discuss briefly the career of Mary Wakefield, who will be known to Ruskin scholars through her book *Ruskin and Music*, which was lavishly published by George Allen in 1884.

At first glance the book appears to be a piece of pious anthologizing on the same level as, say, Mary and Ellen Gibbs's *The Bible References of John Ruskin* (George Allen 1898). Yet on further reading it is clear that, by her extensive commentary, Mary Wakefield has more to say, and more considered and sensible things to say, on music than Ruskin. It comes as no surprise to learn that Miss Wakefield was in fact a highly-spirited and efficient pioneer of competitive music festivals, and laid special emphasis on the need to democratize the understanding of and participation in music.[17] The point I am making is that Mary Wakefield could and did derive much of her inspiration from Ruskinian views on musical education, but that her work was really part of much wider educational and social trends. By constantly stressing the *Ruskinian* elements of her thought, Miss Wakefield is only doing what many other social thinkers and activists were doing. Ruskin's personal example, his continual hostility to mass industrial production, and his advanced methods of discourse rather than his specific economic and social policies were what his disciples associated themselves with, and thus his life and work became the sanction for a vast range of activities which had only the barest literal source within his work. It is largely this huge discrepancy, most noticeable in the period between 1880 and 1914, between what Ruskin said and what was done in his name which makes discussion of Ruskin's influence so imprecise.

It is ironic, though not perhaps surprising in view of the complexity of the subject, that several accounts of the influence of Ruskin's ideas in America and in Europe exist, while there has been no sustained study of his influence on English thought. The interesting feature of R.B. Stein's account of Ruskin's influence in America and of J. Autret's study of Ruskin in France is summed up in the sub-title of a third study by H.R. Hitchcock – 'Regeneration Long Delayed'.[18]

All three of these studies refer to the way in which there is a significant delay between the publication of Ruskin's works and their assimilation into public consciousness. The reasons for these delays outside of England, as I have already suggested, are partly pragmatic. Ruskin frustrated his own

market not only in England but also in America, where his influence was only ensured by pirated editions of his work, and especially in Europe, where translation rights were largely refused until a few years after Ruskin's death. Yet very much the same delay occurred in Britain. Here, though, I think the key factor is Ruskin's own presence. I have attempted to suggest that I see Ruskin's active presence as a central factor in the understanding of his late work. Yet that presence seems, by its originality and willingness to abandon traditional literary discourse, to have inhibited rather than advanced discussion. Ruskin's way of arguing was either in advance of his age or else he failed in his attempt to develop a successful literary method: I have largely put forward a case for the first of these possibilities. Only after Ruskin was reduced to books, to ideas on the page, did his work become a harmless, indeed a socially approved, focus of social and economic discussion in Britain. It is this process of de-radicalizing which I have attempted to describe.

Thus at risk of finishing with a whimper, I am not going to push on here into the extremely difficult area of the correspondences between Ruskin's ideas, the thinking of individuals who were influenced by Ruskin, and the changing social and intellectual needs which made Ruskin's works extremely widely known between 1890 and 1914. Such a study would involve an account of such disparate individuals as William Morris, W.G. Collingwood, J.A. Hobson, C.R. Ashbee,[19] consideration of Ruskin and the aesthetic movement, of parodies and satires of Ruskin,[20] of Ruskin and changing educational attitudes which would in turn be related to new kinds of class mobility, and of the growth of economic science. Instead of an account of how Ruskin was interpreted after his withdrawal from public life, what I hope to have given is a version of the differences between a self-conscious, alert Ruskin present in the intellectual life of late Victorian England, and a body of Ruskin's works open to public inspection and general interpretation. The complex mediations which occur to take us from a consideration of an active author with a highly-developed understanding of the potentialities of public debate to a relatively docile canon of work point to two basic needs in discussing Ruskin. The first is that the essential correspondence between mode and meaning in his work is in fact the result of an extremely vivid and

perceptive awareness of the possibilities of literary genre, and this sophisticated awareness has not yet been properly described. The second is a truth which should scarcely need reiterating. For Victorian readers the personality of a writer like Ruskin could not be excluded from the study of the printed page, and by 'personality' I mean here the calculated, highly-developed and literary persona which Ruskin was only barely able to control in his late work. The contemporary reader has to reconstruct Ruskin's presence, as well as a sense of the literary and social discourse of the period, before he or she can begin to understand the domestication and re-interpretation which Ruskin and his works endured before they became available to the late Victorian and Edwardian public.

NOTES

1 D.F. Skinner, 'T.C. Horsfall – A Memoir' (unpublished typescript, Manchester Central Reference Library), p. 53.

2 The dates for the small editions of the main works are: *The Seven Lamps of Architecture* 1890; *The Stones of Venice* 1898; *Modern Painters* 1897. Many of Ruskin's books on political economy and social issues had always been available in relatively cheap form.

3 Unpublished letter from George Allen to William Hale White, 16 August 1898.

4 This contradiction can be clarified by appeal to the problematic notion of 'success' in literature. On one level *Fors* has, to my mind, to be described as a successful development of an original and radical literary mode. At another, the book was unsuccessful in developing the large alternative readership implied by Ruskin's subtitle.

5 Frederick Rogers, *Labour, Life and Literature* (London, Smith Elder 1913), pp. 61-2.

6 The two different *Fors* are splendidly distinguished by Frederic Harrison in his *Realities and Ideals* (London, Macmillan 1908), p. 366. Harrison's sense of the quality of the two versions, however, runs directly contrary to my own: 'Nor can I agree with the view that *Fors* should be read as whole consecutively. It may be judged as a whole For my part, I read it through in the shorter form when I wrote Ruskin's *Life*; and I have now read it again in the new longer form. But it does not gain in the process. The incessant digressions, the wild flights of fancy, the lyrical eulogies followed by furious anathemas of indispensable things and illustrious persons, all this incoherent irony and commitation – not with the

merry bad image of Elia or Titmarsh, but in fierce earnest and passionate hot-gospelling – make *Fors* a book to dip into, to take up in a mood as desultory as that of the writer, but not a book to study seriatim and to digest from cover to cover.'

7 Of these the most significant are: *Lectures on Architecture and Painting* 1854; *The Political Economy of Art* 1857; *The Two Paths* 1858-9; *Sesame and Lilies* 1864; *Crown of Wild Olive* 1866. These are followed by all the Oxford lectures, and the late London and Oxford lectures.

8 Especially *Unto this last* 1860 and *Munera Pulveris* 1872 (first published in *Fraser's Magazine* in 1862).

9 The obvious example from each genre is *Mornings in Florence* 1876-7; *Ethics of the Dust* 1866; *Notes on the Construction of Sheepfolds* 1851; and *The King of the Golden River* 1851.

10 For the Ruskin literary circle see B. Maidment, ' "Only Print" – Ruskin and the Publishers', *Durham University Journal*, 63 no. 3 (June 1971): 196-207.

11 Work on both these firms remains to be done. V. Neuberg, *Popular Literature* (London, Penguin 1977), chapter 4, makes the salient points.

12 Unpublished letter in the possession of Mrs D.M.M. Betts, Norwich, and quoted with her permission.

13 Sheila Smith, Countess of Birkenhead, *Illustrious Friends* (London, Hamish Hamilton 1965); J.S. Dearden (ed.), *The Professor: Arthur Severn's Memoir of John Ruskin* (London, Allen & Unwin 1967); H.G. Viljoen (ed.), *The Brantwood Diary of John Ruskin* (New Haven and London, Yale University Press 1971).

14 A full account of these difficulties can be found in my 'John Ruskin and George Allen', unpublished PhD thesis, University of Leicester 1973.

15 E.H. Scott, *Ruskin's Guild of St. George* (London, Methuen 1931), p. 133.

16 Manchester Central Reference Library, for example, has a fine collection from which I have drawn much of the factual material in this section.

17 E. Mackerness, *A Social History of English Music*, 2nd edn (London, Routledge & Kegan Paul and University of Toronto Press 1966), pp. 203-5, gives an account of Mary Wakefield.

18 R.B. Stein, *John Ruskin and Aesthetic Thought in America 1840-1900* (Cambridge, Massachusetts, Harvard University Press 1967); J. Autret, *Ruskin and the French before Marcel Proust* (Geneva, Droz 1965); H.R. Hitchcock, 'Ruskin and American Architecture, or Regeneration Long Delayed', in *Concerning Architecture*, (ed.) J. Summerson (London, Allen Lane 1968).

19 An early, and still very convincing, model for such study can be found in F.D. Curtin's 'Aesthetics in English Social Reform: Ruskin and his Followers' in *Nineteenth Century Studies*, (ed.)

H. Davis, W. De Vane, R. Bald (Ithaca, Cornell University Press 1941). Curtin discusses Morris, Hobson, and Patrick Geddes.
20 The useful work would be a comparison of Victorian with Edwardian parodies and satires. See B. Maidment, 'Ruskin and *Punch'*, *Victorian Periodicals Review*, 12, no.1 (Spring 1979): 15-22.

13

Afterword: Ruskin and the Institutions

Robert Hewison

'*No true* disciple of mine will ever be a "Ruskinian"!' (24.371). When Ruskin wrote these words he could not know that a hundred years later students of his work would be calling themselves Ruskinians, nor that they would savour this additional irony. His words, in their context, paradox and meaning, are a direct challenge to any would-be explicator of Ruskin, for this typically Ruskinian statement follows typically Ruskinian procedures, and demands a typically Ruskinian method of analysis. And if we are to be logical about Ruskin's paradox, we should reverse its terms, and admit that to be truly Ruskinian, we must at all costs avoid discipleship.

I do not intend to devote the rest of this essay to these ten words, and like Ruskin I must take the detail for the whole. But in order to demonstrate what I mean by Ruskinian methods of analysis, and because this particular detail *does* illuminate the whole, I must try to explain a little more about the typically Ruskinian aspects of the aphorism, aspects with which readers of this volume will have become familiar.

To begin with, there is the total obscurity of the location of what has become one of Ruskin's more celebrated phrases. Its obscurity is such that the bibliographical complexity of the context alone is a rewarding study: the phrase appears in Ruskin's 'Preface' to the fifth section of a part-work, *St Mark's Rest* (1877-84), that went out under Ruskin's name, although two sections, including the majority of the section under discussion, were written by assistants. Technically, this is the Preface to the 'Second Supplement' of *St Mark's Rest*, the fifth part in order of publication, issued

April 1879, later becoming chapter eleven of the work in volume form. The work was never completed as projected, and its original appearance as a series of small maroon pocket books gives a totally different impression from the tidied-up and impressively mounted production in volume 24 of Cook and Wedderburn's Library Edition of the *Works*, the standard text for most writing about Ruskin today. Bibliographical complexity is linked to biographical complexity, for although the Preface is dated 'Brantwood, 26th January, 1878' a tail-note by Ruskin is dated '6th March, 1879'. The note refers discreetly to the first interrupting bout of madness that struck him down in February and March 1878.

These bibliographical niceties are necessary, for not only do they help to dramatize the serious consequences of Ruskin's madness, they also explain some of the reasons for Ruskin choosing to make the statement in the way that he did. Stripped of the religious overtones to which Ruskin is plainly alluding, the term disciple applies to one who follows another in order to learn from him. Ruskin is introducing the work of James Reddie Anderson (1850-1907), who as an undergraduate at Balliol had been one of the diggers at Hinksey, and who had assisted Ruskin in Venice in the winter of 1876-7. He was therefore a suitable candidate for treatment as a Ruskin disciple. This biographical information helps to explain the imagery of Ruskin's paradox, for Anderson had been, literally, the pupil of the Slade Professor. In explaining why he must introduce the work of another, Ruskin establishes his terms of master and pupil in reverse, with a witty description of himself as schoolboy dismissed by his master at the very moment when the pupil is ready to take his education seriously.

It is now, having sketched some of the bibliographical and biographical background, that we can put Ruskin's paradox in its wider literary context:

> I imagine the sorrowfulness of these feelings [of being a dismissed schoolboy] must be abated, in the minds of most men, by a pleasant vanity in their hope of being remembered as the discoverers, at least, of some important truth, or the founders of some exclusive system called after their own names. But I have never applied myself to discover anything, being content to praise what had already been discovered; and the only doctrine or system

215

peculiar to me is the abhorrence of all that is doctrinal
instead of demonstrable, and of all that is systematic
instead of useful: so that *no true* disciple of mine will
ever be a 'Ruskinian'! - he will follow, not me, but the
instincts of his own soul, and the guidance of its Creator.
Which, though not a sorrowful subject of contemplation in
itself, leaves me none of the common props and crutches
of halting pride. I know myself to be a true master,
because my pupils are well on the way to do better than I
have done, but there is not always a sense of extreme
pleasure in watching their advance, where one has no
more strength, though more than ever the will, to com-
panion them. (24.371)

In this broader context - and the necessity of long
quotation is emblematic of the need for long reading when
studying Ruskin - Ruskin's key phrase is only one paradox
among several. He denies - he, the tireless investigator, list-
maker, collector and rearranger - ever trying to discover
anything; he dogmatically states that his one dogma is
absence of dogma. He makes himself humble, and congratu-
lates himself on being a true master. He says that he has
given up, but he wants to go on.
Such use of paradox requires a special method of inter-
pretation. To borrow a phrase out of context from Alan
Lee's essay, we need a 'dynamic analysis' that keeps a hold
on the moving line of argument without grasping it so tightly
that its sustaining energy is lost. It is, after all, through his
dialectic of paradox that Ruskin animates his argument.
Similarly, we must always keep in mind the dialectic between
what Ruskin is writing, and the personal and intellectual
context in which he is writing it. There is but a modest
exaggeration in R.H. Wilenski's comment that: 'There is
hardly a page of his writings which can be properly appre-
hended until it is collated with the condition of his mind and
the circumstances of his life not only at the general period
within which the book falls, but on the actual day on which
that particular piece was written.'[1] If we extend this to the
intellectual sphere, and try to establish what Ruskin was
reading at the time he was writing, the context, and so our
understanding, will be enlarged. Contributors to this collec-
tion, notably Patrick Conner and Nick Shrimpton, of course
consider the question of sources and influence, but there is

216

still a great deal of work to be done in this field. David-Everett Blythe has shown how extensive the range of reference can be.

So far, I have subjected Ruskin's phrase to what I believe are typical, and necessary, methods of explication, which can cope with the confusion, the long-windedness, the contradiction that can be such irritants when reading Ruskin. (I do not have the space here to discuss the sustaining system of symbols that unifies many of his disparate arguments.) The fact that the obscurity of the actual location of Ruskin's statement, let alone the obscurity of its meaning, is at least partly attributable to Ruskin's interrupting madness means that special, biographical allowances have to be made. Are not then Ruskinians, when they follow such procedures as those I have applied, trying to justify Ruskin, rather than explain him, just as Ruskin's paradoxes quoted above try to justify himself? Are we not guilty of special pleading?

I have, of course, in making this case, exaggerated in typically Ruskin manner. The procedures I mentioned, thorough knowledge of text and context, bibliographical and biographical disciplines, awareness of the cultural influences acting and reacting on the writer, are as necessary for reading Norman Mailer (as George Landow reminds us) as for reading Ruskin, and there is nothing, at base, in the methods which I have described as typically Ruskinian that are not applied to any other writer. None the less there are ways in which writing about Ruskin demands a unique approach, for Ruskin is himself unique. That is the simplest way in which he meant that no disciple could be a Ruskinian.

That Ruskin was agitated by the problem of disciples underlines the special relationship he developed with his public, and by extension, with us his public now. That he was *right* to be agitated by discipleship is confirmed by Brian Maidment's discussion of what happened when his direct contact with the public was broken off, and he became revered, rather than learnt from. When writing of the major figures of the nineteenth century, we do not in general speak of Dickens disciples or George Eliot disciples, nor even of apostles of Carlyle or the other Victorian sages. But Ruskin's personality seems to have exercised a special fascination over some (though by no means all) of his contemporaries. I believe this

to be true also today, and while the obvious scandals and oddities of his private life made him a biographical case-study long before people began to examine his ideas seriously, Ruskin's personality affects even those now carrying out the most rigorous investigation of his work. Empathy, if not sympathy, seems a necessary part of a Ruskinian's equipment.

Again, there is not space here for a biographical study, but there are ways in which the unusualness of Ruskin's personality affects the distinctive nature of his work, and so its interpretation. (To the unsympathetic, this is another example of special pleading.) As a demonstration, I offer a brief consideration of Ruskin in relation to that abstract entity, the Institution. An institution, of course, is not an abstract entity when it exercises its function of promoting its interests and regulating its members in the light of the conventions it wishes to impose; institutions are established and run by individuals, but their effect is to create an abstraction: the principle and practice of the institution to which the individual member must defer, or become an outsider. Ruskin never got on with institutions.

Ruskin's training, for education is the means by which the individual is prepared for the institution of society, did not particularly mark him out for a non-conformer. True, the familiar facts of his childhood would suggest otherwise, but Professor Van Akin Burd's researches in *The Ruskin Family Letters* have shown that his early days were not as toyless and companionless as the toyless and companionless Ruskin of *Praeterita* would have us believe. His religious and intellectual education as an Evangelical romantic was, if rigorous, conventional, and the fact that he did not go to some unreformed public school of the 1830s is hardly surprising. Before entering the adult world he was sent to what his father considered was the best possible institution to prepare him for what he would encounter: the gentlemen commoners' table of Christ Church College, Oxford. It is with conscious irony that Ruskin sums up his father's ambitions for him in the most institutional terms:

His ideal of my future, – now entirely formed in conviction of my genius, – was that I should enter at college into the best society, take all the prizes every year, and a double first to finish with; marry Clara Vere de Vere; write poetry as good as Byron's, only pious; preach

sermons as good as Bossuet's, only Protestant; be made at forty, Bishop of Winchester, and at fifty, Primate of England. (35.185)

Ruskin did win the Newdigate Prize, if he did not get a double first, but the interruption of his studies by illness seems less unusual when we find that his Christ Church friend, Henry Acland, experienced a similar breakdown. He did not become Bishop of Winchester, but his religious doubts, and then loss of faith, were entirely typical of the mid-Victorian spiritual crisis that affected many besides himself. As for his not taking up a recognized profession, that is entirely understandable in the light of his father's wealth and wishes.

The first time that we find Ruskin in any difficulties is with the institution of marriage. The annulment placed him in some social isolation, not that he minded particularly, since it was Effie's desire to go out into 'society', and his boredom with it, that had contributed to the failure of the marriage. The long love affair with Rose La Touche that followed was partially a victim of Effie's revenge, but the passion of an older man for a young girl is not so unusual, indeed seems a particularly Victorian feature.[2] For another example of erotic attraction to virginity, we need look no further than to a Christ Church friend of a later period, the Reverend Charles Dodgson. It is with Ruskin's public life, though, that we are most concerned, and it is clear that he was prepared to join and work within public institutions, from the Geological Society, of which he became a Fellow in 1840, to the Metaphysical Society and the Mansion House Committee for the Relief of Paris. However, his relations with these bodies were never particularly happy, and his knowledge of practical politics, in spite of his breakfasts with Gladstone, slight.

Ruskin's institutional difficulties truly began with the articles in the *Cornhill Magazine* in 1860 that were later published as *Unto this last*. His proud profession of ignorance of economics, ably confirmed here by Alan Lee, is just one more Ruskinian paradox to add to the list, but it is more significant, so far as the present argument is concerned, as an example of Ruskin's refusal to accept institutional categories of function. However far Ruskin had stretched the categories of architectural history in *The Stones of Venice* –

and John Unrau's contribution suggests that he broke them altogether – he was still operating within the terms of critic and historian. A direct intervention in the science of economics was an attack on the categories themselves, regardless of the implication of what he said. (A refusal to respect the categories, and the institutions that enforce them, can be demonstrated on a purely technical level, as Dinah Birch has done with Ruskin's science, where he is trying to remake the categories and reorganize the accumulation of knowledge.)

The result of Ruskin's intervention in economics is well known. George Smith, Ruskin's own publisher as well as publisher of the *Cornhill Magazine*, ordered Thackeray as editor to cut short the series of articles. Ruskin was refused access to that particular institution, and the same thing happened with *Fraser's Magazine* and *Munera Pulveris* in 1863. We can see why Ruskin turned to publishing his own journal, *Fors Clavigera*, and indeed to publishing his own books. We can also see why his election as first Slade Professor of Art at Oxford in 1869 was so important to him.

In May 1875, noting that it was the fortieth anniversary of his matriculation at Oxford, Ruskin wrote: 'Looking back, it seems to me as if I had been rebelling in the Wilderness forty years, and were now only received again by the University as her prodigal son' (37.166). Oxford was the institution that had formed him, and he was susceptible to the style and traditions it represented. Further, since he was not interested in conventional politics (Jeffrey Spear points out this important difference from William Morris), education was the primary means by which he hoped to promote his ideas. Conversion of Oxford to his views would have a vital influence on the future leadership of the country. Above all, this was the first time that a major institution had not merely honoured him, but, as he saw it, invited him to participate positively in its affairs.

Ruskin thought he had two allies at Oxford from his earlier days at Christ Church: Henry Wentworth Acland, and Henry George Liddell who had been a young tutor when Ruskin and Acland were undergraduates. Acland, while establishing a medical practice in Oxford, had devoted his life to University politics, so that he was simultaneously Regius Professor of Medicine, Professor of Clinical Medi-

cine, Radcliffe Librarian, and a Curator of the Bodleian Library; similarly Liddell had risen to be Dean of Christ Church, and was Vice-Chancellor of the University between 1870 and 1874. Both Acland and Liddell were Curators of the University Galleries, and it is hardly surprising that both such powerful men were on the committee that elected Ruskin as Oxford's Slade Professor. For his part, Ruskin recognized that Oxford must be treated with respect. Writing to Acland on 19 August 1869 to accept his appointment, he assured Acland and Liddell:

> The last ten years have ripened what there was in me of serviceableness, and chastised much of my hasty stubborn and other foolish, or worse, faults – more than all that had happened to me in former life – and though much has been killed and much spoiled of me – what is left is, I believe, just what (if any of me) will be useful at Oxford. I believe you will both be greatly surprised for one thing – at the caution with which I shall avoid saying anything with the University authority which may be either questionable by, or offensive to, even persons who know little of my subject, and at the generally quiet tone to which I shall reduce myself in all public duty. (20.xix)

But the prodigal son did not keep this promise to behave, and he found it necessary to resign from this, the institutional pinnacle of his career, not once, but twice. Ruskin's letter to Acland of 1869 should be contrasted with one written to him a decade later:

> You and I *can't* talk about the future of Oxford. All our past talks were really play; and now, after being taken down into Hell as I was last year, I've no more mind for play – about serious things. Oxford has *no* future to look to, or think of, God only knows what is to happen to her, and He will tell her, in his own time. In the meantime, she is no more a University – but a mere shop of adulterated knowledge – poisoned to the customers' taste – which is principally for skulls patched with venereal disease – and new shops and streets – such as have been opened since I came in 70. I have no more talk to give her – or her customers.[3]

What went wrong? According to Ruskin the University was wary of him from the beginning; he accused Acland: 'you tried to stop up my mouth at the very first lecture!'[4] The authorities may have felt that they had cause for concern, for although Ruskin's first series, *Lectures on Art* given in 1870, are presented in a very disciplined manner, even at his inaugural lecture he could not resist a peroration that alarmed his supporters, for it began by announcing that essential Ruskinian principle: 'The art of any country *is the exponent of its social and political virtues*' (20.39). As the course of lectures progressed through the following years the style of presentation became more relaxed and extempore, and more and more Ruskin's characteristic method of discourse led him to stray across the categories, from engraving to economics and mythology in *Ariadne Florentina* (1872), to lectures on ornithology in 1873 and geology in 1874. For Ruskin 'the teaching of Art, as I understand it, is the teaching of all things' (29.86), but this was not what the authorities had in mind for the Slade Professorship.

Ruskin offended the University in other ways besides interweaving art and social criticism. The popularity of his lectures (for he usually had to give them twice) caused jealousy, not respect, among the senior members, who did not appreciate his use of the lecture-platform to be outspoken about University affairs. He gave particular offence by criticizing the Michelangelo and Raphael drawings in the University Galleries (22.77-108), and when he launched the Hinksey road building experiment he appeared determined to bring the University into disrepute. But Ruskin's reasons for trying to get undergraduates to level roads and lay drains show just what it was that made him disenchanted with the University. In a letter already quoted by John Hayman, he wrote to Acland:

> I am resolved now to let the men understand what I mean
> by useful art. I have waited patiently for five years to
> see if any good comes of lecturing. None does, and I will
> go at it now otherwise.[5]

It was less the ridicule in *Punch* than the lack of support from the University, that made him bitter about the failure of the project. He wrote in his diary in September 1876: 'how I shall give it them this year, the Masters, for not helping me at Hinksey' (*D*3.906).

Ruskin's most embittering experience was over the Drawing School that he founded, for here the University was prepared to accept his money and gifts of works of art, but gave only half-hearted support in return. Far from helping Ruskin, Acland and Liddell forced him to compromise. Art classes were already in operation in the University Galleries where Ruskin wished to establish his school, classes that followed the government-run 'South Kensington system' which Ruskin abhorred.[6] His own school was intended to be a criticism of the national system, but both Acland and Liddell, besides being Curators of the University Galleries, were also members of the governing body of the Oxford School of Science and Art which Ruskin wanted to dislodge. Ruskin got his Drawing School, but he was forced to accept the former headmaster of the Oxford School of Art, Alexander Macdonald, as his own Drawing Master. The school was never run to Ruskin's satisfaction, and after his final resignation as Slade Professor he tried to have Macdonald dismissed. Acland and Liddell protected Macdonald, and the man whose 'position in the school was false, and his teaching useless', enjoyed Ruskin's salary as Drawing Master for fifty years, not dying until 1921.[7]

Ruskin's first resignation as Slade Professor in 1879 was partly the result of his first complete breakdown in 1878, partly disgust with the verdict in the Whistler libel case, revealing as it did for Ruskin the absurdities of the institution of the law. When he recovered his health and spirits, he tried once more to come to terms with Oxford, and in 1882 asked to be reappointed. But this only led to a second resignation, more bitter than the first, when Ruskin and others in Convocation lost the battle to prevent funds being allocated for a laboratory for the newly created Waynflete Chair of Physiology. The first Professor held a licence to conduct experiments on live animals, and Ruskin, who had once used his own Professorship to attack 'the vanity of surgical science' (22.98) for its deleterious effect on the art of Michelangelo, feared that the laboratory would be used for vivisection. In this last battle with Oxford Ruskin had no hope of success, for the leader of the pro-laboratory faction was Henry Wentworth Acland.

Ruskin's disappointment with Oxford seems entirely justified: he was allowed to operate in its institutions provided he neither said nor did most of the things his reputation had

caused him to be invited to Oxford for. He summed up the reasons for his failure at the beginning of 1886, in a new introduction to his first Oxford lectures, the *Lectures on Art*:

> Men of the present world may smile at the sanguine
> utterances of the first four lectures: but it has not been
> wholly my fault that they remained unfulfilled; nor do
> I retract one word of hope for the success of other
> masters, nor a single promise made to the sincerity of
> the student's labour, on the lines here indicated. It would
> have been necessary to my success, that I should have
> accepted permanent residence in Oxford, and scattered
> none of my energy in other tasks. But I chose to spend
> half my time at Coniston Waterhead; and to use half my
> force in attempts to form a new social organisation, – the
> St. George's Guild, – which made all my Oxford colleagues
> distrustful of me, and many of my Oxford hearers con-
> temptuous. My mother's death in 1871, and that of a dear
> friend [Rose La Touche] in 1875, took away the personal
> joy I had in anything I wrote or designed: and in 1876,
> feeling unable for Oxford duty, I obtained a year's leave
> of rest. (20.13)

Ruskin's special pleading is an invitation to consider what happened when, disenchanted with others, he tried to establish his own institution, the Guild of St George.

Regardless of the dangers of such pleading, it has to be admitted that Ruskin's mental disorders, which virtually prevented all decision-taking after 1889, did not help the proper functioning of the Guild. At the same time other institutions, such as the Board of Trade, hampered Ruskin to the extent that although he announced his plans in 1871, the Guild did not come into existence formally until 1878. Even then, Ruskin had been forced to compromise, and change the name to 'Guild' from 'Company', because the law could not accommodate a Company that did not seek to make a profit (28.628-9). But the stark contrast has to be acknowledged between Ruskin's plans and his achievement. In *Fors Clavigera* Ruskin projected a world where:

the fortunes of private persons should be small, and of

little account in the State; but the common treasure of the whole nation should be superb and precious things in redundant quantity, as pictures, statues, precious books; gold and silver vessels, preserved from ancient times; and gold and silver bullion laid up for use, in case of any chance need of buying anything suddenly from foreign nations; noble horses, cattle, and sheep on the public lands; and vast spaces of land for culture, exercise, and garden, round the cities, full of flowers. (27.121)

In actuality he acquired a few acres of woodland in Worcestershire, some slum cottages at Barmouth in Wales, three-quarters of an acre of rough ground at Cloughton near Scarborough, and thirteen acres of poor farmland at Totley, near Sheffield, occupied at first by a group of squabbling would-be communists who later had to be removed. Even the one practical achievement, the Museum of the Guild of St George, standing on its own ground at Walkley in Sheffield, is brought down to its proper size by this report in the *Sheffield Daily Telegraph*:

> set amid squalid surroundings, and free from the slightest architectural adornment, the outer aspect of the building was forbidding – tolerable in summer, but bleak and cheerless in the months of winter. The truth must be told that the people for whom Mr Ruskin had done so much refused to climb the painful slopes, flanked by unsightly blocks of bricks and mortar, to reach the little temple of art, and so it gradually, but surely, came to be regarded as utterly inaccessible. Nor was that all. Within its humble walls the costly treasures were cribbed, cabined and confined, and either piled in neglected nooks or thrust into positions which robbed them of half their beauty. And in addition to this the place was beset with restrictions of a most irritating nature.[8]

The truth is that as an institution the Guild of St George was a failure, and responsibility for that failure was Ruskin's.

The reasons for this failure lie in precisely those aspects of Ruskin's nature that were such a refreshing challenge at Oxford. His refusal to respect the categories led him to 'thinking out my system on a scale which shall be fit for wide European work' (28.424), for his scheme had to be total,

taking in all aspects of social and economic organization, with an elaborate hierarchy of duties and responsibilities for Guild members, a system of education for their children, museums, libraries containing Guild books, and such details as designs for dress and coinage. But apart from a general 'statement of creed and resolution' (28.419-20) and the articles of association under which the Guild was registered with the Board of Trade, there was no coherent description of the scheme Guild members were supposed to follow. (Not that it was easy to become a member of the Guild, since acceptance depended on Ruskin's judgment of a candidate's probationary behaviour in correspondence.) *Fors Clavigera*, that most individual of Ruskin's writings, was the vehicle of his ideas about the Guild, and he would from time to time point to certain Letters, as at (28.650):

> These state clearly what we propose to do, and how:
> but for the defence of our principles, the entire series
> of Letters must be studied; and that with quiet attention,
> for not a word of them has been written but with purpose.
> Some parts of the plan are confessedly unexplained, and
> others obscurely hinted at; nor do I choose to say how
> much of this indistinctness has been intentional.

No wonder the would-be disciple felt baffled.

At the same time, Ruskin's refusal to respect the categories meant, as he well knew, that he spread his attention far too wide, and dissipated his energies. Writing despairingly of Oxford, he would blame the Guild (20.13-14, above), writing of the Guild he would say that his true work was at Oxford (28.236). This led to the absurd position that having established an authoritarian organization that only he could understand, he claimed that he was totally unfit to lead it: 'I am only a makeshift Master, taking the place till somebody more fit for it be found' (28.644), he explained, pointing out that he could not even obey his own rule, that members should live by the work of their hands. Yet Ruskin relished his lonely and pathetic state: 'Such as I am, to my own amazement, I stand – so far as I can discern – alone in conviction, in hope, and in resolution, in the wilderness of this modern world' (28.425). As if to confirm this, Ruskin quarrelled with supporters like Acland, and there is a sad pattern of disillusion with the humbler men who were

called upon to assist his schemes. Ruskin tried to sack
Macdonald from the Drawing School and he wanted to
replace the Curator of the Guild Museum, Henry Swan.[9]
He quarrelled with George Allen, and it would appear that
the success of his publishing enterprise, which restored his
fortune and led to profound changes in the book trade, was
due more to the patience and business acumen of George
Allen than to Ruskin's self-indulgent publishing habits. In
the end, as Brian Maidment has shown, Joan and Arthur
Severn found it simpler to present his admirers with a
surrogate Ruskin. The real Ruskin and the surrogate Ruskin
struggle for dominance in the pages of Cook and Wedderburn's
Library Edition.

Does it matter that Ruskin was the only true member of
the Guild of St George? In the end, no. *Fors Clavigera* was
an argumentative letter, employing all the varieties of tone
we hear in conversation. The Guild of St George was an
extension of his discourse, his practical and impractical
schemes were gestures, challenges, ways of getting people to
act and think for themselves. He was quite right to say that
he was unfit for responsibility for others; what he wanted
was that people should be, not his devoted disciples, but
responsible for themselves. That is why there is no coherent
dogma laid down for the members of the Guild to follow.
'The ultimate success or failure of the design will not in the
least depend on the terms of our constitution, but on the
quantity of living honesty and pity which can be found, to
be constituted' (28.436). Ruskin certainly demanded com-
mitment, but not to the extent of surrendering responsibility
for oneself. Similarly, he chose to be vague about the precise
organization of his institution, for precision falsified:

> I am wrong, even in speaking of it as a plan or scheme at
> all. It is only a method of uniting the force of all good
> plans and wise schemes: it is a principle and tendency, like
> the law of form in a crystal; not a plan. If I live, as I said
> at first, I will endeavour to show some small part of it in
> action; but it would be a poor design indeed, for the
> bettering of the world, which any man could see either
> quite round the outside, or quite into the inside of. (28.235)

So we are left with another Ruskinian paradox, a one-man
institution which even that one man did not claim fully to

understand. But that self-dramatization is a clue to the fascination Ruskin exercises over those who study him today. He uses his own personality as part of the argument, sometimes commanding, sometimes self-deprecating, but always managing to attract our sympathy, not just for his views, but for the man who is expressing him. John Rosenberg's masterly analysis of *Fors Clavigera* Letter 20 demonstrates how Ruskin places himself at the centre of the piece, as a suffering human being, and we suffer the shriek of the steam-whistles with him. It took Ruskin time to perfect the technique, for it is not easy to project oneself without distracting from the argument. Contemporary Ruskinians find this imaginative skill seductive, which explains why Ruskin's later rather than early works have attracted the most attention in this collection.

Finally, we must ask whether Ruskin has not himself become an institution. The publication of these essays, with a primarily academic audience in mind, would suggest that he has. The old Ruskin Societies have disappeared, but there is now a flourishing Ruskin Association that reflects the Ruskin 'industry' that has grown up as more and more studies of his work are published. For the sake of Ruskin's ideas, and for a truthful apprehension of the nineteenth century, it is entirely right that this should be so. Yet there are aspects of his work that give hope that, if Ruskin has become a 'subject', then he is a subject like none other.

Ruskin's disrespect for categories makes him as hard to fit into a University course as it was to accommodate the first Slade Professor of Art, and as a later Slade Professor, Kenneth Clark, has remarked: 'As so often in studying the nineteenth century, we shall be astonished at the tolerance of academic circles compared to those of our day.'[10] The teaching of Art may be 'the teaching of all things', but the teaching of art history is another matter, and art historians are wary of his wayward methodology and misattributions. Literary critics are faced with an imaginative writer who wrote no fiction other than a fairy tale, and his literary judgments are no more straightforward than his artistic ones. Analysis of his prose style for its own sake is only narrowly rewarding, and there is the daunting fact that Ruskin, to be read at all, must be read at length. (This is written at a time when most

of his work is out of print, and the once ubiquitous second-hand volumes are hard to come by.) According to the categories he was neither philosopher, scientist nor economist. Only the vague genre 'cultural history', of which Ruskin was a pioneer, can accommodate all the facets of his work, but that genre is so vague, and its methodology so unestablished, that Ruskin may yet escape academic institutionalization.

As a Ruskinian, I am delighted that this should be so, even if it reduces the academic profitability of our work. This does not mean that I am committed to Ruskin's political, religious or cultural view of the world, far from it, for that would mean being a Ruskinian in Ruskin's sense of the word. To learn from Ruskin we must follow him into the labyrinth of his writings, but the true disciple of Ruskin will find his own way out.

NOTES

1 R.H. Wilenski, *John Ruskin* (London, Faber & Faber 1933), p. 10.
2 Admirers of Ruskin should read Effie Millais's letter to Mrs La Touche reprinted in W. James, *The Order of Release* (London, John Murray 1947), p. 255.
3 Bodleian Library Oxford, MS Acland d. 73, folio 149 (no date, but the context strongly suggests late 1879).
4 Bodleian Library, Oxford, MS Acland d. 73, folio 162 (9 February 1882).
5 Bodleian Library, Oxford MS Acland d. 73, folio 106V (no date, possibly spring 1874).
6 I have written a full account of Ruskin's foundation of the Drawing School in the introduction to *The Ruskin Art Collection at Oxford: The Rudimentary Series*, to be published by the Lion & Unicorn Press, Royal College of Art. Stuart Macdonald's *The History and Philosophy of Art Education* (University of London Press 1970) gives a detailed account of the 'South Kensington system'.
7 Bodleian Library, Oxford, MS Eng. Lett. C. 49, folio 79 (2 November 1886).
8 *Sheffield Daily Telegraph*, 14 April 1890. The past tense is used because the Museum had just been moved to Corporation property at Meersbrook Park, Sheffield.
9 Ruskin Galleries, Bembridge School, Isle of Wight, letter of Ruskin to Joan Severn, 25 July [1882], BEM MS L43.
10 K. Clark, *Ruskin at Oxford: An Inaugural Lecture* (Oxford, Clarendon Press 1947), p. 5.